Photography for Architects

We live in a world driven by images, but with so much visual noise, is anyone really looking? How does an architect ensure their portfolio is within view of the right audience? Photographs are still as vital to architectural practice as they ever were. However, creation and circulation, once in the hands of skilled professionals, is now perceived as being 'free' and within easy reach of all. But where is the clarity? What is the message? By setting out the case for curated image making, considered photography may again be placed at the centre of architectural marketing strategies.

Photography for Architects guides the reader through various topics: from establishing a visual brand and sharing images online, to producing content in-house and commissioning professionals. It explores the still and moving image, creating books and exhibitions for legacy value, compiling award entries, and engaging with trade press. Little understood aspects regarding legal rights and obligations, ethics, copyright, and licensing images for use are discussed in clear language. Multiple photographic examples and conversations with international practitioners highlight the various themes throughout.

Written by a working architectural photographer whose life has been spent in commercial practice, this easy-to-read, richly illustrated guide is essential reading for architects and designers alike who are working with images and image makers.

Martine Hamilton Knight DLitt (Hon), FHEA is a professional architectural photographer with over three decades of industry experience. Her images are published worldwide in books, journals, and have been the subject of several exhibitions, most recently with her photographs for Sir Nikolaus Pevsner's *Buildings of England* series of guidebooks.

Awarded an honorary doctorate by the University of Nottingham in 2012 in recognition of her photographic work, the last ten years have seen Martine's practice widen to encompass speaking and teaching. She has run professional development seminars for a number of organisations across the UK including the Royal Institute of British Architects and hosts regular workshops for The Royal Photographic Society. A senior lecturer on the BA and MA courses at Nottingham Trent University, Martine continues to shoot commercially and also offers a consultancy for practices seeking advice on photographic procurement and management.

www.builtvision.co.uk

T0392715

Martine Hamilton Knight

Photography for Architects

Effective Use of Images in Your Architectural Practice

Routledge
Taylor & Francis Group

LONDON AND NEW YORK

First published 2024
by Routledge
4 Park Square, Milton Park, Abingdon, Oxon OX14 4RN

and by Routledge
605 Third Avenue, New York, NY 10158

Routledge is an imprint of the Taylor & Francis Group, an informa business

British Library Cataloguing-in-Publication Data
A catalogue record for this book is available from the British Library

Library of Congress Cataloging-in-Publication Data
Names: Knight, Martine Hamilton, author.
Title: Photography for architects : effective use of images in your
 architectural practice / Martine Hamilton Knight.
Description: Abingdon, Oxon : Routledge, 2024. | Includes bibliographical
 references and index. | Identifiers: LCCN 2023012418 (print) | LCCN
 2023012419 (ebook) | ISBN 9781032189109 (hardback) | ISBN
 9781032189116 (paperback) | ISBN 9781003256953 (ebook)
Subjects: LCSH: Architectural photography. | Architecture and photography.
Classification: LCC TR659 .K59 2024 (print) | LCC TR659 (ebook) | DDC
 778.9/4--dc23/eng/20230712
LC record available at https://lccn.loc.gov/2023012418
LC ebook record available at https://lccn.loc.gov/2023012419

ISBN: 9781032189109 (hbk)
ISBN: 9781032189116 (pbk)
ISBN: 9781003256953 (ebk)

DOI: 10.4324/9781003256953

Designed and typeset by Alex Lazarou in DIN Printed in the UK by Severn, Gloucester on responsibly sourced paper

COVER CREDITS

Front Cover
Row One
01 Wall and moon in Fuerteventura. Ph: Martine Hamilton Knight
02 National Centre for Sport and Exercise Medicine, Loughborough University by Broadway Malyan. Ph: Martine Hamilton Knight
03 British Library Centre for Conservation, London by Long & Kentish. Ph: Peter Durant
04 Victoria Leisure Centre, Nottingham by Levitate Architects. Ph: Martine Hamilton Knight
05 Armada Housing, S'Hertogenbosch by BDP. Ph: Martine Hamilton Knight

Row Two
06 Winter Park Library, Florida by Ajadye Associates. Ph: Ron Blunt
07 Maggie's Centre, Dundee by Gehry Partners LLP. Ph: Keith Hunter
08 Derby Arena by FaulknerBrowns Architects. Ph: Martine Hamilton Knight
09 Residential Interior, London by Nicholas Jamieson Architects. Ph: Sally Ann Norman
10 Residential Interior, Nottingham by Brightmans. Ph: Martine Hamilton Knight

Row Three
11 Vitra HQ, Basel by Frank O. Gehry Associates. Ph: Richard Bryant
12 School of Engineering, University of Leicester by James Gowan and James Stirling. Ph: Martine Hamilton Knight
13 Salesforce Park, San Francisco by Pelli Clarke & Partners. Ph: Tim Griffith
14 Timekeepers Square, Salford by Buttress Architects. Ph: Daniel Hopkinson
15 Island Rest, Isle of Wight by Ström Architects. Ph: Hufton and Crow

Back Cover
All photographs: Martine Hamilton Knight
01 Lace Factories, Nottingham by TC Hine
02 Graystacks, Nottingham by Omni Developments
03 No.1 Nottingham Science Park by Studio Egret West
04 HDTI, University of Coventry by Associated Architects
05 Theatre Royal, Nottingham by Frank Matcham

MIX
Paper | Supporting
responsible forestry
FSC® C022174

CONTENTS

PART 3
Where seen and where next?

PART 4
Legal and ethical

Afterworld

ACKNOWLEDGEMENTS

Writing *Photography for Architects* was the outcome of serendipity. It followed a conversation about an entirely different idea for a book on photography and architecture, one which remains as a 'what if' for now. It placed me in touch with Fran Ford at Routledge, an action which has resulted in the most enjoyable of working relationships. I am incredibly thankful for her belief in someone who has worked on several books as photographer, picture researcher and project manager, but whose role as an author of something on this scale was untested. The wider editorial team have been just as rewarding to work with – Hannah, Alanna, Alex, Emily, and no doubt others at Routledge who I will come to know as this book reaches its audience, thank you.

As a long-established photographer in the field, my career has meant forging links with architects, consultants, magazine editors, journalists and other architectural photographers. These professional relationships have often evolved into friendships, ones I value dearly. Together with the goodwill from previously unencountered industry experts who've agreed to my request for information, to partake in interviews or provide material for inclusion, I am incredibly grateful. I must take this opportunity to single out several people who have gone above and beyond to ensure safe passage of this book. These stemmed from ideas hammered out on my mac after returning from photographic shoots or giving university lectures, morphing into something more tangible and, hopefully, readable.

To my fellow photographers, some of whom are amongst my oldest friends, Ron, Richard, Keith, Sally, Dan and Peter, thank you for sharing your wise words and your work. For Tim, Nick and Allan, your vital insights and generosity in jumping on board from the first second I called; this book greatly benefits from your pictures. I hope we all collectively, visually make a compelling case for why we believe great images make a difference to our clients.

To my long-established clients and industry colleagues, together with more recent connections, Alex, Isabel, John, Liz, James, Keleigh and Stewart, I am enormously grateful for your time and viewpoints, your interviews contribute immeasurable value to my own voice. For every client I've worked with over the last three-plus decades, if your work is in here, then it is because your buildings and the stories taking place in and around them perfectly illustrate the points I wish to make. Thanks also to Philip and Alison who allowed me to photograph their home for Chapter 3.

Of course, exposing views and evaluating the worth of your own voice is a risky endeavour. To my most wonderful reviewers, Richard, Jon, Chris and Joshua, thank you for your interventions, informed insight and kindly guidance. This script reads a thousand times better as a result of your generous time. I would never have thought to encapsulate the points for image making into the wider cycle of design and delivery and this took an architect's perspective – I am so grateful.

To Lynne who has followed my career since the very start, your mentoring and friendship means so much. Thank you for believing in me. Finally, to the three most important people in my life – my father, husband and son, Dennis, Paul and James; you're the reason the sun shines brightly in my world, and this book is dedicated to you.

FOREWORD
LYNNE BRYANT

With a life in photography, architecture and media, Lynne has travelled extensively visiting old and new buildings partnering her husband, photographer Richard Bryant, on assignment to seminal locations. Her texts have been widely published and for ten years, she wrote features on architecture and interiors for German and Australian publications.

Founder, and for many years owner, of Arcaid Images, a resource for photographs of the built world, Lynne was also Chairman of the British Association of Picture Libraries and Agencies. In 2012 she pioneered the Architectural Photography Awards and was instrumental in founding the cross-cultural Global Sino Photo Awards. She is Honorary Chairman of the Architecture Club, established in 1922 to encourage interest and discussion among the wider public. Lynne is not an architect.

The American Embassy, London
designed by KieranTimberlake
– Ph: Richard Bryant

Now that 'everyone's a photographer', the importance of good architectural photography has increased because of the myriad images that potential clients (and award judges!) encounter every day. Architectural photography can enhance our understanding of design, rather than merely recording what is there.

An extract from text by *Paul Finch*,
Programme Director, World Architecture Festival[1]

I have spent my working life immersed in architectural imagery and texts, working with architects, design practices, trade, and consumer publications worldwide, through analogue to digital.

There have been substantial changes, laws have tightened for professionals, but to date, many of the Instagram generation dive in and appear to 'get away with it'. It will be a tough ask, changing this attitude and an impossible task to police – but for professionals it is imperative to abide by the rules.

Images drive interest.

Images in reports and communications increase engagement, 91% of consumers prefer visual content to written content[2], and, according to researchers from the Massachusetts Institute of Technology, the human brain can process entire images in as little as *13 milliseconds*.[3] Forget the elevator pitch[4] – if you are competing for an award or commission, that's 13 milliseconds to grab attention.

You must do the very best to represent your work and your practice. That means patience and some expense. Patience – I've known practices rush to have images ready for an award or publication deadline.

Don't do it.

You may be pleased at the time to have met the deadline but a few months later when the building has settled down and the weather has improved, you'll look back and regret it. You'll even blame the photographer for not getting the best out of the building.

Expense – Creating a building takes years and yet so little time is budgeted for the photography. Find a way to build in the cost, perhaps share with contractors. Don't wait until it's all over. Think of photography at the beginning when everyone is still excited.

You are building a legacy not just an award submission. Architecture is complicated, its story has many elements – a story that includes a combination of information and intrigue.

Build a relationship with a photographer, understand each other and there will be a consistency that helps consolidate your brand.

In this publication, Martine is providing much needed, in depth advice to anyone specifically involved in architecture. A great deal of this publication's content is transferable to other areas of photography and should be on any public relations agency reading list.

The best images will win.

1 "The Best Photographs of the World Architecture," Press release of the Architectural Photography Awards, 8 November 2022, https://pressat.co.uk/releases/the-best-photographs-of-world-architecture-380914ad9a6c31110de466f1bbf45646/

2 Zohar Dayan, "Visual Content: The Future of Storytelling," *Forbes*, 2 April 2018. www.forbes.com/sites/forbestechcouncil/2018/04/02/visual-content-the-future-of-storytelling/

3 Anna Trafton, "In the Blink of an Eye," *MIT News*, 16 January 2014, https://news.mit.edu/2014/in-the-blink-of-an-eye-0116

4 A brief talk or pitch intended to sell or win approval for something, as a product or business proposal: a two-minute elevator pitch to a prospective investor.

INTRODUCTION

In this book:

1. Points for emphasis are in italics.
2. Publications/book titles are in italics.
3. On first introduction, technical terms and phrases are in bold.
4. Some chapters use footnotes. These feature especially in sections concerning historical and legal matters where further reading/online viewing is suggested. Other sources are referenced in the almanac at the rear of the book.
5. Some of the people who feature in the book are personal friends and professional colleagues. Others, I've had the pleasure to come to know through my research. Once introduced, dependent on the context of the narrative, I mostly refer to them by their first name.
6. Where photographs taken by other practitioners are used, I credit them, along with the architect and location. In all other instances, photographs or photographs used in third party documents and publications are mine.
7. I have written in the first person and am addressing *you* personally. In matters accepted as common in either knowledge or practice to both myself and readers, I use 'we', 'us', 'our'.
8. Who 'you' are will vary. This book is aimed at sole practitioners, staff-team members and practice heads. There will be readers who are *not* qualified architects: students and aligned professionals – engineers, surveyors, public relations consultants and interested photographers. As such, there will be points where it's you behind the camera, and your budget spent on kit to shoot with. *Or*, it might be you taking pictures, but the directives and the financial decision-making sit at another level.
9. 'Where' you are is also relevant. Whilst a book of this nature is specialist, its publication reach is broad. I have written from the perspective of a professional trading in the UK, but also looking at approaches in the EU, North America and Australia. There are visual examples and shared experiences of photographers, architects and industry professionals based in the UK, North America and Australia. To reach further, by citing practice and legal matters in other continents is best left for other opportunities.

Why are we talking about pictures?

Ask an architect about the value of images to them and doubtless they'll assert that the photographs in their portfolio are of importance in explaining their work to their clients. Yet these images are often accrued in a haphazard manner, their cataloguing and storage unmanaged with materials and format not standardised. Indeed, all manner of vagaries and varieties could conceivably exist under the same roof, in an unregulated and non-user-friendly form.

Why? This book sets out to challenge such a method of acquisition and image management.

For the majority of *audiences* for architecture, familiarity with the subject is through pictures rather than tangible physical experiences. Shouldn't the administration of such a vital asset to one's business take top level attention at all times?

Yet, for most practices, the value of photographic images representing the nature of work undertaken is little considered; they're simply accepted as being 'required' in some form or other, but the detailing of such matters is frequently left open to interpretation.

So, again, why?

Statistics

We can readily assert that architects are extremely busy people, whose primary attentions are concerned with the actual design of buildings, as opposed to the documentation of them. According to the RIBA (Royal Institute of British Architects) *Business Benchmarking Executive Survey 2022*, in the UK qualified practicing architects number some 44,300.[1] Once qualified, the vast majority work within small practices. Over 50% of all revenue comes from private housing where there are ten employees or less.

The Architects' Council of Europe's 2021 report: *Architecture, Passion or Profession?* states that of the 500,000 architects listed across 30 countries (excluding the UK), 93% of practices employ five people or less and 65% are sole practitioners.[2]

According to a report released by statista.com in 2021, of the 22,122 firms canvassed in the USA, 13,696 were trading with four or less employees. If you place that into the context of some 116,000 registered architects, small practices are the mainstay of the industry. In January 2023, AACA's website (Architects Accreditation Council of Australia) noted that of the 11,800 registered practicing architects, only 1.6% of firms employed 20 or more people, and 34% were sole trader status.[3]

This implies that the thrust of marketing and promotion of their work is down to architects themselves working within their (mostly) small scale enterprises, rather than to outsiders. It means taking photographs of their projects and understanding how to best use them in their brand building or knowing how and when to call in the professionals. Certainly, the decision making for the lion's share of practices falls into their own hands daily. However, as any architect

1 "Business Benchmarking 2022 Summary," *RIBA*, 1 December 2022, accessed 21 May 2023, www.architecture.com/knowledge-and-resources/resources-landing-page/business-benchmarking.

2 "Architecture: Passion or Profession?" *Architects' Council of Europe*, accessed 21 May, 2023, www.ace-cae.eu/fileadmin/user_upload/Publication_on_new_business_models.pdf.

3 "Architects in Australia," *AACA*, accessed 21 May, 2023, https://aaca.org.au/architectural-profession-in-australia/#.

understands, the ability to focus one's attention on such matters is not ever likely to be a daily, weekly or even monthly occurrence.

If you consider when a conversation last took place about photography within your own circumstances, it may well have been at a moment when you've been asked to prepare a pitch for a new project at extremely short notice, or because someone suddenly noticed that the annual industry award deadlines for entry were within the following week. Panic!

How can you avoid this type of situation from arising within your company? Regardless of whether you are a team of one, five, 50 or 500, it will pay to have a visual strategy, one that places your brand and image right at the *heart* of your practice.

This book aims to position you at the centre of visual decision making, because statistically, as we've seen, the bulk of its readership is likely to be in the form of sole practitioners, closely followed by those who reside within the context of an SME (Small to Medium Enterprise). For SMEs, you may be solely responsible for procuring images, or one of several people in the team who are asked to pick up a phone or camera and document what's going on.

However modest the scale of practice is, it never hurts to aim high, and I have taken care to research across the profession at both ends of the scale. Interviews have been conducted with sole traders utilising a planned approach to image procurement, along with highly curated strategies being pursued by architectural firms working to a far greater market share. Some of these have clientele straddling international boundaries and employ dozens of qualified individuals across multiple locations. Voices from the world of architectural media have been consulted, as have experts in print and online communication.

Photographs are everywhere

The following extract is something that we might recognise as the reality of our everyday life with pictures. It is a life dominated by capturing photographs with our phones and navigating the web with image driven websites showing us resources, materials, architectural projects, etc. It is a life where our business and social communication is broadly exchanged via social media platforms and illustrated documents which accompany our exchanges via email and 4-colour printed documents.

> Today the eye of the modern man is daily, overfed with images. In nearly every newspaper he opens, every magazine, in every book – pictures and more pictures. … This kaleidoscope of changing visual impressions spins so rapidly that almost nothing is retained in memory. Each new picture drives away the previous one.

When do you think this was written (notwithstanding the outdated gender norms)?

Answer: it appeared in an article by German writer Paul Westheim titled 'Bildermüde' in *Das Kunstblatt,* 16 March 1932.

Does that seem astonishing?

It illustrated that since the invention of photography and therefore the ability to create countless reproductions of the regional without any loss in quality, distribution of images had become straightforward. Mass dissemination of this visual communication means that each successive generation has seen themselves as being surrounded, indeed swamped, by images. Westheim spoke of 'image-weariness' and almost a century later, we might readily concur with that sentiment.

Photographs and photographers

I am a British photographer and in the 1990s my work was predominantly commissioned by the UK architectural press and commercial clients. Latterly, my working life has seen me blending my shooting schedule with that of illustrating books on historic architecture, together with lecturing on undergraduate and postgraduate photographic courses. My network of peers in the industry, many of whom have contributed to this book, allow the photographic discourse to have an authority which should give readers both clarity and confidence in what they will read in the chapters ahead.

Certainly, as Ron Blunt, one of my lifelong professional contemporaries based in the USA has stated,

> The democratisation of the medium does impact professional architectural photographers' ability to make a living – more of the work is shot in-house or casually on a phone. On the upside: the main commodity that an architectural photographer offers to a client is not the access to, or knowledge of technology, but rather, their unique vision, compositional skills, and overall learned experiences of shooting the built environment.[4]

This means that the collective photographic voices herein acknowledge that we, as professional practitioners, may not be called upon as regularly as we perhaps might have been in times past. However, we – and this book – understand that architects could and *should* be participant in the manner in which their visual voices function. Moreover, we sense that there is a *partnership* to be had, whereby some of that language is spoken firsthand by designers themselves. Equally, there is still a need for expression by a specialist individual who understands both the subject at hand *and* the means of conveying it in a way which lends communicative resonance to both the design process and end-client confidence.

A win-win for all.

How to use *Photography for Architects*

Part 1 of this book looks at how photography might currently be embedded in your professional life. It explores how visual images shape the way you understand the built environment just as profoundly as your physical encounters with it, and how this came to be so.

It then takes a practical approach to developing a framework for effectively using photographs with your practice – as part of a meaningful brand strategy. How you procure your images may currently be part of a considered approach, or not.

4 Ron Blunt, personal conversation with author, 28 December 2020.

Part 2 places you in the driving seat. – Are you:

- Making pictures with your phone?
- Using a dedicated camera to record your work?
- Employing others to make meaningful creative interpretations of your built folio?

Any of these methods may result in you using the outcomes for your online and physical outputs, with still or moving images. When, where and how you go about this is the subject of several chapters. A typology is introduced, placing photography into the wider cycle of your project production and delivery.

Part 3 examines what you do with images once you have them, making them work for a living, long after you have pressed the shutter button. We discuss how relationships with others aligned to the industry, – especially those who add written or spoken language to pictures and help spread the word about your work. Are you considering entering awards? Creating books? Putting your work on show? Making your visuals communicate effectively for your business when you're *not* there to do so personally is vital.

Finally, in **Part 4**, we explore some of the legal implications of doing so. There are intellectual property considerations for any creative and artistic output. Your design work falls into this bracket and certainly photography does. What do copyright laws mean for you? Geography from the standpoint of image capture plays a part in this and so does the nature of how you use the work afterwards.

And what of ethical considerations towards those we encounter in our buildings and daily life? How do the rights of people and the living world factor into our image making? Added together with the commercial and legal implications of licensing which allows images to live on and circulate long after you have moved onto your next project is the final topic. The book concludes with a useful almanac; a resource for further reading and services which may support your photographic endeavours.

In summary, this book is about two things: it is written for architects and built environment specialists, but from a photographer's perspective. It recognises that:

1. Owing to the digital revolution, visual literacy has expanded, and the number of photographic images seen via various communicative media forms has vastly increased.
2. Architectural photography serves to *bring buildings to life* and also proves that powerful architectural images are influential in a myriad of ways. Indeed, the very best may stay in view 'forever'. Just how we go about ensuring this outcome for ourselves is the challenge for every image maker and every designer.

▷ Part 1

What & why?

▷ CONTEXTS AND FRAMEWORKS

Foundations of the architectural image in print and press

Before formulating meaningful strategies for marketing your architectural practice, you should consider how photography might best function within that framework. Therefore, it is sensible to begin by providing some context for the genre.

Throughout the history of architectural photography, there has been a recognised and very distinctive way of picturing the built environment. The 'look' of an architectural image has foundations which go back to the emergence of the medium of photography itself. How and why? Later in this book, you will need to decide what this means for *you* and *your architectural practice*, and how you direct your own visual voice. Whilst this first chapter is more an 'essay' compared to other sections of the book, it makes sensible background reading. Understanding the framework for why something is like it is forms a really important bedrock for shaping one's own opinion.

▷

For most of us, our first encounters with buildings are via looking at pictures as opposed to our physical interactions with them. Indeed, much of our knowledge of architecture is only ever through the circulation of written and visual information on printed or web pages.

Richard Bryant's photograph of Gehry Partners' Vitra HQ in Basel, Switzerland was widely published at the time, but only a small number of those who know it are likely to have ever visited the location to see this building in three dimensions.

How do we encounter buildings?

As readers of *Photography for Architects*, most of us will have done our formative learning about the architectural industry via books, journals and the web. These impressions will have been gained alongside formal teaching and insights from our leaders and role models, both in education and commerce.

Our understanding of how buildings and environments are conceived, designed and executed will have been through the illustrations of such structures. It could be argued that the most meaningful of these encounters will have been shaped by photographic representations.

This view is widely shared. Adrian Boddy, Australian photographer and academic from Sydney's University of Technology wrote:

> There is no doubt that photography influences architecture. It is the principal means of communicating new architectural constructs and processes in various forums, including photographic exhibitions, audio-visual presentations, architectural journals, television and the press. Architectural photography presents its audience – architects and the general public alike – with new perspectives on buildings and the built environment. Comparatively little knowledge of recent architecture is gained by first-hand experience: so much happens in architecture around the world that most of it can only be known through images.[1]

Whether it was the 1950s Californian Case Study Houses of Richard Neutra et al., seen in glossy Taschen books, or the sound of Thursday's *Architects' Journal* dropping on to the doormats of UK workplaces in the 1980s and 1990s, for many senior practitioners in the industry, the *printed page* formed the backbone of that global architectural awareness. Today, more than print, it is the e-journals of *ArchDaily* and *Dezeen* which place us 'in the know' as we ride trains, trams or sit with coffee in our home offices first thing in the morning.

We return to the importance of online journalism later in *Photography for Architects*, but it is the printed periodical where we begin the exploration of how buildings are largely seen and understood by an audience.

Print journalism has largely existed on two levels since its inception: either a consumer format or for consumption by a professional market. In each output, aligned product advertising takes place. For the consumer press, the readership is engaged through an informative conversational editorial form, peppered with advertising for the products and accessories associated with the structures discussed. Many interviews are with the actual users of the architecture, the homeowners or travellers who interface with these environments. Aspirational lifestyles and celebrity endorsements are encapsulated and since the introduction of 4-colour print on press stands, the use of polychromatic palettes has been vital.

Conversely, for industry press, journalistic and peer review has been the norm. Until relatively recently, the need to evaluate a project in full colour has been deemed unnecessary and, indeed, more costly for the (largely subscription based) professional journals.

So, what are the characteristics of architectural images in the press?

1 From A. Boddy, Australian Architectural Photography and Architecture Australia – www.adrianboddy.com/?p=683

2 See later in this chapter for a description of large format cameras and their operation.

A potted history of the medium – representations of architecture in photographs

Plenty has been written about the early history of architectural photography and the photographers whose individual styles of work were seen to influence certain characteristics of modern design. From the first experimental photographic materials of the mid-1800s until the digital revolution of the early twenty-first century, contemporary architecture of the day has almost exclusively been captured by specialist photographers working on sheet film and **large format cameras**.[2]

It is worth outlining a few key moments in the development of the medium along with practitioners whose work typified each era:

- In the 1830s, Henry Fox Talbot in England and Joseph Niépce with Louis Daguerre in France almost simultaneously developed methods of capturing reality using lens-based material. The built (static) environment became a natural subject for their attentions, especially in a period where exposure times were long. For almost a century, emulsion-coated glass plates brought design to an audience who might never see such structures in real life but would inherently be able to appreciate and understand them through the medium of photography.

▷

Cameras have come a long way since their first development. The top image shows two film cameras – a replica of a nineteenth century large format plate camera, and its more familiar counterpart – a **35mm SLR** Nikon. The bottom picture shows the contemporary digital cameras, a **DSLR** Canon and an iPhone. We discuss the tools of the trade in *Ch. 4 Calling the shots 1.2: Which camera system is best for you?*

- As developments in the printing press allowed affordable mechanical reproduction (now with photographs as opposed to drawn illustrations), architectural photography could be used for both trade and consumer editorial purposes. For our industry, journals such as *Architectural Record* (1891), *Architectural Review* (1896), *Architectural Digest* (1920) and *Domus* (1928) began to chart design and structure from across the globe, commissioning their visual narratives from specialist photographers including Francis Yerbury who shot Gilbert Cass's Woolworth Building in New York in 1913 [Fig 1.1].[3]

Fig. 1.1

- In 1920s Europe, Láslo Moholgy-Nagy and the Bauhaus practitioners depicted the first modernist buildings with their simple lines and palettes. The UK's Dell & Wainwright in the 1930s cemented the look of these bold monochromatic spaces in their features for the architectural press whilst John Maltby's images for the Odeon Cinema chain led him to work with Berthold Lubetkin and other modernists.

- Photographer Lucien Hervé worked with Le Corbusier in Europe on projects such as Unite D'habitation in Marseilles – an emerging theme whereby designers aligned with preferred image makers. Sustained relationships between architect and photographer created organic 'brand strategies', and particular partnerships embodied recognisable 'looks' for practice portfolios. Eventually, the two mediums – 3D designed spaces and 2D photographs – became synonymous with one another.

- In this vein, the vibrant staged narratives and formalist lines of American image maker Julius Schulman and his fellow contemporary Ezra Stoller captured mid-century modernism across the United States. Think of the West Coast Case Study houses or Eero Saarinen's TWA terminal at JFK airport, New York and iconic shots instantly spring to mind.

- Acting as a counterpoint to America's colourful glamour, photographer Henk Snoek brought a British post-war sensibility to visual work, whilst fellow photographer Richard Einzig captured Brutalist icons including London's New Brunswick Centre [Fig 1.2].[4] In the southern hemisphere, where a steadily increasing population meant innovation and investment in building, photographer Max Dupain carried the baton for Australia's architects.

3 Francis Yerbury (1885–1970) was a regular contributor to *The Architect and Building News*, *The Architectural Review* and was the first Director of the Building Centre for the Architectural Association. Photo © Francis Yerbury/Architectural Association Photo Library.

4 Brunswick Centre, The Foundling Project, London (1966–71). Architect Patrick Hodgkinson. (One of two plates by © Richard Einzig/Arcaid in this chapter.)

Fig. 1.2

- This structured visual approach employed by the global mainstream architectural press and its image makers was eventually pushed away. For a time, people were placed centre-stage with architecture in a documentary format. This could be seen as part of a wider cultural trend; France's 'Cinema-Verité' – translated as 'truthful cinema' – was a film movement which began in the late 1950s/early 1960s. Thereafter adopted in the USA as 'direct-cinema', it celebrated the ordinary and the everyday. It was seen in the *Architectural Review*'s brave, but heavily criticized, 'Manplan' series in 1969.[5]

These eight special issues were illustrated by English photojournalists including Tim Street-Porter, Tony Ray-Jones and John Donat. They were tasked to provide a documentary response, 'truthful' imagery, using 35mm

△

Architectural Review's Manplan-1 & 2 in September and October 1969. It is hard to reconcile these artworks with orthodox magazine covers, which usually bear titles of features inside the issue in addition to the regular title and logo. Both feature camera lenses in place of eyes and issue 2's artwork is by Wolf Spoer. Photojournalists including Patrick Ward and Peter Baistow capture gritty images of post-war Britain. Coupled with powerful straplines, Ward's appeared in *Manplan-1*, focusing on a month of frustration across the country, whilst Baistow's featured a spread centred on Preston, Lancashire for *Manplan 7*.

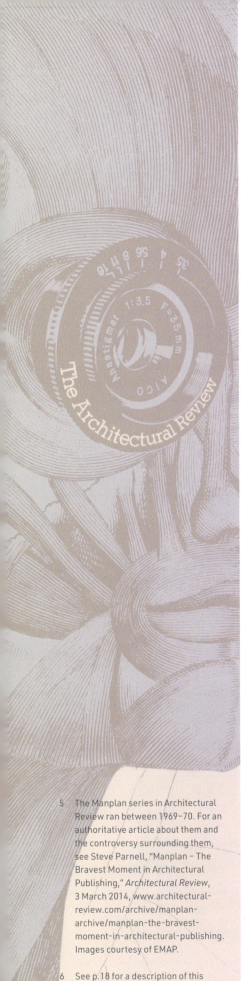

SLR cameras.[6] The liberation from tripods and grids previously employed with **5x4" monorail cameras** (large 'Victorian style' cameras using individually cut film sheets) resulted in sometimes harsh renditions of social housing projects and everyday life. Instead of a brave new world, they portrayed a depressing realism that architects reacted against. Holding a mirror up to post-war Britain's built environment in this way was met by strong resistance from the readership who immediately cancelled their subscriptions in droves.

- In the same period, American Stephen Shore blended the built environment, landscape and documentary photography together in a movement that – with others such as Robert Adams, Lewis Baltz and from the Dusseldorf School, Bernd & Hiller Becher – was championed as 'The New Topographics'. This style of image making placed the work into a fine art market. Throughout the 1970s and early 1980s, Shore was commissioned by practices such as Venturi, Scott Brown, whose built works and writings were the subject of critical discussion in architecture schools both then and today. His colour plates showed mundane views of everyday buildings in a passive and observational manner, which became critically acclaimed collectors' pieces in the archives of New York's Museum of Modern Art (MOMA) and other international galleries.

If you are interested to learn more about the photographic practitioners and their outputs across this period, writings by historians such as Robert Elwall are wholly worth engaging with. There have been notable exhibitions of architectural photography over the last three decades across the USA, Australia, UK and Europe. Much of this catalogue of our architectural heritage is now of interest to a cultural audience and attracts a mixture of revery and criticism for its approaches and forms, not to mention an ever-increasing financial value in the fine art collector's market.

For the purposes of this book however, I have limited desire to investigate such authoritatively explored ground in greater depth. Instead, the focus is to understand whether anything about the way buildings and environments are depicted has *altered* between then (the nineteenth and twentieth centuries) and now.

Historic limits on self-promotion for architects

Rather than being first encountered in printed journals, today's pictures are more likely to be seen via social media or featured in architectural news sites. Much of this dissemination is self-generated promotion, but historically (and technology aside), this was simply not possible.

Even into the twentieth century, architecture was seen as a 'high art', akin to the noble arts of sculpture and painting. It was perceived that a good architect would never find themselves short of commissions. *Competing* for trade was not the 'proper' way to work. Wherever one was situated, the industry simply relied on word-of-mouth referrals, a sort of elite 'club' where patronage was of a high calibre and outcomes of merit were their own referent for more work of the same ilk. More than simply being regarded as 'bad-taste', in 1909, the American Institute of Architects (AIA) forbade the use of even the most basic form of marketing.

5 The Manplan series in Architectural Review ran between 1969–70. For an authoritative article about them and the controversy surrounding them, see Steve Parnell, "Manplan – The Bravest Moment in Architectural Publishing," *Architectural Review*, 3 March 2014, www.architectural-review.com/archive/manplan-archive/manplan-the-bravest-moment-in-architectural-publishing. Images courtesy of EMAP.

6 See p.18 for a description of this camera system.

Architectural firms could not engage in actions that might be deemed 'advertising'. This could have even been the simplest act of putting their firm's name on a board in front of a site during construction, something which we tend to regard today as ethical and informational; absolutely *not* marketing.

The AIA issued fee-scales which banned any form of enterprise, and any competition or brokering had to be held under AIA guidelines. It was seen as a risk that if any one architect charged less than another, there would be a reduction in the quality of the resulting building. Instead, prestige came from repeated recommendations and rather ensured dominance by a few practices. It must have been very hard to become established from the ground up without any form of previous track record nor the means of talking about future ambition, never mind past builds.

This partly explains why early and mid-twentieth century magazine relationships became so pivotal to an architect's exposure. The press had their own independent voice, and this allowed practices to have some traction in front of an audience, both through their professional peers and especially for the residential market, in consumer journalism.

Across the United States and elsewhere, it was this limited status of engagement with a marketplace that made architectural journalism and the exposure of work via the printed page *vital* to the global communication of a nation's buildings. This was the same for both a professional and consumer audience. It sets up the case for why the predominant 'look' of architectural photographs became as they were – they needed to function as a showcase for each project they represented – as well as conveying vital visual information about a building. They were, in effect,

▽

Mid-century covers of *House & Garden*, Oct/Nov 1950 (UK) and *Architectural Record*, mid-May 1965 (USA) show residential designs.[7] Notwithstanding the ban on advertising, in the case of private homes, post-completion access for photography and public exposure is always difficult to arrange. It makes these forms of exposure critical to a firm's commercial success. Indeed, even a century later this continues to be the case.

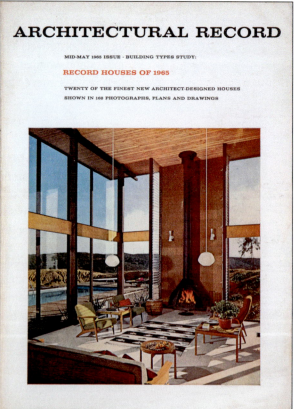

7 *House & Garden* – © Hera Vintage Ads/
 Alamy. *Architectural Record* – courtesy
 © BNP Media/Douglas Simmonds – House
 in Del Ray, California by Frederick Liebhardt
 and Eugene Weston III.

8 Figures 1.3 and 1.4 by courtesy of
 © J. Paul Getty Trust. Getty Research
 Institute, Los Angeles (2004.R.10).

9 Julius Shulman, *Julius Shulman –
 Architecture and its Photography* (Cologne:
 Taschen, 1998), 16.

10 For the estimated values of both Case
 Study House 22 and the images, see "Case
 Study House No. 22, by the Numbers," *Los
 Angeles Times*, 27 June 2009, www.latimes.
 com/home/la-hm-stahlnumbers27-
 2009jun27-story.html. For the photo and
 the story of the house, see Sarah Amelar,
 "A Hidden History of Los Angeles's Famed
 Stahl House," *Architectural Record*, 6 April
 2022, www.architecturalrecord.com/
 articles/15594-review-of-the-stahl-house-
 case-study-house-22-the-making-of-a-
 modernist-icon.

the ticket to the next job – needing to succinctly cover the salient points – facts and potential sales.

Probably one of the most evocative and enduring twentieth century images of residential American architecture is the night shot of Pierre Koenig's 1960 Case Study Stahl House #22. This view of two young women sitting in the window of the glass living room seemingly cantilevering over the Los Angeles skyline by photographer Julius Shulman is so ubiquitous that it barely needs illustrating [Fig 1.3].[8] Shulman, shown working there earlier in the day [Fig 1.4], himself quotes *The New York Times* architecture critic, Paul Goldberger, in his book *Julius Shulman – Architecture and its Photography*, saying;

> *The night scene represented an idealistic image of young people's dreams; what they visualised living in the hills of Hollywood, California could be – without ever having been there! This photograph has impressed all the architectural works and has appeared in practically every architectural magazine throughout the world.*[9]

No one could argue against this photograph not having been subject to extremely careful composition, lighting and styling in order to become the icon that it did. Indeed, today, as it graces book covers and poster art globally, it could be argued that the economic value of this single image has caused the value of the real estate it depicts to be significantly inflated.[10]

The relationship in the twentieth century between architect–photographer–publisher could be seen as transformational, indeed necessary, in communicating work to the public and acting as press release, advert and legacy – 'art' even.

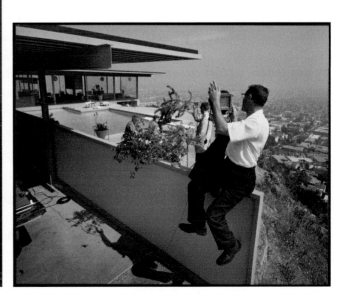

Figs 1.3 & 1.4

The limitation on overt advertising began to change in 1972, when the AIA permitted members to engage in competitive bidding. Not that the flood gates to blatant television or billboard advertising immediately rushed in. Instead, the industry began a restrained and tasteful engagement with its client base. This was largely through increasing awareness of competition wins and professional award successes, or via marketing aligned with memberships of trade bodies and business organisations.

In the UK, commercial promotion was also cautioned. Note 3.2.2. of RIBA's Code of Conduct in January 1981 stated: "It would be contrary to this Rule for a member to submit estimates of fees and expenses knowing that they would be used for the purposes of **competition with other members**."[11]

This replaced an earlier code which had directly instructed members not to "solicit a commission or engagement". It was only by January 2005's edition that the rhetoric had softened to:

> Rule 2:2 – Where members are engaged in **any form of competition**[12] to win work or awards, they should act fairly and honestly with potential clients and competitors. Any competition process in which they are participating must be known to be reasonable, transparent and impartial. If members find this not to be the case, they should rectify the competition process or withdraw.[13]

Whilst this language is not specific to advertising, it is a shift from previous diktat which deemed it unprofessional for members to compete with one another on price. So, until relatively recently, it has been widespread across the industry to discourage the exposure of projects in the interests of gaining future commissions, or directly competing for work. Therefore, the viable means of bringing visibility to projects for others to view, judge and buy associated services was via trade and consumer press.

What eventually emerged was a process of architects directly engaging with journals and their writers to solicit peer review editorials. This was brokered via industry networking opportunities or through working with public relations agencies. However, this is a very recent trend, only gaining traction into the new millennium. We still have a little ground to cover here regarding the more contemporary look of architectural photographs which accompanied this press.

As stated, throughout the twentieth century there was a broadly universal, stylistic approach to architectural photography. This distinctive look was developed partly through the physical attributes of the technical equipment which practitioners were working with, but also the realities and limitations of the subject matter itself.

How do architectural photographs look?

In his book *Shooting Space*, Elias Redstone states:

> ...photography is the ultimate communication tool for architecture. A photograph has the ability to influence and transform the way people perceive and value a building. Although mediated, a photograph can appear more real than the building itself, as it is the image consumed most widely. However, photography is by its nature subjective and presents a highly personalised view of the world.[14]

11 RIBA's own bold font. See Heather D. Hilburn and Will Hughes, "Regulating Professions: Shifts in Codes of Conduct," www.irbnet.de/daten/iconda/CIB6216. pdf, Section 4.2 Observations and Fig 3 which compares the change in wording from 1981–2005.

12 RIBA's own bold font.

13 Heather D. Hilburn and Will Hughes, "Regulating Professions: Shifts in Codes of Conduct," www.irbnet.de/daten/ iconda/CIB6216.pdf, Fig 3.

14 Elias Redstone, Pedro Gadanho and Kate Bush, *Shooting Space – Architecture in Contemporary Photography* (London: Phaidon Press, 2014), 6.

Unlike drawn, painted and photographic portraits, or Hollywood style filmmaking where light is controlled by creatives on the tools, the lighting of architecture as a subject is mostly on a scale far too large to be manipulated. Instead, these vast 3D 'models' require their various attributes of scale, form and material to be conveyed to the viewer and *externally*, at least, this will be by natural means.

If there has been any single aspect which denotes the 'look' of an architectural photograph, it's the fact that nine times out of ten, it will have been made under an open and sunlit sky. Added to this, the desire to have images appear as we actually encounter a building – with parallel walls and removal of the hallmark of 'amateur' photographic endeavours, i.e. converging verticals – results in the characteristics of how traditional architectural photographs appear: boldly lit, high-contrast forms of representation.

△

The Wave, for The University of Sheffield by HLM Architects is shown under cloud, and again, some minutes later in direct sun. Even with a structural form like this, one with plenty of articulation to express scale and shape, it is far more difficult 'to read' as 3D when represented on a 2D page without the assistance of modelling from ambient sunshine.

In almost all types of photographic expression, there is a freedom of the medium which allows a variety of means for conveying a scene, person or object by the individual operating the camera.

This may be through lens choice, viewpoint and varying attributes of light. Even in what may be described as pure news journalism, allegedly 'impartial and faithful' reporting, there may be a mixture of angles of view and varying vantages where capture might be made from. There can be differences in where focus (attention) is placed in a frame. For an example of this, think of a portrait with a blurred background, which places clear emphasis on the individual rather than their surroundings. We explain how this look is technically created in *Ch. 5 Calling the shots: Camera controls and considerations.*

If we speak of architectural views, in the main, they are trademarked with a sharp focus through the image, allowing for critical and close examination of detail across *all* areas. Instead of a 'shallow' field of view, anticipate a 'deep' front-to-back plane of focus. In addition, there are also several 'standard views' which typify the look of the work. Linear elevation shots – **single-point perspective** – reflect typical architectural elevation drawings and show a viewer the direct relationship between 'what-was-planned' and 'what-was-executed'.

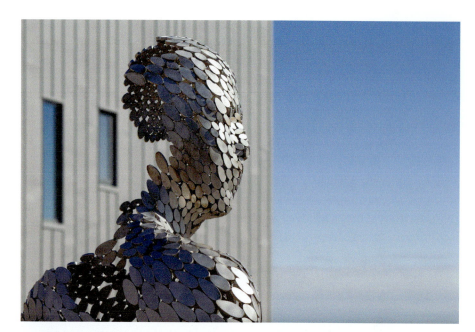

One of the markers of creative photography is the use of a technique to place the attention on a specific subject within the frame through a defined plane of focus. Sculptor Joseph Hillier's 'Cloud Rock Man' is seen crisply detailed, whilst cladding on HLM Architects' Bradfield School in Yorkshire provides a gentle backdrop to the artwork.

This shot of Graystacks, Nottingham by Omni Developments uses single-point perspective to convey the building in a linear form. Only the strong directional illumination from the sun reveals the soffit and fascia of the north elevation. If it was shot in flat light, there would no means of visually conveying change in depth across the facade.

This sets up a strong argument for employing high contrast, directional lighting as a methodology for shooting architecture.

There is also the broadly used **two-point perspective** approach, often employing a wide-angle lens for a three-quarter view to show depth across two elevations.

▷

Elizabethan Wollaton Hall in Nottingham by Robert Smythson is shown utilising classic two-point perspective. Structure, scale, form, and material would be difficult to convey without that powerful key light – aka, the sun. Seeing two sides of the building together with light and shadow falling across them allow a viewer to understand what they are seeing without visiting the location in person.

Finally comes **three-point perspective**, which is employed less frequently. This is seen in two opposing directions in interiors by Associated Architects in Coventry – Severn Trent's HQ looking up [Fig 1.5] and looking down at Coventry University's HDTI [Fig 1.6]. Externally, three-point perspective is one of the hallmarks of drone photography where it is possible to get above a structure and reveal two sides of a building, see *Ch. 7 Moving the story: Video and viewpoint.*

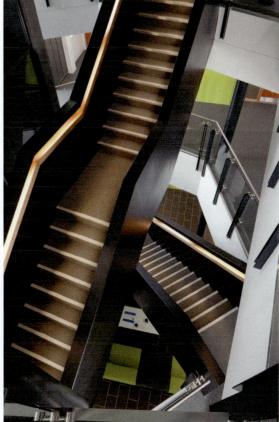

Figs 1.5 & 1.6

The majority of images, however, are made from human eye-height, in the same way as we might encounter buildings in person. As repeatedly expressed in this book, they are usually captured in the highest contrast of lighting conditions (a sunny sky). This approach to showing 3D structure in a 2D form reveals modelling, depth and scale in materials together with relationships to adjacent objects.

An 'uber-realism', bright, bold, graphic – and where colour is concerned, an often highly saturated tonal range – makes some question an image maker's motives. For the art world, this look is often criticised as pure **formalism** (derided because it has no deeper meaning) compared to 'real art', which is often laden with symbolism. Even more accusatory than the employment of formalism is the levy that such images are highly contrived. They might be seen as advocating themselves as 'truthful' in a documentary sense – it's a real building in a real setting – but are heavily constructed by careful and skillful image doctors. We might associate these characteristics with computer software – 'Photoshop re-touching' and Instagram filters – however, image manipulation as a trope is actually as old as the hills.

Is all as it seems?

Just as oil or watercolour painting is a form of **subjective representation**, so is photography. A person with a camera has chosen 'where' to stand and 'how' to show that particular subject. Every image is subjective.

Physically doctored images are not new – image retouching and postproduction is not a by-product of the computer age by any means. Stage management and postproduction is not peculiar to architectural photography either, even though it is one of the forms more overtly associated with it. Victorian photographers were highly skilled manipulators; for example, Henry Peach Robinson staged and blended images when making his fine art pictorial narratives. Building and styling sets, giving direction to his models, shaping light and creating composite pictures by combining multiple negatives in the darkroom gave creative outcomes which would have been impossible to stage as a single exposure.

Even 'documentary' photography was not exempt from intervention. In the Crimean War, Roger Fenton's 1855 scene of a valley littered with canon balls was contrived – he actually moved them across his field of view to create a more dramatic picture. In addition to photographers, architects themselves sought to control how work was shown. Le Corbusier was a skilled doctor of other people's work, in his *Vers Une Architecture* (1923) – he took an earlier frame by Walter Gropius from *Jahrbuch des Deutschen Werkbundes* and removed a dome on the rear right hand side. The contrast was significantly altered and the concrete forms smoothed and delineated in a graphic manner [Figs 1.7, 1.8].[15]

15 From Andrew Higgott and Timothy Wray (eds), *Camera Constructs: Photography, Architecture and the Modern City* (Oxon: Routledge, 2012), 35–46, Le Corbusier and the representational function of photography – Andrzej Piotrowski.

Figs 1.7 & 1.8

The outcome on the right is clearer than its predecessor; the increased contrast and removal of unwanted visual clutter allow the viewer to see the structure more clearly. There are multiple other examples of this type of practice throughout the history of photography.

Technological developments in recent decades

Regardless of whether photographs have been styled or heavily post-produced, the lynchpin for architects since the beginning of mechanised press both sides of the Atlantic has been to earn publicity via esteemed peer review. This has inevitably come through the trade journals representing the profession. Even more significant than industry award programmes, which could be said to allow any sector – cars, food, medicine, etc. – to bask in their own reflected glory, trade journalism was seen as more useful (not to mention legal) to an architect than blatant advertising could be. Because of journalism's own mantra of ethical and non-partisan review, this praise, when won, was deemed well deserved and carried much clout. In this respect, it's possible to see why the use of photojournalists to work on architectural editorials in the 1970s was embraced, even though it also met with resistance for its 'warts and all' approach.

Throughout the 1980s, 1990s and 2000s, the global architectural press had healthy subscription rates and active news-stand sales, supported by robust advertising revenues from building product manufacturers. This meant that they had their own budgets for commissioning renowned freelance writers and photographers, as well curating a well-respected regard for their own staff editorial teams. It was a powerful alliance and a relationship that saw cherished teams of editors with their preferred image makers and architects taking the written and visual voice of the profession to its readers.

By the 1980s, conveying realism for viewers could extend further than when print was simply monochrome. This period saw a technological progression in the print industry which allowed far more economic use of 4-colour print than had been previously possible. Instead of colour covers and the odd (expensive) insert for special features, full-colour layouts could now be achieved throughout a magazine at moderate cost.

Parallel to this, a preference for architectural photography to embrace perspective control was re-established. Shooting in high-contrast lighting conditions to convey scale and form meant that working with physically large camera equipment continued. Controlled, highly technical image making was the order of the day, as seen in the work of Richard Bryant and Dennis Gilbert (UK) and John Gollings (Australia). All received formal architectural or engineering degrees and operated from within the bounds of design principles. Along with USA-based Peter Aaron who trained under Ezra Stoller, these practitioners found no issue in embracing a curated view rather than reacting against it in the way the 1960s and 1970s image makers had.

It is this style of capture which my peers and I trained and traded in, and the cost of doing so was financially high for our clients – shooting was extremely expensive and required specialist labs to process the emulsions. Despite use of contemporary kit built with finely engineered components, the physical appearance of these cameras bore a close resemblance to their Victorian predecessors. A type of film known as colour transparency similar to the consumer market's Kodachrome 35mm slides, but far larger at 5x4", was used. It was slow in terms of its working exposure speed and the cameras were cumbersome, tripod-bound tools. They required a black cloth to shield daylight from the ground-glass screen on the rear and the use of special holders called **dark-slides** which contained individual sheets of film. The cloth was worn over

△
It had become commonplace for photographers to work with colour emulsions far earlier than the point the journals themselves embraced the technology. Richard Einzig's 1976 image of Runcorn New Town (now demolished) by James Stirling was shot in colour but other than the actual cover shot, editorials were usually only in monochrome.

the photographer's head whilst they worked with bellows, spirit levels, lenses mounted on metal plates and a heavy-duty tripod to go with it all.

The act of this type of analogue photography was a spectacle in its own right, turning heads as well as emptying wallets. In Ch. 2 Representation of your work: Constructing your practice brand, an example of this 'dinner and a show' is given.

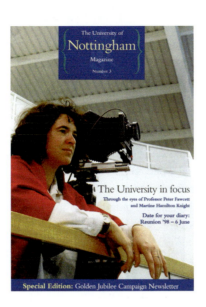

▷

I was photographed with my 5x4" camera – a Linhof Tecnikardan – in conjunction with a feature about my work for the University of Nottingham in spring 1998. The cloth around my shoulders is to shield light from falling on the ground glass screen on the rear of the camera. It is still possible to purchase film for this format but the cost of this, along with the necessary chemical processing makes it fairly prohibitive for regular commercial application today. Ph: ©SBS Photography.

There was a gradual shift in methodology following the digital revolution, as well as some of the financial burden. However, with it also departed the drama, which, frankly, was a pantomime for the right reasons – it stopped traffic and people, who then wanted to help. Photography in the 1980s and 1990s was still exciting, and the act of shooting a new building meant that people would move furniture, open the curtains and generally engage with the endeavour required to make a project sparkle.

Of course, like any style of image making, architectural photography on film could be conducted with smaller camera equipment than the 5x4" kit, but there was an elitism associated with the large format, not to mention the ability to make walls appear straight, a look impossible to achieve with most cameras. A little like driving a nice car, if a practice could justify the approach, they were inclined to embrace it, plus the technical and aesthetic outcomes rewarded those who made the jump. Certainly, the industry press accepted it as the preferred material for submission for their cover shots and editorials.

Digital capture

In 2005, Canon became one of the first manufacturers to introduce an affordable digital 35mm camera body with a play-back review screen on the rear. Polaroid as a proofing technique became virtually obsolete overnight, and the economic values in Kodak, Agfa and Fuji, as producers of film, plummeted. Eventually, some 130 years after it began, global supplier and household name *Eastman Kodak* filed for Chapter 11 bankruptcy in January 2012. Citing debts of $6.75bn, it was a sorry end to a venerable stalwart which had a market value of $31bn only 15 years earlier.

The rest (as they say) is history. Digital cameras became the norm for professionals and enthusiasts right across the image making sector. In addition to levelling the playing field for photography in terms of image capture methodology, by association, it also reduced the financial burden for clients and sped up production time. The digital revolution profoundly affected the print industry too. Even by the turn of the century, and whilst film emulsions were still ubiquitous for image capture, the postproduction side of things had begun to modernise. There was a gradual replacement of the 4-colour lithographic press into one of digitally led print production.

The requirement for output of physical photographs also diminished as clients changed their requests from printed brochure outputs to those via CD and DVD, presented via computer screen. There were big redundancies in the print industry as the millennium came to pass. As the web took over as a primary broadcaster for multiple businesses and mass-communication, the printed page waned. Advertisers retracted, news-stand sales dropped, subscription revenues fell and job losses followed across architecture's modest trade press. The clout of the architectural journalist to make or break the careers of individuals, their buildings and even whole practices were reduced, and with it the precious relationship of the photographer as go-between for each respective party.

Challenges to stylistic interpretation of the subject

As mentioned in the photographic timeline on p.8, there have been various backlashes against a 'curated' appearance in images, with mixed success. Over and above the Manplan issues of the *Architectural Review* in 1969–70, the British architectural press has had other pushes against the prevalent style of the industry's photographs. *Architects' Journal* brought out two issues titled *The Craven Image* in 1979 in which guest editor and photojournalist Tom Picton attacked the industry's continuation of making images conveying "necrophilic excellence" which "march across the pages of architectural magazines like tombstones in a graveyard." Ouch. Even on the cover of the second issue, on 1 August 1979, the photographer Richard Einzig is quoted as saying: "I think magazines and the architectural photographer are all in the public relations business whether they like it or not."

Photographers throughout history have understood what they are being commissioned to achieve. They comprehend that the relationship between all three parties, photographer–editor–architect, in promoting the work is intrinsic. For the works themselves, they are documents of truth to a degree; after all, they show what is designed and constructed. However, they are also controlled, styled and therefore contrived in their underlying need to showcase to past, present and future clients what is on offer for the price.

Australian photographer John Gollings stated in 1994 that he recognised;

> *A symbiotic relationship has always existed between architects and their photographers. Both professions are commercial arts depending on patronage and working with the inherent limitations of client requirements*

and budgets. Photographers need good buildings to photograph and publish for a living, architects depend on good photographs to promote a design or attract new clients.[16]

Yet every now and again, someone will provoke a negative reaction against the prevalent tide. In 2012, *The Guardian* journalist Owen Hatherley was interviewed for London's *The Photographers' Gallery*,[17] wherein he berated modern architectural photography seen in websites such as Dezeen and Archdaily. He accused them of being; "utterly disastrous..... glossy images of buildings that you will never visit, lovingly formed into photoshopped, frieze-dried glimmers of non-orthogonal perfection, in locations where the sun, of course, is always shining."

Dezeen's response was interesting in that it noted the fact that architecture is still recorded conventionally in the main – i.e. in static photographs, despite the availability of new technologies. Naturally, they carried on by defending their reporting, with chief editor Marcus Fairs stating:

> *Rather than being ‹utterly disastrous' for architecture, sites like Dezeen are a powerful new platform for presenting and discussing architecture in new ways, in front of bigger and more diverse audiences than the old magazines (and their hermetic writers and critics) ever managed to reach. It's a huge opportunity.*[18]

In contemporary times, the use of smartphones to simply 'click' and immediately disseminate what's in front of the lens could be described as one type of move against such formalism. This said, the on-board software algorithms in a phone embed saturation and reduce contrast, changing the result even before we're offered the chance to use in-app editing filters to enhance the outcome even further.

Today, documentation of a project throughout its build process is commonplace for social media dispersal. This might be via ad-hoc capture with a phone during site visits by those involved in the build, or by more remote means, for example permanently fixed time-lapse cameras. There may be a need for visual documentation from a legal standpoint too, and such images do not need to be aesthetically endearing, they simply need to record time-sensitive evidence, hence the opportunity to automate the process.

As it was 30 years ago for me and my contemporaries, the true investment point for photography is a set of 'hero' images on completion. These definitive image collections supplement social content generation and are expected to work very hard for the client in their immediacy for awards and publicity as they always have. However, today the critical budget belonging to an editor is missing from the equation. In my career, I have witnessed a significant shift away from calls for my images to record completion of a project and support peer review by magazine editors. Instead, it is now architects themselves who will pass pictures forward for publication and review. Today, the role of the photographer, journalist and architect is still intertwined, but far more loosely than in the twentieth century.

16 Gollings quoted in "Constructive Images: The Nexus Between Architecture and Photography," *Adrian Boddy Photography*, accessed 21 May 2023, www.adrianboddy.com/?p=678.

17 "Owen Hatherley on Photography and Modern Architecture," *The Photographers' Gallery*, 10 December 2012, https://thesandpitdotorg1. wordpress.com/2012/12/10/ photoarchitecture1/.

18 Marcus Fairs, "Architecture 'No Longer Interested in Anything but its Own Image'," *Dezeen*, 12 December 2012, www.dezeen.com/2012/12/12/ architectural-photography-owen-hatherley/

Summary

Since the 1970s (in the USA at least), architects have had more freedom in their ability to speak about their practice, and to use photography of this ilk to advertise their work. Over the last 15 years, the role of image-text as news for our industry has been mostly conducted via a server, either as internal comms for larger companies or via the web to a globally unknown, unseen, but occasionally very vocal audience. The world-wide web has completely changed the one-way traffic of press-release/news mass media broadcast into a two-way traffic of broadcast and commentary. Despite a more overt link to sales and publicity for editorial picture making, it is only very recently that in the UK, at least, the weekend broadsheets have begun to feature actual box advertisements for architectural practices. These reflect a growth in interest for home improvements, ably assisted by multiple 'makeover' TV shows and social media channels.

Print press is still with us, but far more modest in its physical iteration, whilst the online platforms for traditional architectural titles create accessibility and attract readership in greater numbers than they perhaps ever did when they were in print. Despite their large global audience, advertising revenues are not significant enough to support sizeable editorial teams. Some of the same names who were regular scribes in the 1990s are still at their keyboards, writing about the news and developments across the built environment, just as they always did. *Ch. 10 Getting your story out: Working with journalists* looks at how these contemporary relationships work, and *Ch.11 Social media: Disseminating your brand online* examines the means by which much of the messages are propagated.

Despite several documented challenges to the genre, there is a 'look' to architectural photography. It is generally very finely detailed, invariably bold and colourful. The scene depicted may have been subject to 'enhancement' in some form or other regarding styling or editing in order to highlight the best features of the subject. These photographs hope to convey a great deal of information about the design and setting of a building to educate and inform the viewer concisely about what is there – the next best thing to actually being present on site in person.

As a result, this book takes the stance that the language of *commercial* architectural photography is largely the following: a representation of the built environment, positioned to reveal a building's design, context and use to its best effect, helping shape future markets.

The prowess of that visual language is dictated by who is 'on the tools', tasked with bringing a project to life. Today, there is a plethora of digital devices to assist image making. The power of directing storytelling and dissemination rests more in the hands of the creators of built environments than ever before, and in the context of this book, that means *you*.

How you go about it, however, is the story of the next 17 chapters.

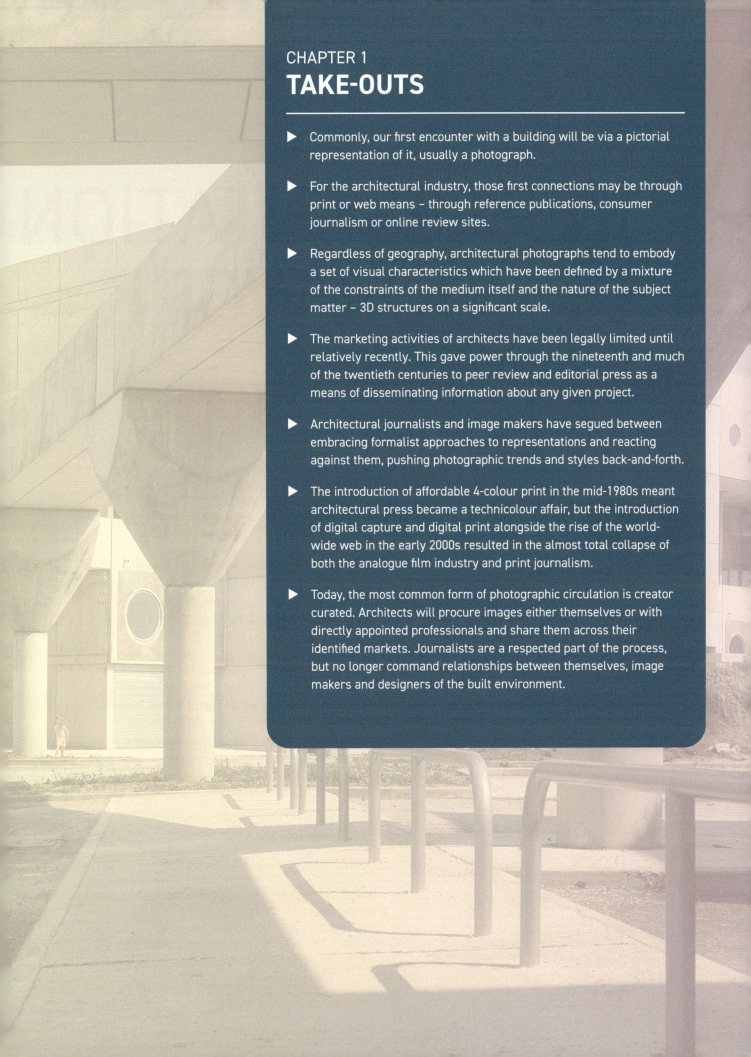

CHAPTER 1
TAKE-OUTS

▶ Commonly, our first encounter with a building will be via a pictorial representation of it, usually a photograph.

▶ For the architectural industry, those first connections may be through print or web means – through reference publications, consumer journalism or online review sites.

▶ Regardless of geography, architectural photographs tend to embody a set of visual characteristics which have been defined by a mixture of the constraints of the medium itself and the nature of the subject matter – 3D structures on a significant scale.

▶ The marketing activities of architects have been legally limited until relatively recently. This gave power through the nineteenth and much of the twentieth centuries to peer review and editorial press as a means of disseminating information about any given project.

▶ Architectural journalists and image makers have segued between embracing formalist approaches to representations and reacting against them, pushing photographic trends and styles back-and-forth.

▶ The introduction of affordable 4-colour print in the mid-1980s meant architectural press became a technicolour affair, but the introduction of digital capture and digital print alongside the rise of the world-wide web in the early 2000s resulted in the almost total collapse of both the analogue film industry and print journalism.

▶ Today, the most common form of photographic circulation is creator curated. Architects will procure images either themselves or with directly appointed professionals and share them across their identified markets. Journalists are a respected part of the process, but no longer command relationships between themselves, image makers and designers of the built environment.

▷ REPRESENTATION OF YOUR WORK

Constructing your practice brand

How do you make your visibility stick?

The control and management of your external voice is a vital element of your business and its ultimate success.

How an audience comes to know your work and its ethos will be through a combination of separate elements. Depending on the age of your business, this expression may be led by an exposition of proposed designs, or in the case of established trading, a balance between projects planned and schemes completed. These visual messages will be shared with your own physical network which connects you (and your team) with your clients.

Placing connections aside, any perception the as-yet *unknown* audience has of your practice will mostly be through the images that they come across in some form or other, as unlike your existing clients, they will not have the benefit of a personal relationship with you. Connecting with these unknown others and, moreover, ensuring the *right* message reaches its intended target and is subsequently remembered is vital.

▷

We are all familiar with brand markers, especially when it comes to consumer products. Cadbury's headquarters in Bourneville, Birmingham by Stanton Williams has the iconic 'glass and a half' logo on the familiar purple™ background in the reception atrium. For UK and Australian-based chocolate eaters, it needs no additional wording to allow us to recognise what we are looking at. How do your clients know you?

Any practice will be keen to share their design output via their own website or social media platform. Having a balance between projects conceived and constructed buildings is sensible. This demonstrates that you have credible design skills and, moreover, can deliver on what you say. Some of these images may be in the form of hand drawn sketches, technical drawings or CGI renderings rather than actual photographs.

Denying a visual link between thinking and doing is understandable if the photographs of completed work you have are poor, or (as is often the case of occupied residential builds) access to photograph the final work is not granted. However, there is a risk in 'parking' a project visually at the CGI concept stage, even if a physical output followed. You may only have neglected to record completed outputs simply because as a practice you have since moved forwards and are now working on fresh sites and with new clients. However, displaying images of active, occupied realities is an imperative, surely?

△
Bond Bryan moved the project beyond the CGI stage and proved an outcome, as seen here in the case of The Power, Electronics, Machines and Control Facility in Nottingham.

A swift trawl of the internet reveals a multitude of websites indicating projects which from their narratives inform the browser that each build is complete and operational, but their visual accompaniments only imply, rather than prove, their reality. Does this inspire confidence in a viewer placing a potential new enquiry?

Remember, your external web presence is your 'shop window', and savvy digital shoppers conduct their fieldwork remotely, only beginning to make their presence known to you when they're already some way towards commitment.

Surely displaying photographs of active, occupied realities is vital, *bringing your designs to life*? Fundamentally understanding how and why good photography can be transformative in this process is vital.

- What do your current photographs do for you and what do they mean for your practice?
- Do they best express your values?

You may need to backtrack and consider the framework for your visual strategy.

It's all in the brand

Do you have a brand ethos? Indeed, do you currently even have a brand?

In the wider world, our knowledge of companies comes through products, their design, their recognisable packaging, words (slogans) and pictures. Famous personalities are their own brands and may in turn be seen to endorse branded products; one party aligned to another, whose values and attributes are seemingly complementary.

Most of us are aware of the 'starchitect' cliché, a term given to a collection of headliners whose work is recognised globally, company names driven by their founders who are synonymous with their output. Their visions and personal presence signify their buildings; 'it's a Foster', or a 'Zaha'. Images of them and their projects across the globe attain an almost reverential status. These structures are known via a clutch of equally iconic images. It is reasonable to assume that not every building which starchitects' practices deliver is legendary. However, the weight and gravitas of the brand grants a wider audience than might be anticipated when set on a level playing field of anonymity.

△
One of Foster + Partners' lesser-known projects, the Djanogly City Academy in Nottingham was an early output for UK Prime Minister Tony Blair's BSF (Building Schools for the Future) Programme. Not a multi-award-winning iconic structure, simply an inner-city school. But by Foster + Partners, nonetheless.

Styles and brands – visual literacy

In architecture school, students learn that working within a specific typology of building may lead to development of a set of attributes through which that building style becomes known. Historically, building types were also driven by the period of construction or availability of certain products and materials, such as wrought iron for the industrial age railway stations. Regional trends, driven by the education and movement of skilled workers, transportation of local materials, coupled with the level and type of patronage all contributed to distinctly recognisable qualities.

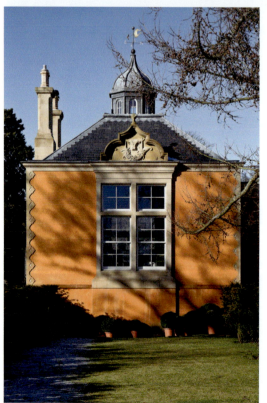

◁ + △
Photographed by Keith Hunter, Bonnington House (1622) near Edinburgh was re-modelled in 1858 in the Jacobean style, with the central block and right wing. Today, as Jupiter Artland, a sculpture park (and home to Charles Jencks' *Cells of Life*), it has been the subject of structural additions and a conservatory was added to the left of the house in the early 2000s. Benjamin Tindall Architects respected the existing architecture in replacing this with a new wing matching that on the right of the house, both balancing it and reflecting the vernacular of the region.

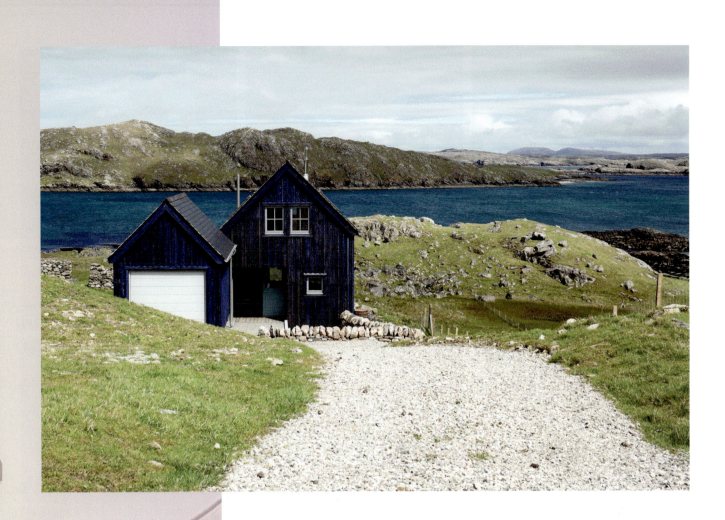

△

Keith Hunter travelled out to
the Scottish Isle of Lewis to
shoot Valtos House by Nicole
Edmunds (Edge Architecture)
who specialises in sustainable and
ecological design work. This small
dwelling embodies a vernacular
synonymous with crofting and
island buildings: simple and
unassuming.

Globalisation, however, has made regional design language far harder to
determine, as today sees parity in materials and construction methods across the
globe. Differences in physical geography, e.g. an earthquake zone, flood plain, etc.,
which previously forced variations in method/output have been largely eroded.

Today, the world traveller may have difficulty knowing where they are when faced
solely with contemporary builds. Given that historically the output of an architect's
hand would be driven in part by their geography and materials, each particular
style (brand) would have a recognisable palette, one which was then sought by
their patrons to embody on their behalf. Today, the built environment is a fully
global export; movement of architects and their design prowess is borderless and
construction technology has largely homogenised outputs right across sectors.

Yet even now, we encounter familiarity of format in many firms' outputs. Students
learn to identify specific structures and therefore each designer by the look of
the work. Despite the negation of localised stylistic traits, certain individual
design typologies are so *distinctive* that visual brand recognition becomes almost
instinctive. There will be a 'house-style' that is recognisably from 'the stable of...',
and that's part of brand recognition., working together with our visual literacy.

Working during the second half of the twentieth century, the following designers
were responsible for work that, for many who encounter it in picture-form, is
easily recognisable:

- Carlo Scarpa
- Irata Isozaki
- Tadao Ando
- Rafel Viñoly
- Stirling & Wilford

- Terry Farrell
- Renzo Piano
- Zaha Hadid
- Richard Meier
- Kenzō Tange

- Rogers, Stirk Harbour & Partners
- Jean Nouvel
- Herzog & De Meuron
- Hans Hollein

- Frank Gehry
- Daniel Libeskind
- Peter Zumthor[1]

With the caveat that many readers have received an architectural education, you will be part of a group of people likely to know the work of each architect here just as easily as distinguishing a Tesla car from a Ford. These building styles are recognisable through the specific hand together with the palette of materials that they embody.

1 Project and architect identification are given at the end of this chapter.

James Timberlake, director of Philadelphia practice KieranTimberlake, perceives this ability as "A method of making connections...I understand that I've 'been' in that building because I can **recognise** the image."[2]

As Timberlake alludes, one doesn't need to physically visit and experience each site to know it was designed by Frank Gehry or Zaha Hadid. This is down to visual literacy. You are able to 'know' the designer of the work via the format it has been shown; in this instance as photographic images.

Interestingly, whilst all these pictures reveal projects by different and distinctive architects whose buildings undeniably embody their brand, what you possibly wouldn't realise is that every one of these pictorial representations has been made by the *same eye,* that of photographer Richard Bryant. UK born and based but working globally from the 1980s onwards for his international clients, Bryant's work became synonymous with a number of well-known architectural practices, and they relied on him to deliver their vision through his lens.

This is not to say that he was tasked to follow brand guidelines for each practice. Far from it. There was, instead, confidence from each commissioning client that Bryant would understand their style and ethos, offering them *his* interpretation of that structure, creating memorable and iconic documents of light, place, space and time. Each appointment placed implicit trust in him as visual practitioner. These were partnerships, just as American photographer Julius Shulman's was with Richard Neutra, William Pereira Associates and the other major practices he worked for in the mid-twentieth century.

In Julius Shulman's autobiography, this process is described beautifully. He recounts a time when, as a younger man, he was given the opportunity to freely interpret one of Frank Lloyd Wright's earlier projects. The building in question was the V.C. Morris Gift Store in San Francisco (1948) [Fig. 2.1].[3] Today it is a restaurant on a pedestrianised lane just off Union Square; the facade is still immediately recognisable.

Shulman didn't photograph it until 1950, by which time there were already several existing visual interpretations of the deep-set entrance with its arched brickwork taken by notable photographers such as Maynard Parker. Shulman relates Lloyd Wright's reaction as he examined the monochrome prints,

> ...to my surprise, he swung an arm around my shoulders: 'Shulman,' he exclaimed, 'at last someone understands, in a photograph, my statement – you have penetrated the spirit of my design! ... I have seen numerous photographs which failed completely to express that design'.[4]

Perhaps what Lloyd Wright was trying to convey to Shulman was that in the photographs previously created of V.C Morris, the architect saw earlier ones as purely technical responses. These were likely to have been adept, competent, allowing the store's brick facade to be recognisable, but in Shulman's new image the designer sensed that a powerful, individualised interpretation had been created. The photographer had used overt additional (non-architect installed) lighting in the store's interior for this. Bold use of flash-lighting was one of the Shulman's very discernible tropes which helped define his own brand, never mind the architect's.

2 James Timberlake, interview with author, 20 December 2021.

3 Fig 2.1 courtesy of © J. Paul Getty Trust. Getty Research Institute, Los Angeles (2004.R.10).

4 Julius Shulman, *Julius Shulman – Architecture and its Photography* (Cologne: Taschen, 1998), 122.

5 Stephen Bayley, "Foreword," in *An Architect's Guide to Fame*, edited by Paul Davies and Torsten Schmiedeknecht (Oxford and Burlington, MA: Architectural Press), 13.

Fig. 2.1

This meant that the outcome was a subjective, stylised one. Nevertheless, Lloyd Wright 'identified' with this visual approach. He saw it as *transformational* to previous iterations and made the new photograph (in Lloyd Wright's view) far more memorable. Shulman had *added value* to an already iconic brand.

In *An Architect's Guide to Fame*, Stephen Bayley recalled the late journalist Tom Wolfe and author of *Bonfire of the Vanities*, saying that he "... coined the brilliant term 'kerbflash' ... What's needed is instant iconography. Kerbflash is an instantaneous architectural image which excites desire and then tickles the itch to consume."[5]

It is possible to recall any number of kerbflash images that you've seen throughout your working life, defining the buildings they represent together with the designers behind them. They assist in creating and then reinforcing each individual brand.

Is branding about advertising and marketing?

Back in 2005, in his book for the American market, *The Architect's Essentials of Marketing*, David Koren posed that practices were often uncomfortable with the concept that they actually had a 'brand', and they might have associated brands with products or goods, rather than their services:

The idea that a services company has a brand in the same way a products company does is, relatively new. Professionals such as doctors, lawyers, accountants and architects have historically relied on other reputations to build their businesses, not advertising or brand-building. If they did good work, their clients would spread the word and the professional's reputation would grow.[6]

If this was the case, there may have been 'confusion' over whether architecture related to products or services. It might be one of the reasons why (and from what I have ascertained in my conversations with studio directors on both sides of the Atlantic), in the 1980s and 1990s, there was a lack of taught modules encompassing marketing or brand-values in their university programmes. This, coupled with the prohibition on advertising in the USA and beyond throughout the greater part of the twentieth century, meant that architects could leave the potentially thorny issue of advertising and marketing well alone.

Today, in a world of web activity, marketing still appears to be an element of business conducted mostly by others. Digital natives are more comfortable with speaking about their work activities on social media, so slowly and steadily architecture as a conversation in sales terms may become more commonplace.

Whilst photography *is* intrinsically linked to marketing, few architectural photographers get directly involved with marketing activities that architects require their pictures for either. Working with creative directors, stylists, facilities managers, journalists and editors, yes … but marketing consultants? Less so. Marketeers might deliver a brief on behalf of practice partners but once the images are submitted, the photographer is placed outside conversations about *how, where and why* the images are utilised. Other than in-house roles in larger practices where direct connections may be made across teams where an image maker is employed, actual marketing remains a specialist service, best discussed elsewhere.

Working with a brand

Some firms have **brand guidelines** or contractual directives that they issue to those carrying out visual exercises on their behalf.

These instructions may inform placements/choices in image-based and written documentation and communications, including:

- Colours
- Fonts
- Use of logos
- Styles of image making
- Placement of images/graphic elements/physical collateral in view
- Lighting styles
- Use of models
- Characteristic markers in specific places or sizes
- Aligned product placement

We readily recognise these elements in consumer products and associated advertising, but this also occurs across the building industry. Image makers may be asked to work with such constraints. Sometimes they are overt instructions,

6 David Koren, *The Architect's Essentials of Marketing* (New Jersey: John Wiley & Sons Inc., 2005), 42.

7 Buildings of England covers courtesy of © Yale University Press, photographers – Nottinghamshire – Martine Hamilton Knight, others – James.O.Davies.

but they also may be *implied*, in place simply because of the strength of the brand itself. Those chosen to work on materials will be expected to fall into line with their deliverables. This is especially the case where specific building sectors are involved, for example hotels and retail.

Magazines such as *Architectural Digest* have a strong set of brand guidelines to which their writers, photographers and editors are asked to adhere. This gives the publication its distinctive form, and readers can easily identify the brand. *Architectural Digest* is not unique in this endeavour.

Publishers commonly unify their stables of books, which means that although their subject matter may vary within a series, they're each recognisable as being from distinct collections. A good example of one which does not issue formal deliverables in terms of the 'look', but yet has a very clear brand, is the renowned *Buildings of England* series of reference books.

In 1951, a German academic named Nikolaus Pevsner began writing about English Architecture from its earliest built forms to the present day; a subject so large, that he divided England up county-by-county in order to do so [Fig 2.2].[7]

Fig. 2.2

Originally published by Penguin books, the titles swiftly became recognisable for their centrally placed photographic plates, which were monochrome, small and chronologically ordered. In addition, the written tone and look of each book became established across the 46 titles that Pevsner himself authored, or co-authored. Pevsner was highly respected as an art historian and research into the histories of the buildings he explored was regarded as some of the most thorough ever conducted at the time he was writing. As more volumes compiled, the more recognisable the house-style became, and beyond Pevsner's own lifetime, subsequent revisionists became tied to the format because that is what the readership understood and valued.

The authority given to the series, which by the 2010s was into the third revision and in colour, ran to some 82 titles across Great Britain and Ireland and had a global distribution. This meant that even though there was a change of publisher to Yale University Press, a decision was made for the brand to retain its distinctive approach and legacy value across the collection. For any practitioner to be associated with the title, it is seen as a privilege, yet the challenge is to *blend* rather than bend.

Looking at the photographs in any volume from the collection, it is possible to see a very distinct approach to picturing the architecture. It is very beautiful, very controlled and by necessity, very timeless. The 1974 Staffordshire title, for example, is the last to be revised for publication in 2024, after a 50-year shelf life.

◁ + ▽

T.C Hine's Nottingham Lace Factories (1856) are revealed in isolation from their modern city setting in the 2020 Nottinghamshire edition. No cars, pedestrians, Letting (Realtors) signage, etc. Another city structure, A.E. Lambert's 1904 Nottingham Midland Railway Station, is always busy in daytime, with congested traffic and heavy footfall. Not for Pevsner, whose unanchored context is a necessity if the images are not to 'constrict' the buildings to a specific era, allowing the viewer clear analysis of architectural styles.

Conventionally, the attributes of any building project are visible through their materials, fixtures, users, the decor of the era, their physical contexts, etc., and these aspects emphatically date stamp each project to a specific moment in time.

Pevsner pictures cannot be anchored in this way. They must be *timeless.* This is a huge challenge for any image maker, to situate the subject in the here and now, yet also in the past *and* the future. By virtue of longevity and legacy, and despite no contractual directives being issued by Yale University Press for the series' respective writers and photographers, no stronger set of brand guidelines could exist.

Clearly, Pevsner is its own entity, and removing contextual markers from visual records of buildings is unlikely to serve in the best interests of most commercial practices. However, it's a good example of how our own visual literacy is in part guided by what we *expect* to see for each type of output, often underpinned by overt or implied brand guidelines shaping that reality.

Recognising if *your* current image bank has any sense of cohesion is the first step to evolving a visual brand for your practice.

▷
'Spot the difference' with John Carr's Newark Town Hall (1776). This handsome structure sits in the busy Market Place with twenty-first century life taking place around it. The view was taken early one Sunday morning when the square was quiet, however much postproduction was required to eradicate the distracting visual clutter and leave the structure unencumbered for reader appraisal and to provide the Pevsner 'timelessness'.

Recognising your visual brand

You will need to look at the photographs you already have in the practice.

- Whatever you have, gather the material into one folder (physical or digital) and evaluate it. How might you do this?
- Utilise your preferred search engine's formula for ranking its search results. This is a solid base for questioning the helpfulness of what you have to hand.
- When people consult Google's search engine, for example, it ranks the results it displays using a pattern known as E-A-T. This stands for Expertise, Authority and Trustworthiness.
- People who create online content use E-A-T to help them effectively compile and manage their websites, and thus assist them with search engine optimisation (SEO).

It doesn't matter what a user is searching for, whether it's a supplier for a widget (buy), a set of directions to a location (find) or an understanding of a subject for a school class (learn). Google knows that users will turn away from the search engine if the answers it gives are wrong. If results are incorrect geographically for someone wanting a local answer, are out of date or are irrelevant to the question inputted, then Google has failed. Part of its measure of ranking is based on other browsers who are also online and referencing the content. This is a form of 'authority' given by other sites, thus validating any claims that the creator of the original uploaded content makes.

Use the same criteria in your search for answers relating to the photographic assets which represent your portfolio and therefore market your business. You do not need to be online for this, simply embrace the methodology which asks:

- Do they show your *expertise*?
- Are they *timely*? In other words – are they current?
- Are they *representative* (trustworthy) of what you have been doing in the last two years as well as showcasing your earlier work?
- When you do look online, is anyone else talking about, sharing or exposing the very same photographs of a particular project? If others are using them too, is it because they're seen as an *authority* view for that structure?
- Are the images in your collection *relevant* to your output?

These are the key facets under E-A-T's umbrella of evaluation. Drilling down further though, ask more of the pictures in your image collection:

- Is the quality of the photographs high?
- Is there a regularity in that quality, or are there discernible variations?
- Are the images consistent? By this, we could mean a uniformity in shape and format, a continuity in the colour gamut, type and range – are they exposing similar tonal values or saturation?
- Are they clear? In other words, possessing enough of a sharp focus to allow examination of the design quality and detailing of your projects?
- Do they amply show material, form and dimension?
- Quantity wise, are there enough of them to exhibit consistency in any/all of these areas?

These are specific and important questions. If the answer is 'yes' to a good proportion of them, then quite probably you're already in possession of a discernibly distinctive visual brand.

However, if the answer is 'no', or perhaps only in part, then take yourself back through the image bank and try and divide the work into two piles: one where the shots *do* exhibit some of these traits; and another which possess either very few of them, or worse still, none.

Retire the second pile. These images are unlikely to be bringing your portfolio any recognisable benefits, and in the short term you would do better to describe the buildings that they relate to by other means – words, drawings or CGI files. The chances are that these redundant images were acquired by distanced means as opposed to conscious commission – gifted via a sub-contractor at the end of the project or forwarded from someone's phone on a last site visit.

Address your audience

Displaying photographs over which you've had no part in the creation and don't represent your own sense-of-self as an architectural practitioner may not be in your best interest. Aim to rectify this situation. Move from a position of having images in-house which only represent your values and portfolio in a haphazard way, to one whereby distinct and meaningful visual collateral is curated. These images need placing to best reflect the practice's aims and ambitions, and this is the focus of the next dozen chapters. Attention will be given to the construction of the photographs themselves and then to their dissemination and effective circulation.

Knowing *who* you want to put them in front of, and *why*, is the key here.

Under the auspices of creating your brand, a conversation needs to be held with your audience, and some practices are rather inarticulate with this conversation. They either don't know, or perhaps haven't ever stopped to look at, *who* they are currently talking to.

We discuss the important relationship between words and pictures in Part III of this book, but for now, it's worth mentioning some research by Anca Mitrache, a Romanian architect and academic. In *Branding and Marketing – An Architect's Perspective*,[8] Mitrache describes a struggle with 'target confusion', suggesting that in the main, architects are successful only at broadcasting to themselves. She senses that this trait is borne out of many years of professional training, where the conversation is solely with peers (fellow students) and superiors (academic teaching staff). Learning is referenced via scholastic papers and industry journals. These are written by specialists talking to architects in the academic and theoretical language of the subject and may mean that written communications become highbrow and self-serving.

There may be a continuation of this language style in communications with *all* audiences. This is fine when used with the professionals you are working with on a contract, but less so in other territories. If your clientele is unfamiliar with building industry terminology (and in many instances this will be the case), then your ability to lend a credible and easily understandable voice to your brand will be sadly lost.

8 Anca Mitrache, "Branding and Marketing – An Architect's Perspective," *Procedia, Social and Behavioural Sciences* 62 (2012): 932–6.

One needs to couple this barrier with the reality that for many small practices, the client base is organically driven and mostly by word-of-mouth referral. A firm's workload might continue for years in a similar vein, moving from one completion to the next, simply on chance encounters made during the design and construction period of any given building. In each instance, this is rarely met with success in articulating a firm's mission and thereby lacks the opportunity to grow brand awareness across a variety of audiences.

So, what is your specialism? If you've got a track record in a particular field, try to recognise this and sell on the basis of your expertise.

The introduction to this book shows that in Europe, the average practice size is overwhelmingly based on either sole operators or studios with two to five people, representing some 94% of the industry. In the UK, according to the *RIBA Benchmarking 2022 Executive Summary*, 30% of all revenue in the architectural sector comes from private housing and for smaller firms with fewer than ten staff, that sector accounts for more than 50% of their workload.[9]

Combining independent and developer-led housing projects in 2021, this amounted to a higher income than any other sector, encompassing offices, other commercial, health, education, mixed and other (industrial, transport, etc.).

Using the premise that a good percentage of readers will be involved with private residential commissions, it makes sense to look at a brand strategy for a practice specialising in this sector of the market and to discover what makes their approach resonate with their clients, how they view the role of their image makers and how these factors allow them to be highly visible and, in turn, successful in their field.

9 "Business Benchmarking 2022 Summary," *RIBA*, 1 December 2022, accessed 21 May 2023, www.architecture.com/knowledge-and-resources/resources-landing-page/business-benchmarking.

COMMUNION ARCHITECTS

I interviewed Alex Coppock, the managing director of a UK-based architectural firm in Herefordshire. Communion Architects is a small company whose work focuses predominantly on residential and ecclesiastical projects, mostly situated in the Welsh Borders, the Cotswolds and the south of England. Alex works with a team that has never extended beyond ten employees.

Communion – the brand vision

On the home page of its website[10], the practice clearly express its brand ethos which rests under the name: *Communion – Shared Vision,* stating,

> **Communion means 'shared vision'. We believe successful buildings are the result of people working together to deliver a shared vision. We work closely with our clients to deliver exactly what they need and we build strong relationships with other stakeholders involved in the project.**

Alex explains a four-step process for their prospective clients, demonstrating how they take a project from concept to completion. Across all public facing platforms, through their website and a variety of social media, the company is very clear about who they are, the way they work, potential costs and, moreover, make their past clients very visible in their broadcasting. This is a key strategy. Allowing clients a voice (Simon, Jenny, Susanna, etc.), through visually illustrated case studies, means these individuals, couples and families can function as 'peer reviewers' for potential new engagements. This places such people as *trusted advocates* for Communion.

The way that the practice uses photography within its brand communications and aligns images with the written word is effective. It stems from a fundamental belief in the power of the image itself in the first place. This came from Alex's own training, when he worked under an architect who understood the potential of photography. In the case of a widely published church re-ordering project in Hereford called All Saints, he saw how his employer – architects RRA – gained significant publicity and lasting economic return from a set of images. These were commissioned via *Architects' Journal* and subsequently acquired by RRA, being re-used multiple times.

10 https://communionarchitects.com

◁ + △
All Saints Church, Hereford was reordered by RRA in 1997. Regarded as a pioneering exercise in mixed use for this type of building, it won a RIBA Award, Civic Trust Award, Conservation Areas Award and was cited on multiple occasions in books and reports as an exemplar project.

Moving on, and a later project for RRA, Alex's team hired another of the UK's leading practitioners to document a modest church refurbishment. This was in the early 2000s when architecture was still captured on large format film and was almost performative in its methodology. The photographer wore a black cloth over his head to block out light falling on the ground glass screen of the camera.

In this type of film photography, there was necessity to use Polaroid film to help verify exposure and composition, prior to dark-slides (which are cut-sheet film holders) being inserted into the camera. There was a mass of equipment which travelled with a photographer at a time when image capture was slow, and the scale of the enterprise often drew onlookers.

Alex tells me how he, the client team, the photographer and photographer's assistant stood around the camera whilst lighting was set up and the Polaroid image was procured. As it was revealed and passed around, Alex recalls that the client declared:

> **'Wow, this is a beautiful building.' But it wasn't the building, it was a picture. The architectural photographer came in and with the very act of us saying that this building was going to be shot, it also said to the client that we wanted to invest in their project. He (the photographer) came in with enough drama or enough authority to say 'this is how we're going to do it', and he commanded respect in the room which was quite amazing. And then there was this bit of theatre, but within that one act that you could see that there was a mind shift. It was transformational. 'This is a beautiful building', but up until then, as a site, it had been hard work, and stressful.**
>
> **So, I think that at the 'point' of taking the photograph, this is the point between the building project stopping and the building being birthed as a 'thing' in itself. There is a certain kind of iconography about it. There's value created. It's transmutable, and this becomes the way in which we communicate the work that we do.[11]**

Alex is sensing that the images themselves are signifiers, representations of something physical, which then have a value in their own right, outside of the value of the actual property they show: "…people understand buildings as pictures, and that pictures themselves are the commodity."

He carries on explaining the process of taking a potential new client from the opening conversation to contract: "You know clients start with pictures of buildings and then unless they finish with pictures of their own buildings presented back to them in their same way, I don't think they've gone on that complete journey."

In other words, he's saying that a commissioning party starts with a concept for their proposed project in their head and they use the language of images to try and show the architect what they're interested in developing. It's then the architect's challenge to realise the output in three dimensions and create that building for them. The built form is then re-interpreted back into a set of 2D values (photographs) by which the rest of the world will know it, and moreover, judge it.

11 "Alex Coppock, interview with author, 30 December 2020.

NEEDS

1 DEVELOP NEW HOUSE DESIGN WITHOUT DISTURBING THE SETTING OF THE OLD POST OFFICE

2 BASED DESIGN ON BARN LIKE AESTHETIC THAT WILL SETTLE WITHIN COUNTRY EDGE SETTING

3 CONSIDER LIGHT, VIEWS AND SETTING OF NEW BUILDING

IDEAS

1 TWO GLASS WALLS - ONE FOR LIGHT AND ONE FOR LIGHT

2 SIMPLE BARN LIKE STRUCTURE

3 FORMAL AND INFORMAL GARDEN

4 MINIMAL EXTERNAL WORKS

DESIGN MEETING 1

communion
AWARD WINNING ARCHITECTS

Contact:
T. 01432 314300
INFO@COMMUNIONDESIGN.COM
WWW.COMMUNIONDESIGN.COM

Notes:
1. DO NOT SCALE OFF THIS DRAWING
2. REPORT DISCREPANCIES TO THE ARCHITECT
3. THIS DRAWING IS TO BE READ WITH ALL RELEVANT SPECIFICATIONS AND OTHER INFORMATION ISSUED BY THE ARCHITECT, ENGINEERS & OTHER SPECIALISTS
4. THIS DRAWING IS COPYRIGHTED TO COMMUNION LTD

Drawing Title:
PROJECT NEEDS & IDEAS

Client:
MR & MRS

Project:
NEW DWELLING -

Job No: **A.214** 13.01
Job Stage: **P.05** -

Drwn by: AJC | Chkd by: AJC | Scale: 1:200 @ A3 | Date: 23.01.16

◁ + △
Client meetings are held during which conversations inform mood boards and space design, shown here for a private family home in Ledbury, Shropshire. This project utilises previous photos from The Oaks, Worcestershire. Using existing archive images to inform new projects is something discussed in *Ch. 8 When is now? The right time to shoot your project*.

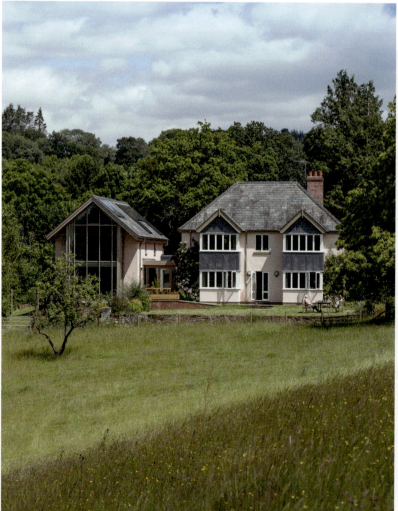

△ + ▷

Finished projects by Communion Architects – The Oaks, Worcestershire, and Twyn-Y-Corras, Herefordshire – are shown on the left. Top right shows the orangery extension to a Worcestershire cottage and a family home in Ledbury, Herefordshire, centre and bottom. Alex and his team make images like this work hard for the practice, not just in terms of marking their respective builds but to help inform future client proposals.

Alex concludes:

> **I think it's like cash. Cash is a promise backed up by confidence. It's the way you trade that; you produce a building, but the way you trade that building is through the use of architectural photography. That is your currency.**

Alex is talking about kerbflash here, and not at the level of starchitect led, multi-million-pound environments, but instead being applied in a very measured way in the English provinces on projects with an average build value of £300,000–£700,000. This practice understands that photography, for them, is *the hook*, the element via which a prospective enquiry may become a real client and, of course, the bottom line: revenue for the practice.

Communion also take the trouble to reinforce that line of argument by spending money on printed manuals which are given to couples and families at the outset. These are detailed guides to the process of commissioning a home extension, restoration, refurbishment or new-build. Their book, *Getting Started*, takes the first steps in charting the progress of how a project will move from a conversation to the concept [Figs 2.3, 2.4].

Figs 2.3 + 2.4

Making it Happen covers the steps through which design is led and planning consent will be granted. In *Materials*, construction items, products and finishes for the build are described and illustrated via clear narratives and case studies of projects they have worked on. These bound books, together with the blog posts of interviews and podcasts covering any number of topics relating to working with listed houses, the quality of a wood floor, fulfilling Building Regulations, etc., all reinforce confidence in Communion's brand, in their service and the quality of product which they deliver.

▽

The Oaks is committed to print form, a bound book for the owners to share with their friends, and a fitting conclusion to the 36-month-long project.

It's interesting that Communion is able to explore private homes on camera to the degree to which they do and then can share them publicly as a call-to-action for new work. But again, there is strength and confidence in the approach that the practice uses. Alex continues:

> **We are a service – a service has no set fee, it's what you want to charge. People like to buy products as they come with guarantees. People like to buy products as they understand what they will receive for their money. We've written it down in a book because then people can understand. We've positioned it up front. They then also understand that image making is part of it. I can ask the client 'if you have found these images helpful to you, would you be willing to place yourself in a similar position?'.**

He's elevating his clients to status of 'trusted consultant' and 'peer referents' which is interesting psychology. It doesn't feel as if the architect needs to 'show off', as each story is about his clients, it's their story. This is good communication. Certainly for Communion, little of this message can be effective without the images, which Alex, like his former mentor, sees as a key investment in his business. He concludes, "They're top drawer, gold plated, worth every penny. If you only think you're buying them once, they're a really expensive commodity, but if you know you're going to use them time and again, they are a *valuable* commodity."

And really, there's still more to add to this. Communion is ranked number one online in its market, Alex and his team win awards for their work and the order book is full. The practice is in a position where it can take on the projects it wants and will enjoy, curating trusted and enjoyable relationships with clients who are happy to spread the word with them. Photography plays a part in the client journey all the way through and is seen as a consistent and core facet of the brand message.

Summary

In understanding that the external face of your professional practice is largely perceived by unknown audiences through *pictures* that they see of your projects, it makes sense to take ownership of the 'image' you wish to be known for. This means acknowledging not just *your* visual literacy, but that of your *audience* too, and therefore recognising the value of implementing a brand that everyone can align to and identify with.

As we've seen with the example of *Buildings of England* and Communion, the legacy of photographs and their stylistic conventions can endure well beyond the scope of the original time of capture. Photographer Tim Griffith remarked in a conversation with me:

> *... it goes beyond books and things like that. It goes to how the firm is perceived in 30, 40, 50 years' time. And if you think about the perception of Skidmore Owings & Merrill for example, it's largely based on a set of photographs which were taken 30, 40, 50 years ago by photographers such as Ezra Stoller.*

> *The understanding that the world has of that architecture is largely dependent on the quality of the photographs that were taken. So, it serves an architect well to be aware that when they make a choice on a photographer, they're looking at investing in the future perception of their work. If they sell it short now, then the only record that the world will have of their 'prowess', is the photographs that were commissioned at the time.*[12]

Photography is key in establishing and carrying every architect's brand vision forwards, regardless of company size. Done well, it becomes a far greater promise about the practice, the person and vitally, the structures designed; and as we've seen, not just in one's working lifetime, but quite possibly far beyond.

Recognising your market and where you sit in it is the first step to understanding your brand. Whether the brand you have is the brand you want is entirely another matter, but using photographic imagery to drive it forward in a decisive manner to the point where it may become brand iconography (*kerbflash* even!) is what we will now explore.

In Part II of this book, we will look at matters relating to the actual making of photographs, the equipment, the team behind the camera and when the right time might be to shoot your project. It can often be too early to get out there, but in the case of poor images currently representing your folio, rarely too late.

12 Tim Griffith, personal conversation with author, 11 July 2022.

TAKE-OUTS

▶ Visual literacy, and our own learnt behaviours, allow us to identify styles and brand recognition.

▶ Brands may be recognised through:

 ▷ a person or team – their personality, their output or a combination of both.

 ▷ their ethos – the vision through and by which they carry out their work.

 ▷ looks – typified through form, materials or the manner in which both are distinctively combined.

▶ We've established what brand guidelines are (contractual or implied) and how they drive and reinforce recognition and effective communication for an audience.

▶ Using the aid of Google's E-A-T, it is suggested that you carry out a thorough appraisal of your current photographic collection and categorise the assets according to their effectiveness in conveying your brand directive and ethos.

▶ Learn to recognise which images are successful in visually articulating your practice and discard the ones which you discover are not operating in your best interests.

▶ If they're not, and the search results return a set of visual outcomes which do not best represent your output, take action, regardless of the currency of the completion of projects.

▶ We've introduced the relationship between words and pictures, acknowledging that the written language accompanying your images is a vital part of the communicative process.

▶ Finally, by way of a case study, we've looked at the work of a small UK-based architectural practice, whose development of its brand and visually partnered marketing strategy has enabled it to curate engagement with clients and drive constant referrals for new work.

ANSWERS

Visual Literacy – designers and project identification:

From left to right

1. Imperial War Museum North, Salford
 DANIEL LIBESKIND: STUDIO LIBESKIND

2. La Chiesa di Dio Padre Misericordioso, Rome
 RICHARD MEIER: MEIERPARTNERS

3. Private House, Venice Beach, Los Angeles
 ARATA IZOAKI: ARATA ISOZAKI & ASSOCIATES

4. Serpentine Pavilion 2011, London
 JEAN NOUVEL: ATELIERS JEAN NOUVEL

5. Kunsthaus Bregenz
 PETER ZUMTHOR & PARTNER

6. United Overseas Bank, Singapore
 KENZŌ TANGE: TANGE ASSOCIATES

7. Kidosaki House, Tokyo
 TADAO ANDO: TADAO ANDO ARCHITECT & ASSOCIATES

8. Auditorium Parco Della Musica, Rome
 RENZO PIANO: RPBW ARCHITECTS

9. Barajas Terminal 4, Madrid
 ROGERS STIRK HARBOUR: RSHP

From left to right

1. The Deep, Hull
 TERRY FARRELL: FARRELLS

2. Staatsgallerie, Hamburg
 JAMES STIRLING: JAMES STIRLING, MICHAEL WILFORD AND ASSOCIATES

3. Blavatnik Building, Tate Modern, London
 HERZOG AND DE MEURON

4. Centrum Bank, Vaduz
 HANS HOLLEIN & PARTNER ZT-GMBH

5. Walt Disney Centre, Los Angeles
 FRANK GEHRY: GEHRY PARTNERS LLP

6. Phaeno Science Centre, Wolfsburg
 ZAHA HADID: ZAHA HADID ARCHITECTS

7. Castelvecchio Museum, Verona
 CARLO SCARPA

8. Firstsite, Colchester
 RAFAEL VIÑOLY: RAFAEL VIÑOLY ARCHITECTS

▷ Part 2

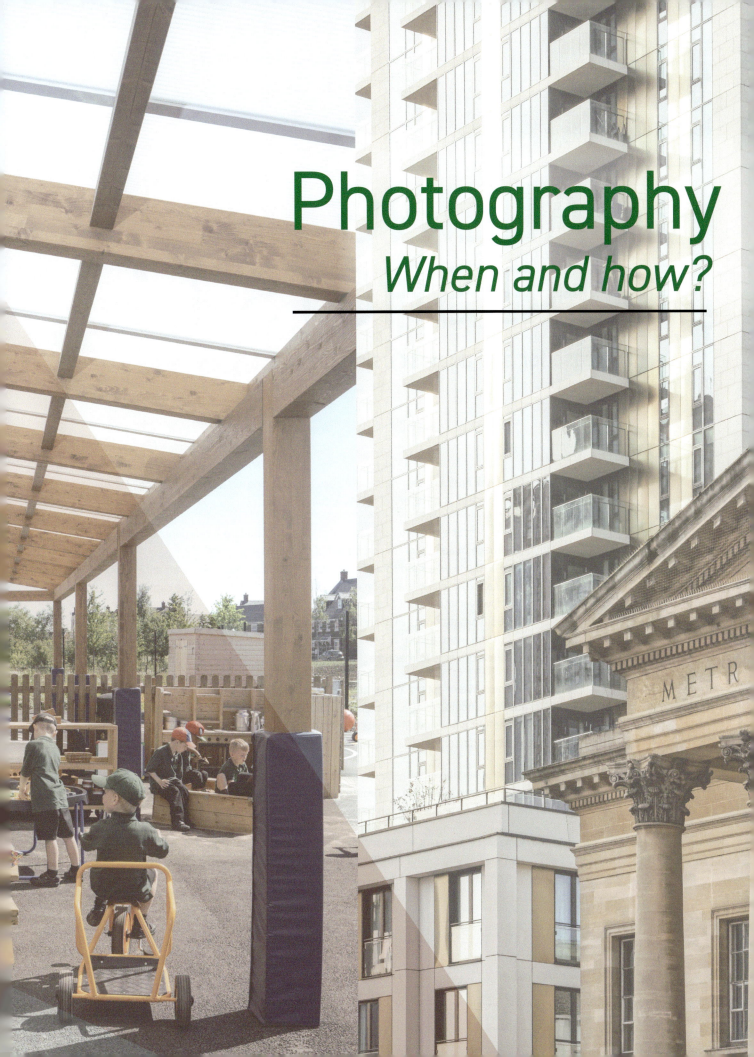

Photography
When and how?

▷ CALLING THE SHOTS 1.1

The case for and against using phones

This book anticipates a range of issues surrounding architectural image procurement at a variety of levels within practice:

1. As practice lead, you may be (or plan to be) building a relationship with image makers working on behalf of the company.
2. For those who hold roles within teams, you may find there's an anticipation that *anyone and everyone* employed is responsible for image capture – however that might happen.
3. Solo practitioners may find themselves 'on the tools', as they may not have the financial luxury of being able to commission another party to document their projects at this time.

The next five chapters aim to address each proposition, first with photography and then moving image. Everyone should be able to technically function as a competent witness to their work or have the understanding to effectively direct others to do so.

This first section employs a device which all readers will be familiar with and yet possibly aren't using to maximum effect. This may be because of the limited time to focus (excuse the pun) on harnessing its full capabilities.

So, wherever you sit in the architectural hierarchy, pull that phone out of your back pocket and take a look at the very brilliant camera you already own.

▷

The Meadow in Cambridge designed by Sisco Architecture features in several pictures in this chapter. The key here is that they were all taken with a phone.

Cameras in phones: What's good and what's not?

There are several points and misconceptions about smartphones which require discussion:

- They are always with you.
- They are only capable of recording wide angles.
- They are poor in low light.
- **Exposures** (in photographic terms, exposure relates to the amount of light falling on the sensor, or previously film, to take a picture) and **focus**, or sharpness, can't be controlled.
- They have small file sizes compare to a standalone camera.
- Perspective can't be controlled.
- Working with a phone means you can share your photographs without delay.

If this book had been written in the 2010s, *all* of these points would have been true, but today in the 2020s, only the first and last points are likely to be irrefutable.

Let's deal with each statement in turn:

1. They're always with you – *true*

Having a camera on you means that you are in a position to capture each and every moment of your working life.

When you're on site, you may already record things, probably because certain activities require documenting from a legal standpoint. Photographing key elements during construction, such as foundations, service elements, plumbing or cabling before they're boxed in, for example, feature as a matter of course. You might take images of a site when you first encounter it, to act as an aide-memoir or for use in planning applications. You'll probably do the same at practical completion as you sign a contract off. In addition to image making within your job, you might shoot examples of material treatments on structures you spot on city walks or visits to public buildings.

That same phone is in use to photograph your high days and holidays too. These form the personal moments in your life when the outlook is bright, your loved ones are with you and memorable activities are taking place. You've either *got* to take the pictures (work) or you *want* to take the pictures (work and pleasure), but the action itself will be swift and intuitive. Whilst you may check the outcome to be sure you've got the shot, you'll probably move on again quickly.

If you're wanting to share project images with your client, or to your broader contacts as a 'news' item for your business, you'll likely attach the image to a text message, email or upload to Twitter/Instagram/Facebook/LinkedIn and share it.

Job done.

Except, the job may *not* have been done to the best of its ability, simply because you didn't make the most of that device, nor the time and opportunity you had with it. Let's look at how to be sure that time with your phone's camera is as effective as possible.

2. Phones are only capable of shooting wide angles – *false*
Traditionally, phones featured one single lens which was moderately wide angle: about 28mm. Before we proceed further, we need to establish what we mean by '28mm'. The 'mm' refers to the **focal length**, an optical system of magnification and angle of view in lenses which brings light into focus. Historically lenses were configured to specific focal lengths, each relating to a specific outcome in terms of 'look' in the resulting image.

△
Phones have come a long way since cameras were included in them. In the Apple models shown here, the latest boasts physically larger lenses than the previous 3-lens cluster handset, assisting image capture in extremely low light. Whilst their range is just one in a plethora of high-quality offers from multiple manufacturers, for simplicity, technical discussions in this book are illustrated with images generated from one model: an iPhone 13 Pro, even though the narrative addresses both Apple and Android.

Today, the majority of phones will feature either two or three lenses. Each of these will be relatively wide angle. If you work with their **optical** (native) focal length and don't try to zoom into the overall view to enlarge the subject beyond its stated width – **digital zoom** – then the quality will be good. Be aware that many phone models with lens clusters have a 'principal' lens, usually the moderately wide angle one, which has superior resolution.

Fig. 3.1

The longest optical focal length on the cluster-lens phones, for example the Apple iPhone 13 Pro, is equivalent to around 77mm – 3x optical, based upon an old-fashioned 35mm film camera. The ultra-wide angle is 13mm – 0.5x and the standard is 24mm. The composite image in [Fig 3.1] of Manchester's Piccadilly Basin shows each outcome. On this basis, it's easy to see that for social media or casual documenting, everyone is placed to capture much of their output with confidence.

Android phones with lens clusters include the highly regarded Samsung Galaxy Notes, or the Samsung S21 Ultra. This has four lenses including a hybrid (not strictly optical) zoom. Sony Xperia, Huawei One Plus and Google Pixel 5 all make enviable models. Frankly, it's like car manufacturers, they all offer similar outcomes, it's down to price and consumer preference. If you're reading this book at a point when the models listed here have been superseded, remember that you need to look for focal lengths which relate to *optical* capture when evaluating which model to purchase. Then you won't go far wrong.

3. Phones are poor in low light – *false:*
computational photography is now the key

If you're shooting interiors, especially prior to on-site illumination being installed, the light levels will be low. Not holding a phone steady when you take pictures will result in poor, blurred images. To counter this:

Aim to hold the phone with both hands

- Avoid, at all costs, having your arms outstretched.
- Brace your arms against your body or lean against a wall.
- Better still, find a surface to lean the phone on whilst you hold it.
- Don't 'jab' the shutter button. This is on the screen itself and may knock the phone slightly. Many phones allow you to use the volume controls as a shutter button.
- Your linked headphones or smart watch can sometimes act as a remote shutter button.

Even with shake issues mitigated, **pixelation** or **noise** (visible artefacts) in images will be noticeable on a desktop monitor when files shot under low light are enlarged. On older models, a phone camera's ability to work well in low light situations was always a deal-breaker as far as image quality was concerned and was to be avoided at all costs.

▽

Viewing The Meadow by SISCO Architecture with the naked eye at this time of evening reveals extremes: deep shadow versus bright highlights. Compared to the reality of the LH dark image which would anticipate seeing on camera, the newest phones have an ability to render the scene in much more depth. They can control the contrast without a significant loss of detail and quality which is quite extraordinary.

If you are trying to document interiors on construction sites which are at first-fix stage, and don't boast commissioned lighting, you've probably already got a cracking software utility on board that negates the need for supplementary lighting and doesn't involve turning a flash on either.

The latest generation of phones can work in low light in their **Night Mode** or **Night Sight**. For best results, securely support the device with a tripod or clamp. Its ability to resolve detail in an exposure is significantly beyond what the human eye perceives. The exposure time can be around ½ second or even longer, so you can see why there is a need to anchor the phone in order to avoid camera shake and unusable files.

Advice historically at this point was always to revert to a full size camera on a tripod and to use long exposures, and/or supplementary lighting. It should be said that this method will still *always* outpace what a phone can do for you, even if that phone is the latest model. This is because the sensor size on a phone is limited by the size of the device itself. Upgrading to a dedicated camera, especially when coupled with the creativity of lighting methods that a professional would employ on your behalf, yields a far more sophisticated outcome.

4. Exposures and focus can't be controlled – *false*

Your camera phone will do its best to evaluate any scene encountered and come up with an appropriate response regarding exposure. A photograph possessing a full range of tones that run from black to white, with detail retained in the highlights, mid-tones and shadows is desirable.

In the 2010s phone cameras became quickly compromised in high-contrast scenes and detail would quickly be lost. However, increased sophistication in software algorithms allows cameras to capture multiple files of a scene almost instantaneously. These are subsequently merged and blended to post-produce an outcome in a single file which encompasses a 'high dynamic range'. This is commonly referred to as **HDR**.

HDR files give pleasing results that in many cases work amply and need no further adjustments. However, your camera never knows what the *story* of a photograph should be, and it is simply concerned with making balanced exposures, regardless of the subject. The story you might wish to convey about a scene is down to you as photographer, using your prior knowledge and skills. Whilst acting on your behalf, and in full auto mode, the phone will attempt to control the highlights in a bright window, for example, but this might render the actual room, and its contents that you want to show, far too dark.

A camera has no idea where we might wish to place emphasis in a scene, or what we want a viewer to focus (concentrate) on. In traditional photography, one of the tropes of the genre is in having parts of a photograph that are 'sharp' and detailed, or 'soft' (blurred). This placement of the viewer's attention is controlled in two ways: first by the focusing of a lens, and second by changing the focal length of a lens. Both contribute to creative storytelling, and both have been rather limited within phone photography in the past.

Sometimes the automatically generated and centre-weighted focus point is out of kilter with where we want it to be. The good news is that both aspects – exposure *and* focus – can be controlled. The methods will vary slightly between Apple's IOS and Android, but in essence, they're going to naturally align to the centre of the frame unless the handset has been prioritised for facial recognition.

There should be a method of separating both controls and allowing you to place emphasis on both the exposure and focus by way of on-screen sliders/side buttons.

Look out for symbols which show either a sun for IOS or for Android, an **EV +/-** (Exposure Value) slider. It's far better to adjust the exposure at the point of capture, as intervention *after* the event in trying to brighten areas which are too dark will only serve to increase the visual noise in those sections of the picture as you lighten them.

△
With an ability to control focus on a phone, storytelling is in your hands. Both images have emphasis in different places. For the LH image of The Meadow, our eye goes to the glass panel and ironmongery at the front of the shot, for the other, the emphasis is on the space more generally and view to the garden.

Another problem that can occur when *not* intervening with exposure is the accurate representation of subjects that contain many dark tones. Imagine working in a bar or club where the walls are dark in colour and the lighting muted. Your phone is pre-programmed to brighten things up to a mid-point level exposure wise (mid-grey) so that you can see them easily. The trouble with this approach is that tones which are deliberately dark will be artificially lightened; blacks become washed out greys, intense purples become mid-tone mauve, deep forest greens become pale and thin … you get the picture. Or rather, you get the wrong picture.

If this were the case, at the point of capture, simply drag the EV exposure slider (or sun symbol) downwards into the minus zone. Watch your colours and tones retreat (and likely as not, re-saturate) back to where they need to be. Your photograph will become darker again overall, but if that is the reality of the space you are documenting, your picture needs to reflect this.

△

On iPhones, the yellow box relates to the focus area and the exposure is controlled by a slider that has a sunshine symbol. It is possible to move these around the screen together, to affect the outcome. In the first two pictures you can see that the focus is in different places, to the front and then the rear.

Should you choose, as well as locking the focus, you may then control the exposure of the overall image. This time, the focus is locked at the front of the shot, but the brightness slider has been first raised, and finally lowered, making the whole picture darker.

5. Small file sizes compared to a real camera – *relatively ...*

All phones can produce **jpegs** (type of photographic file) or **HEIC files** (commonly produced by modern iPhones). The most recent models are now enabled to shoot **RAW Files** too. More on this file type in *Ch. 5 Calling the shots 1.3: Camera controls and considerations.* Frankly, this is a game changer. However, even when employing the RAW feature, one should still avoid zooming in on a subject wherever possible as the file quality in digital zoom mode will rapidly decrease.

Contemporary Android and Apple devices can create files which are more than adequate to function for you in a wide range of both screen and printed outputs. Typical 2023 release models generate native files which are 4032 x 3024px in dimension on a **12MP** (megapixel) sensor, well capable of being printed out at **300dpi** (dots-per-inch) for standard A4 use. Provided images are taken with enough good light and therefore not compromising the small sensor's capabilities, files stand in good comparison to any decent standalone camera when printed at A4, or in some cases far larger.

Sensor size is always the key factor in determining quality, over and above pixel count. Individual pixels account for fine detail; however, the relative *size* of those pixels dictates their light capturing properties. We will discuss this more in the next chapter when we explore the merits of moving up to a system-camera. These are accompanied by broader lens options, physically bigger sensors and more powerful processors.

6. Perspective can't be controlled. *Except, with planning, it can ...*

This is something which (optically) may only ever be resolved by moving into the top financial tier of dedicated camera equipment. It normally runs hand-in-hand with knowledge required for operation both in the field and in postproduction. For professionals, time spent controlling perspective is one of the most significant aspects of setting up shots for architectural photography. Nevertheless, modern software sophistication is where the playing field can be levelled to a certain degree, and this applies for both phone use and standalone cameras.

Assuming you are currently limited to working with your phone, let's look in a little more detail about how to best plan for this.

Fact: the majority of structures have straight, parallel walls and do not converge as they increase in their number of storeys. When standing in close proximity to buildings and wanting to capture them in their entirety, our first recourse is inevitably to set the camera to its widest angle of view. We also tend to tilt the device backwards in an upward fashion, aiming to capture all floors, including the roof and sky above. This usually results in a significant tapering of the sides of the structure, giving the appearance of **converging verticals**.

Whilst this is dramatic, it doesn't follow the convention of architectural drawings and is something which true architectural photography seeks to address.

Assuming you'd like to correct this and finish with a picture appropriating your drawings, you have two options, and both involve standing further back.

First, set your camera so that you are shooting with your screen 3x3 grid lines activated. There is an almost identical menu selection in both Android and iPhones. This is a 'must-do' for all of your photographic activity, as so much of showing architecture in two dimensions is about working with lines. Once you've switched them on, there's probably no need to ever turn them off again.

Approach1:

1. Take yourself a significant distance away from your initial position and at a point where the entire scene appears *without* tilting the camera as seen here at The Meadow [Fig 3.2]
2. Compose your shot, using the lines of the composition grid to help you judge when everything is squared up as it should be
3. Take the image – not forgetting to set your focus point and exposure
4. In Review Mode, go to your editing area and look for a way of activating the crop feature. This will bring up a list of options of how to crop your image, either to the same 4:3 proportions [Fig 3.3], or square, 16:9, freeform etc.

Figs 3.2 + 3.3

Result? No distortion.

Approach 2:

1. Retreat again from your starting point. Like before, make sure you have some 'breathing space' around your entire subject, as seen here at The Meadow [Fig 3.4]
2. Compose and shoot (again, not forgetting to set your focus point and exposure)
3. Next, enter your review mode again and find the 'perspective' or 'straighten' section
4. You will probably have options to choose to correct either the **horizon** level, the **vertical axis** level (which is what you'll utilise here) or, finally, the **horizontal perspective** axis (L-R swing) [Fig 3.5]
5. Moving the sliders will allow you to view the outcome on each of the three axes of perspective control
6. Once the verticals (or horizon, etc.) have been corrected you can still crop the image in review mode to discard the areas outside the reconfigured shot [Fig 3.6].

Figs 3.4– 3.6

In this method, the phone's software is using algorithms to either squeeze and compress pixels, to stretch and enlarge, or duplicate them in order to manipulate the image. The software will then discard the redundant areas and re-map the centre of the picture, allowing you to save the revised result. Happily, most phones will continue to store the original file, meaning you can re-visit the frame and change the editing parameters – but to be safe, it may be good practice to work on a duplicate image rather than just the original.

Unfortunately, using the built-in image correction software or just straight cropping of the image means you will be left with a lower pixel count than the original photograph. You've reduced the final picture to be smaller in dimension than the native file would have been. This means a loss in overall image quality, and sadly there's nothing you can do about that. It won't pose an issue if you're limiting your publication of the work to web-based media, but issues may quickly ramp up if you choose traditional print and increase the scale beyond A5 at 300dpi. Expect pixelation to become more noticeable at A4.

Another factor to consider is that in order to get to this point, your distance may have been increased to the degree that unwanted elements intrude into the shot. Parked cars, perimeter fencing, mature trees/shrubbery, or even other buildings may creep into frame. There's little you can do about this and is an issue that's not limited to phones.

7. Working with a phone means you can share your photographs without delay – *true*

The ability to disseminate your work to a specific and limited audience either through a text message, WhatsApp, Snap Chat, etc., or to a potentially far larger and unspecified number of people via social media, for example Twitter or Instagram, is something one has always been able to achieve with a smartphone.

However, you'll have noticed that this chapter is titled: *The case for and against using phones.*

So, what is the problem with phones? In my view, it is this ... just because you *can* broadcast with immediate effect, *should* you?

It's important to consider that your visual output is likely to be the most remembered view of your work. With respect to a receiving audience who don't know you in person, this is where the publication of compromised images could be the most impactful. In your haste to broadcast the latest iteration of your firm's output, you may do well to hover above the 'send' button just a little longer...

My favourite adage is '*measure twice, cut once*'. Probably the biggest risk your camera phone poses for your firm, regardless of who's holding it, is the possibility that pictures reaching the public domain don't function for you in the best way possible. Your ability to instantly record something is of immeasurable value, but recalling that material once it is broadcast is nigh on impossible. Particularly in the professional realms of a Twitter, LinkedIn or Instagram audience, the knock-on effect of sharing a weak image could be damaging rather than beneficial for your practice.

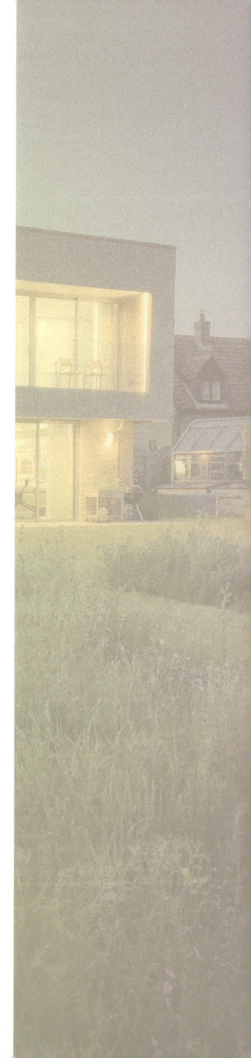

Consider implementing a policy for staff whereby images collated on site are moderated/edited before social media dissemination. That 'pause' may only be for a few hours but could be justifiable. We shall explore social media in Part III of this book, looking at the benefits of developing a strategy for your images whereby broadcasting is planned, timely and subject to a considered editing process. The very nature of carrying a dedicated camera on site, and especially forcing oneself to use a tripod for that exercise, means that the photographic process becomes more tactical than it ever might be with a phone.

▷ + ▽
'Torus' by David Harber is seen here at The Meadow in phone photography 'overload'. Film simulation filters, high saturation, and vignetting applied ... Insta-heaven. But really, are they necessary? Treatments such as these may date swiftly. This chapter's cover shot says plenty.

Tips

i. Keep it real

One of the advantages or downsides of phone photography, dependent on your personal view, is that the phone itself works behind the scenes with your image the split second you've taken it and 'massages' it into a pleasing outcome. Software algorithms kindly balance contrast, add sharpening, and saturate colours, so that your world looks bright, punchy, and 'insta-ready'. You're presented with something that looks terrific, and then you're invited to intervene further – with software apps that allow you to add more saturation, filters, vignetting ... the list goes on.

If you want to create authentic, memorable pictures which represent your practice, perhaps just steady the ship.

ii. Keep your camera lens clean

Phone lenses are on the reverse of your phone, so you're far less protective of them than the screen facing you. Phones get placed in pockets and down on surfaces which may not be clean and are always at the mercy of fingerprints. Unlike a camera with a lens cap, these lenses are exposed to every element in each place they are left. Whilst their glass is toughened and not too prone to scratching, smears are the main enemy.

- Dirty lenses mean soft, low contrast images which may appear blurred. This effect is worsened when contrast is high (in your pictures, it will become low – you'll lose blacks) and flare will appear across the shots.
- Clean your lens with a lens cloth or lens tissue prior to each photography session. If you don't have either to hand, use a clean, soft fabric such as the shirt or t-shirt you're wearing. This is far better than nothing.

iii. Keep it visually simple

If you plan to share your images via social media, then the size of screen you are shooting with is going to match the size of screen your viewers will see them on. This means small images. These are probably being encountered as part of a scrolling news feed. Your time with your audience is short. Statistics about waning attention span abound – especially for online content compared to print media.

Where possible, try to create straightforward, clear images without cluttered backgrounds. Messy, complicated shots will be harder for viewers to decipher, and if your quest is for clear communication, you'll need to consider the surroundings of your subject and place yourself in the best position for a bold, graphic shot. Remember, as you are the photographer, you're fully conversant with what you've stood in front of to capture. You will have no problem re-interpreting that visual outcome, even years after the event. Your viewers, however, will not be able to relate to this. More on this in *Ch. 11 Social media: Disseminating your brand online*.

- When composing your photograph, remember, less is more.
- Don't over complicate your pictures.
- Too many details can distract and confuse your viewer.

▷
Simplicity is the name of the game
for effective photographs viewed
at small scales. Fussy, cluttered
images will be overpowered
by simple bold, graphic shapes
and colours as seen here in the
University of Sheffield's 1966 Arts
Tower by Gollins, Melvin, Ward &
Partners and their A57 Concourse
Lighting scheme by Arup.

iv. You and your camera – the visual voice of your brand

Finally: this tip is about your mindset, rather than technique. If the phone in your hand is the camera you are using for your business, treat it with the same reverie you would if you had gone out to spend thousands on bespoke recording equipment to make pictures with. Think. Plan. Execute.

Do not tear round the site and snap, or your results will be exactly that. Snaps.

Summary

The digital technology revolution and convergence of multiple media appliances into one item has transformed photography, together with the ability to speak to an audience almost instantaneously. Whilst earlier generations of phones yielded image quality somewhat below par, today, camera phones are versatile in their usability. Moreover, they are eminently capable of performing as a visual right hand for any business concerned with disseminating content through social media platforms or via desktop print media.

With the increase in lens quality and variety of focal lengths, these devices, coupled with a little know-how, are an essential part of your professional workflow.

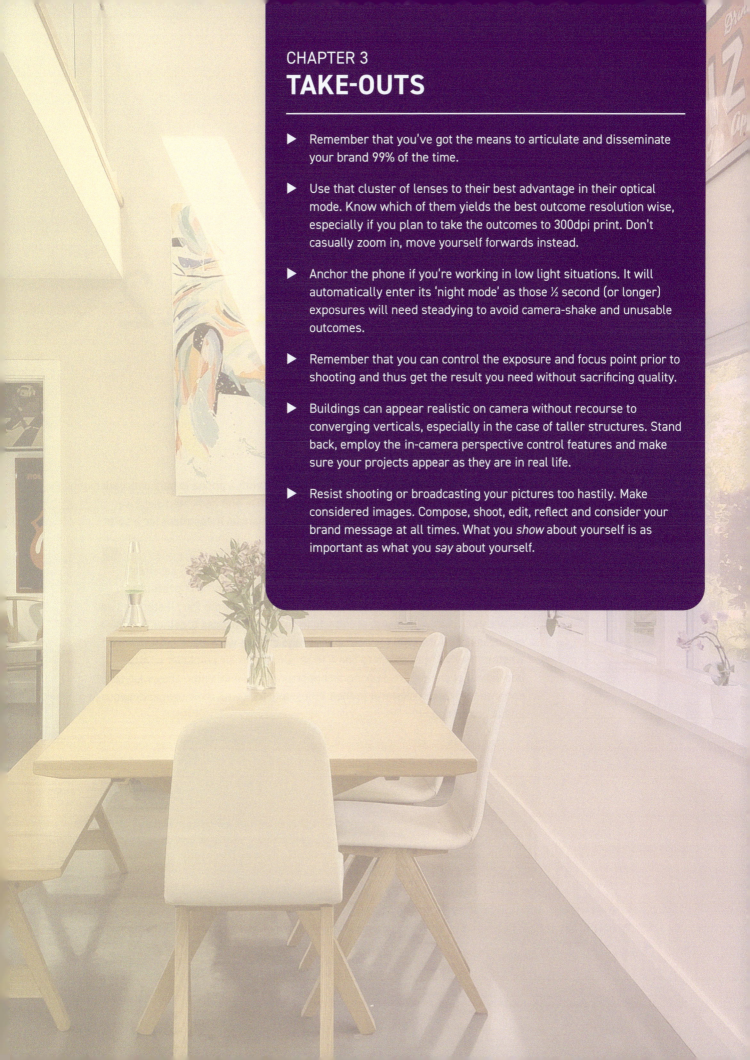

CHAPTER 3
TAKE-OUTS

▶ Remember that you've got the means to articulate and disseminate your brand 99% of the time.

▶ Use that cluster of lenses to their best advantage in their optical mode. Know which of them yields the best outcome resolution wise, especially if you plan to take the outcomes to 300dpi print. Don't casually zoom in, move yourself forwards instead.

▶ Anchor the phone if you're working in low light situations. It will automatically enter its 'night mode' as those ½ second (or longer) exposures will need steadying to avoid camera-shake and unusable outcomes.

▶ Remember that you can control the exposure and focus point prior to shooting and thus get the result you need without sacrificing quality.

▶ Buildings can appear realistic on camera without recourse to converging verticals, especially in the case of taller structures. Stand back, employ the in-camera perspective control features and make sure your projects appear as they are in real life.

▶ Resist shooting or broadcasting your pictures too hastily. Make considered images. Compose, shoot, edit, reflect and consider your brand message at all times. What you *show* about yourself is as important as what you *say* about yourself.

▷ CALLING THE SHOTS 1.2

Which camera system is best for you?

Moving from a mindset whereby capturing work with a phone is part of broader site activities to one where photography is an active and dedicated exercise is likely to be both a considered decision and a financial investment for a sole operator or small practice.

I have taught many Continuing Professional Development (CPD) sessions for RIBA across England and these have been attended by time-pressured individuals varying in industry experience. They range from Part II students and early career professionals to architects from large practices together with solo business operators, who may be at any stage of their working life. Attendees, whether they've been asked to come to sessions by their employer or have booked out of choice, are seeking an opportunity to uplift skills. They wish to enhance the visual collateral in their folios, together with their own endeavour in image production.

▷

Taking your own photographs is the most economical way of procuring visual assets for your practice. Having the right camera for your skill level *and* your wallet is vital. Knowing what you can do with a modest arsenal of kit is half the battle. Enjoying the process is the other.

Assuming you have the desire to make your own pictures, the following two chapters look at how you might proceed. This image of Fairlawns, a house in Nottinghamshire by Brightman Architects, is one of very few shots I have taken where specialist lenses were not necessary. Residential architecture is often on a scale where a good eye and understanding of the subject is more important than high end camera equipment.

There is a broad perception from anyone working *exclusively* with a phone camera that photography is 'easy'. People anticipate a smooth transition between image capture with the device in their pocket to one made with a physical and purpose-built camera. However, there is often a swift rejection of dedicated camera equipment after a short trial. Users often discover that, quite simply, photography – and moreover *good* photography of the type we are striving to achieve here – is not that easy after all.

Unlike pressing a software button on a phone screen, photography is a separately acquired skill. Happily, all models of dedicated cameras feature simple tiers of operation. Once a user's confidence grows, the camera's helpful 'hand holding' modes for a beginner can slowly be relinquished. Semi-automated and thereafter fully manual operation can bring autonomy and creativity to your fingertips.

This chapter recognises that a financial commitment will need to be made at some point in order to begin the process. Like any other investment, capital purchases may be offset against profits for your business. We are going to stay away from specialist equipment (notably perspective control lenses and contract-based postproduction software) because as a package, this will cost several thousand pounds, dollars or euros to acquire. Added to this, you'll need to spend a measurable amount of time operating it all which may impact too greatly on other areas of your business. It probably makes more sense to dedicate a budget to award-worthy projects and get these covered by a professional.

Instead, this section of the book sets out to give you essential knowledge about general camera equipment and photographic terminology, aiming to expand on what phone photography may currently achieve for your practice.

Going shopping? The camera – that's right for you

The analogy has already been made that smartphones are like cars. A lot of aspects are simply down to consumer preference. With *phones*, they all do pretty much the same thing. Just buttons in different places with subtle changes in size, comfort in handling and lens range.

For the new product under discussion, let's just change one single word and repeat that sentence.... With *cameras*, they all do pretty much the same thing. Just buttons in different places with subtle changes in size, comfort in handling and lens range.

This sounds like an attempt at humour or just plain cynicism, but it is the truth. There are few truly poor, modern digital cameras and very many options are on offer. With multiple manufacturers to choose from, each has a variety of platforms and model ranges within them. Let's look at the pros and cons.

1. The compact (or point and shoot) camera

In this field we have genuinely *pocket-sized* cameras with small sensors and a moderate zoom range. They begin at around the three-figure mark in any of the £/$/€ currencies. An increase in price to several hundred £/USD/€ sees multiple benefits coupled with the compact product scale – better low light handing and higher image quality to go with the benefits of a longer optical zoom which initially was limited to 24–70mm but is now far greater, to 250mm or more. At the time of writing, the pricier models had exchanged their historically tiny sensors for either 1" versions or even bigger.

△

Entirely pocketable, a higher-spec 1" sensor compact with a viewfinder, spirit-level *and* rear screen provides benefits when compared to a phone, if simply for the extended range of the optical zoom.

Rubberised, shock-proof and water-proof models also feature in this field too, but when compact cameras are hand-held, they all flounder in low light. Happily, they all feature a tripod mount on the bottom and give you the ability to use a self-timer function. This means that you can shoot in virtually zero lighting on a very long exposure. All can knock out a jolly decent picture when handled with skill, yielding files far outpacing a phone, which just cannot match the benefits of the longer zoom range.

The very nature of a small camera is likely to invite hand-held operation but typically, pocket cameras lack a traditional viewfinder. This can be a real issue, and it's recommended that you try and source a model with one. Why? Well, like your phone, in order to see the image being generated in real-time on the screen, you are forced to hold the device away from your body. Your arms act like a pivot and the physical action of pressing the shutter button can induce camera-shake. The longer you've got the zoom lens extended, the more 'nose heavy' the camera becomes. In lower light conditions and at longer zoom lengths, because of the way cameras work, the exposure time will also increase, thus amplifying the danger of shake. Built-in image stabilisers will help to some degree but ironically, normally need to be tuned off during very long exposure times whilst cameras are on tripods.

For a relatively low investment and a decent zoom range (10x zoom – 25–250mm), a 1" sensor *and* 4k video, the 2018 Panasonic ZS100/TZ100 is terrific. Given its age, the price has dropped to around £(UK)380.00 and noting that this sector has curtailed market investment today because of the leap in phones, it's probably a good model to weigh the competition against.

2. Bridge cameras

So called, because when they were first introduced, they 'bridged' the gap between the two existing platforms of the day: compact cameras and **DSLRs** – Digital Single Lens Reflex cameras. Whilst the original compact camera was extremely popular with the general public because it was far more portable than a DSLR, its zoom didn't offer enough scope for those wishing to shoot subjects at a distance. Hybrid **Bridge Cameras**, however, made an ideal travelling companion. They had a larger body size than a compact meaning they could no longer be 'pocketable', yet they were still a single entity with a built-in flash, HD video and now with the ability to magnify at 30x, 40x or 60x plus.

Although certain bridge cameras only retain the compact camera's 1/2.3" sensor size, some models can yield a whopping 920mm in magnification. In the case of the long-feted Sony series, now on its fourth generation of model, the Sony RX10mk IV has an increase of the sensor to 1" which grants a significant 24–600mm range. There are also some great models by Panasonic and Nikon in this stable and each are capable of superb image quality, even at the longest reach. Significantly, you're more likely to see viewfinders in this camera type, an enormous factor in mitigating shake at longer zoom lengths.

On the smallest sensors (1/2.3 inch), the zoom range can run from an equivalent of 24mm to a powerful 1000mm +, which practically speaking would place you at ground level and able to focus on a single brick at first storey level, without any loss in quality. Simply extending from 24mm to 600mm is all-encompassing when photographed from the same spot, as shown on Lewis & Hickey's Si Yuan Centre at the University of Nottingham [Figs 4.1, 4.2].

△
Bridge cameras are a jump in size from the compact (far left), especially bearing in mind the comparable 1" sensor on both recommended models. However, the money goes into the lens glass and an enviable built-in zoom range on the Sony (shown on the right with the lens extended to maximum length). No dust issues – and all in a single unit which yields vastly enriched image quality compared to the average pocket-compact.

Figs 4.1 & 4.2

Again, like the smaller compact camera, whose market investment has more or less ceased, for a single office product which anyone in the team can pick up, take around site and literally 'point and shoot', this is a really viable option.

3. DSLRs

We will now look at the pinnacle of traditional consumer, prosumer and professional options and see why, *until recently*, a DSLR camera system has been the leader across all markets since its inception. It was developed as the successor to the **Single Lens Reflex (SLR)**, a camera which became synonymous with press and journalism use in the 1940s & 1950s. A mirror held at a 45-degree angle inside the chassis allowed optical viewing of a scene for instantaneous capture, whilst an interchangeable lens system meant the desired angle of view for coverage could be matched. Film came on a roll contained in a light-sealed

cartridge and was fed across a plane in-line with the lens. Individual negative or positives measured 24 x 36mm. This 'analogue' system of shooting film, which was subsequently processed in wet chemistry, remained the norm until around 2000.

In what became termed the 'digital revolution', and by retaining the body housing and lens mount type, manufacturers were simply able to trade the film cartridge section of an SLR for a micro-processor. A digital sensor was sited where film had previously passed through for exposure. With images subsequently evaluated (or 'processed') and shared via computer technology, users were able to transfer their skills from the earlier platform to its modern replacement, and very swiftly, DSLR technology almost comprehensively superseded film shooting.

Whilst many film manufacturers have now ceased production in the two decades since then, in the fashion and fine arts sector there has been a resurgence in film photography. The same trend has *not* come to pass in professional architectural photography though. Cost and the technical, time consuming process of technical capture makes analogue film use financially prohibitive for most commercial practices. Despite my own affection for the craft, those days are gone.

So, what does investment into the DSLR platform bring to your office? Image quality far above that possible in the previously discussed camera systems and a vast array of options, from body and lens manufacturers to the accessories available to pair with this system including filters, tripods, lighting, stands, bags and boxes. You name it and you can spend money on it; at its height it was a multi-billion-dollar business. Certainly, many professional photographers are still engaged with this type of kit and it's where the dedicated lens types for architecture are to be found.

△
Prior to 2005, I exclusively worked on film for my clients. On the left are 35mm slides of The Vasco da Gama Tower by Leonor Janeiro & Nicholas Jacobs at the 1998 Expo Lisbon, Portugal. A 35mm camera system was practical for travel, but the individual frames are miniscule in scale and image quality compared to the 5x4" film transparencies I used to shoot. On the right is the coastguard's office, part of Bauman Lyons' South Promenade regeneration in Bridlington, North Yorkshire.

Interestingly, within the DSLR model platform itself though, *two* sensor sizes evolved. Why? Well, at the transition from SLR film to DSLR digital, the manufacturing of sensors at full frame was almost prohibitively costly for consumers. Anxious to retain market viability, brands dropped the physical size of sensors, all settling on slightly different outcomes. This meant that within individual manufacturers, two almost identical looking (in terms of physical shape) camera types emerged, one with a sensor matching the traditional film 24 x 36mm and the others around 22.2 x 14.8mm or 23.5 x 15.6mm, both known as **APS-C** or **crop-sensor**.

▷
On the left is a current full sized 35mm sensor DSLR model, the Canon 5D mk4, next to an earlier, crop sensor 60D. There's little to differentiate these two camera bodies to the untrained eye. No wonder confusion reigned throughout the DSLR years. Familiarity with a manufacturer's model names was essential for buyers.

These had similar and ever-confusing model names and numbers, creating all manner of muddles with users. For some manufacturers, lens mount sizes changed to match the reduction in the crop-sensor size too, so two separate lens platforms also came into the market for each manufacturer. Madness, one might say, but that's market forces for you; economics and the bottom line always come first.

There's no single camera manufacturer recommended for architecture *unless* you choose to go the full journey with your photography and wish to invest in perspective control lenses. Why? Even today, there are only two manufacturers to have a quality *and* relatively extensive, dedicated lens range for this work. If you are trying not to spend too much money (and there are not just financial considerations for the hardware and software, but also the time needed to work with it), then the two big names in DSLRs are Canon and Nikon.

Today, across every manufacturer, there are a plethora of little-used, high-quality secondhand lenses and bodies available on the market. When purchased from a reputable outlet, the kit will usually boast a six-month or even 12-month warranty. As more and more names pull back from making DSLRs and if you want the full versatility of quality and application – from macro to sports or wildlife to architecture – a pre-owned DSLR system is a great way to go.

In the first instance, you would do well to select a single body/lens combination. You can always increase the lens collection later. For a purchase in the crop-sensor size, a pre-owned or new Canon 80D with an 18–200mm lens is a decent choice. If you want to go the whole hog and head for a full size 35mm sensor system, the Nikon D850 and 24–120mm lens or a Canon 6D mk2 and 24–105mm lens are both decent choices.

However, contemporary investment in the industry has led to the creation of a final, hybrid product that we must investigate next. If you are prepared to invest in a separate body/lens, rather than heading the way of the bridge camera, then this next option is of logical appeal to a typical architect's office.

4. The mirrorless system
Today, almost all manufacturers sit on the mirrorless playing field, which represents a rapidly expanding range of bodies, with accompanying lens ranges designed for both general and specialist application. Fresh investors in photography as a standalone activity are likely to find themselves directed here, and certainly I would do little to counteract this advice if you have a decent budget available and want to buy 'new'.

Historically, the biggest criticism levelled at DSLR shooting was the sheer size and weight of the equipment required, especially when a number of lenses were being carried about. This is what led to the original development of pocket cameras and the bridge system, but with the compromises noted, manufacturers were challenged to find yet another pathway. With advances in digital technology, by ditching the mirror and replacing it with an **electronic viewfinder** or **EVF**, body size could finally be reduced. The smallest mirrorless bodies completely lack the viewfinder, simply boasting a rear screen. This makes them comparable to old digital compact cameras, and far more pocket friendly than the bridge system.

▷

In the interests of stripping back the bulk of a DSLR (far right), many of the first new mirrorless cameras lost their viewfinders as well as the mirrors, relying entirely on the rear LCD screen for composing and playback. Whilst the body was compact, as seen in the model on the left, problems ensued. Viewing that screen in bright conditions was awkward and again the risk of camera-shake magnified through needing to hold the camera away from one's face. However, the image quality from the larger sensor was far superior to anything a 1" version could produce. The Sony in the centre represents the current hybrid 'best case' outcome, smaller than a DSLR *and* boasting an EVF.

In keeping with the arms-race in DSLR crop sensors and their physical size variations, the same event took place here too. For example, an Olympus has a sensor which is approximately 50% of the size of a 35mm one. However, the Olympus platform is accompanied by light, physically compact and retro-looking bodies and lenses. Across manufacturers, there are variations in sensor sizes, just as there are in the compact, bridge and DSLR platform.

△

So, where do you put your money? There's a big jump between the phone and a dedicated camera. There are pros and cons across all platforms, which is probably why I've invested at every level across the years. Be wise, and if you can, borrow and try before you buy. What feels 'right' will probably be right.

Do you want to produce images that can be enlarged for exhibition/trade stand size at 300dpi together with the ability to record at the closest distance (macro) *and* the distance of the moon? If so, a full size 35mm sensor in a mirrorless housing is likely to be your choice.

The major downside with interchangeable lenses on a body where the actual digital sensor is openly exposed with each focal length change is *dust*. Certain manufacturers are working hard to mitigate this risk by placing a form of sheath over the sensor during lens changes. Researching models on offer which do this is advised.

◁

On the left is a crop-sensor, found in the left-hand and right-hand Canon cameras in the top image. The Sony boasts a full size 35mm sensor, seen here with an orange mount on the right, but both types invite exposure to dust which is revealed on pictures after image capture and has to be removed during postproduction. The mirrors and closed shutters on older DSLRs gave some environmental protection from this risk.

5. Medium format camera systems

Throughout this chapter, one of the discerning factors with each system change is the sensor size. Larger than those discussed previously are the medium format sensors which accompany a limited but valuable market [Fig.4.3]. Historically, medium format film cameras sat between the traditional 35mm and 5x4" platforms and used 120 roll film. Their modern digital counterparts are widely used for the fashion and advertising industries. It's possible to see that their sensors are far larger than those used by 35mm bodies. With some cameras yielding files in excess of 100MP, the images produced are of fabulous quality.

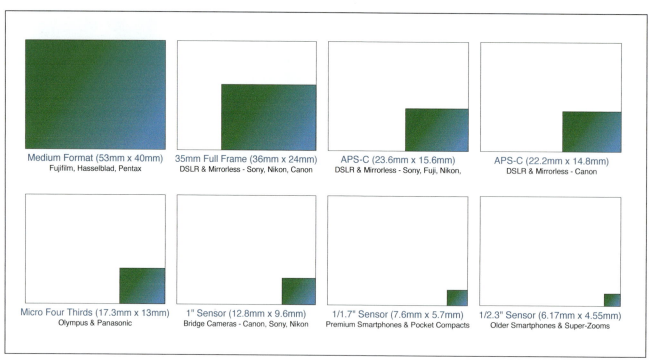

Medium Format (53mm x 40mm)
Fujifilm, Hasselblad, Pentax

35mm Full Frame (36mm x 24mm)
DSLR & Mirrorless - Sony, Nikon, Canon

APS-C (23.6mm x 15.6mm)
DSLR & Mirrorless - Sony, Fuji, Nikon,

APS-C (22.2mm x 14.8mm)
DSLR & Mirrorless - Canon

Micro Four Thirds (17.3mm x 13mm)
Olympus & Panasonic

1" Sensor (12.8mm x 9.6mm)
Bridge Cameras - Canon, Sony, Nikon

1/1.7" Sensor (7.6mm x 5.7mm)
Premium Smartphones & Pocket Compacts

1/2.3" Sensor (6.17mm x 4.55mm)
Older Smartphones & Super-Zooms

Fig. 4.3

For architectural photography, the camera of interest is the Fuji GFX 100 II, as at the time of going to press, this new body, together with two perspective control lenses, has become available. Until this point, it had only been possible to place intermediary adaptors onto the body, allowing the Canon lens range to couple with their previous model. This brought restrictions on focal length and coverage, which is now negated. However, the price tag for this kit is considerable, just the body and one of the two GF TS lenses available will represent a 10K USD investment.

Some professional photographers work with hybrid digital systems which use adapted lenses from large format cameras and medium format digital backs, but they are outside the scope of this particular discussion.

Lenses – the good, the bad and the ugly

Both myself and my husband (who is a broadcast cameraman) are of the firmly held belief that 'good glass' is the best investment an image maker can make. Camera technology changes continuously and for those in the business of regular image making, camera bodies are likely to be upgraded every three to five years, whilst decent lenses are enduring.

For those shooting throughout the 1990s, their analogue lenses required replacing when digital came into being, because of the restrictive depth of focus which applies to a digital sensor. Film had a tangible thickness which allowed some tolerance in regard to the separate wavelengths of light (colour) aligning throughout its depth. For digital sensors, that tolerance of focus depth was eradicated and even today, some cheap digital lenses flounder in this capacity.

Tell-tale signs of this mis-match are a misalignment of colour around objects, causing magenta/cyan halos, which are especially visible in high-contrast areas of a picture. For UK readership of a certain age, if you are to think of the 'Ready-Brek' glow from the 1970s TV ads, you wouldn't be far wrong. Whilst modern software can deal with this **chromatic aberration** to a fairly successful degree, it is far more preferable to shoot with a modern digital lens in the first place and avoid the issue.

Another issue with lenses is the *angle of view* you're trying to capture in your images. For the majority of building projects, the emphasis will be getting everything in frame that you need within a single shot. Therefore, wide angle is where you're most likely to be working. Where space is restricted, for example in interiors, extremely wide angles reveal accompanying distortion as they attempt to grant you a generous field of view. Again, budget kit can be very guilty of causing **barrel distortion** or **pin-cushioning** effects. Software fixes are at hand, but even these imply further budget as you'll need to purchase or subscribe to a postproduction package which manages the workflow and manipulation of images post-shooting.

Another consideration, although of less concern with architecture as subject matter, is the accuracy, speed and quiet operation of auto-focus in lenses. With a largely static subject at hand, this is far less troublesome than to a wildlife photographer, for example. Often though, you're paying a premium not just for the sharpness of lenses, but their ability to perform well in focusing. This applies to high end camera bodies as well.

You may have heard people referring to 'fast' lenses, so called because they are able to perform well in low lighting conditions – such concerns are justified for anyone photographing people, events, sports ... indeed, *any* subject that moves. More expensive lenses may be internally **stabilised** to help counteract the risk of

△
The top room shots seem ok on first viewing, but the grid screen laid over helps show the barrel distortion on the vertical elements despite a level horizon. The enlargement reveals the chromatic aberration in this inferior quality lens, manifest as green and magenta 'halos'. These are most noticeable in high contrast areas and the edges of subjects.

camera-shake in low light. These are signified by 'IS' on Canon, 'OSS' on a Sony and 'VR' on Nikon. Better quality lenses also feature low f-numbers (more on what this means in the next chapter). For now, know that anything with a lower numerical value than f/3.5 at the widest focal length will come with a higher financial cost.

△
Looking at the front of a lens will tell you its maximum aperture (or f-number) and whether it is stabilised. The Canon's zoom is between f/3.5–f/5.6 dependent on the position of the zoom angle, whilst the Sony is f/4 throughout its zoom ratios. They both also display their range – the Canon is 18–200mm and the Sony is 24–105mm.

The language of lens focal lengths can cause a little head-scratching too. If we consider the variety of sensor sizes across the different camera platforms – compact/bridge (in all their varieties); crop-sensor DSLR, 35mm DSLR, 35mm mirrorless – the focal length found on one system will *not* have the same value as on another, despite having the same actual angle of view during image capture.

Because of the 100+ year history of 35mm roll-film cameras, most manufacturers will tell you what their lens systems are 'equivalent' to in 35mm-SLR speak. As a result, learning to understand the 35mm 'full-frame' (24 x 36mm) sensor focal lengths will help you understand what this means in regard to the camera type you are looking at. This also applies to phones. Phone camera lenses are generally given in 35mm equivalents too.

So, in full-frame 35mm sensor terms, a super-wide-angle lens allowing full width sensor capture with little optical distortion would be 11mm. A lens working to this extreme field of vision is very costly. The Canon 11–24mm zoom for a full-frame DSLR is currently priced at just over £3,000 in the UK.

Such a wide angle of coverage afforded by an 11mm lens is not often required [Fig 4.4]. When in use for an interior, to record the extreme L–R coverage as stated, there is a trade-off visually – expect to see yawning floors and ceilings. This manifests itself as floors which tilt down to meet you and ceilings which fly away from you. Objects in the centre of frame seem to be pushed further away; it's not an attractive look, and moreover is very far from reality. Whilst dramatic photographically, such extreme angles *do not* reflect what you have designed, so remember to think about what you are trying to convey to your clients when they see your portfolio – 16mm is kinder and reflects the limit to how wide I'm personally prepared to shoot [Fig 4.5].

Instead, the more commonly accepted 'standard' wide angle is recognised as **24mm** at full frame [Fig 4.6]. I am much more comfortable shooting with this focal length, indeed, the 24mm is my 'go-to' lens for most 'establishing shots'.

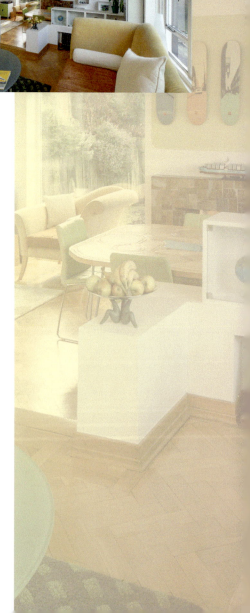

Figs 4.4– 4.6

Focal lengths themselves were originally designed to match the requirement for a specific type of job. In the early days of photography there was no high-quality zoom-lens technology, and a photographer would possess a number of **Prime Lenses** (individual fixed focal length lenses) for different subject types, landscape, reportage, portraiture, etc. The classic focal length was always deemed to be the 50mm 'standard' lens which was issued to press photographers.

Why?

Because, when working on a full frame 35mm sensor, if you lift a camera to your eye and look through the viewfinder, you are pretty much seeing a representation of 1:1 reality. The phrase "*what you see is what you get*" applies here. For press and journalism, this was a really important aspect in conveying an accurate sense of what was going on in the world, bringing news 'accurately' to an audience. Of course, we know that any photography is highly subjective by its very nature. Nonetheless, working with a focal length that bore more than a passing resemblance to the human eye's field of view was a sensible move.

What one should understand is that *any* deviation away from this key 50mm length is therefore applying some form of perspective change, either stretching or compressing the relationship of objects in a scene to one another. This, seen at wide angles, is exaggerated, hence the example here of an interior captured on 11mm. For the vast majority of architectural work, the physical scale of internal spaces, and the situation of external visual barriers around exteriors (perimeter fences/cars/other adjacent buildings, etc.), usually means that standing back far enough in a scene to work with a 50mm lens is nigh on impossible. There will still be *some* distortion at 24mm, but it is far more acceptable to a person's sense of scale and space.

△
Using the same 11mm picture as on p. 88, but juxtaposing it with a second shot, this time on a 50mm lens, shows the space as it really is. At 11mm, judging the relationship of one object to another and conveying scale is extremely difficult.

Extending past the 50mm length brings *compression* to a photograph – the distances between one subject front-to-back and its neighbour are reduced. Think of cityscapes seen in stills and in films where diversely situated buildings such as those on the Manhattan, Sydney or London skyline appear much closer together than they really are.

There is a specialist lens range which is directed for architectural use, allowing optical perspective control at a variety of focal lengths. Almost *all* the photographs in this book were made with them and we discuss their build and application a little more in the next chapter. For now, note that every lens purchase makes for careful consideration and research.

△
Peter Durant's images of Rogers Stirk Harbour's One, Elephant and Castle in London show how relationships between buildings change with longer focal lengths. The image on the left is around 17mm and angles begin to appear 'stretched' but the one on the right compresses the tower hard against the Metropolitan Tabernacle church. This suggests a magnification of 200mm or more. Also, what these photographs 'show' in terms of distortion indicates the traits of having been shot with perspective control lenses.

Keeping it steady

For almost all architectural picture making, it is best to set the horizon level.

In the construction process, if one considers that photographs are the 'after' based on architectural drawings representing the 'before', then the majority of architectural photographic interpretations are based on straight lines and level planes. Working on a tripod will achieve two things. The first: your horizons can be controlled, therefore you can keep your buildings looking straight on a L–R axis.

The cheapest tripods are a pointless purchase. I am fearful when I see a nice camera system on a set of flimsy legs that were £40. Why entrust an item of such value to something which will topple on unstable ground or in a gentle breeze and is dangerously top-heavy as soon as you extend your zoom lens? Avoid pressed aluminum with box profiles and look for tubular construction, it is far more durable. Carbon fibre legs will be stronger and lighter than tubular aluminum, but at a higher price. Decent tripod legs are purchased separately to heads and popular brands are Manfrotto, Gitzo, Benro, Vanguard and 3Legged Thing.

Just as there are variables in camera systems, there is more than one option for tripod heads. Many photographers steer for a ball and socket head [Fig 4.7 left], as these are compact. However, these will quickly become frustrating for architecture as they're like your own shoulder/arm socket. Whilst they can be positioned at infinitely variable angles in one swift move, judging a level horizon and locking it in place is often tricky.

A three-way head [Fig 4.7 centre] is more useful as movement may be confined to one of the three axes: left/right (pan), up/down (vertical tilt) and clockwise/anticlockwise (horizon rotation). However, really precise alignment to a spirit level is still awkward. For fine precision to the last degree, there is one single choice for architecture and that's to employ a 'geared' head.

Fig. 4.7

Again, there are several to choose from, but one of the lightest precision models is the Manfrotto X-PRO-3WG geared head [Fig 4.7 right]. Swift moves can be made with the clamp grip, whilst the dial allows fine tuning to the last degree. Married in use with your in-camera spirit level [Fig 4.8] or a spirit level in a top plate [Fig 4.9], you'll be steady, accurate and your buildings will begin to stand up straight [Fig 4.10].

Figs 4.8–4.10

The second point is that working with a tripod will slow you down. Right down. What may at first be extremely frustrating should become a good thing as you will now be inclined to consider far more carefully how your image is composed. It also gives you the opportunity to walk away from the camera and around the set, arranging and removing unwanted elements where appropriate.

△

Decide on the shot, leave the camera on its tripod and then fine-tune the styling of the space. The scene will be roughly set, but final touches – props, people and lighting do make a difference, as seen in The Centre for Biomolecular Sciences at the University of Nottingham by Benoy. More on this topic in *Ch. 9 Briefing your images makers: What should they be doing on your behalf?*

Summary

For those making a serious commitment to architectural photography, investing in a system which uses a full frame digital sensor is sensible in order to maximise the use of perspective-control lenses, photographs from which are seen in almost every chapter of this book. For an up-to-date purchase, a 35mm mirrorless body is the way to go. However, currently, most perspective-control lenses will need an adaptor to work on new mirrorless bodies.

With all of this in mind let's now use the next chapter to explore what decisions you need to make when you are taking photographs. This is utterly irrespective of which of the camera platforms you invest in, because the considerations are all the same.

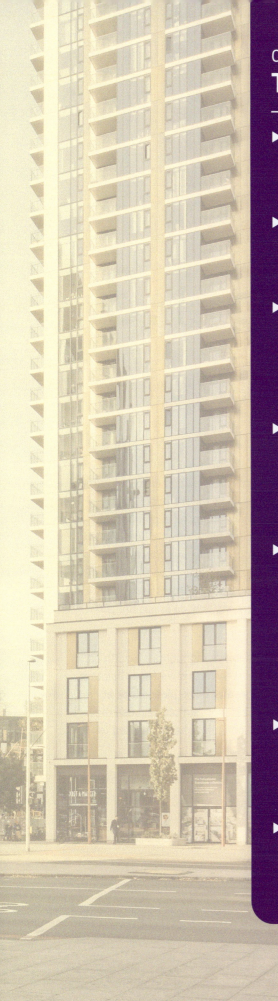

CHAPTER 4
TAKE-OUTS

▶ Decide what the best type of camera is for your practice to invest in. Do the research, be decisive and don't just settle on a 'hand-me-down' from a friend or relative. This tool is representing your professional livelihood.

▶ With a compact (point-and-shoot) camera, most makes have a 1,2/3rd" sensor. Seek out a model with a viewfinder as well as a back screen and a 1" sensor if you can. Be prepared to compromise on zoom length for that pocket-ability.

▶ On bridge cameras, you'll make a trade between portability and extreme zoom range. Again, the longest-range zooms tend to be trapped with the small sensors. Look for 1" sensors. Really good models can be similar sizes to DSLRs and cost a similar amount to a decent DSLR body; however, you're buying a single, self-contained unit. No extra lenses to tote about. And crucially, no dust issues.

▶ DSLRs are divided into two sensor categories, one with a crop-factor and the other with a full 35mm (24 x 36mm) size. Remember, it's that optical viewing system via a mirror which makes the body size deeper and taller. You'll find the widest variety of lenses and accessories for these cameras, and a healthy secondhand market. Dedicated architectural lenses are currently only made for DSLRs.

▶ Mirrorless systems are where manufacturers are investing their research and development. Expect to see a variety of sensor sizes across the range and a competitive market across all makes. If you wish to upgrade to perspective-control lenses for this type of body, currently you'll need the added element of an adapter to consider but expect bespoke lenses with a movement facility to come online soon. For a lighter-weight, high-quality system with dedicated separate lenses, you're in the company of both pros and enthusiasts who love their camera gear.

▶ Choose your lens with care. Understand the relative focal lengths for the platform of camera you purchase, and which 'mm' setting gives you that 1:1 ratio non-distortion. Be mindful about how increases and decreases in focal length changes the visual appearance of your designed work.

▶ Be stable – support your camera with a tripod, and a sturdy one at that. A three-way head, or better still a geared head, is advised.

▷ # CALLING THE SHOTS 1.3

Camera controls and considerations

There are countless books, YouTube videos and courses you can enroll in online, or participate in face-to-face, and all will teach you how to take photographs. There are dedicated books and advice for specialist architectural photography too and I see little point in covering the same ground here, especially as a good 300 pages would be needed on the subject. *Photography for Architects* aims instead to cover a far broader remit than this, by spending time on matters which profoundly affect the way we make and use photographs in professional practice. This is something which other forms of tuition perhaps only do in passing, or even avoid altogether.

At the rear of this book, you will find the almanac, which highlights a wealth of information and services to be found which support the narrative from Chapters 1–18. If you want a dedicated 'how to take photographs' book, please look at this section. Many would-be photographers stall early on, simply because they discover that 'real' photography is not as easy as one might have been led to believe.

In this context, please forgive the rather 'modest' foray into the technical side of operating a camera.

▷

Staff work in the late afternoon sunshine at the National Centre for Sport and Exercise Medicine, Loughborough University by Broadway Malyan.

Perspective control is one of the hallmarks of architectural photography, yet sometimes eye-catching views can be captured on a standard camera kit without compromise. Understanding some of the technical aspects of image capture (like viewpoint, focal length, exposure and composition) are helpful.

How to operate *any* camera – key considerations for architecture as subject matter

1. Camera settings

File types and saving

When starting out in photography, it is logical to work with the file type you are already familiar with – **JPEG**, an acronym so named in 1992 by the Joint Photographic Experts Group. Most camera types shoot 8-bit jpegs as their default file.

A jpeg image can discard a little data each time it is compressed and resaved, which causes a gradual loss of quality over multiple saves. This is known as a lossy-file.

All but the simplest point-and-shoot cameras shoot **RAW Image Files** in addition to jpegs. Named for their 'raw' state and unlike their smaller counterparts, RAWs are **non-destructive** file types, storing *all* of the information captured by the sensor. The camera will usually generate a quick jpeg image from the RAW data, which is then displayed on a camera's playback screen. RAW's superior **bit-depth** (the number of colours which may be displayed by a digital device), produced by the camera's internal hardware, always needs **RAW processing**. This intermediary process which allows you to make changes to the appearance of the file (often to 12-bit or 14-bit or even back to 8-bit), without destroying its integrity, requires the use of postproduction software, for example Adobe Lightroom, Photoshop, Capture One or Serif Affinity.

These programmes are standalone, available for use via monthly subscription or single-point purchase. Every camera manufacturer supplies their camera models with associated RAW file handling software, allowing the user to work with them but, troublingly, there is no standardised form of RAW image file. Each camera manufacturer uses their own proprietary file type. Each suffix varies – a Canon RAW file is a .CR2, a Nikon is .NRW, a Sony is .ARW, etc. In 2006, as a response to the risk of obsolescence, Adobe decided to create an open-source generic format which they titled **DNG** or **Digital Negative**. This allows conversion of a camera's native RAW file into this widely supported, and hopefully future-proofed, DNG. Whilst your camera will still produce native RAW files at the point of shooting, they may be exported into DNGs for added versatility.

Why are we interested in RAW files?

RAWs yield superb image quality. Think of each as being akin to a bucketful of data from each and every sensor pixel; a vast pool of information relating to a scene's colours and luminance. With any jpeg, the vast majority of this data is permanently discarded in favour of a compact, punchy outcome. Nice, but limiting if you wish to make changes thereafter. With RAW you can effectively place your hand into the bucket and slosh it around, exchanging where the data moves to, but still retaining *all* of the information for each pixel. This preserves everything the sensor has captured, providing an array of extra detail and fabulous quality. You stay in control throughout the process, working with the full gamut of information, to produce a strong and permanently stable photograph. Shooting with RAW files, the amount of 'pixel data' in the bucket always remains the same even after intense postproduction alterations.

Once modified to your satisfaction, a RAW file needs to be exported into another proprietary file such as a **TIFF** (from **Tag Image File Format**), a file designed to store raster graphics and image information. TIFFs are larger (compared to jpegs) lossless files, retaining their full range of values. Jpegs can also be exported from RAWs (and DNGs). Working with RAW and DNG files requires some training, and every image produced by your camera requires time attending to it, whereas jpegs created by your camera are ready for *immediate* use.

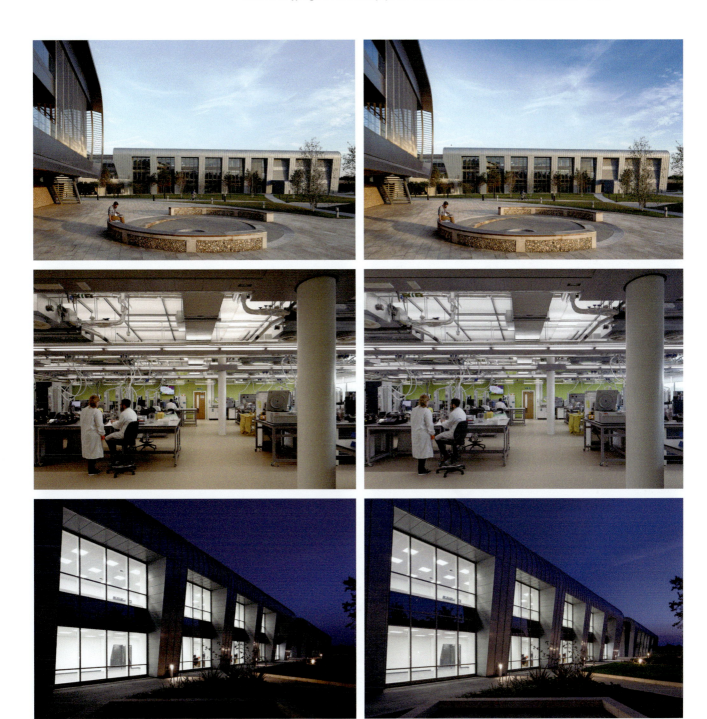

△

Fairhursts Design Group Ltd's BIC Laboratories at the Cambridge Wellcome Genome Campus reveal a typical exercise in RAW processing L–R. The immediate difference is seen in the dusk shot, but closer examination of all three images reveals a far wider tonal range, richer colours and detailed information in the shadows. In summary: a vastly superior outcome, enabled through postproduction software.

Most digital cameras use **SD Cards** (Secure Digital). Be sure to set your camera to record the *highest* quality of jpeg (and/or RAW file) it offers – and given the affordability of large-capacity SD cards, don't lower it. Going forward, most manufacturers are moving towards using Compact Flash Express cards in their camera bodies (**CFExpress**). They can have an enormous capacity and have increasingly faster read and write speeds over traditional SD cards.

2. Exposure

Controlling exposure is the name of the game, and specific actions inside the camera combine to give you a photographic outcome when you press the shutter button. If you wish, all decision-making about exposure can be left to the device itself. What's going on behind the scenes when you activate the full **Auto** setting (marked usually as a green rectangle or green camera symbol or the word Auto on the top camera dial) is the outcome of three distinct things: **ISO**, **Shutter Speed** and **Aperture**.

Let's consider each in turn.

ISO

ISO is a word that the International Organisation for Standardisation created and is derived from the Greek 'isos', meaning equal. It is the foundation and base of our 'virtual triangle of exposure' [Fig.5.1]. ISO indicates a sort of 'sensitivity to light' by your camera, but in reality represents the amount of amplification or 'gain' that the sensor is receiving and that alters the signal to noise ratio. ISO is often found via a dedicated button which activates a sub menu on the camera's top plate or rear display screen. Choosing an appropriate ISO rating greatly affects the Aperture and Shutter settings.

△
SD cards and CFExpress are the most common form of storage for image files. Fast speed, high-capacity cards capable of still and moving image capture are affordable and mean that there is no reason why you shouldn't shoot at your camera's highest quality. Despite a card being able to store thousands of image files, do get into the habit of regular downloading and backing up of data. Failures are rare, but not unheard of.

Fig. 5.1

- Low ISO settings such as **100 ISO** will yield low visual noise, high-quality images with smooth tonal changes and rich colours, but take relatively slow acquisition times for the camera to create. This may mean it's an impractical setting to use in low light situations where the camera isn't stabilised or the subject matter is moving. However, the image quality of files produced by your camera is at its *optimum* here. Around 100 ISO is often called the default or 'native' sensitivity or the sensor.

- A higher ISO (around 800 or above) means you can work hand-held in lower light, or with swiftly moving subjects. Unfortunately, on small sensors your pictures will become 'noisier' with each higher ISO setting used. Files will be increasingly pixelated, exhibiting a loss of fine detail in the shadows and 'blocky' colour/tonal changes. Modern prosumer cameras can feature ISO levels up to 50,000 and above. You'd have very few situations where you'd wish to employ such high settings owing to the significant compromise in picture quality, but if you're trying to capture something moving at speed in extremely low light without a flash, then you're covered.

For architectural work, staying *below* 400 ISO is the norm, as the emphasis is usually on image quality, with finely detailed images and smoothly graded tonal ranges.

▽
The top LH image is 100 ISO, with a 100% magnification on the right. The objects feel rich and three-dimensional. By comparison, and at this scale, the 25,600 ISO (bottom left) manages to retain reasonable colour and tonality as it is taken from a full frame sensor DSLR. However, magnification to 100% reveals how badly destructed the file actually is.

Shutter speed

The duration of the exposure is controlled by **shutter speeds** – the amount of time the camera's shutter (either mechanical or electronic) is open. It is measured by time-values in fractions of a second. Modern cameras will range between around 30 seconds to 1/4000th of a second and sometimes higher.

Apart from directly adjusting your exposure, choosing a shutter speed is the primary method to control the amount of 'motion-blur' in your photographs. Do you want to freeze the movement of people and traffic? Or make them blurred and ghostly streaks?

- If you're hand-holding to take a picture, you are most likely to see the effects of camera-shake on settings slower than 1/60th. Use of a tripod is sensible in these situations, especially considering your built environment subject matter. Buildings don't move. (Image stabilisers in the lens or camera body will also help.)
- A full **stop** change (a photographic term) to the setting of the shutter speed, either up or down, means you are *doubling or halving* the light reaching the sensor. 1/30th is twice the speed of 1/15th, for example. This difference would also result in a dramatic change in your exposure's brightness. We discussed this in *Ch. 3 Calling the shots 1.1: The case for and against using phones*, illustrating how you can adjust brightness with the on-screen slider. With dedicated cameras, we can be far more accurate with our exposure adjustments.

Each camera type varies with how and where a user accesses these shutter speeds. Sometimes this is via a dedicated marked speed ring on the top plate, others use a dial on the top or touchscreen menu on the camera rear.

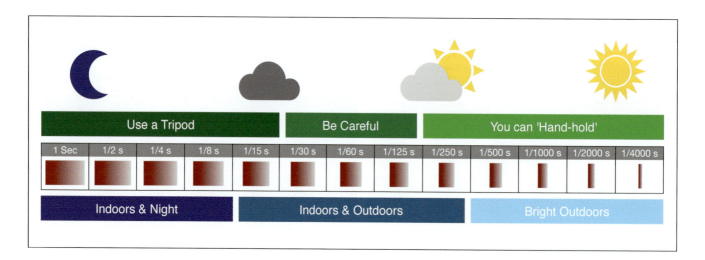

△

This chart is not exhaustive in the number of shutter speeds available, which on most cameras range from 30 seconds to 1/4000th. However, it gives you an indication of likely scenarios for shutter speed choice in whole-stop increments, based on the amount of light and your location.

Aperture

Aperture is also often adjusted via a dial, usually on the top or camera back. This is the third control to affect brightness in an exposure. Like the alteration of ISO and shutter speed, aperture also affects another, quite profound aspect of your resulting photograph. Aperture relates to the physical diameter of the *hole* in the lens, which automatically adjusts to a predetermined size, to allow light onto the sensor when you press the shutter button. This hole is measured in numbers represented by an **f-number**. These quantitative numbers are also known as **f-stops**.

In the same way as the shutter speed can be adjusted up and down to let in more or less light, apertures can be too. F-numbers are derived from a mathematical equation that expresses the ratio of the lens focal length to the diameter of the entrance pupil. Aperture is one of *two* controls that alters the physical size of the **entrance pupil**. The entrance pupil is what the size of the aperture hole, or iris, 'appears like' when viewed through the front of the lens as you look at it. The other is the focal length itself, e.g. a 50mm or 200mm lens.

△
This shows the 'apparent' change in aperture diameter, due to the changing focal length between each lens, even though all three lenses are set to f/2.8. What we are seeing is the Entrance Pupil as viewed from the front of a 24mm, 50mm and 200mm lens.

Each whole-stop change doubles or halves the amount of light let through on to the sensor. The numbers marked in red [Fig 5.2] represent the whole-stop settings. If you recall in the previous chapter, we relayed that more expensive lenses are capable of operation at lower f-numbers, making them 'faster' in low light.

There are additional f/no's in-between the 'whole stop' ones:

Whole Stop f/no's

f/1.4	f/1.6	f/1.8	f/2	f/2.2	f/2.5	f/2.8
f/3.2	f/3.5	f/4	f/4.5	f/5	f/5.6	f/6.3
f/7.1	f/8	f/9	f/10	f/11	f/13	f/14
f/16	f/18	f/20	f/22	f/25	f/29	f/32

Whole Stop f/no's:
f/1.4
f/2
f/2.8
f/4
f/5.6
f/8
f/11
f/16
f/22
f/32

Fig. 5.2

- Low f-numberss – e.g. f/2.8, f/3.5 or f/4 – will give a large opening in the lens iris allowing diffuse light to enter the camera. If light levels are low, you might use a 'wide' aperture (low number) setting to help reduce the chance of under-exposure, and/or if you want to be creative with your depth of field and see a shallow amount of focus in your picture. You may decide to place emphasis on a particular detail, specialist ironmongery for example, so you'd choose a low f-number and focus on that part of the subject. The loss of focus (visual softness) both in front and behind your subject will allow your viewer to really understand the emphasis of the narrative.
- High f/no's – e.g. f/11, f/16 or f/22 – will give you a small hole in the lens diaphragm which will allow more compressed rays of focused light onto the sensor. These are perfect for scenes where details are important running right through the depth of the picture, from foreground to background. For architectural subject matter, it is the norm and you are seeing this comprehensively in *Photography for Architects*.

▷

The LH image is shot at f/4 where the
emphasis is on the fruit bowl and whilst
we can see the setting for it, the story
is the bowl itself, limited by the shallow
depth of field. Conversely, the story on
the right is more about the space, with
the fruit bowl dominating the story.
Arguably this shot is less successful,
the fruit bowl is dominating and the
finely detailed background becomes
distracting rather than enhancing. Do
you want a story about the fruit bowl or
the room?

- Again, be aware that you may need a low shutter speed to compensate for
 the exposure change driven by high f-numbers (small apertures) – tripod use
 is likely if you're staying with a low ISO setting too.
- When someone or your circumstance instructs you to 'open up', or to 'choose
 a wider aperture', they mean you should make your aperture hole bigger/
 wider and therefore allow more light to enter the lens.
- 'Stopping down' means making the aperture hole smaller: a higher f-number
 and smaller hole, which cuts the amount of light in half every full 'stop'
 change. These up and down (increasing or decreasing) instructions apply to
 the shutter speed and ISO selections too.
- Most digital cameras run in *1/3 stop increments* in each of the three ISO,
 shutter speed and aperture settings. Whole stops in shutter speeds are 1/60th
 and 1/125th, for example, but as you spin the dial on your camera between these
 two, you'll find 1/80th and 1/100th settings within. The same goes with ISO and

aperture values. You can be discerning with your choices, and **bracketing** is the term given to shooting the same picture with several variations of setting, thereby providing different final exposures to choose from.

Depth of field

The photographic term relating to the area of acceptable focus within an image is depth of field. Use of a wide angle lens will help emphasise a deep (detailed) depth of field, over and above the use of small apertures such as f/16 or f/22, which will also contribute to a greater area of the shot in focus. Landscape and architectural photographers usually like these finely detailed and sharp results.

In summary, using the fully automated (usually green rectangle symbol) setting on a standalone camera, these three controls are working fluidly behind the scenes with one another to create an acceptable exposure for whatever situation you are in. Certainly, if you're starting out with a camera for the first time, shooting in full auto is sensible. Quite soon, you will find scenarios where wanting to intervene from a trouble-shooting or aesthetic desire will mean you decide to alter the actual ISO, shutter speed and aperture controls independently.

These can be accessed by choosing which **operating mode** you want to work in.

3. Camera modes

Full auto mode

This is *auto-everything*, you just frame up, focus and shoot. The camera makes all decisions relating to the exposure triangle for you. If the camera deems you do not have enough light in a situation, it may increase the ISO, alter the shutter speed, widen the aperture setting, add the flash or do a combination of all of these, thus mitigating the risk of giving you camera-shake. You cannot intervene in this process. It's all automatic.

P: Programme mode

This setting gives you a little more control in the camera's decision-making. It allows you to alter your exposure slightly and make your shots lighter or darker according to your scenario. Crucially, you can now also manually choose the ISO

◁
Cameras often have a top plate with a mode dial, allowing you to select the level of automation you have over the camera. Sometimes these camera modes are selected by a menu setting. Some cameras offer 'scene' modes too; these show a symbol for what situations they work best for.

on most cameras and switch on a live **Histogram** (this should be always available in playback) for exposure guidance. We will discuss the histogram in more detail shortly. Altering exposure yourself to adjust the brightness level suggested by the camera requires using a dedicated control named the **Exposure Value Compensation** or **EV+/-**. This control is also used to amend exposure settings when working in the following two modes as well.

TV (Time Value) or S: Shutter Priority Mode

You can manually set both the ISO and the shutter speed. The camera will then choose an appropriate aperture to create an optimum exposure. Use S mode when you need to be in control of the duration of the shutter, either 'freezing' *moving* subject matter in your shot, or to reveal the effects of motion – like you see in photographs containing blurred figures or vehicles, e.g. Broadway Malyan's National Centre for Sport and Exercise Medicine at Loughborough University or Nottinghamshire County Council's Mansfield Bus Station [Figs 5.2, 5.3].

Figs 5.2 & 5.3

AV (Aperture Value) or A: Aperture Priority Mode

You choose to set the ISO and the aperture. The camera will match your choice with an appropriate shutter speed for correct exposure. Use A mode when you want to be creative with your depth of field. Be aware that a high-number aperture, e.g. f/16, will give you a great amount of detail, but you may end up with a long exposure and need a tripod if you've also kept the ISO low. If you have moving subject matter in the frame, it will now appear blurred again, as Figs 5.2 and 5.3 revealed.

M: Manual Mode

You do *all* the work controlling the three elements of the exposure triangle: ISO, aperture and shutter speed. You'll need confidence and a little bit more time to think in order to achieve the right results with this setting. However, this is the mode that a lot of experienced photographers will employ, and the creative rewards can be plentiful.

Exposure control in semi-automated modes

In P, TV/S and AV/A modes, we've mentioned the EV Compensation, often shown as EV+/- or just **+/-**, as being the way to reduce or increase light onto the sensor over and above what the camera itself might suggest. Normally found as a dedicated button or dial on the top [Fig 5.4] or back of the camera body [Fig 5.5], access to this part of the camera's exposure control is meaningful.

Figs 5.4 & 5.5

Choosing and marrying an appropriate shutter speed, aperture and ISO will give you a correctly exposed image. In your viewfinder your exposure indicator scale will tell you if the shot is on the nail at '**0**', or whether it's over exposed and too bright '**+**' plus signs, or under exposed and too dark '**–**' minus signs.

If a picture appears too light or too dark to successfully show what you wish to communicate, you'll want to alter that and take a second frame which works more effectively. You can use the EV+/- compensation dial or button to do just that.

By depressing the EV compensation button and/or rotating the wheel on your camera (this may be through a combination of buttons) you can *force* your camera to over or under expose the image in 1/3 stop increments. As described, a 'stop' is a measurement of light used in photography. Think of it as 100%, so a 1/3 stop is 33% of that.

△

Each of these top scenes is separated by a 1-stop (100%) change in the amount of light for the exposure. The camera judged the middle scene at '0' and the LH image is minus (−) 1EV and the RH picture is set at plus (+) 1EV. Creating the 'right' exposure at the point of shooting is a far better idea than relying on corrective measures afterwards. For optimum image quality, get it right on site and in-camera.

Depending on the make and model of your camera, it will be able to display these exposure settings in a variety of different ways, as seen on the three lower images. In each case, look for plus or minus symbols. On the LH Sony, it is shown as a −1 to the left of the screen. On the central Canon, the '0' is marked with a small dot underneath. On the top plate dial (RH image), it is shown with a bold +1.

Verifying that your image is the correct exposure for the scene you are recording

Histograms are one of the most significant changes in image capture from analogue to digital processes. As graphs containing numerical data in vertical columns, in digital photography, histograms are used to visually represent the tonal or luminance spread in an exposure. Almost every digital camera can display them in context with each individual frame created.

To recap what we've covered so far, a nicely exposed picture is one you judge to bear the 'right' quantity of visual information in the shadows, mid-tones and highlights relative to the scene. Each exposure is controlled by using an appropriate combination of shutter speed, aperture and ISO.

We use a histogram to help us *evaluate* whether this has been achieved in the way we wanted.

You can usually see a histogram by going into the playback facility and toggling the info/display button. One will be displayed to accompany the image you are looking at. A real-time **live-view** histogram is also available on many camera models and especially vital in judging exposure when shooting video. Histograms may need to be activated in the screen/viewfinder set up menu.

The histogram is measured in an 8-bit graph from 0 black to 255 white, with 254 levels of grey in between. There is no definitive wrong or right shape in the graph – instead, it just reflects a scene's tonal black, white and grey variances:

- A histogram relating to an 'average' scene can look like a mountain range, with peaks near the centre [Figs 5.6, 5.7].
- An over-exposed shot would have exaggerated stacking of peaks on the right, often accompanied by those corresponding bright areas 'flashing' on-and-off on the camera's rear screen, warning you of issues [Figs 5.8, 5.9].
- Stacking to the left side of the histogram often means an under-exposed image [Figs 5.10, 5.11].
- A 'U' or 'valley' shaped histogram just illustrates a high-contrast image, one where perhaps the sun is shining, causing deep shadows and very over-bright highlights.

Figs 5.6–5.11

Getting into the habit of checking your histogram each time you take a frame is good practice, and if it is very 'wrong', you should have the opportunity to re-shoot the frame before you walk away. Again, there is no right or wrong histogram per se – it's just showing you where the different 256 shades of luminance or brightness fall on a graph. It's up to you to interpret the result. Trust the histogram. It cannot lie, whereas just looking at a camera screen on a bright day or in a dark environment can cause you to mis-judge the outcome.

As a random example, a histogram for an image with stacking on the extreme right would be very troubling, as it represents gross overexposure. In this instance, you'd need less light to hit the sensor. Dial down the ISO, speed-up the shutter speed or stop-down the aperture. The highlight peaks in the histogram should now move across towards the left a little. You would expect to see a 'white cube' gallery space represented by a histogram graph with bias to the right though, reflecting the overall pale tones in the scene. A dark nightclub interior with black walls and deep coloured furnishings would also naturally pull the stacking in the graph to the left.

Every situation is different. Practice and learn how to interpret your histograms.

4. Top tips

There is much here to contemplate. Just working through the chapters in Part II of this book will allow you autonomy with your own photography.

We've still not discussed composition. This book is full of photographs which express strong compositions for architecture. Think grids, thirds, dynamic lines, appropriate viewpoints and correct focal lengths to reveal perspective, form and structure.

Good composition is the key to success. In the western world, we read text and images from left to right and like an artist, a talented photographer places narrative elements around the picture to take the viewer's eye on a journey through the frame.

Odd numbers of objects in frame often look better than even ones.

Buildings set in landscapes will benefit from both foreground and background interest and structures such as doorways, arches or tree branches are great for framing the subject.

Use the 'rule of thirds' as another guide to help your compositions. The grid screen on both your phone and camera will aid this. Place interesting and important elements on those intersecting thirds lines [Fig 5.12].

Fig. 5.12

Project Identification:

- William Saunders Partnership: Freemans Quay, Durham; Jubilee 2 Leisure, Newcastle-Under-Lyme;, Leeds Aquatic Centre; University of Derby Sports Centre.
- Race Cottam Associates: North Lincolnshire Council, Scunthorpe; UTC Leeds.
- Pick Everard: Health and Allied Professions Centre, Nottingham Trent University; Salvation Army Sortation & Distribution, Northamptonshire.

Single-point perspective – replicating planning drawings with linear elevations is standard. Two-point perspective will show a long elevation in context with a side view.

Three-point perspective (like the cover shot for this chapter) can work well to express depth or height in spaces.

Use paths, tracks, lines or roads to lead the eye in, thus employing **diminishing perspective**. Don't forget symmetry and repeating patterns for composition ideas [Fig 5.13].[1]

Perfect Symmetry	Vanishing Points	Abstract Patterns

Fig. 5.13

1 Fig 5.13 source: Althorp House stables, Northamptonshire – Althorp Estate. Project identification: Althorp Estate: Althorp House Stables, Northamptonshire; Race Cottam Associates: North Lincolnshire Council, Scunthorpe; George Cannon Young: Church Office Building, Salt Lake City; Hopkins Architects: Holkham Hall Stables, Norfolk; Harry Faulkner Brown: Hallward Library, University of Nottingham; Broadway Malyan: Wyke Sixth Form College, Hull; Hodder Associates: Berners Pool, Grange over Sands, Cumbria; Associated Architects: Severn Street offices, Birmingham; William Saunders Partnership: University of Derby Sports Centre.

All the aforementioned considerations, together with lighting, colour and control of both, make for another weighty book in its own right. The common denominator for lighting in architectural images is often for bold, high-contrast illumination. Expressing 3D structures, forms and materials in a 2D output is best yielded via sunny skies, sunlit interiors and your specified on-site lighting. Working with high-contrast light brings its benefits and challenges.

Finally, the biggest thing of all: the 'elephant in the room' if you like....

Perspective control

A book about architectural photography would not be complete without a conversation about perspective control. With the exception of the chapters which deal with phones and basic photographic competency, or drone/video capture, the images throughout this book have been created using *non-standard* photographic lenses.

Showing buildings 'as designed' is the objective of considered architectural photography and a 'given' if you are planning to commission a specialist in the field. I and my colleagues who have provided the illustrations for this book take great care to convey to viewers of their subject what a structure is, how it is sited, its materials, how it *lives*.

Some of this comes from skill in viewpoint, lighting, styling and the classic 'eye for a picture'. The key in almost everything these individuals do is conveying scale and form with as much accuracy as possible. This task requires the use of camera lenses which are manipulated to correct the appearance of converging verticals. Working with perspective control kit is a big subject. The lenses are costly, there are no zooms, all are manually focused and you will require multiple focal lengths. Canon and Nikon are the main manufacturers producing them for the DSLR system. Fuji make two lenses for their GFX Medium Format system.

△
Perspective-control lenses come in a variety of focal lengths and for the DSLR range currently Canon boast the largest collection with 17mm, 24mm, 50mm (pictured L–R), plus a 90mm and 135mm to complete the range.

△

Physical movement, by way of a dial/ratchet, allows for verticals to stay perpendicular to the sensor and therefore appear correct to the viewer. The degree of movement up or down is almost immaterial: the walls stay straight. As per top image, and from ground level, applying upward movement – shown in the photograph above, Associated Architects' offices for Birmingham City Council, together with the corresponding physical alterations made on the lens.

At the time of writing, mainstream manufacturers were talking of making dedicated lenses to fit mirrorless systems and some third party budget lenses are being launched. Be sure to check the playing field is level (pun intended), as some are compromised in degree of movement and optical quality. For now, most bodies are able to take DSLR lenses via adaptors. The Sony system [Figs 5.13, 5.14], for example, takes the full Canon platform of standard and perspective-control lenses, as long as you use the correct mount adaptor.

At the point of publication, Fuji had entered the market with two focal lengths for their Mirrorless medium format Fuji GFX 100 II body. Whilst this is a game changer, only the GF30mm is the obvious choice for architectural work, as their 110mm is more suited for product and studio work.

Figs 5.14 & 5.15

If you do not have access to any dedicated perspective control lenses, there are other options. Making corrections via computer programmes such as Adobe Lightroom, Photoshop or Serif Affinity can address and modify optical distortion. Each camera manufacturer uses a different approach, and some (Olympus's range, for example) even boast in-camera software.

Remember, if you go outside a proprietary lens range to make your corrections, you can expect some form of compromise to image size/quality. *Photography for Architects* has adopted an approach that readers will wish to make images with the kit they already own, and that this may not encompass specialist lenses. There are some excellent books about taking architectural photographs which go into great depth about perspective-control lens construction, their operation and application. A couple of titles are listed in the almanac so if you are seriously interested in learning skills and making an investment, I would advise close examination of the subject.

Applying extensive perspective control to frames *after* their capture means pixel interpolation via computer software and the subsequent cropping of an image once the rendering is complete. This reduces the output file size and means that future enlargement of the file for print or display purposes is more likely to reveal blocky, broken-up or pixelated photographs. These are most noticeable in the shadow areas of the picture.

▷
By standing far enough back to allow the loss of some of the image for perspective correction, a reasonable outcome can be achieved using postproduction correction techniques. Evans Vettori's Dryden Enterprise Centre for Nottingham Trent University is a small structure on a street wide enough to allow this treatment, but what happens if a building is taller and the distance you can stand from it reduced? Be sure to capture more in frame than you think you might need, in order to allow for editing.

You might make purchases such as a tripoid with a geared head or postproduction software to assist workflow, but again, this book presumes that the majority of your time and specialism sits with *design and management* of building projects themselves. As this section's titles have implied, *calling the shots* trusts that the decisions over who makes the pictures rests in your hands; to do personally, or by tasking others.

Summary

When you're on site with a camera, take your time thinking about each shot. When you get to a new location, even if it's within the same building, don't immediately start shooting. Put the camera down, look around, see what the light is doing.

Know what you want to say and how and why you're going to say it *before* you press the shutter. Employ the controls of your camera effectively to express this; ISO, shutter speeds and aperture controls under your command will give you far greater prowess as a communicator compared to relying on auto-everything.

Assist the viewer in understanding the design of your buildings, their context and their use. Compiling a notional shot list that describes a given genre of building is exampled in *Ch. 9 Briefing your image makers: What should they be doing on your behalf?*. Our task is specific, mobilising *photographic techniques* that convey to our audience what has been constructed. We use the *language* of images to evoke emotions and make them *memorable*.

Successful architectural photography is a challenge. If you feel so inclined, get stuck in and enjoy!

CHAPTER 5
TAKE-OUTS

▶ Start shooting the highest quality of jpeg your camera offers.

▶ Only move to shooting in RAW if you really get into your photography. It will ramp everything up a level but requires more time and specialist software to process.

▶ Get to know the operating modes and what they each represent in terms of control.

▶ Start with Full Auto, but aim to progress to Program Mode swiftly, so that you can control the ISO and EV.

▶ Usual ISO settings for architecture are low ones. If there's no movement at all in the scene, opt for 100 ISO, but be mindful of accompanying shutter speeds. You may need to anchor the camera in order to avoid camera-shake, but the image quality itself will be of the highest level the camera is capable of recording.

▶ Shutter speeds can be controlled in TV or S Mode. For architecture, there's rarely much movement to consider. If you like the style of picture where figures are slightly blurred, then 1/10th second is ideal.

▶ Apertures (AV or A) for architectural photographs are usually set as high f-numbers. For most focal lengths, f/11 is a sweet spot and works well.

▶ Be aware that every location you photograph is illuminated by a source of light that is varied. Feeling that 100 ISO, 1/10th second and f/11 is your optimum choice for architecture is one thing, but unless you can finely control light, you'll only ever be able to realise that combination once in a while. You'll be compromising at every twist and turn, sacrificing one setting in favour of another two. This is the reality.

▶ Learn about histograms and how to influence them. They are your best friend, whatever you are shooting, in any lighting situation.

▶ Try and work with a tripod. Yes, they're cumbersome, but they're transformational: they keep everything squared up, horizons level and make you think twice before pressing the shutter button.

▶ Good composition is king. We're quite traditional in architectural image making. Think about the rule of thirds, diminishing perspective, single point perspective (linear elevations).

▶ Lighting is a subject in itself and worth another book. A good starting point is to work in bold, high-contrast light. Your subject is 3D being shown on a 2D plane. Flat dull lighting usually won't help your case.

▶ Perspective control is worth its weight in gold, but to fully kit yourself out will cost the practice some gold too!

▶ Know what you want to say before trying to say it. Have a plan for how to say it and time your shooting schedule for best effect to achieve it.

Chapter 6

▷ WORKING WITH A PROFESSIONAL

In-house or out-house?

If you're able to grow your business and arrive at a point whereby calling in the services of a professional photographer to undertake your image making becomes part of the equation, congratulations. This means that a combination of you recognising value in what photographs are doing for your practice, together with having the ability to fund the activity itself has taken place.

Assuming you are reading this chapter with an interest in moving from being an architect or part of a design team making images of your own work to a point where you don't, it's also perhaps because you no longer have the time. If you are a strong and effective communicator, reaching your desired client market, then it's probable that your business is growing. Creating efficient marketing is vital if you have a team behind you that can deliver on the promises made. Being too powerful in your endeavours can also cripple a small business, because you may then be in the unenviable position of having to turn work away. Turning work away feels as bad as not having enough of it and striking the balance is hard.

▷

Derby Arena by FaulknerBrowns.

Calling in a professional to help shape your folio of work is perhaps the ultimate step in visually defining your place as a designer. That ambassador has a challenge not just to capture what they stand in front of, but to interpret reality and shape it into something far greater than a record. This is the point when 'magic' happens, the viewpoint, composition, lighting, casting and placement of models aligns to create what French photographer Henri Cartier-Bresson called 'the decisive moment'. The outcome should enrich what you do.

Every time.

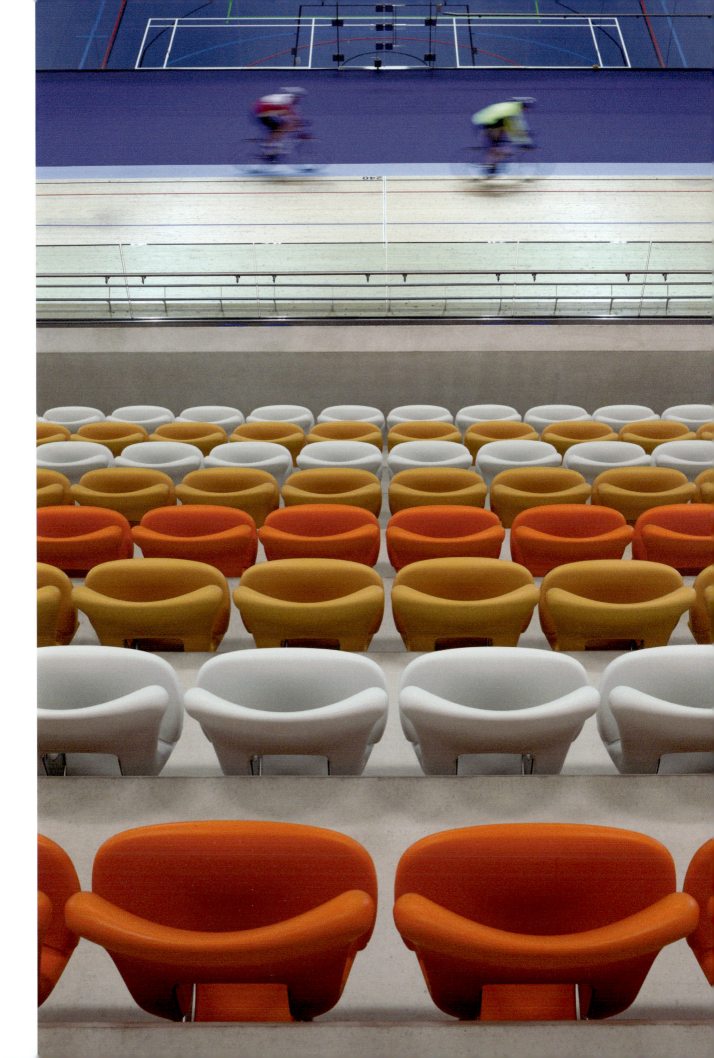

It might be that you now choose to engage with an independent image maker from time to time and carry on with other elements relating to marketing yourself. Or it might be that you recognise a regular need in your practice and wish to facilitate a rounded unit which is able to address multiple facets. These might include:

- Image making
- Copy writing
- SEO (Search Engine Optimisation) and web management
- Social media strategy
- CRM (Customer Relations Management)
- Press and Public Relations
- Marketing

Deciding on whether these services are bought in regularly from a trusted number of separate parties or whether to commit to taking on one or more people to carry out these tasks between them in-house will vary from practice to practice.

I have always provided an independent go-to creative service for multiple clients. I also have colleagues who have spent time as freelance photographers *and* as permanent salaried staff in larger architectural practices and multi-disciplinary consultancies.

Certainly, there is a big commitment financially to take on someone in a permanent marketing role, whether they are primarily an image maker with complimentary skills in other areas or someone with marketing-led training who is adept with a camera. If photography and marketing is seen as the final stage of Building Information Management in your business, it might be that the person dealing with this aspect of the practice's activity is also seen as the person key to presenting projects to an external audience and they need to be proficient with the tools of image making.

There are several stages by which you may make the transition from first thinking about visual asset management for your business to going the final leg and making the financial investment in expanding your team. There will be a huge number of practices that never make this level of commitment either. Dependent on the nature and size of the operation, there may simply be no need.

The first mission for your business is curating a collection of effective visual assets that you can call on to best represent your past and current output. That's the focus of this part of the book. The second part will be the tail wagging the dog – the active circulation of that folio, so let's deal with that later.

Recognising that you've moved past creating your own photographs and now need a second pair of eyes, where might you find them?

Hiring a freelance photographer

Like everything in commerce, spending money on photography will depend on the bottom line. So, who you choose to work with will depend on what you can afford.

Certainly, if you are commissioning a professional image maker, you need one who speaks the language of buildings. Just because you are an architect, it doesn't mean that you'd be the right person to call to design every building type. Photography is like architecture – there's an umbrella title, but a studio photographer has a very different set of skills to a press photographer.

△
Sometimes the photographer's skill is as much in the storytelling as it is in composition and lighting. This may mean bringing people together, directing them to assist in creating a visual tableau which conveys design and purpose, as shown here in the David Ross Sports Village at the University of Nottingham by David Morley Architects.

Like most creative services, a certain amount of work is likely to come through word-of-mouth referrals and that's the best place for you to start. Speak to colleagues in other practices, local professional associations and networks: Who do they use to make their photographs and would they be happy to give a recommendation? All enquiries may send you to one door, so you're done, but it is quite plausible that two or three names will come back.

Photographic agencies are commonly used in fashion and advertising, but these respond to their own specific markets. Whilst there are exceptions in any field, the norm is for individual practitioners to service the profession. Photo-libraries specialising in the built environment such as Arcaid, View Pictures, Esto and OTTO will be helpful to you as directories. Who is on their books? Contributing photographers will then have their respective links so that you can access their folios and discover their geographic locations across the globe.

The next step is to take your shortlist of names and Google them – look at their website and Instagram account. What's on display in their 'shop window'? For an image maker, the profile they convey of themself and their work is vital – do you like their visual style and their ethos? It's important to align how they speak about themselves with their images alongside how you wish to convey yourself visually too. Do they use their photographic voice with the same clarity and empathy that you recognise in yourself and your own work?

There will be various types of photographers by subject. There are those who sell their image making services as a part-time venture and perhaps have a completely separate day job but shoot mostly for pleasure and seek renumeration where they can. Quite often they'll be members of photographic clubs and associations; keen hobbyists. You will find them to be the most affordable image makers, but you might need to significantly compromise with their availability, depth of understanding of the subject matter and the suitability of their equipment to tackle the job. Primarily, their passion will be the medium of photography, not the architecture behind it.

An enthusiast with a good website/Instagram account is likely to display nationally recognisable builds but actually doesn't have genuine working relationships with the headline practices who designed them. You'll pick this up pretty quickly once you spot the hallmarks of an enthusiast with a deep wallet for exotic holidays.

These folios will have publicly accessible buildings – galleries, monuments, castles, cathedrals and tourist hotspots from around the country/globe – but they're all likely to be shot from viewpoints in the public realm, such as squares, bridges, viewing decks, etc. If you start to notice shots taken from beyond perimeters or within interior spaces of these projects (and not just hand-held grabs), but insightful aspects conveying the fullness of the building, then you might be looking at a photographer who really does do this for a living.

Another, more serious aspect for consideration is whether such image makers carry the right insurances for site work – do they have Public Liability and Employers Liability cover for example? It is surprising (at least it is in the UK where registration with an industry body is *not* a mandatory requirement to trade) just how many individuals 'sell' their services without any form of legal protection for either them or the people who engage them.

Your search may start to become more viable when you have the confidence that your image maker is an established business promoting professional values. You will come across multiple commercial photographers who hold a diverse folio. These may straddle skills which encompass the needs of the building industry. Let's look at what some of those areas might be:

- Perhaps they shoot a mixture of business portraits – these probably take place on location, therefore requiring an understanding of lighting control in and around buildings.
- Maybe they also shoot products in the studio, which again requires a good understanding of light control and how to reveal shape, form and material.
- Third, they may have a folio of building pictures too – perhaps residential real-estate and, perhaps, commercial and industrial structures.

- Finally, editorial and documentary photographers understand the art of good communication and seeing shots where others might not – they're swift and effective, although they are less likely to embrace specialist perspective control than perhaps a studio and product photographer would.

These photographers trade business-to-business as opposed to wedding, portrait and high street photographers whose main custom is in selling to the public.

For commercial folios with building pictures in, do these images show the form and structure of the buildings in the way you'd expect to encounter the real thing? You might want to be wary of websites depicting dramatic angles and extremes. Do all the pictures have converging verticals or do the structures appear lifelike? If not, they might be memorable and dynamic perhaps, but 'photographic' for the sake of photography more than being able to convey the reality of the architecture itself in an informed, communicative manner.

Finding an overtly specialist architectural photographer may be straightforward in major cities, but whatever country you operate in, once you get away from major conurbations where investment in the built environment is considerable, dedicated practitioners are likely to be thin on the ground. Frankly, the day rates between good professionals and specialist architectural photographers are likely to be nominal. If you're buying the services of any reputed professional, why would one be more expensive than another? Indeed, you may find an architectural photographer charges less than a studio shooter; their overheads will be lower as they work on-the-go rather than factoring in heavy property rates relating to square footage for commercial premises.

This said, if you're in an area where you can access a dedicated practitioner whose folio is one you rate, direct conversation may now commence.

Things to ask of your potential practitioner

In all honesty, you may not have many questions by the time you actually speak to a viable photographer for your firm. The road travelled until this point will have been where the major hurdles lie in terms of the 'ask', so think of the following questions as your internal ones at the research stage, *prior* to dropping that first email or picking up the phone to the individual you've identified.

We've already stated that a creative practitioner's 'shop-window' is their online presence. This means that 95% of searching may be done by you remotely. The image maker in question is possibly blissfully unaware of the homework being undertaken at their door. I've found during my working life that I've rarely been asked to pitch against multiple others for general work. In the main, people either seek me out because they want to engage (and often with a specific project in mind) or they've already moved onwards in their quest without making direct contact at all.

- What does each website say about the person in question and their folio? Look at the pictures and study the narratives that accompany them.
- Are you looking for a new approach? An edgy vibe? Is the practitioner young, with a compact but vibrant folio?

- Are you drawn to a wide range of building types illustrated that convey experience? Classic views, technically adept and memorable? A client list you recognise?

Drilling down further, it's not simply the projects themselves that you need to be mindful of, but also *how* the places depicted are being conveyed to their audience. Knowing a practice's work is helpful here. If you can see images of a building that you actually know personally, how has that structure been photographed? Do you understand what you see? Being shown something you already are familiar with in a new and interesting way is great. Be sure that it is memorable for the right reasons and not just entropic because it is whacky. Unless you want whacky, of course.

Does the photographer you are researching embrace perspective control? Are walls straight, perpendicular to the horizon? Are subject–camera distances natural? Are the scales and relationships of one object to another realistic? This rarely takes place unless specialist lenses are employed or significant postproduction is undertaken, especially with tall buildings. It is important to understand that any intervention in controlling perspective is *far better* at the image making stage as opposed to afterwards. This is because if it is tackled optically, you will receive images that will *not* be compromised in file size. Instead, they will be native to what the camera can produce and therefore should be of the highest quality possible.

Are the pictures similar in style to what journalist Owen Hatherley reacted against back in Chapter 1? Do they ignore the reality of our busy world that historian Robert Elwall spoke of when he reviewed Gabriele Basilico's pictures in Phaidon's 1999 monograph of the photographer? As Elwall said: "Basilico's desolate, monochrome cityscapes represent a kind of 'neutron bomb' photography, in which all structures remain intact, but the inhabitants have chillingly vanished."[1]

This is not to be entirely dismissive of empty spaces; sometimes there is a time and place for stillness, as seen in *The Buildings of England* books featured in Ch. 2. However, if this is the case right across a portfolio, does this approach work for you? Are they quiet, elegant studies of the building that allow you to know the design and character of the space? Perhaps this is your preference.

1 Robert Elwall, *Building with Light – The International History of Architectural Photography* (London: Merrell Publishers, 2004), 199.

▷ + ▽
These studies of Herzog & De Meuron's De Young Museum in San Francisco and SOM's Cadet chapel for US Airforce Academy in Colorado Springs don't require the presence of humans or wider context to allow the viewer a sense of their design and material qualities.

Has the photographer worked with people? Have they involved the users of the building? And if that's the case, are the photographs still about the architecture, or have they become portraits? This is a very different outcome. If they do involve people, do they manage to become something powerful, beautiful and enlightening too – not just about the form, but also the function?

◁ + △
Daniel Hopkinson's images of Two, St.Peter's Square, Manchester by SimpsonHaugh and Partners (above) and The Spine, Liverpool by AHR (seen left) are about the volume and design of the spaces. People add animation, helping the story, but not becoming the defining elements.

How is light handled? Is contrast beyond the reach of the eye, with blown out highlights and deep recesses in shadow? Or is there a viable range of tonal values from the brightest whites to rich blacks with natural, noiseless (smooth, not pixelated and broken up) shades between?

This is architectural photography.

It is driven more by the love of the subject rather than the medium itself by which it is delivered. Speaking personally, my favourite thing in life is exploring buildings and observing light in and around surfaces and forms. Photography is simply the delivery medium to facilitate my encounters with designed spaces.

Find someone with that passion and you'll discover someone who understands what they are looking at and, moreover, how to convey and celebrate it in a joyous way too.

You should discover this work in the website of a dedicated Architectural Photographer (AP) with decades of image making behind them. You could find it within the portfolio of an experienced commercial shooter who understands the language of architecture just as well as a true specialist but embraces a broader church. Or you may see it in someone who has had limited exposure to the market, but just 'gets it'. Gets the subject, understands light and is in love with the architecture in the same way as you are. You can see it when it's there.

To instill further confidence, look at the terms and conditions stated in their promotional material. Are they citing copyright in the work? If they understand and demonstrate copyright, they should also understand your rights in your work too. Mutual respect for both parties is important. For more about copyright, see *Ch. 14 Copyright – Whose right and who's right? Understanding and controlling copyright.*

Does the geography work? Great to find your perfect visionary, but if they're the wrong side of the country (unless you're based in Luxembourg or Malta!), it could be a real issue. Travel costs, weather variations ... these are real barriers to practical and aesthetic success.

What of any regulatory certification that they might carry?

For those designing for education, healthcare or vulnerable/frail adult care, check if your image maker is cleared to work unescorted in such buildings. There is detailed discussion about the principles and paperwork for such encounters in *Ch. 16 Ethics: Visual thinking and accountability.*

In the UK, anyone designing for patient care or for special educational needs will carry paperwork to be able to work on site unescorted. The same regulatory certification needs to be in place for image makers too. If you're sending someone external to cover the project, be sure they hold the right permissions for the job.

Requirements for unescorted access to construction sites vary from country to country. If you're a multi-disciplinary practice with engineering and civil structural work as part of your day-to-day activity, using a professional with site health and safety knowledge and compliances will be useful to you. These papers are less commonly held by dedicated APs who tend to make their livelihood from shooting completed and occupied builds.

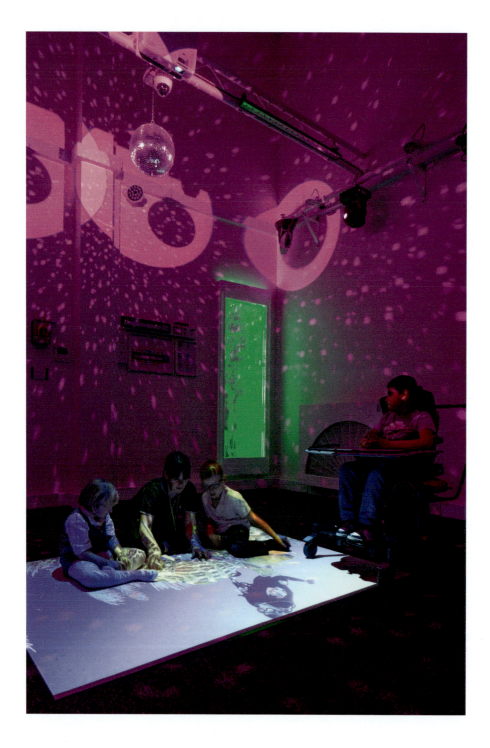

◁
Active consent from a parent, carer or guardian is required for anyone appearing in images and unable to give their own consent, such as this one at Ashmount S.E.N. School in Leicestershire by A+G Architects.

Some specialists carry Construction Site Certification. The majority of readers are likely to be familiar with this already, but for those researching roles without day-to-day site experience, it is important to understand that such paperwork allows work to be carried out unescorted on sites whilst builds are active. Holders will be abreast of current health and safety regulations. Registration commonly requires a short course of study followed by a test procedure and the resulting paperwork is valid for up to ten years in some countries.

The following table lists some of the main site certification bodies.

Territory	Organisation and Details
UK	**CSCS** Construction Skills Certification Scheme (www.cscs.uk.com) and also **ECTIB Engineering Construction Industry Training Board** (www.ecitb.org.uk/qualifications-and-training/ecitb-safety-cards/engineering-construction-industry-safety-card/). The most appropriate card for photographers is the Construction Site Visitor Card which allows image makers to work unescorted. From 2024 this card is being withdrawn and at the time of writing, a replacement scheme had not been announced.
EU	Commonly across the EU, including Germany, Austria, Belgium, Switzerland, Poland and the Netherlands, the **SCC** (Sicherheits Certificate Contraktoren) is recognised. This is known as the Safety, Health, Environment, Subcontractor's Checklist. France uses the **MASE** (Manuel d'Amélioration Sécurité Santé Environnement des Entreprises). A useful EU overview can be found at https://business.gov.nl/regulation/contractor-safety-checklist-vca/
USA	In the USA, **OSHA**, the Department of Labor's Department of Occupational Safety and Health administers the scheme. www.osha.gov/construction
Australia	In Australia, they are known as 'white cards', administered by **Safe Work Australia.** www.safeworkaustralia.gov.au/safety-topic/industry-and-business/construction/working-construction-site

If your image maker is conducting photographic surveys on construction sites only once in a while, most contractors will be happy to facilitate the visit, offering health and safety inductions for the visitor and providing a site escort. However, this approach may feel inappropriate for all projects.

SALLY ANN NORMAN
PHOTOGRAPHER

I spoke to Sally Ann Norman, an architectural and editorial photographer based in the north-east of England. Her advice is vital for those who want to bring the construction element of their builds into view as well as the finished outcomes.

This need has increased since the introduction of social media: the desire to drive a story over many months in order to stimulate and engage with an audience about a project can mean ongoing storytelling is important.

Sally notes: "Interestingly a lot of contractors and subcontractors don't allow their workers to take photos on site. Understandable when they might take inappropriate shots of unsafe or incorrect conduct and it ends up on Facebook."[2]

This makes sense; having a photographer visit site in a more formal context means that workers can continue in their various skilled roles and an image maker can observe them working. Sally continues:

> Allowing a photographer to work at their own pace on site is vital for the best shots. If you have a knowledge of construction and health and safety on site:
>
> - You can anticipate and pre-empt great shots. By knowing what might be about to happen, where's going to be a safe and good viewpoint, what any given procedure is likely to involve, what to wait for, where to be etc; a photographer can capture great shots;
> - You can avoid taking shots which might show unsafe conduct or might be perceived as doing so – images which can damage the reputation of the construction company, sub-contractor or the building itself.
>
> For example, knowing what is safe practice: should there be a kickboard on that scaffold? Is that ladder safe? What should a worker be wearing to carry out that task?

Sally's experience tells us that despite the best intentions of a site providing an escort, that escort's time may be limited and becomes a defining factor of what may be achieved if one is being taken around a site to work. This is also my own view. The best arrangements are those which facilitate, not control.

2 Sally Ann Norman, personal conversation with author, 10 July 2022.

△ Sally's image shows workers installing curtain walling at Ad Gefrin Distillery & Visitor Centre, Northumberland designed by Richard Elphick.

Having freedom on site is KEY to getting the best images. If you're chaperoned, you're walked round the site: shoot that, walk on, shoot that, 'surely you've got enough now, yes?'

What your chaperone thinks is a good photo often is not. The best construction shots I've ever taken are when I'm not in a hurry. A chaperone will take you to the concrete pour, for example, let you take some shots and then assume you're done. 'No ... please let me stay for longer, let different stages of this process unfold and allow me to get the best shot possible'.

◁ + △
Scaffold work and concrete pouring at
The Boiler shop, Stephenson Quarter
in Newcastle upon Tyne by Xsite
Architecture LLP for The Clouston
Group. South-west Scotland pipeline
installation at Cluden and steel erection
at Ad Gefrin Distillery, Northumberland.

△

The following series depicts Space Architecture's restoration of the Globe Theatre, County Durham. As a holder of safety certification and enhanced public liability cover, Sally works at heights with her photographic kit across demolition and construction sites.

Given the many hours that she spent on site during the contract, this would have been difficult without carrying the relevant legal paperwork and she would have needed escorting throughout.

Sally also offers a drone capture service too, concluding:

> **When you're working on a site, being able to place the camera exactly at the heart of the narrative is vital. Having the right set of skills plus the right kit to maximise opportunities is vital for my clients to best tell their story.**

Clearly, construction sites invite slightly different approaches to conventional architectural image making and moves into documentary and editorial photography. Finding a practitioner who can straddle this myriad of skills and deliver on all counts could be transformational for your brand.

Other certifications offering customer confidence which a professional may state in their website could include membership of an industry body. There are a variety of these – in most countries photographers do not need to hold mandatory memberships or registrations in order to trade; there is no equivalent of the UK's ARB (Architects Registration Board), for example.

In Germany and until 2004, professional photographers were required to complete three years of vocational training before they began trading, but this has now been relaxed and registration now takes place with the local chamber of commerce instead. Broadly, across the EU, Canada, USA and Australia the ability to operate successfully is about one's business sense and a strong portfolio. These might not be considered as heavyweight assurances, hence many professionals undertaking bachelor's degrees and holding memberships of professional associations to help endorse their viability and build trust for clients. Look for these accreditations in the form of suffixes to names, or trade association logos embedded on website footers.

Assuming you like what you see and may have identified more than one party offering a service you feel is a match, what next?

How to go about commissioning

Engaging a photographer is a personal decision that rests as much with the heart as the head. This is distinct to the speculative competition approach that architects are regularly asked to engage with, and which sadly ignores inter-personal relationships.

It is also rather different to the world of advertising and fashion where photographers are regularly asked to submit their **books** (folios) and prepare **treatments** (detailed pitches responding to specific briefs complete with cost breakdowns). Treatments are speculative pitches, fraught with risk in terms of time and effort, a familiar story for architects. For architectural photographers in the UK, the approach is far more polite. Instead, it is in keeping with engagements discussed in *Ch. 1: Contexts and frameworks: Foundations of the architectural image in print and press*; more akin to the pre-1972 advertising days, where one was awarded work based on merit and reputation.

For their US projects, Philadelphia-based architecture firm KieranTimberlake use a regular stable of photographers, both on the East and West Coasts. Senior Associate Daniel Preston explains their choice of image makers:

> *A lot of working with photographers is a relationship that you build up with them, but also each one has a very unique set of skills and photography repertoire ... trust is big and if we can work with the photographer, trust them to understand our project and study the site, study the building and not just show up blind; that's extremely helpful for us.*[3]

Liz Earwaker at Grimshaw endorses this relationship of trust as well. She explains that in a larger practice, it is a relationship that moves far beyond buying a product or installed service. Therefore, there will be preferences by individual partners over who is engaged and for what project.

> *We do use multiple photographers – for different reasons. It may be a result of the story we want to tell and we know that a specific photographer has that eye or it may be the working relationship that, over time, certain photographers have built with the practice – knowing what images will best represent the work that we do. Our Partners and Principles take a keen interest in the commissioning of our photography.*[4]

Certainly, one of the major aspects of engaging someone will be down to their folio and their price, but the retention of that service beyond the first engagement will be down to them and you; a brokerage of understanding that develops. Much of this section of the book describes briefing logistics, timing considerations and how relationships with others result in a top line set of pictures, but certainly the number one priority is based on trust. You need to trust that someone is an ambassador for you and your building and able to deliver a legacy for your project that is enduring.

The nitty gritty of commission number one will be ascertaining a price for the work as closely as you can ahead of the day and being sure about what the agreed package encompasses. There are many variables to this which mean you should expect an *estimate* to be offered as opposed to a *quote*. You're not ordering a palette of bricks, delivered to site on a specific date and thereafter the transaction is concluded. It just doesn't work like that.

3 Kieran Timberlake, interview with author, 20 December 2021.

4 Liz Earwaker, interview with author, 10 December 2021.

Here is a typical estimate structure:

Heading	Details
Fees	Usually by the half or full day, relating to the time taken to capture a 'day in the life' of a building and the subsequent usage of the work (see additional note in the last section of this table on the *Licence*). Architectural photography is rarely charged 'by the hour', unlike photography for press or PR engagements.
Assistant/stylist	Usually shown as a separate charge.
Travel	Mileage/other transportations costs.
Subsistence/ accommodation	Usually only if the engagement is beyond a standard working day in length.
Extras	This may relate to props/models or specialist equipment hire – see *Ch. 9: Briefing your image makers: What should they be doing on your behalf?*.
RAW processing	Often shown as a separate charge to on-site photography fees, may be accompanied by delivery of proof sheets for selection.
Postproduction	This may be a standard per-file charge, or be charged by the hour, dependent on the nature of the work, and may or may not include extras over and above dust removal, colour corrections etc. If pictures require significant remedial work, eradication of scaffolding, vehicles or other impeding obstructions, be sure to ask for a price.
Prints	Less common than previously, but there may be physical assets produced – printed folios/books.
Delivery	Mostly relating to charges for physical assets as the majority of files are delivered via **FTP** (file transfer protocol – online movement of files from one computer server to a different external server) and not usually accounted for in a separate charge.
Licence	This is where the *terms* of the commission will be set out which relate to the planned usage of the images. The client (architect) will hold the material assets of the project for their use after payment. However, the *ownership* of the intellectual rights rests with the creator in just the same way as the design rights to a building belong to the architect. This means that in order for a client to use the work, the image maker will need to set out the terms of a licencing agreement for the commissioning party. These terms are negotiable between both parties, but commonly allow the client certain uses over the work which may have a date or geographic limitation. In addition, they may be issued for a sole party's use: **exclusive** or allow the photographer to issue on behalf of others, known as **non-exclusive.** The scope of such rights will have a bearing on the overall project fee. *Photography for Architects* explores rights and licencing for intellectual property in Part IV of the book.

Because the finances of each job are the absolute cornerstone of whether or not an engagement is carried out, it might be that for the very first time, you do ask a shortlist of parties to price the work. You should end up with a ballpark set of figures to go over. This will take you down to 'the one', or perhaps two. It may not be the lowest price either that is the clincher though; you want value, but not with a heavy compromise.

For the first time working with a professional, it wouldn't be usual to conduct the entire pre-shoot relationship via email. Talking to a variety of architectural teams and photographers over the years suggests to me that the investment you are making does require a deeper connection than that.

Whether you do this exercise by calling them in for a face-to face meeting, or, setting up an MS Teams or Zoom call, is up to you.

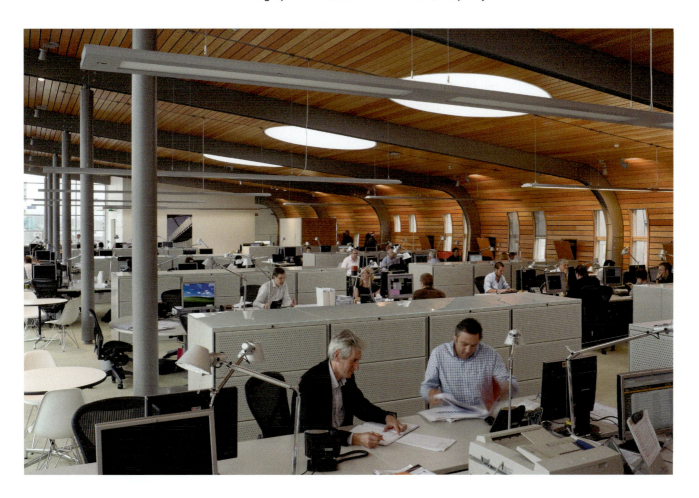

△
Inviting a photographer into your office to meet the partners responsible for decisions about image making may only ever need to happen once, but 'getting to know' your ambassador in person is a sound idea if logistics allow. Pictured is BDP's Manchester office.

With the portfolio, personality and price established, you are now ready to hand the baton over and brief your image maker. *Ch. 9 Briefing your image makers: What should they be doing on your behalf?* goes into detail about what things need considering. Whether a contract is created for that commission will depend on where you are in the world and how you like to conduct your business. Some areas will anticipate both parties signing contracts in order to proceed, with terms of copyright and payment set out in formal terms. Other commissions will be far more relaxed, with simpler email exchanges stating the details and terms of that work being undertaken from the practitioner.

Be sure of what you are asking – supply drawings, shot lists and any other permissions or directions necessary – and be confident that the photographer understands these. Next time you communicate, the work may already be complete and ready for delivery. Do not risk ambiguity prior to commencement that could result in disappointment and disagreement over the pictures together with the price you are asked to pay for them. It's not fair on them and it's not fair on you.

All of the preceding information presumes that you will seek to work with an image maker on an occasional basis. They may become your go-to person forever, but the work you have for them may be only a few days a year, or in the case of many smaller practices, only once every couple of years. Don't worry as freelancers get that. It's the nature of the game.

Remember that because they need to have many, many clients to fill their annual diary on that basis, it might be that, once in a while, they are already committed and reluctantly have to say 'no'. If they value you and your work, they'll do their level best for you, but it is unfair to back someone into a corner if they're really busy. The worst outcome of this will be that they feel obliged and may end up having to work at a time or in weather conditions that are less than ideal from either party's perspective. Saying 'no' occasionally is a reality that we all have to face and a risk we have to take.

If you reach a point where your business demands more than a few days a year, and you need the services of marketing and image making, you may actually decide to create an in-house role for this. It's a big step but measured against the investment of each individual set of project photos, you may feel it is something worthwhile. Grow further and you may need a full-service team, where photography alone becomes the full-time role for a person.

I spoke to one such photographer, an individual who has straddled boundaries and seen both sides of the coin – starting out as a freelancer with a successful business until the 2008 recession. A multitude of pressures saw him working in-house for a large UK practice for a period, but today, he shoots full-time in his own business again.

DANIEL HOPKINSON
ARCHITECTURAL PHOTOGRAPHER

Founded in 1835, AHR is a multi-service, multi-sector practice with eight offices across the UK. Working out of its Manchester office, Daniel Hopkinson brought with him an international reputation curated over the previous decade, and for both parties, there was much reward in their relationship.

Discussing Dan's time in-house, I asked him how the role was different for him and his employer compared to their previous relationship, where he was commissioned on a regular project-by-project basis. He raised some very interesting points.

> It was very strange working for one practice with one style. I wasn't used to that ... [AHR's multiple offices] all carried out different sorts of projects. They all had their own style. And what tied them together was me. There was this one photography style that went through it. And it took two years. But after two years, if you now go on AHR's website, it has a style that runs through it, whatever the project, whether it be a school, a skate park, an office, an old people's home.[5]

So, what Dan recognised was that the two brands had become aligned, his and theirs. The longer he was there, the more there was a defined visual aesthetic that was able to run throughout AHR's stable of offices, and it was able to unify and characterise their portfolio. As we explored in *Ch. 2 Representation of your work: Constructing your practice brand*, each photographic practitioner has their way of seeing, their style of work, just as architectural firms will also have a set of characteristics, through their use of materials, their design ethos, etc. Marry two strong forces together and a recognisable brand of its own is likely to emerge, as exampled here.

5 Daniel Hopkinson, personal conversation with author, 3 September 2021.

▽ + ▷
AHR's UK Hydrographic Office, Somerset. Barbara Hepworth Building, University of Huddersfield, Blackpool Council's Talbot Offices. Oasis Academy, Oldham (both Lancashire).

Case Study Daniel Hopkinson

Another feature of bringing the work in-house relates to intellectual property, which is discussed in detail in Part IV of this book. In the majority of territories, a defining feature relating to copyright ownership depends on whether the creative output is made under regular employment, or a bought-in, freelance service. Dan continues:

> **Because they employed the photographer, basically they owned the copyright on the work. I'd shoot these images, so now they had the pictures that everybody wanted and they were in control. Now they got to have more of a say in the marketing. So instead of all the images going out without them in control, what they were saying [to third parties] is 'well, you can use these images free of charge but you need to credit AHR every time you use them'.**
>
> **So historically, what would happen was everybody [other consultants on a project] sent their own photographers and then AHR wouldn't get mentioned and the photography wasn't always from an architectural perspective so they were frustrated. But instead, 'if they're our images, we'll licence you to use them, as long as you mention us.' It kept AHR's name out there and enabled them to show their projects in the best light.**

Another direct, yet possibly unforeseen, benefit of Dan's permanent presence was that instead of simply being on hand to capture showcase projects for each office, he had the time now to be able to document far smaller jobs which wouldn't conventionally have realised a budget for photography. This was largely because he was not required to undertake the actual marketing of the builds. It recognises the fact that AHR's scale meant they had a full in-house marketing and graphics team.

▽ + ▷
AHR's Blackburn Skatepark, West Lothian.

> **They'd had photographers a long time ago, but never a true architectural photographer. They didn't really know how to use me properly at first ... but then I got to do some really interesting stuff. Photography of skateboard parks and projects that were done on a very low budget that I never would have normally got to photograph because the client couldn't afford to have a photographer there. But because I was in-house, they got me to go and do it. And so I did one of these sites at night and one of the architect's kids was a skateboarder. It was in the poorest area of Glasgow. So honestly, I thought I was gonna get issues at 10.00 o'clock at night, but it was amazing. And all these kids came down and they were doing stunts that were incredible. And I'm photographing it!**

Dan and I discussed how this conceivably brought value-added benefits for his employer. Every fee-earning job has its place in a company, and just because one build doesn't have 'award' written on it, doesn't mean its income isn't vital to the well-being of the business. Effective marketing of any project should translate to the bottom line: more income and financial security for all.

Often, the day-to-day images which Dan made were used for fee-bids rather than legacy marketing. Indeed, he was tasked to enrich the visual story beyond that of *architectural photography* explaining:

I started to be led less by the architecture teams and more by the marketing side of it and they had a long-term plan that would change depending on what bids were in. I did a lot of work for stuff to go into bids; they'd say, 'We really need this project for a bid that's coming up.' I would then go and get some good shots for it that we were really short on. We wanted people socialising in the office or pictures that showed community, more portraits and documentary work. So, I tended to take it all on.

I became part of the bid and the bid team. … Marketing spend 90% of their time doing bids. They'll have somebody that does tweets and a bit of Instagram, which everyone's aware of now and they occasionally want to do a book call or put something out to a journal, but a massive, massive part of what they're doing is bidding for work. … They're busy. And that's my stuff inputting directly into that. And so they would ask me, 'have you got anything that shows this element' and 'what project shows that?' Because I was the person that was visiting everything. They didn't get to site a lot of the time.

This is an interesting point which Dan raises. It ties in with me being informed many years earlier by the chair of the UK's RIBA Awards that one of the reasons they often selected architectural photographers to be jury members for competitions was because such photographers look at many, many buildings on an annual basis. It translates into them not only understanding what they encounter, but also allows them to swiftly assess how a site is functioning and whether the design rationale actually delivers what is required. In this case, it meant Dan was able to understand where extra visual value might be brought to tender documentation.

He has some sound advice for practices considering setting up their first position for an in-house image maker. HR teams need to understand that a photographer is neither an architect nor an office worker. Dan's role was not of a fee-earning associate, nor that of an administrator. For partners whose hour-on-hour billing

◁ + ▷
Neither AHR's Stranraer Gateway on the west coast of Scotland or Peterhead Court in Southall, London are swiftly reached from Dan's Manchester base. Even further afield and flights/ rental cars become part of the equation. These are all variables which require consideration when weighing up the potential creation of an in-house role.

Case Study Daniel Hopkinson

represents a sizeable contribution towards turnover, in-job benefits may come with the post. With a photographer's role, similar budgets may need ring-fencing to allow them to have access to the tools and materials they need to operate well for you.

If the post needs to cover more than one geographic location, consider the time taken for travel in a working week. Project heads across various offices will be aware of what amount of time might be required for a site dependent on its scale and nature, but might not necessarily consider the time needed for the movement of photographer and kit between disparate locations. A photographer does not travel light and even in major cities with good public transport links, a car may be a necessity rather than a luxury. AHR recognised that Dan needed to be able to change locations swiftly following weather patterns and provided him with a vehicle. In many companies, there is an expectation that material assets such as cars are part of the role-related assets for senior partners. Using rental cars could hamper the process and possibly becomes more costly to facilitate in the long run, especially considering frequent pre-dawn starts and black-of-night finishes.

The same applies for the postproduction side of the job. Image makers use powerful computers with large hard drives and fast graphics cards in the same way as CGI teams do, not machines specified largely for word processing. Couple that with a pro-spec camera body, geared-head tripod and a suite of perspective-control lenses together with lighting; now you may begin to see why a freelancer's fees are what they are. Bigger projects will need an assistant for speed or health and safety implications too. We are not discussing modest investment levels and bringing a role in-house requires a need, together with the means to meet it. AHR understood this and facilitated the necessary requisites for Dan to operate effectively.

Today, Dan is back in his own business again, but continues to shoot AHR's flagship projects, much in the way he originally did. He is able to 'top-up' their very focused and distinctive bank of images which he curated whilst in post, and both parties continue to reflect on their time together with satisfaction.

In summary

Like AHR, you may be at the point of considering making marketing a part of your everyday voice, but unlike them, you may not be able to facilitate a team with separate job titles and functions. Instead, your new right-hand may need to be an all-rounder; a bid-winning, copy-writing SEO expert who can make a fine photograph too.

On the other hand, you may be at the point in your business where you're moving from being the individual making the images and designing the building into one who hires in professionals with visual skills and the kit to make compelling images on a day-by-day need.

It is worth finishing with a comment from Sally Ann Norman's client Ad Gefrin (featured in the earlier case study). They emphasise that success is a mixture of:

> *a strong relationship between photographer and client, with high levels of trust due to the empathy and understanding of the photographer. In this instance the photographer is the eyes of the brand, and central to the vision of the architect and client in presenting the images as such.*[6]

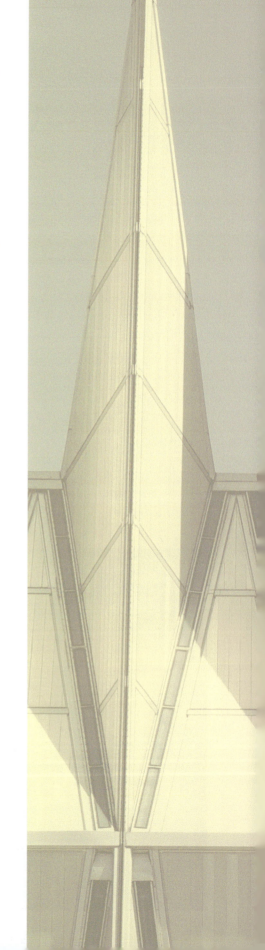

6 Conversation between Ad Gefrin
 and Sally Ann Norman on
 10 October 2022.

CHAPTER 6
TAKE-OUTS

▶ If you're at a point for growth, work out what role you need. Do you need a specialist AP to work with your established marketing team, an all-rounder who can do multiple marketing associated duties including image making, or simply a trusted freelancer who you can call on when you have the need?

▶ Talk to peers and the local/regional branch of your country's architectural body. Who do they recommend?

▶ In the case of the freelancer, who is Google showing you the work of? A 'weekend-warrior'? A general commercial photographer, or a dedicated AP?

▶ Where are they located? What's their style? Does it identify with your own brand and ethos?

▶ What do they claim as value-added in their website 'about' page? Do you need a construction site certification? A drone-licence holder?

▶ Do they understand copyright and trade with the relevant insurances?

▶ If you seek further validation, do they hold awards, memberships or accreditations which you recognise and value?

▶ Once you're pretty sure, request an estimate and an opportunity to converse. It's not just about the money, it's a personal relationship you are seeking to curate, that's brokered on trust together with mutual creative and technical alignment.

▶ Discuss the needs for the licence: How are you planning to use the work? See Part IV of this book for further information about this subject.

▶ For in-house roles, define exactly what your company needs. Does the photographer receive support from others? Are they supplying their work for a wider team to actively place in view, or do you need them to carry out the marketing work for the practice too?

▶ Invest in what your image maker needs to carry out the work effectively and to a standard you'd expect from a professional freelancer: car, camera equipment, lighting, high-spec computer. It is a far greater undertaking than a pair of hands and desk-space.

▶ Recognise that such an investment could and indeed should bring value-added to more than simply supporting gongs and accolades for your firm. You've just given a huge asset to the teams bringing work into the practice, as well as showcasing those projects at the point they head out of the door again. We live in the world of the ubiquitous image.

▷ # MOVING THE STORY

Video and Viewpoint

Photography for Architects is largely a book about individual frames. Across the 18 chapters, there's a strong focus (excuse the pun!) on capturing single moments in time. However, in reality we spend much of our lives engaging with the moving image, therefore it is sensible to dedicate a section to the benefits of this medium.

We will also look at drone capture. Just as both still and video may be recorded by one device, the same goes for drone stills and moving images. Given that this is a book and books are traditionally physical entities, browsed at the reader's personal pace, the illustrations for this chapter relate to discussions about moving image conventions, drone photography and for the case study, stills from projects relating to the architectural practice in question.

▷

Changing your perspective will grant you a different eye on the world. This chapter explores working with drones and video-capture and illustrates that once you send the camera on the move, everything alters as contexts shift away from those experienced in conventionally anchored scenes.

Historically, the all-important plan-view of a site has been parked at drawing stages... until now. Tim Griffith's shot of Salesforce Park in San Francisco by Pelli Clarke & Partners illustrates why drones are able to enrich the visual offer of those plans once realised.

So, why should you move the camera? It is going to take more of your time, planning, skill and budget than a set of traditional photographs. There are multiple different ways to capture moving images and this section will cover a variety of these. However, true films – ones which are memorable – are so simply because of their story. The way they are shot, the lighting, the locations, the action … all of this is about supporting the story, and the story is the driving force behind those that leave you with some emotional resonance.

In a nutshell, if you haven't got a strong story to tell, don't make a film about it, but if you feel that an engaging video is the way forward, then here are some guidelines:

- First and most important, what do you want to say?
- What can you say by this means, that doesn't get you there with a set of beautiful still pictures?
- Know the power-line, the money statement and the raison d'être of why you want to speak to your audience in the first place.
- Work out what you want to show or inform your audience about and take it from there.
- Use video when you feel that it is the correct solution for your storytelling problem.
- Don't use it by default, or simply to take your brand message over a wider range of platforms in the aim of increasing your audience and exposure. There will be less complex and cheaper ways of doing this, although arguably the outcomes may not be as powerful as a narrative-driven video that is compelling and informative.

Despite the longevity and popularity of film and video, for many in the architectural community, its use as part of everyday brand marketing is on the margins of business activity, rather than the mainstream. For some, when aligned with the use of drones or 3D capture, it might be regarded as being in the realm of future technologies, which we explore at the end of *Photography for Architects.*

Films vs video tours

There is an important distinction between sequenced moving images (which mostly function as a tour for newly completed projects) and actual documentary filmmaking. The former sits in the same realm as CGI moving visualisation techniques, which are employed by many practices at the design and planning approval stages of a project. Such pieces are often set to music. They might be captioned, or sometimes have voice overs. They are usually short in duration, perhaps 90 seconds–3 minutes, because if they are much longer, they often begin to lose their momentum. Matterport, the brand name associated with 360° walk-throughs is also discussed in the future technologies section.

Perhaps strangely, considering the popularity of CGI motion shorts created ahead of a project, there are far fewer instances of real life fly-throughs and video tours of completed buildings compared to the plethora of still photographs created to represent those same finished outcomes.

△
FaulknerBrowns' Moorways Sports Village in Derby was in the public eye for a good 36 months before construction. CGI views were used in the promotion to local residents, which were then exchanged for the reality. Blending frames to overlay between concept and reality in a moving story allows you to affirm your ability to deliver on what you promise.

When we use the term 'films' in association with architecture, in order to separate them from the product described earlier, we tend to mean short documentaries. These are larger endeavours than video tours, which are straightforward and can be created by one or two people compared to the relative complexity of documentaries. The equipment used in making both types is often quite similar. However, the need for specialist sound and lighting equipment starts to come into play when interviews and clear recordings of ambient sound are required.

Recording equipment for filmmaking

Producing moving-image files can be straightforward and achieved simply via a smartphone, or with action devices such as with UAV aircraft: **drones**. Equally they can be generated with sophisticated, costly specialist camera equipment. As alluded to at the beginning of this chapter, the best films and videos are ones which you remember, and you will remember them for the power of their stories, not the type (or expense) of the kit they are made with.

As ever, which method of image capture you engage with as an architectural practice will depend on your need, available time and budget. Let's look at some camera types and the functions they perform.

1. The smartphone

Unsurprisingly, the ubiquitous smartphone gets the first billing. With each successive model release, vying manufacturers embed their devices with ever more hardware and software that affords users freedom to generate footage which is technically and visually adept. With files exported for broadcast across different platforms or disseminated directly from the phone itself, scenes may be recorded under challenging technical conditions yet still result in perfectly watchable footage.

Phones can be operated across a variety of modes, capable of shooting a predetermined amount of frames per second resulting in a number of outputs, from **time-lapse** (accelerated time) to **slow-motion**, or a broadcast compliant speed (**standard frame-rate**).

2. Action cameras

GoPro

Despite there being plenty of other manufacturers such as Sony, Garmin and Polaroid in this market, GoPros as action cameras are what Hoovers are to vacuum cleaners. A GoPro is a small palm sized cube which can be roughly handled and yet still associated with quality image capture. The GoPro Hero series is the most familiar model to cyclists, water-sports enthusiasts, skiers, rock climbers and anyone wanting to record action on the move. With contemporary models boasting weather-proof and shock-proof housings, these little cameras can be placed in a huge number of situations, set running and left whilst the action takes place around them.

For construction site recording, whether for aesthetic or legal reasons, using this type of device for long form time-lapse is straightforward. Affordable and discreet, mounting a number of these across a single location with a power source and simply downloading the file cards every so often is one of the most popular uses of them in architectural circles. GoPros can be employed creatively, but in keeping with the physical form, have in-camera controls which are only accessed via menu systems on the touch screen (therefore slightly more limiting practically than a larger camera type with a number of role-dedicated buttons) and are usually fitted with a fixed focal-length wide angle – 16.5mm lens.

Drones

Before examining the nuts and bolts of what's out there and the legal attributes of working with drones, it is worth contemplating what the value might be of utilising aerial footage within your arsenal of image capture options.

This lends itself to a larger conversation ahead of the technical information to ask what it means to move the lens to another place in space altogether.

Get on? Get up

Drone images are pretty sexy. They have 'kerbflash' written all over them and, moreover, they offer something that sits as a hybrid medium – whilst the camera is on the move, the image doesn't necessarily need to be.

The team of UK-based image makers, Hufton and Crow, spend much time on the move from continent to continent and a drone is now part of the standard kit bag. A brief glance at their website tells the viewer instantly that not only are drone stills part of the service, but they form a key hallmark of this team's output. Six out of 11 images on the home page of their website in 2023 were from drones. Drilling deeper, in the 16 projects showcased, seven exposed drone views, and not simply as 'token' images within each wider case study. In the case of projects such as BIG's Armakker Bakke in Copenhagen, nine out of 22 are from the air. For Mann Shinar's Ramon International Airport in Eiliat, 12 out of 20 are so. Thomas Heatherwick's Eden project in Singapore gets 12 out of 25, and William Matthews' Tintagel Footbridge has 13 out of 22.

Hufton and Crow's viewpoints of BIG's Amager Bakke in Copenhagen illustrate that both convention and intimacy might be expected at human eye-height compared to the other extreme of a serene mist-shrouded flight above the facility.

When viewing the projects, it's easy to see why 'going up' expresses these designs so well. It's also immediately clear why certain case studies don't utilise the technology. The contextual relationships between certain buildings and their surroundings either negate this approach logistically, or the projects themselves simply wouldn't respond in the same way; the drone images would seem gratuitous, unnecessary. Hufton and Crow are not the only photographers to notice the benefits of working with drones.

Image maker Tim Griffith, whose portfolio also showcases aerial work, offers this advice,

> *Drones are an amazing tool which enable you to create imagery that hasn't really been possible previously, facilitating a new understanding of architecture. Physically and logistically, they enable the movement of the camera in a much more fluid way than relying on a balcony or adjacent roof. You can be much more specific about where you place the camera in composing the image. This is particularly relevant for buildings that are 5–20 storey towers. Logistically, such projects can be a nightmare to capture by conventional means, from a traffic perspective, a safety perspective ... drones outpace cranes and raised platforms for speed. You can do in some minutes what a crane might do in 6 hours.*
>
> *Also, they provide what a helicopter usually cannot, by going low. They enable a shooting range (perspective) which has not been possible until*

▽
Tim Griffith's images of Malpaso Residence by Studio Schicketanz on Big Sur and San Francisco Conservatory of Music, Bowes Centre by Mark Cavagero Associates show the 'middle' viewpoint. These are lower than commercial helicopter flying, but far higher and more budget friendly than crane work.

recently, particularly in urban environments. Drones have created a new vocabulary for architectural imaging. This imagery can be 'object driven', about the structure itself or easily pulled back to put that building in context. They can, in ways that were not easy previously, place buildings within a broader context; urban, or cityscape, or rural. That opportunity in itself, has been a paradigm shift in the language of architectural photography.[1]

He goes on to point out that phone-cameras and drones have become part of many households' weekend and family story capture. While the internet is full of sometimes spectacular and seductive drone imagery, much of that is simply not considered legal. Commercial drone photography requires working within the limitations of local laws and typically involves some degree of insurance coverage. It should be clear that there is a marked difference between the two activities.

Tim concludes that:

Broad availability of these new technologies means that there are many new practitioners out there who may own the tools, but don't fully comprehend what they're looking at. Software can help mask a lot of poor choices but the most important decision on every shot is always – 'where' to put the camera to tell the story of the architecture, and not enough people understand that.

1 Tim Griffith, personal conversation with author, 11 July 2022.

Nuts and bolts

In the marketplace, according to a variety of 2023 review sites including Techradar, DJI is the brand leader, with a number of drone models varying in size and build quality to suit the wallet.[2] Only manufacturing rivals BetaFPV, Autel and Ryze make the top ten; the rest of the drones are by DJI. In the USA, however, being of Chinese origin, this manufacturer is currently on its 'Entity List'. The restriction means that they cannot work with US technology on product development. This does not seem to be restricting its activity or reputation, with the platform still being widely on sale.

Even the smallest models produce decent 4K footage and have 12MP sensors but move up a scale and budget and one can expect 1" sensors with 20MB capture. Spend even more and drones may be fitted with much larger sized sensors, RAW capture, zoom lenses, anti-collision monitors and adjustable apertures. Some can move very fast too – one of DJI's popular models can fly at 87mph in Sport Mode. The sky really is the limit, but drill down a little further and limitations begin to emerge. These include:

- The weather proofing and stability of models limiting the conditions one may fly in.
- The distance from the operator that the drone can legally fly.
- Real world flight time, battery life and recharge time.
- Limits to heights one may operate in, and also weights of the devices themselves, especially in built-up environments.
- Wearable headset models, known as **first-person view (FPV)** worn to give a sense of flying, may need an independent observer standing with the operator in order to legally maintain line of sight with the device.
- Registration for drones over 250g in weight (UK, EU and USA limit – other territories vary).
- Need for operators to have licences if performing functions in certain countries.

Licensing laws vary depending on where you are.

UK and EU: since 2020, the owner of any drone of any size with its own camera (including those under 250g) must have an **Operator ID**. In the UK, this registration currently costs £9 per annum. For those above the 250g weight, a **Flyer ID** is also required. This permit involves taking a simple online theory test, whose correct answers are gained from familiarisation with the **Drone and Model Aircraft Code**.[3] There are 40 multiple choice questions to be completed and no limit to the number of times you may take the test. If you plan to register on behalf of your business rather than as an individual, you need to go down the Organisation route, and this licence is currently £10 a year. There should be an accountable operator/manager in the company and their home address is also required.

The law itself asks flyers to abide by the following rules for models *unless your vehicle is under 250g*:

- Keep the drone in direct line of sight – less than 500m (1640ft).
- Not to fly above 120m (400ft) from the ground.
- Avoid flying within 50m (150ft) of people outdoors, in buildings or vehicles both horizontally and vertically.

2 Timothy Coleman, "The Best Drone 2023: Top Flying Camera for all Budgets," *Techradar*, 8 March 2023, www.techradar.com/news/best-drones.

3 The Drone test in the UK is free to take at https://register-drones.caa.co.uk/individual/prepare-for-the-drone-theory-test.

▽+▷

Hufton and Crow's work at Ramon International Airport in Eilat by Mann Shinar shows not just the dramatic contextual overviews, but also how tall structures, or conversely, low-rise buildings from close proximity at ground level, are difficult to 'read'. Parts of their design are lost because of the camera height relative to viewing distance. From a similar 'anchor' position but raised, the view now shows the control tower together with its mountain backdrop. In addition, using a far longer focal length has enriched this outcome; the same lens choice at human height would have realised a detail of the cladding near the base of the tower, arguably still a nice picture, but a very different one with a different use.

- Not to fly within 150m (500ft) of residential, recreational, commercial and industrial sites.

This is all pretty common sense. When it comes to your proximity to certain facilities, for example airports, there is a complete exclusion zone of 2–2.5 nautical miles and a 5km long and 1km wide exclusion to either end of the runway. Military installations understandably also bear similar restrictions. Police in the UK can forcibly land, inspect and seize drones with on-the-spot fines for offenders.

If you're working with a heavier drone model, 250–900g, you need an actual formal qualification (in the UK, it's a Civil Aviation Authority approved **General Visual Line of Sight Certificate – GVC**), which requires completion of a fee-bearing course and a test.[4]

USA: Here the Federal Aviation Authority controls the skies, and the **Operations over People** rules came into being in January 2021.[5] For category 1 aircraft – those that are 0.55 pounds or less (the same 250g limit as the UK and EU) – they are permitted to operate over people for pleasure or work purposes, but anything heavier (categories 2 and 3) incurs restrictions and the operator to hold a **Remote Pilot Certification**.

▽
Hufton and Crow's views of Olsen Kundig's revitalised Seattle Space Needle reveals the relationships from both in-to-out and out-to-in. Both viewpoints are valid. Indeed, Vital.

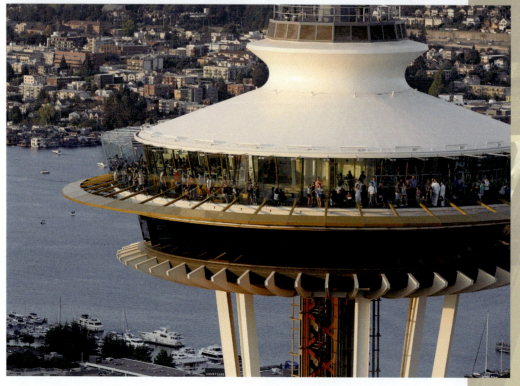

4 Whilst there isn't specific UK and EU category defining commercial use, most commercial uses would be likely to take place on higher payload drones, and such operation falls into the Specific Use category – for more information see https://publicapps. caa.co.uk/docs/33/ CAP2005_EU_Drone_Rules_ Factsheet_V7%203.pdf.

5 For an overview of this legislation, head to www.faa.gov/uas/ commercial_operators/ operations_over_people/.

Australia: The Civil Aviation Safety Authority broadly follows the same rules for recreational use.[6] For business activity, which architectural photography falls under, registration is required. They define this professional use as:

- Selling photos or videos from a drone.
- Inspecting industrial equipment, constructions sites or infrastructure.
- Monitoring, surveillance or security services.
- Research and development.
- Any drone activities on behalf of your employer or business.

This applies to drones up to 500g in weight which are free to register and $40 AUSD for higher weight models. You need ID and proof of address, and unless you're working on your own land with a drone weighing more than 25kg and less than 150kg, there is a **Remote Pilot Licence (RePL)** test to take. This includes logging five flying hours and carrying out a practical skills test.

With these various hurdles surpassed, and wherever you are based, what was once the behest of specialist helicopter pilots and expensive fees is now firmly accessible on a modest budget and readily available. If you do not have the time or inclination to personally skill-up, multiple companies compete in the market for aerial stills and moving-image capture. These certified, insurance bearing professionals will bring the ability to record high-quality images of sites with proposed projects, those under construction and completed buildings in high density areas. It has been a popular service for architectural photographers to offer as an extension to their traditional groundwork.

Tim Griffith's aerial of Australia 108 in Melbourne by Fender Katsalidis offers a contextual view, which with its hemmed-in downtown setting could never have been appreciated at street level. The vast scale change between it and other buildings around it is clear, together with the wider plain beyond. The birds and the low evening sun, however, begin to lend it an 'otherworldly' presence, challenging the viewer to ask: Is this really a photograph of a structure built, or is it a CGI? Blending the believable with the unbelievable is the subject of *Ch. 18 Tomorrow is today: Future technologies.*

6 See www.casa.gov.au/knowyourdrone/drone-rules.

Be sure to risk assess the situation that you wish the drone footage to be captured in ahead of time, gaining permissions and being sure of site logistics for both take-off, landing and with regard to navigating any physical obstacles when airborne. You may wish the drone to record whilst flying inside a space – large industrial site or sport venue, for example. All of this will require planning ahead of time and needs ring fencing for safety and security. Most importantly, legal permission/compliance will be paramount as not following the rules could incur uncomfortable fines and litigation.

Before moving on, it's worth giving the last word back to Tim Griffith again, who makes this salient point:

> a lot of drone imagery is really substandard, and all it is trading on is that it's created with a drone. It is not well considered. Like everything, it's about 'where' you put the camera. If the camera is in the wrong place at the wrong time, the photograph does not succeed. It's the same with a drone. This takes skill, and a lot of images take place when a [non-specialist] drone operator is in control rather than an architectural photographer.

3. Filming with a DSLR, mirrorless system or video camera

The most familiar method of storytelling with a moving image is most likely to be garnered with a standalone camera bearing either a fixed zoom or interchangeable lens system. With larger sensors and a variety of means of moving the viewpoint, rich editorial footage may be created by someone with a creative and technical understanding of the art of storytelling. Frankly, some pretty poor videos have been made with this kit too. Simply adding more budget to the project won't make your piece any stronger if you don't have a plan, but that's another conversation....

Think of filmmaking with a stills camera as making one photograph with all of its compositional and technical considerations, but then taking dozens of them every single second. Moreover, you're linking each composition sequentially, leading the viewer on a journey visually, but also cerebrally; either learning or being entertained, or both at the same time.

Despite most modern camera systems being able to function in both stills and video-mode, the number of variable controls across models typically increases as the budget goes higher. Low-spec models will limit the ability to capture a high dynamic range of contrast and may have limited colour capture fidelity. Their compression algorithms may be more aggressive and images can lose their subtlety in tonal ranges. They might only shoot HD rather than 4K, and there may not be the choice of high frame-rates for slow-motion. Budget lenses with restricted maximum apertures will limit the light levels one may work in without resorting to extremely high ISOs (or additional continuous lighting). On-board sound recording is only accounted for in simple terms on equipment associated with still photography; yes, they can record sound, but their built-in pre-amps and mics are small and rather crude. These camera bodies are just not set up for specialist audio recording.

However, having said all that, with the right choice of camera gear and a little background knowledge, some absolutely amazing moving images of architecture can be captured with these types of devices. The image quality continues to rise too – the Fujifilm X-H2 launched in 2022 records 8K and high end cameras now shoot RAW video as well.

Today's dedicated video cameras are also in a different league to the old-school handy-cams which tourists and home-movie makers toted about between the 1980s and early 2000s. Professional video cameras sometimes share their lens platforms with DSLRs, but their bodies are physically far larger and they usually output images which are a league above the DSLR and mirrorless systems. Marrying them to professional sound equipment is more straightforward. They're designed with sound inputs that are far more robust than still cameras can ever be. These 'cine' style cameras are specialist, expensive and need to be operated by skilled creative technicians and are beyond the scope of this particular book. Canon, Sony and Panasonic have their own series of dedicated video/cine cameras and other specialist professional brands include Blackmagic, RED and ARRI.

It is an art, and notwithstanding budgetary considerations for this type of activity, it is usually more successful in the hands of a small team, rather than a single individual. There is much more to consider, especially when including people in your film, either observed or directed. When sound recording is required for monologue pieces to camera (stand-uppers), for example, or when interviews are to take place on location, then with any and all of these situations, additional considerations/complications will arise.

Filmmaking considerations

Like the still photography described in the previous sections of the book, exposure and composition take up just as much time and consideration for moving image capture too.

Colour balance

One of the problems of leaving your camera in full auto mode is that it allows the camera to **auto white balance (AWB)** in every shot. This may provide an inconsistency of colour representation between sequences. This mis-matching of individual shots can be very difficult to correct in postproduction, and your shots may look as if they've been captured at different times or even different locations, even though they may have been shot within the same space, and time-frame.

Having a camera that can manually white-balance is essential for video, which is another reason why a smartphone can be problematic.

Frame-rate

Unlike still photography where for exposure one considers the triangle analogy of ISO, shutter speed and aperture, all of which are inter-related and variable, selected according to light quality and subject matter, in filmmaking, the one setting that is mostly non-variable is the shutter speed. This is different to the **frame-rate (fps)**, which refers to the number of images-per-second that the

camera's digital sensor generates and, instead, relates to the actual exposure time the shutter is open for on each individual frame of video. The correct shutter speed also controls the 'motion-blur' effect on each of these frames and therefore allows a moving image that is always made up of a series of still images, to appear smooth and more natural.

Let's look at frame-rate first and see why we need to consider this prior to considering the shutter speed, which is usually chosen to match the motion-blur needs of the frame-rate.

Your frame-rate will depend on where you are in the world and also which medium you plan to share your finished work on. If planning for traditional television broadcasts, where you're geographically based comes into play, as the UK, Europe and Australia work on the **PAL TV** system that is aligned to the mains electrical frequency of 50Hz. This means that a frame-rate of 25fps is best, compared to the USA's 60Hz electrical system where the **NTSC** broadcast frame-rate is around the 24fps mark. If you are solely filmmaking to exclusively distribute over the internet, then making your piece at a frame-rate (30fps) which ties in with the normal computer and internet refresh frequency (which is 60 cycles per second) is ideal. For most situations, with viewing habits becoming dominated by phone and computer screens, and given the fact that smart-televisions are actually becoming computer monitors in their own right, working to the 60 cycle refresh rate (and therefore 30fps) probably makes the most sense going forward for web distribution.

If you're working on a phone or DSLR camera, you should be able to select the frame-rate – but higher end video cameras will usually provide much more choice. Where you position your actual fps will depend on the type of shot you wish to create.

a) Standard motion
For advancing the action at a conventional speed, shooting at 24, 25 or 30fps will be the norm. As discussed earlier, this is defined by what you intend to broadcast on and geographically where you are. These 'normal' frame-rates are where you're likely to be operating much of the time. You'll need a standard frame-rate for talking heads, conventional movement, human and vehicular motion, indeed for anything to record as you'd expect it to play back normally.

b) Slow-motion
Shooting at 60fps (in 4K or HD resolution) will allow you to slow the action down by 50% (if using a playback speed of 30fps) but setting it at 120fps is even better for slo-mo emphasis. The iPhone 14 Pro, Pro Max and the Sony Xperia 5II can do 4K at 60fps. But for many models it would use too much computational and therefore compression processing to record – not to mention the huge amount of data storage space needed. However, 240fps at 1080p is now do-able on most modern phones and some Huawei models allow capture at up to 960 or even 1920 frames/sec, but typically you'll be restricted to a 720p resolution for this extreme slow-motion.

For less compression artifacts and better quality, it is suggested that one would benefit from stepping up to a higher end dedicated camera rather than using a phone for slow-motion footage.

▷
The stages of taking this refreshment counter at St. Matthias Church (frames 1–9) in Devon by Communion Architects from closed to ready for service was captured through a succession of still frames and then edited into a 45-second mp4 looping sequence. As a way of demonstrating a process as well as for time-period capture, e.g. weather changes, construction periods etc., this style of animation works very well.

c) Time-lapse

For this effect, you may simply engage the time-lapse mode on a DSLR or mirrorless camera and steady it with a locked-off camera position. Use a good tripod or mount the camera on a dedicated bracket, then placed on a supportive and stable vantage point the camera will record individual still frames at a set interval rate. If you're using a phone, it will self-define the rate depending on final clip length, but if you wish to have more control and set your own intervals, working on a DSLR or mirrorless system you can usually alter the built-in **intervalometer** (timer function) settings and pre-define the capture rate per second/hour or day. As mentioned earlier, GoPro style cameras are great for time-lapse. The following list gives handy tips on utilising the time-lapse mode:

- To work out how big you wish the time gap to be between frames, downloading one of many available apps to your phone that can do the maths for you is logical. Knowing your desired length of sequence to be, say, 15 seconds and the length of time the particular activity being filmed is going to last will determine the frequency of each picture taken.
- If you are installing a project over a short period of time and wish to document the activity, simply set your camera somewhere with a broad angle of view to observe the action taking place. You can create short-form footage which may be successfully looped and embedded into social content or websites.
- Dedicated electric panning camera mounts can be purchased which allow the camera to slowly track across a scene during the period of capture, again calculable by the user to result in a pre-chosen movement length.

- Little skill is needed for content creation as the equipment does most of the work, normally calculating the exposure throughout but always double check your focus and compositions. The output file is a movie file – often an .mp4 or .mov which is readily recognised by the web.
- For time-lapses which need to document activity over a significant period, e.g. construction of a school over 12 months, reverting to a fixed (and most likely theft- and weather-proof) dedicated camera is the norm. Remember that as well as checking the card it's recording on, you will need to provide permanent power for the device if it is to be left for a significant period.

Getting on the move

For architectural storytelling, movement poses a special challenge as by their nature, buildings are static. Creating motion and transitional experiences for the viewer can only be achieved by recording people or activity moving across the frame, or by taking the camera itself on a journey through the space.

The key to compelling built environment footage is keeping either the action, the camera, or both, on the move. Stabilisation is vital, simply locking it off in multiple, single positions to create static shots, albeit with moving content, will quickly become dull for the viewer, even if you do vary the camera height and angle of view throughout your sequences.

▽

Here, the tripod head is static, but the action takes place via the pedestrians and cyclist. There's no need for the camera to pan. If the movement is *somewhere* in the frame, the eye won't be too disappointed. The GSK Centre for Sustainable Chemistry, the world's first carbon neutral laboratory at the University of Nottingham by Fairhursts Design Group Ltd was the subject of a six-minute film.

Mounting the camera on a support which promotes steady movement is vital, and a conventional photographic tripod will swiftly prove limiting because panning (the simplest form of motion for the camera) is best done with a **fluid-head**. These are non-standard fittings for regular stills shooting. Video fluid-heads enable smooth panning and tilting movements which stay on a stable axis, whilst keeping horizons level.

Panning smoothly helps create interest, but moving with the camera is even better, although how smooth this looks often still depends on the operator. Hand-holding whilst filming with no form of stabilising intervention will quickly begin to look amateur. When you start to travel and follow the action or move through an environment, you will at the very least need a **slider** (usually 1m in length and excellent for making short but smooth and controlled moves), but even better is a hand-held **gimbal** or pivoted-support enabling rotation of the camera around an axis.

Three-way electronic gimbals are now becoming a game changer, allowing for stable, motion-based capture, almost like a CGI fly-through. Budget models are widely available, and the camera controls themselves may be operated though the handgrip, as opposed to physically tapping the screen of the phone/camera and potentially nudging it when it is in use.

Driving the narrative

Planning for filmmaking is not quite the same as planning for still photography. My husband is an experienced TV cameraman who has created documentaries for architects and has found that although practices are aware that they want to talk about a project, they have little idea of 'how' to make this happen. He is often left to drive not just the practical shooting detail, but to structure the story for them, which he's only able to do in simple terms, responding to what *he* can see of a building's design and operation. This process would be far better led if clients understood *how* they wanted their films to speak for them ahead of the production. Whilst this style of film might be visually adept and energised from a sequencing perspective, it may slightly 'float' on the surface; a tour with talking heads.

If you want your film to have emotional depth, consider placing yourself at the heart of planning. Decide what the mission is and understand how the end result needs to function for your firm. This will drive where the story starts and, moreover, hopefully give it a satisfying conclusion.

The journey it goes on between these two places requires diligent planning: **storyboarding** (visual plan of sequenced shots – akin to a strip-cartoon) with either a loose Q&A for encounters and interviews, and perhaps a formal script for the principal protagonists.

There could be an 'opening a shot' list:

- Where are the establishing shots?
- Do you need access to other buildings to set yours into context?
- Has yours replaced something?
- Is it a greenfield site?

Certainly, alluding to what was there before, or how people worked/lived previously before they commissioned your practice, might be very important as a driver for the story.

You'll then need the 'hero' shots of your project – much like one does for stills:

- What is it?
- Where is it?
- What are the materials it is made from?
- What is the scale?
- What are the construction and material details?
- Will someone talk over these?
- Will there be captions?
- Is there an in-person guide or presenter?

And what of the interactions across the site? Are there pieces to camera by the presenter? Interviews? Who will you talk to? People ahead of the delivery involved with the planning? Is the client interesting to talk to? Are there users with interesting stories? All of these facets are critical to being able to build viewer engagement, interest, empathy, etc. And finally, if there is a call to action, make sure it is clear and made as a point that is supported visually too.

Sequences will be a mixture of key shots and what's known as **b-roll** and you will also need plenty of **cut-aways** for any of your interviews. Imagine one of the interviewees is describing something specific about the building. You might interview them in their office, showing them seated with plans, for example. This may take 60 seconds to describe, but simply locking the camera on them will be dull after a few moments, even if what they are saying is really interesting. Cut-aways are needed to illustrate the things they are talking about, so take plenty of shots to visually validate and emphasise that section of speech.

▽
British Sugar in Cambridgeshire by CPMG Architects has a central atrium whereby the portrait orientation images communicate the verticality perfectly. Moving from place to place to take photographs expressing the design is natural.

B-roll is a sequence of footage which either sets things up, links things together or illustrates a particular point. Do you need to move locations from one site to another during the film? If so, b-roll could be viewpoints along that journey, shots of the presenter in transit perhaps, and certainly any landmarks or key facets of that link from a-to-b which move the story along.

And always, as the story moves towards its conclusion, the camera moves too. Wide angles, close-ups, high, low, medium viewpoints, the pans, tilts and movement are all planned ahead and may need shooting more than once. Presenters fluff their lines, the sun goes in, a car drives into shot ... there are endless reasons for breaking with continuity, but that's real life and you will need to do it again.

Sound is a new matter and one which requires careful attention. Quality live-capture is usually vital, and if you are interviewing people in places where ambient sound is loud, intermittent or rough, considerations must be given as to how this will be captured without compromising the clarity of the spoken word. Using music? Where from? Similar to sourcing rental images from photographic stock libraries (see *Ch. 17 Forever in view: The global image market* for more information), music may be leased for use with your video and there are vast catalogues of compositions in varying length and taste which can be aligned to your piece. These will come with their relevant licenses allowing them to be broadcast publicly without contravening intellectual property and future royalties.

Coupled with attention to lighting (a huge subject) and direction, these aspects of production are the make or break of your film. Editing is entirely another topic and skill. As a result, dispensing detail for this amount of information is easily the cause of an entirely separate book, which could be titled *Filmmaking for Architects*, and currently hasn't been written!

To help underpin the value of video in a portfolio, even though there are likely many obstacles to overcome, I examined the output of an architectural practice which endorses this activity, regularly making short documentaries about its work.

▽

For video, transitions from floor-to-floor, where different functions of a building may need explaining, or for interviews to take place, may be driven by traversing the levels in real time on camera (gimbal or jib movements). These will form the b-roll links you need. They are visually informative, but also allow for the transition from one aspect of the narrative to the next.

GRIMSHAW

UK-based Grimshaw was founded by Nicholas Grimshaw in 1980. The practice became a partnership in 2007 and operates today with offices in Los Angeles, New York, London, Paris, Dubai, Melbourne and Sydney, employing over 650 staff.

I chatted to Liz Earwaker, Grimshaw's Director of Strategic Marketing and Communications who is based in the London office.

With a multi-disciplinary team of designers wishing to educate their audience through moving image as well as through stills, they produce films about their projects, which fulfil a variety of needs. They create short pieces which introduce new builds, and in addition, they actively use them to create conversations around long-completed structures too. They recognise the legacy value in projects which have been in active service for several years, and in some cases, two decades or more.

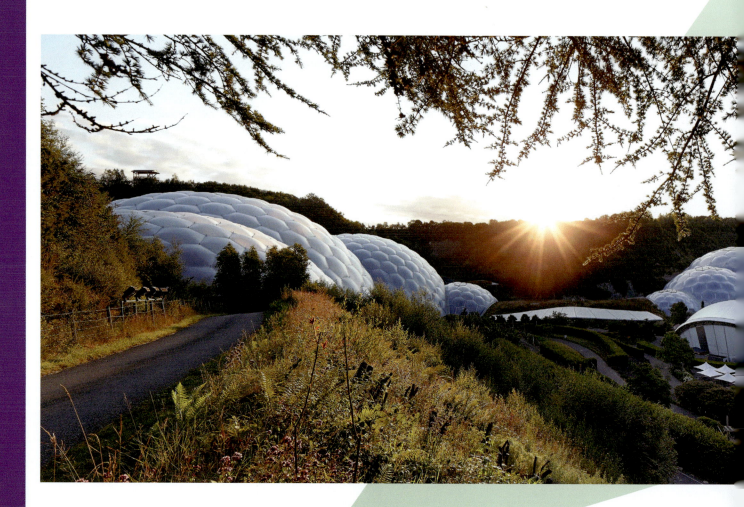

One of their most familiar structures globally is Cornwall's Eden Project from 2001.

This is an environmental transformation of a former clay pit with biomes (geodesic transparent domes) covering botanical gardens. Originally envisaged as a single entity, it has since attracted 13 million visitors and inspired a satellite operation in Qingdao, China (opening 2023). There are proposed projects in Oman, Columbia, Australia and at Morecambe Bay in the UK.

The practice continues to reflect on the legacy of the Eden Project, especially in the context of events such as the annual United Nations Climate Change Conferences. The public awareness and focus on the Eden Project today is just as immediate as when it opened. There's currency in talking about something that was driven by an ecological 'vision' in the late 1990s, that 25 years later is enduring for Grimshaw, despite the diversity of its portfolio across all studios and their 20+ partners.

In doing this, they're able to re-evaluate a variety of buildings that have long been in the public eye, placing a fresh interpretation on old news. By interviewing the original team behind projects – many of whom are now emeritus to the firm, together with contemporary occupants and users, Grimshaw creates compelling stories and testimonies which reinforce the brand ethos and design prowess.

▽
Hufton and Crow's images show the Eden Project – green, pleasant and immediately recognisable for its linked Biomes. Its original state was a blighted and disused industrial landscape which was taken on by Sir Tim Smit, an entrepreneur already widely known for his work on the adjacent Lost Gardens of Heligan.

Partnering with Grimshaw Architects and structural engineers Anthony Hunt Associates, they developed the hexagonal and pentagonal Ethylene Tetrafluoroethylene (ETFE) inflated cells. The spaces contain thousands of plant species from across the world. Of Grimshaw's significant builds over the last three decades, the Eden Project remains enduring and influential on a worldwide scale.

◁ + ▷
Given that Grimshaw is a multi-national practice, it uses the visual voice of a variety of imaging specialists around the world. In Australia, they've worked with Tim Griffith, who captured Olderfleet in Melbourne, a 40-storey office building utilising a historic street frontage. In addition to the stills, Tim created a time-lapse in the atrium which was embedded into a short film about the project.

Liz explains the validation behind mixing both static and moving content on their website:

> **With a strong directive on the delivery and desired outcomes on all of our projects, the photography that we commission seeks to represent this and tell the best visual story every time, from the detail to the wider scale. The introduction of more video to our visual stories has helped us to expand on this significantly, particularly in representing the impact buildings and places which have a direct impact on cities, communities and people, often changing places for the better. Seeing this as live-action and through interview and talking heads is transformative.[7]**

As indicated earlier, Grimshaw places a small team to work on making documentaries which vary in length. Despite the geographic extents of their projects, they tend to use a consistent team for each story, working with:

> **… the same producer and same editor. There are two forms of moving content – two ways of doing it. There's a kind of long-form record for the projects that we do, and telling that long, really interesting story. And then there's the quick fit. That might be using people in a certain country for a quick 2-minute soundbite for use on social media.**

Grimshaw understands the power of visual imagery depicting completed work to best express its brand, and Liz continues:

> **Today, it is probably more vital than ever however, imagery – photography or film – is crucial in order to tell effective stories to our clients, peers, and employees. And with multiple platforms from which to access this imagery, our focus on it is more important than ever and not leaving it to others to tell that for us. In addition, it is worth noting that not only the content, but the quality of the imagery is important: representing the high-quality offer of the brand throughout.**

I was keen to explore the approach to some quite elderly projects in the portfolio. Clearly, any project fees relating to long-completed schemes (and accompanying marketing budgets which could be aligned to them) have been lost in the ether. On the face of it, returning to old stories could be seen as illogical perhaps, hanging on the coat tails of past glories. But emphatically, this is *not* the case here; instead, there is a deliberate and considered investigation of projects from early in Nicholas Grimshaw's own career: The British Pavilion at Seville's Expo in 1992; the Channel Tunnel Rail terminus at Waterloo Station from 1993; the Eden Project in Cornwall in 2001; 664 Collins Street, Melbourne from 2006; Bijlmer Station, Amsterdam, 2007 … the list goes on.

7 Liz Earwaker, interview with author, 10 December 2021.

The people interviewed in these films play a vital role in validating the sense that Grimshaw's projects are no short-term investment. Individuals speak of their engagement with buildings that may have been operational for a generation or more. These voices are not those of actors, they're *users*. Liz explains:

> … catching that narrative – the 'talking heads' – on the impact our projects have had is invaluable to telling the wider stories about our role in shaping cities and communities. These assets can then be used, edited and reused over time to tell further stories and support specific initiatives. For instance, we recently created a 2-minute Climate Showreel to help deliver a clear message on Grimshaw's commitment to tackling the climate and biodiversity crisis. This footage was predominantly taken from existing videos and our extensive experience in delivering sustainable projects. Using and reusing this material will be essential going forward. It follows on from the point above, about how our legacy of projects and imagery to support will help deliver our consistent messaging.

Certainly, harnessing stories about older projects which have links to current affairs of the day is a sound reason for re-use of content, and one we've explored in other chapters across *Photography for Architects*. Again, it endorses the investment that any practice makes with their images.

Grimshaw's output across the various platforms that can display moving image is extensive, but it does not replace still photography and nor is their emphasis on communications limited to visual representations of completed environments either. Their messages are conveyed across a variety of media in multiple ways. These encompass traditional printed means, the photography and film media under discussion, but also their aural communications, through their podcasts and journal. They take their brand communications seriously. They invest in the time, management and distribution of it, and ensure that as an architectural practice, they have a rightful seat at many different tables across the world.

Summary

In conclusion, film and video making is a big topic for consideration. Your team should certainly discuss *how*, *if* and *when* it may take its place in the roll out of your brand strategy. It is complex, as this chapter alludes, and it may stay beyond the reach of your professional output, but in turn it may just be the very vehicle that drives your vision right to the heart (and wallet) of your next client.

CHAPTER 7
TAKE-OUTS

▶ Understand the difference between a self-guided video-tour and a short documentary.

▶ Research the equipment best for making your film with. Perhaps a smartphone is all you need, or you may choose to supplement it with a couple of time-lapse sequences from a GoPro.

▶ If you're using a drone, is this you, or are you hiring someone to make this footage for you? Check for the relevant rules and regulations where you're working. Does the pilot need qualifications (most likely) and do they have insurances in place?

▶ Risk assess locations for sequences that the drone is required to capture. Are you outside? Indoors? Are there visual obstacles that might contravene security or IP in view from above?

▶ If working with a DSLR, mirrorless system camera or dedicated video camera, check the specification of the model, especially with regard to on-board sound recording. Phones and still cameras are far less adept at this aspect of filming. You will be likely to need standalone equipment for this task if you wish to create quality audio recordings.

▶ Colour consistency is absolutely vital in video production. Try editing mis-matched shots together and you'll discover that correcting these biases in editing is often very time-consuming.

▶ Where are you in the world? What are you going to broadcast your work on? Television? A computer? The frame-rate you film in needs to be chosen in alignment with this.

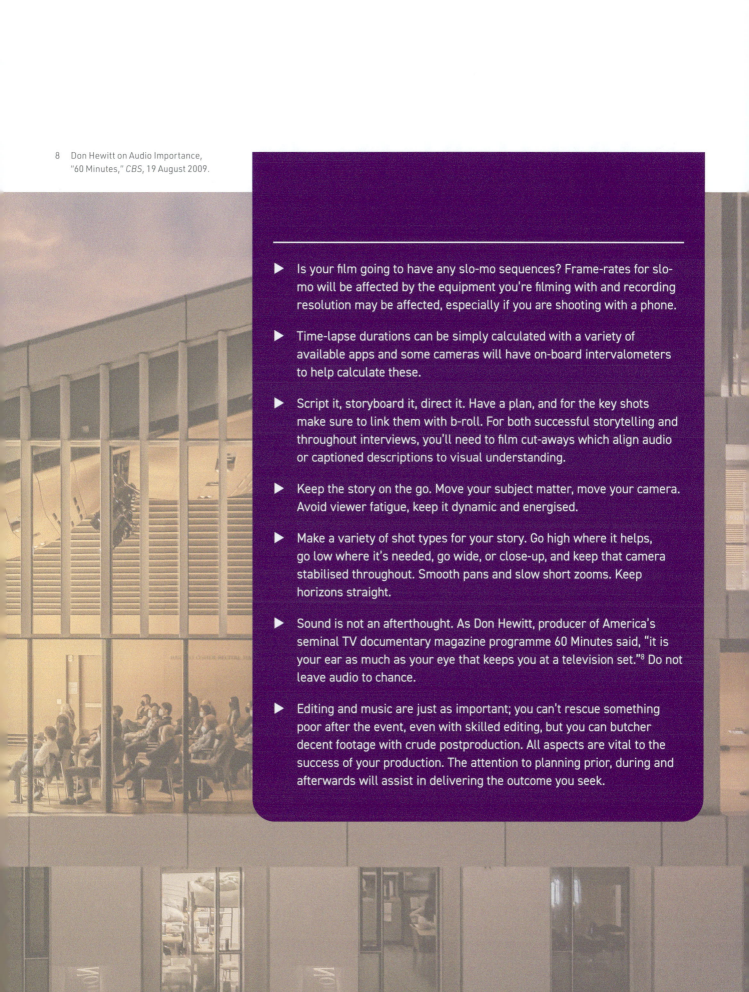

8 Don Hewitt on Audio Importance,
 "60 Minutes," *CBS*, 19 August 2009.

▶ Is your film going to have any slo-mo sequences? Frame-rates for slo-mo will be affected by the equipment you're filming with and recording resolution may be affected, especially if you are shooting with a phone.

▶ Time-lapse durations can be simply calculated with a variety of available apps and some cameras will have on-board intervalometers to help calculate these.

▶ Script it, storyboard it, direct it. Have a plan, and for the key shots make sure to link them with b-roll. For both successful storytelling and throughout interviews, you'll need to film cut-aways which align audio or captioned descriptions to visual understanding.

▶ Keep the story on the go. Move your subject matter, move your camera. Avoid viewer fatigue, keep it dynamic and energised.

▶ Make a variety of shot types for your story. Go high where it helps, go low where it's needed, go wide, or close-up, and keep that camera stabilised throughout. Smooth pans and slow short zooms. Keep horizons straight.

▶ Sound is not an afterthought. As Don Hewitt, producer of America's seminal TV documentary magazine programme 60 Minutes said, "it is your ear as much as your eye that keeps you at a television set."[8] Do not leave audio to chance.

▶ Editing and music are just as important; you can't rescue something poor after the event, even with skilled editing, but you can butcher decent footage with crude postproduction. All aspects are vital to the success of your production. The attention to planning prior, during and afterwards will assist in delivering the outcome you seek.

▷ WHEN IS NOW?

The right time to shoot your project

"What's the deadline?" That's a question that every architectural photographer asks their client early on in a conversation about a new commission. If you are both the architect *and* photographer/videographer, you'll have it in your mind that you want to capture your project at its most pristine. Almost as soon as you begin to discuss the nature of it with others, you will be keen to set a time-frame for shooting. But is this the *optimum* time for image capture?

Introducing a framework based on the UK's RIBA *2020 Plan of Work* is a good idea at this point in the book.[1] RIBA is not unique in proposing work stages for design and delivery for their members, set out in an easy-to-follow table. Germany's *HOAI Leistungsphasen* advocates a similar methodology too, and it seems sensible to use this as a way of helping place *photography* into the equation.[2] My own adaptation covers the entire process of research, design, construction, occupancy and legacy.

1 "RIBA Plan of Work," *RIBA*, 9 November 2021, accessed 21 May 2023, www.architecture.com/knowledge-and-resources/resources-landing-page/riba-plan-of-work.

2 See www.hoai.de/hoai/leistungsphasen, and also "UK's RIBA Plan of Work, Germany's HOAI Leistungsphasen. What Are the Differences and Similarities of Construction Project Work Stages in Different Countries," 12 April 2021, accessed 21 May 2023, www.magicad.com/en/blog/2021/04/uks-riba-plan-of-work-germanys-hoai-leistungsphasen-what-are-the-differences-and-similarities-of-construction-project-work-stages-in-different-countries/.

▷

A world class facility for book and paper artefacts: the British Library Centre for Conservation in London by Long & Kentish Architects is shown here in Peter Durant's photograph.

Being able to convey structure is one thing, but a sense of purpose is entirely another. Understanding when to send an image maker to capture your project is vital. This chapter looks at how to be in the right place at the right time.

Image creation and management in your business should be seen as a cyclical exercise. How a set of photographs (and moving image) serves you depends on the day-to-day activities that you and your team are undertaking at any given time. Whilst a set of pictures might only be made at a certain point and depending on what they depict, their role may be set into one context. However, they might have multiple 'lives' in your practice.

Image Management Within The Project Design And Delivery Cycle

STAGE OF PROJECT	ONE IDENTIFICATION/ DEFINITION	TWO FORMATION OF PROJECT BRIEF	THREE DESIGN CONCEPT	FOUR MODELLING AND ANALYSIS
DESIGN PROCESS STAGE OF ACTIVITY	Client identified along with need/ ambition. Site located and acquired.	Initial budgeting, surveys and pre-application advice sought for site.	Outline specification and outline planning submissions	Project strategies, detailed planning, regulation compliance
IMAGE PLANNING TASKS FOR THE VISUAL STRATEGY MANAGER	Research what images already exist relating to aims and intentions.	Once site access is secured, visual evaluation may commence to assist in design process.	What existing site features/structures are to be retained? are these already documented?	Once detailed plans are available, particularly in the case of sites where existing structures are to be restored, facilitate first engagement point for 'official' photography to create definitive 'before's.
IMAGE PRODUCTION HOW PHOTOGRAPHY FITS INTO THE CYCLE	Collation of existing imagery and evaluation of relevance.	Non-specialist camera kit used for creation of 'mood boards' showing influences, trends, and materials.	Broad documentation of site and locality, ground, and aerial.	Be sure to brief your image maker with marked-up site drawings so that key viewpoints can be replicated after the build. This is especially vital in refurbishments.
POINT AND PURPOSE OF USE THE AUDIENCE	For **in-house research** and discussion.	Useful for confidence-building between **design team and client.**	For limited circulation between **planning authorities, legislative bodies & client.**	Utilise **in-house** for embedding in **CGI renders.** Useful for sharing with **technical terms and contracting framework parties.**

So, roughly based on RIBA's Plan of Work, which describes the various stages of taking a project from concept to completion, I have now placed image making into this sequence. The arrows indicate that once a project reaches Stage 9, it may not be 'the end'. Frequently, archive pictures may be used as part of the research and discovery process for new projects, thus refreshing the cycle.

On the basis that most practices will commit to a *specific, singular* point for image making, much of this chapter explores a variety of considerations which influence shooting a *completed* project – *my Stage 8.*

FIVE TECHNICAL DESIGN	SIX CONSTRUCTION	SEVEN HANDOVER	EIGHT OCCUPANCY & USE	NINE LEGACY
Detailed specification, materials, methods, framework for delivery teams/ sub-contractors	Onsite groundwork and construction period, hard landscaping	Project Completion, removal of site works, soft landscaping installed, defects.	Post-occupancy evaluation, final certification	Re-fit, refurb, re-use, re-evaluation.
As above	Consider stage assessments, either timed by calendar, or event led.	6-8 weeks prior to practical completion, contact framework to create coordinated and co-funded documentation strategy.	Photographs and video are useful tools for illustrating a building's performance in use as well as brand marketing.	Your visual archive should help form part of the practice's reflective learning circle, informing choices for future projects.
As above	Are views controlled remotely - time lapse for example? Are these used as part of your social media strategy?	When is the right time for image capture? Seasonal variants, together with occupant activity will dictate type and timing of access.	Different types of image serve different functions - be sure to differentiate between information-rich award submission images and brand reinforcement, style and design-led Instagram shots.	What can be learnt from re-visiting and visually re-assessing a project some years after completion?
Good timing point along with CGIs for first **outward facing press releases** – a 'coming soon'.	Have a programme for **social media** with updates about site progress.	What deadlines do you have for image circulation and use? Are **local, national or specialist press** likely to publish?	**Strategic Award submissions, project sheets and case studies** should now be created for web and (where relevant) **print use**. Is moving image part of this process?	**Books, exhibitions, films...** Can past visual case studies inform new projects? **client proposals? Mood boards?** Return to Stage One for re-contextualisation.

Is there an actual deadline?

The 'window' for best image capture is usually small. It is often driven by a mixture of both real and imagined deadlines. Indeed, the deadline may be an artificial one, driven by a desire to capture the project before it is 'broken in' and begins to yield to the occupant's livelihood (and of course the specified purpose for which it was designed).

As the designer of a building project, you will have a desire to achieve the best possible images at the earliest possible opportunity. This is logical. At the point of handover, your project will notionally be at its prime. Crisp, unscarred by the clutter of an occupant's chattels; with furniture you never specified, or that you feel is the wrong colour, scale or inappropriate. These items may eschew good design or have simply been transferred from the previous building and being 'secondhand', renders them unsuitable for use within the context of your new work.

'Now' might feel like the perfect time to get a camera onto site, and in the experience of professional architectural photographers, is the natural moment for our phones to ring. It is at this juncture that a series of questions should be asked, of yourself, by your image maker, or the wider framework. Is this 'as good as it gets?'. What propels you into going now? What stops you from returning later?

A key element will be the people who you are creating the building for. Are the occupying users bound by privacy laws: patient confidentiality, or some other legal constraint denying a camera's access? This could place a very firm 'due-by' date on picture making. See *Ch. 16 Ethics: Visual thinking and accountability* for more information.

◁

The King's School (top left) in Worcester on the banks of the River Severn has its own rowing club and boathouse. Designed by Associated Architects, pupils can train inside when the weather is inclement.

The image below shows the 50m pool at Moorways Sports Village in Derby by FaulknerBrowns. Both spaces are pristine and shown ready for use. Are these the best possible representations for each project?

A fixed deadline may be a press/publication deadline, a tender document that you need a visual case study for or an award submission date.

Earlier in my career, I was commissioned by both the UK's *The Architectural Review* and *Architecture Today* magazines to shoot Hopkins Architects' Inland Revenue Centre in Nottingham [Figs 8.1, 8.2, 8.3, 8.4, 8.5]. It was finished. The contractors had left, it was furnished, but not yet occupied.

The project had attracted global interest throughout the build, owing to its method of fast-tracked pre-fabrication. This had resulted in outstanding quality for its pre-cast concrete floor decks and brick piers. These were constructed off site under cover and erected 'Meccano' style at the location at twice the pace of the adjacent magistrates' courts, which were also under construction using traditional methods.

There were several press dates and award submissions to make. Moreover, regulations dictating anonymity for personnel in the financial services sector needed respecting – see *Ch. 16 Ethics: Visual thinking and accountability*.

The project was a joy to shoot architecturally, but the resulting photographs expressed little sense of function in many of the spaces; they were simply sculptural shapes and forms. The most meaningful (and therefore repeatedly reproduced by publications) were a shot of the gatehouse where the security guard was already in residence, together with dusk scenes from the canal side showing the buildings lit from within. Both implied occupancy and operation.

The grand view of the multi-purpose amenity space underneath its tensile canopy in the centre of the site just begged for basketball to be played with a clutch of spectators ... but no. The set of pictures were used widely, but could they really offer certainty into who the users might be and their roles? In other words, *why* was the project designed the way it was? The press deadlines for the shoot, together with the privacy restrictions, made it very difficult for me to convey such things.

How does one plan for the *best* time? The architects were rather caught in this instance, and it forced documentation into Stage 7 of our notional photography time-frame, rather than Stage 8. Interestingly, at the point of publication, the campus had just been listed, one of the youngest projects in the UK to ever be granted this status. No longer the home of the Inland Revenue, Castle Meadow's new owner is the University of Nottingham, and I have just returned to document the site. This is in anticipation of its revitalisation as home to the business school and a postgraduate centre. This visual exercise is entirely in keeping with Stage 9 re-evaluation of projects, which will in turn inform a new Stage 1 of the image making cycle as remodelling work begins on site in the coming months.

Returning to our original topic, what other factors might dictate image making at the earliest available opportunity? Awards are usually annual events, and a 12-month delay to entry is unlikely to be welcomed by you or your clients as a preferred option for your practice. In these instances, a building that is still notionally 'rough round the edges' may need access securing and proceeding with, whatever the time of year. Please see *Ch. 12 Awards: Everyone's a winner* for more about the reasons for entering your project into an award and how to navigate competition entries image-wise.

Figs 8.1–8.5

Are you frightened of a 'steal'?

What might this look like? Is it someone else taking control of the visual record of the project?

If you feel that this might be the case, be proactive during the latter part of the construction and finishing. Talk with the site managers and suppliers whilst the contract is active and you're meeting regularly on site. Explain that you'd like to steer the photographic record of the outcome and invite the rest of the delivery team to contribute to making a definitive body of visual work. So many projects are the subject of multiple bouts of image making, and most of them are not good. This often leads to occupant fatigue, as facilities managers and staff are tasked to host yet another photographer working in their premises.

Given that 99% of all capture is destined for web broadcast, poor pictures, once posted online, simply cannot be recalled. The earliest photographs from a project's completion are unlikely to show it at its best, for a number of reasons outlined in this chapter.

We discuss more of the objectives and sensibilities for advocating a *shared* commissioning framework towards the end of this book, but for the time being, let's continue exploring why the time to shoot might *not* necessarily be right now.

What is the time 'in the life' of the building?

As we've seen, visually, it can be too soon to shoot a project. Buildings are created for people, they're not pieces of art. Instead, they're designed to perform a function of some kind, and therein will lie a narrative. Such narratives need communicating, and it is a tough job for a set of pictures to serve as a descriptive voice for the architecture if little is happening on site. You may well have come across photographs of schools without children, warehouses without stock on their shelves, sports centres without activity and homes without families. Have you felt that they don't have a sense of life in them? Perhaps they're beautiful in their pristine condition. Doubly so, if captured in stunning light, but they may also have a mausoleum-like quality. In all but a few exceptions, this is unlikely to be the best outcome for a project.

It's straightforward (albeit time consuming) to tidy spaces and perhaps feasible to move furniture around. It's far harder to magic-up art for walls, work on desktops or occupants using the coffee hub if these assets simply aren't present. If you absolutely *must* have your project photographed prior to any form of occupation (the 'white cube' approach), then the most critical aspect for success is cleanliness of the building.

Every image maker will have encountered projects where, for one reason or another, they had to be shot in their shell-like state. For these jobs, insist that once the builders have left site, cleaners should go in and thoroughly vacuum, mop and dust all surfaces, together with washing all windows and glazed partitions. Simply asking contractors to wear shoe-covers in the last couple of days of the contract before you have your camera on it will not be effective enough.

The time between the deep-clean and shooting needs to be close, as dust will re-settle quickly and show on pictures. Any residual dust and marks will be seen on surfaces and difficult to remove in postproduction. Ironmongery and glazing are a particular headache and whilst carrying a cleaning cloth in the kit bag is wise, big panels of glass or mirrors are a real issue. The more time spent cleaning and tidying, the less time there is for practical shooting. Time is money; a day's budget needs using effectively.

Set dressing is not uncommon for high end residential projects and often speculative commercial developments will install show-suites. These are fine for photography to take place, and significantly better than empty spaces, but they still rarely look 'real'. Any level of occupancy will be more helpful.

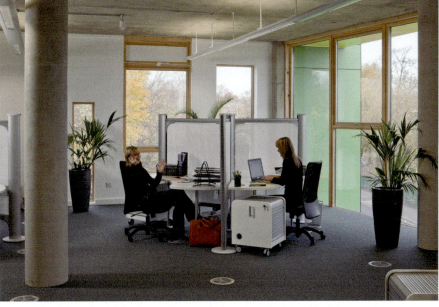

▷
Show-suites are common in speculative office and housing developments. Here, on-site sales team members 'act' as staff in an imaginary design studio at No.1, Nottingham Science Park by Studio Egret West.

Completion: occupation

For commercial projects, is there a phased occupation? In big buildings where teams may be relocating from more than one premises, occupancy may take place over several weeks or even months.

Is the project functional and is everyone carrying out their daily activity as your design brief intended? If not, pause a little and wait until it is. Can the inhabitants be photographed? Are users in the categories of society where their inclusion in photos is likely to be restricted for safeguarding or security, like the aforementioned Inland Revenue? This means shooting may have to take place after handover, but prior to occupancy. It is also worth checking if weekend access is possible; photographing a building that's operational but closed will still yield more narrative value than one which is totally empty.

△

Maggie's Cancer Care Centres are found across the UK in the grounds of NHS hospitals. They offer guidance and holistic therapies for cancer sufferers and their families affected by the condition. CZWG designed the Nottingham centre. With interiors by Paul Smith, there was a requirement for images for his team before the centre was up and running. Despite bespoke furnishings and optimum weather, the earlier photographs were quickly superseded by the later set featuring users.

How do the external works look?

A significant issue with any new project is the outdoor space around the building. Most contracts have their hard surfaces completed at the point of handover, but with soft landscaping, stock is likely to be immature.

Has the site got an integrated planting scheme? If so, will this be fully planted up at handover, or (dependent on geography) is there going to be a revisit by the landscape team to embed bare-root stock in the late autumn/winter?

There can be significant time gaps between internal occupancy of a building and external completion. Away from the equator, visual maturity is then at least another 12–18 months, and a delay of this length is invariably too long for any practice to wait for photographs. The only clients who might consider sending a photographer to site at this late stage are landscape architects themselves, a specialist sector of the market in its own right.

△
Ron Blunt captured the Wellness Center at Arthrex Corporate Campus, Naples, Florida by Leo A Daly, shortly after completion. Except for the mature tree to the left of frame, the new planting looks verdant and established. Depending on the climate, barriers to stock maturity faced in the UK may be negligible for you.

△

The University of Warwick's Sports Hub by David Morley Architects was commissioned before the soft landscaping had been fully realised. Over a 30-minute period, several shots were taken to create an illusion of busy pedestrian activity in front of the entrance, together with additional angles over the turfing.

Working on a tripod and using the same exposure settings allowed for consistency between exposures. Individual frames were blended into a single file using Adobe Photoshop. This took time on site and even more in postproduction. The outcome functions as a satisfying image but stalling a little longer could have realised a similar outcome more efficiently. So, what's the bottom line? A case of, 'can you afford to wait?' versus 'can you afford to shoot now ...?'

If your site looks incomplete externally, can you access longer distance views from beyond the site perimeter? Shooting from further down the road, looking across the mature grounds of an adjacent existing building or from a high vantage point may minimise visual clutter or raw, incomplete frontages.

In addition to hard surfaces, does the project have grassed areas? If so, are these turfed or seeded?

If only sections of the landscape are complete, and you're working with an experienced image maker or you have in-house CAD teams, they may be able to superimpose features into immature looking scenes. If you're doing this with photographic files rather than CGI, it is vital that the perspective, focal length and viewpoint of the camera doesn't change at the time of shooting, nor the direction of the light illuminating the scene. If you are shooting in strong sunshine, the modelling of light across surfaces must be consistent on the infill areas – shadows must fall in the same direction or the results will look 'faked'.

There are very different visual challenges when a project is set in a mature landscape or streetscape. Trying to capture a building set hard against an avenue of 150-year-old broad-leaf trees in mid-summer is just as frustrating as fighting with a scheme that is barely in existence. To delay a shoot of this nature to a time when the leaves have dropped off, or even better, to shoot in early spring when the sun is high, but the leaves are only in bud, is a far nicer outcome for sites of this type.

Time of year

Easier to measure than the 'time of life' on the project is the time of year. Unless you are in a part of the globe where seasons are blended, the quarterly variations are significant enough to mean there is a loss of working daylight from the summer's 12–16 hours. It can be down to just three or four hours of substantive light in the winter months. This makes a huge difference to the visual outcome.

Light quality and quantity drives everything photographic. For many photographic subjects away from architecture, lighting may be modified or entirely created from scratch using flash equipment or constant sources. With buildings we are clearly documenting a subject which *cannot* be moved and re-orientated to suit light direction. Externally, during daylight hours, a building's elevations can only be lit by the sun, and as physical entities, buildings are on a significant scale. They are frequently surrounded by other objects of comparative size. Both are at the mercy of shadow massing by themselves *and* other nearby structures throughout the winter quarter.

So, for urban projects in a large number of countries, wintertime is a barrier to easy visual outcomes. Sometimes, photography will still need to proceed when the season simply does not offer a good outcome, even with diligence in choosing the right weather and the right time of day for the orientation. At this point, the only recourse is for 'damage limitation' and this is where the experience of a trusted professional is likely to pay dividends.

If it's winter and the building has an atrium or glazed central space, avoid shooting it in high-contrast conditions. Only the uppermost storeys will reap the sunshine, leading to 'canyon-like' interiors [Fig 8.6] which are gloomy at ground level even in the middle of the day. Working in summer when the sun can reach the ground levels, as seen here in Hopkins Architects' Newton Court for Nottingham Trent University, allows for a far livelier depiction of the space [Fig 8.7].

Figs 8.6 & 8.7

On the basis that you must proceed in winter and document this type of space, choose to work just prior to twilight. The contrast will be at its lowest, allowing for meaningful illustrative depth to surrounding floor plates. You'll benefit from seeing the ambient internal lighting scheme and still have pale blue light penetrating at the top. Importantly, these lower external light levels will allow fenestration to show fully on the pictures without risk of overexposure.

▷
Adopting the approach described in the main narrative for this deep atrium space, the Monica Partridge Building at the University of Nottingham by MAKE Architects is revealed at each level without loss of detail.

Students are shown working and moving through the space. We discuss working with non-paid models in *Ch. 16 Ethics: Visual thinking and accountability.*

Another aspect affecting the ability to shoot dictated by time of year is less the season from a weather perspective, but more through our own cultural traditions, depending on what we celebrate and how. Christmas, Hannukah, Diwali, Chinese New Year ... the list goes on, and all have decorative elements used on or in buildings, some of which stay in-situ for days/weeks.

For myself and my contemporaries based in the geographic regions covered in this book, our businesses are practically inoperable between the first week of December to the first week of January: few occupants are willing to dismantle commercial/domestic displays for a photographic visitation.

The 'magic' hour

If you're planning on shooting the project externally at dusk, consider the amount of glazing. For best results, employing a tripod to avoid camera-shake and setting a low ISO will avoid excess image degradation and noise in the shadow areas.

If there's only limited external lighting for the scheme, or it's not possible to get much illumination from within the building, check if it is visible from a roadside. Can passing traffic create 'streaky taillights' and give a sense of animation to the images?

Whilst an issue with footfall sensitive lighting is not the case with residential schemes (other than in communal areas and stairwells of apartments), most commercial projects will have lighting schemes which minimise excessive energy consumption and will be subject to automated movement sensors. For photography this is problematic unless you're documenting a project in the darkest winter months when people are working.

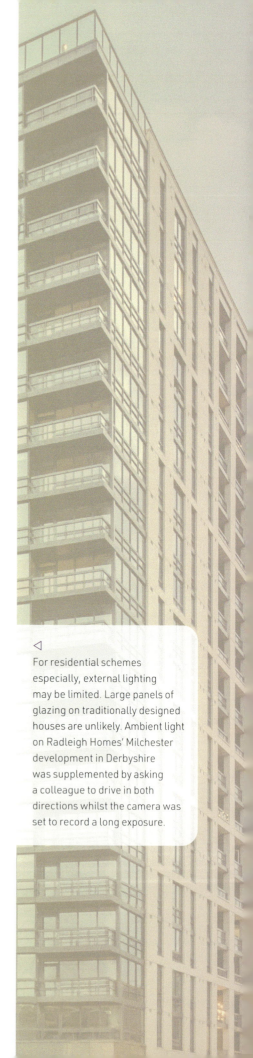

◁
For residential schemes especially, external lighting may be limited. Large panels of glazing on traditionally designed houses are unlikely. Ambient light on Radleigh Homes' Milchester development in Derbyshire was supplemented by asking a colleague to drive in both directions whilst the camera was set to record a long exposure.

For buildings where 'out of hours' lighting is needed, forward planning with security and facilities management teams is essential. Access back onto sites after occupants have left for the day will need negotiating. In the case of multi-storey blocks, organising personnel to walk the floors at each level and keep lights on is vital. I find that walkie-talkies are easier to communicate with my helpers, rather than repeatedly making phone calls to them as sections of a building plunge into darkness. Utilising this strategy is effective on partially commissioned schemes to give the appearance of 100% occupancy. See the next chapter for further insight into working with on-site facilitators.

△
BDP's City of Edinburgh Council's offices (left) and CPMG Architects' Teesside University Centre for Professional & Executive Development (right). Both buildings give the impression of being active owing to the light emitting from within. Beyond the working day, assistance of individuals to walk each level and keep lights from going out is vital.

△
Ron Blunt's image of 4000, North Fairfax Drive in Arlington, VA by Hickok Cole is lively despite many apartments not being illuminated. Controlling internal lighting in residential blocks is nigh on impossible after the point of handover. Here, lighting in *some* residences and amenity spaces supplemented by traffic and pedestrians allow this image to communicate all it needs.

Those finishing touches ...

Are there artworks or signage planned for walls, doors or on external boundaries? Whether it is company names, branding manifestations on glasswork, sculptures on plinths or paintings on walls, these final touches can make the difference between 'satisfactory' and 'satisfying' in terms of creating a 'sense of place'.

This applies to a two-bedroom apartment and a branch office of any company, right through to a five-star hotel or the global HQ of a multinational. Speak to the occupant and find out their schedule for installing such elements, as there can often be a period of 'bedding in' before they are ready to make these purchases. Bare walls are terribly telling. In the life of the building, they speak of its' 'adolescence' and any set of pictures taken prior to this will invariably want replacing.

If you cannot coincide your shooting schedule to show a dressed, occupied building, at least be consistent in your visual narrative. Most photographs of architecture are seen as a series of images rather than just one 'hero' shot. If you cannot get people to appear in a meaningful number of pictures, consider shooting without, but style the shots to look as if they have 'just walked out of frame'. Coffee cups on tables, the odd jacket on a coat peg, schoolwork open on desks, having windows open or doors ajar to lead the eye to the next space, etc., all give a sense that occupants are home, and the building is 'alive'.

▽

Regardless of whether the objective is simply to show bespoke joinery and craftsmanship or installed signage, trying to create a sense of space for any building is tough until it is fully commissioned. Chapel FM Arts Centre in Leeds by Groundworks Architects (left); Twyn-Y-Corras, Herefordshire by Communion Architects (middle); and a family home in Rawdon, Yorkshire by Bauman Lyons Architects (right). All reap the rewards of occupancy and don't require models to assist in expressing their sense of life and place.

As this chapter has discussed, sometimes the freedom to choose the best time for image making is not negotiable and this is often the case when it comes to award deadlines. An operational yet visually challenging project with one of my clients, Church Lukas Architects, had a target date for the end of January that particular year.

BYRON HOUSE

NOTTINGHAM TRENT UNIVERSITY

This city-centre site in Nottingham comprised high-density residential accommodation, together with the main Students' Union offices, social and leisure facilities.

With a tight physical footprint, next to one of the city's tram lines, there was limited opportunity for me to stand back to observe the block in its entirety. Moreover, despite the principal elevation being south facing, adjacent campus buildings were equal in mass, density and close in proximity. The other aspect forcing a considered strategy was the continuation of external works at ground level. The project was due for completion prior to the students' return in mid-September, but various factors had caused the main contractor to run beyond schedule by several months.

I'd stalled shooting until the eleventh hour and was now right on the heels of the deadline. I had a window of good light (rare in the UK in January) but there were big holes in the road, plant vehicles and workers in high-vis gear. With security fences surrounding the site, marking out 'safe routes' for students to access entrances, one might appreciate some of the challenges that lay in front of me. ...

A visual assessment of the conditions meant that the obvious viewpoints were simply not viable. You can see this in the recce shots I did [Figs 8.8, 8.9].

Figs 8.8 & 8.9

I contacted the client to propose a two-stage completion of the brief; I would go ahead and shoot a *limited* set of images for submission that could fulfil needs in the short term, yet still be of sufficient quality to be part of the legacy set.

Given the city-centre location, there was a building greater in height than Byron House itself, but still close to the site. Negotiating with the facilities management team, I was able to get a roof permit and work on long focal length lenses. Not only did this vantage allow for a good contextual view, but the effect of the shadow massing was also significantly minimised [Fig 8.10].

Fig. 8.10

Lastly, for ground views, I worked at dusk, which again minimised the high contrast, whilst passing trams obscured the roadworks from view. The outcome to this approach was successful, and when added to the photos of the interior spaces, which were already completed and in operation, I had enough images to structure a successful visual submission on time. However, I also sought a return to the site in the spring when the sun was far higher. Happily, the client was amenable to this, seeing logic in the approach.

△
Shots to the left show the changes
between January and April, the dusk-
to-day, the height of the sun and the
subsequent reduction of the shadow
massing in the right-hand images.

Once the season changed, heavy shadows were minimised, external works were long completed and I could capture life around the blocks. The students were happy to model too, something they would have been far less willing to do in the depths of winter. Some images from January were replaced, but there were also views from the first shoot which proved enduring and retained.

In the end, owing to an enlightened client who listened to my perspective on *how best* to approach the issues, facilitating and funding that second visit, a memorable collection of images was created. These are still being used by multiple parties connected with the project, thus making a lasting Stage 8 appraisal.

◁ + △
The images here show further views from the final set. The use of students is two-fold, partly to animate the public realm, internal spaces and show scale, but also to help drive the narrative. Buildings are for *us*, for *use*, and denying those stories by not including people and the items that they work, rest and play with makes it very difficult to bring any project to life.

Always, good light is your best friend. Having any building alive with people, the specified lighting operational, together with beautiful sunshine penetrating spaces will give a feeling of life and moreover create a three-dimensional, memorably emotive set of images.

Real deadlines permitting, images are best commissioned once, paid for once and most vitally, come to represent the project as *you intended* when seen by others. Remember, 80% of the viewers of your pictures will only know your project through the visual imagery of it. They may never have the privilege of seeing it with their own eyes unless the building is visible from the public realm, or even less likely, internally accessible to all.

Timing factors for shoot scheduling

Is the project urban?	Yes	Prepare for compromise. Plan for dusk shots as part of the approach
	No	Unless walls or evergreens are in close proximity, you should have a broad window for capture and low sun can be stunning
Is it set in existing landscaping?	Yes	Working after the leaves have dropped is helpful for exteriors which may otherwise be screened by heavy deciduous foliage in summer
	No	Discover the planting schedule, avoid capture prior to seeding or turfing especially, as bare soil will look ugly and date the images
Are there any vantage points?	Yes	Work with facilities management teams to agree these ahead of shoot day. Identify accessible roofs, balconies and sash windows.
	No	If you're limited to ground level only, choose foreground features lit by sun, and frame longer views which may set the project in context
Is there an extensive external lighting scheme?	Yes	Plan some shots for twilight, you will have about 30-40 minutes after sunset in clear skies to make images before the sky is too dark
	No	If the project fronts onto a road, utilise the lights of passing traffic to supplement internal lighting which should all be activated
Does the project have an atrium, central courtyard or light well?	Yes	To avoid contrast issues (bleached out higher levels and canyon-like lower floors), work just prior to twilight for best results
	No	Deep floor plans can be gloomy in the centre of spaces away from windows, and even with installed lighting switched on, you may still need to supplement the lighting to avoid too much contrast
Is there significant glazed curtain walling?	Yes	In winter months, the shallow trajectory of the sun means that even deep floor plans can benefit from sunlight penetration
	No	Time interiors to work best for the contrast to be minimised between the light coming from windows versus interior lighting

▷
The King's School Boathouse by Associated Architects and Moorways Sports Village in Derby by FaulknerBrowns (shown unoccupied at the beginning of this chapter). Whilst the earlier pictures were arguably beautiful, they only *implied use*. Both spaces are now seen in use as designed.

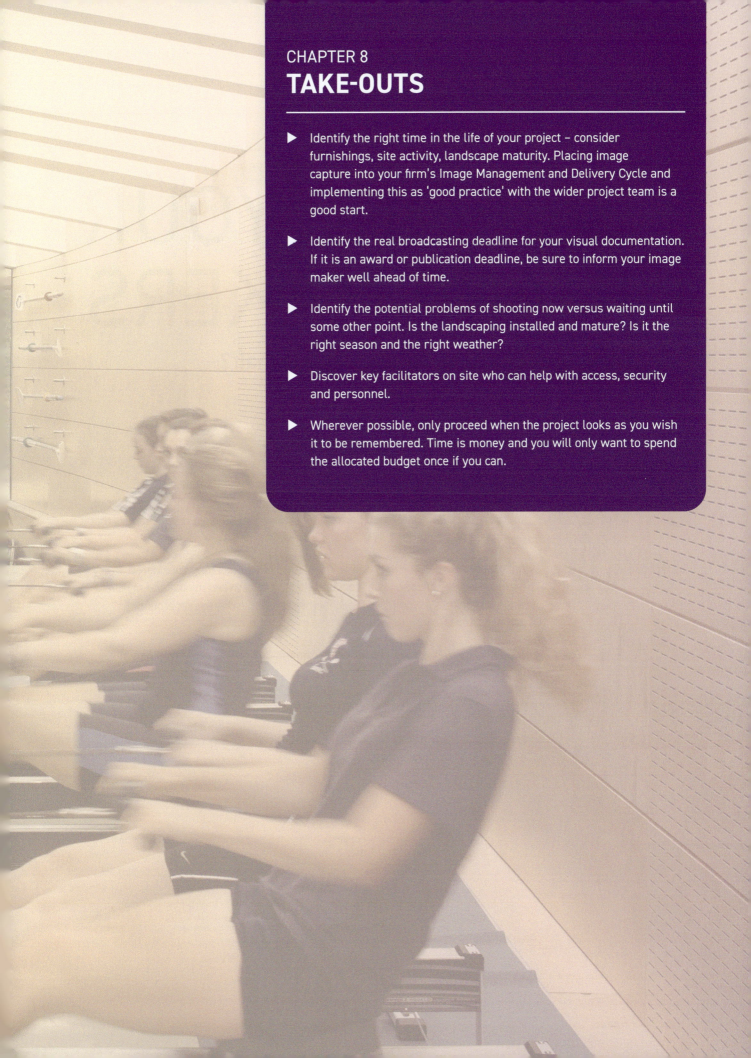

CHAPTER 8
TAKE-OUTS

▶ Identify the right time in the life of your project – consider furnishings, site activity, landscape maturity. Placing image capture into your firm's Image Management and Delivery Cycle and implementing this as 'good practice' with the wider project team is a good start.

▶ Identify the real broadcasting deadline for your visual documentation. If it is an award or publication deadline, be sure to inform your image maker well ahead of time.

▶ Identify the potential problems of shooting now versus waiting until some other point. Is the landscaping installed and mature? Is it the right season and the right weather?

▶ Discover key facilitators on site who can help with access, security and personnel.

▶ Wherever possible, only proceed when the project looks as you wish it to be remembered. Time is money and you will only want to spend the allocated budget once if you can.

▷ BRIEFING YOUR IMAGE MAKERS

What should they be doing on your behalf?

We've established that the photographs taken of your work may be produced in-house or outsourced. Whether the in-house person is you, another member of your team or a commissioned professional, there will be a set of parameters that need to be negotiated.

As explored earlier, the *why* and *when* need to have been long considered. In my experience, they are the initial conversations held between myself and my client when a project is introduced. These factors shape the discussion around the actual brief itself.

You may find that working backwards from the desired outcome will then allow the most logical pathway to formulating a working brief. In most projects, you'll seek to create a body of images *about* a building, rather than a single 'hero shot' as more commonly experienced in genres such as news journalism.

Let's look at some of the things you should consider when creating yourself or others a brief to work from.

▷

This residential interior photographed by Sally Ann Norman for Nicholas Jamieson Architects in London shows the design of the space amply, but also gives the sense of a family home, where the owners are simply 'out of view'. Consideration is given not just to the photographic drivers – angle of view, composition, lighting – but also the styling.

Briefing your image makers effectively and bringing in the services of specialist facilitators who can help on site to achieve whatever it is that might be needed for success on the day is vital.

Set realistic boundaries for your image maker

A story told to me early in my career by a renowned architectural photographer who had hung up his hat at the end of the 1980s still resonates just as clearly today as it did then. This practitioner took a phone call from an excited architect who had just finished restoring a church in Lincolnshire:

> Dave ... I did my final site visit today and just as I was driving away, the rain which had plagued the entire handover meeting stopped. The clouds parted, and the most heavenly rainbow came right over the church tower.
>
> It was magical, ethereal ... just stunning. I want you to capture this for me, it will look incredible in my practice brochure.

Dave, with as much diplomacy as he could muster, gently brought the hapless and enthused client back down to earth by explaining that unless his wallet was very, very deep, there was very little likelihood that capturing a moment like that could ever happen. How could the architect possibly afford to pay someone to sit outside that church for hours, days, weeks, even months on end waiting for lightning to strike a second time (or, in this case, a rainbow)?

These days, happily, you are more than likely to have your phone camera with you to capture extraordinary moments that nature or circumstance sometimes bestows on us.

How long is a job?

So, how much time (in hours) does one need to create a set of pictures?

This is hard to pin down, because every individual building is different, together with the experience (and therefore speed) of the person undertaking the work. There are also variables on the day which may speed-up or slow down (sometimes to the point of prohibiting) meaningful progress.

Whilst digital capture is far swifter than analogue photography and filmmaking was, a job done properly will still take some hours. Not just double or treble the amount of time that standing and tapping a phone will take, but, instead, more likely ten or 20 times longer because of the desire for styling (props/models) and controlling the light to best effect. This may mean waiting for weather/seasonal conditions that are timed to work best for the building. In addition, the project may still require extra, artificial lighting – either flash or LEDs – to supplement what has been installed.

If the image maker is you, set formal time aside for the documenting of your project. Simply bolting a notional hour or two on the end of a site visit will not yield legacy value for a set of pictures, regardless of the size of camera you're wielding. Certainly, the ubiquitous phone camera means that your ability to capture a picture is with you, and the odd hero shot may ensue from simply being in the right place at the right moment. These images are the ones which your Instagram account will cherish. However, a framework based on the ground rule of allocating a *distinct* amount of time to the documentation is the first building block to meaningful success.

There will always be planning to do ahead of working on site. Where, when, what, how? Can you achieve what you need to on your own or do you need help? As much research as you can do up front will save time (and stress) on the day. Avoiding 'surprise' for the occupant is best, so planning *with them* is sensible.

What to tell your photographer

You need to decide what you want from your photographs and work to a set of plans, which should include a north point. This helps plan the day in regard to orientation of the site to the sun. It makes sense to mark drawings up with angles too: arrows pointing in the direction you think you want the camera to face. Consider indicating an arc with each marker to suggest a wide or narrow field of view for the shots.

There also may be an 'A' and 'B' list in case of time constraints on the day. For certain spaces, there may only be access to shoot for a few minutes, so think about the primary angle of coverage. There could be time to capture more than one picture, but unforeseen constraints may prevent the desired view, so having a plan B makes sense.

Talk to others in the practice who've been directly involved in designing the project. Even if they were not party to the conceptualisation and simply worked on technical aspects, their opinion might have value, especially if those individuals have visited the site itself during the construction and handover period.

You're now creating a shot list, in just the same way a filmmaker would work to a storyboard. This list will help you define how much time could be needed to cover a job and if you're outsourcing, allow your practitioner to price the work far more accurately than if you just told them to 'shoot everything important'. You may, of course, have a relationship with your image maker that is established to the degree that simply issuing them with a set of unmarked drawings with a north point will suffice in terms of briefing.

Accusations to your image maker of 'you missed the plant rooms' may be met with a retort stating that unless you specifically requested their inclusion ahead of time, how could they have read your mind? Most professionals will have a set of terms and conditions that form part of your contract with them, which might stipulate that written direction should be given to avoid later disputes.

This may seem an obvious position to avoid, but even if it is *you* operating the camera, you might just simply forget to capture one or two pictures on the day. That's really infuriating if you've driven some distance to record the job and find you need to return as the result of having been distracted. So, carry that shot list in your back pocket and get it right.

△

The briefing by architects Shepheard Epstein Hunter for Percy Gee Building at the University of Leicester included drawings with marked viewpoints. A photographer isn't often contractually bound by these, but provision is extremely helpful for the person carrying out the work. Sometimes, desired views just aren't possible, either for logistical or technical reasons, but if they look 'right', then invariably they will be created.

▷
Occasionally, those driving the shoot brief may be the actual occupants themselves, allowing the building's design team to benefit from creativity and co-operation without risk of causing issues or overstaying one's welcome. Building R100 by Fairhursts Design Group Ltd at RAL Harwell in Oxfordshire is the main development facility for the UK Space Agency. Photographing the technical staff fitting out giant vacuum chambers was straightforward to do as the occupant-generated shot list *requested* these spaces be captured.

Allowing the image maker flexibility to interpret a shot list creatively, rather than slavishly following it to the letter, is a sensible mindset to be in. How spaces are designed and their subsequent use by others may be slightly different, and that can mean pictures will take on a slightly, or occasionally, vastly different form to what one has in one's mind's eye. Conversations that I've held with other photographers and filmmakers over the years have reported clients expressing "oh gosh, I hadn't quite envisaged this, it's different to what I imagined", and, moreover, mostly accompanied by "and it's a far better outcome than I could have anticipated". This is a sign that not only is a willingness to accept different interpretations vital, but also that a fresh pair of eyes on a project can reap rewards.

Certainly, a useful accompaniment to site for anyone taking photographs is a set of the visuals or CGIs that have accompanied the approved planning application. These may already exist on your company website as the known 'face' of a given project throughout its design and construction period. To have a photographer replicate those views, thus proving that the reality of the project *is as planned* will allow you to create compelling endorsements of the practice's ability to successfully execute work. It will help maintain confidence in your brand.

These key views are likely to become the bedrock images of any project case study. They're usually wide angle 'establishing shots' and are (hopefully) taken from human eye level, allowing them to be more easily replicated. It is infuriating to be given a set of such visuals only to find they've been created from a fanciful aerial viewpoint. If this is the case, is drone capture possible, or is there a tall building adjacent?

△
Both LH images show CGIs of BDP's Victoria Station in Manchester. Happily, it was possible to replicate them (RH photographs) from the station's concourse and also a nearby rooftop.

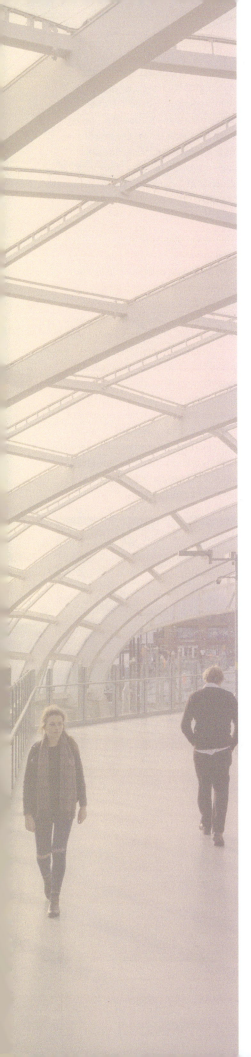

How many pictures?

Is the building typical of its genre? Assuming your practice has a specialism, which many do, a pattern is likely to emerge regarding the approach to documenting your projects. They may have few variables and follow repeated patterns in terms of scale, budget and materials.

In my own experience, the average UK primary (elementary) school, for example, embodies a formulaic design rationale in terms of size, number of spaces, types of rooms and activities taking place therein. It's therefore useful to describe how one might approach a site of this nature.

Again, I should stress, if you're the project architect, try not to tag picture making on to a planned site visit. Instead, approach the venture as a standalone endeavour, one where you can plan for optimum picture making and not get swamped with conversations based on post-occupancy evaluation.

Just to go back to the 'when', this should ideally be at a point that the site is fully operational, our Stage 8 of the photography cycle. For educational buildings, one of my questions is to check if walls have plenty of pictorial displays on them. Bare walls in schools are an instant tell-tale of recent occupancy. Before any image making commences, gaining consents for photography of children is mandatory. See *why* in *Ch. 16 Ethics: Visual thinking and accountability*, which discusses working with people.

This considered, the logic behind my shot list and visual approach for an average primary school is as follows:

1. Establishing shot: contextual, the building within its site – one shot
2. Main elevation – one shot
3. Entrance or reception – one shot
4. Main circulation spaces. These are usually a broad spinal route through the school where art displays, class breakout spaces and library materials may be located – two shots
5. Typical classrooms – three or four pictures in total, illustrating uses by different age groups. I am sure to emphasise important design elements: doors onto the playground, fitted sinks and bespoke built-in furniture, etc.
6. Main hall: aim for different configurations. These spaces may be used for physical education, dining, general school gatherings (assembly) or performance – two shots
7. Outdoor play and recreation – four or five angles showing dedicated play equipment, multi-use courts/pitches and wider playing field shots. Different specifications relate to early-years provision compared to those for older children
8. Special design features/details/craftsmanship – two or three shots

Shot tally: For most primary schools, unless they're the outcome of unusual design approaches and materials, I anticipate 16–20 shots.

◁ + ▷
Wixams Tree Primary in Bedfordshire by Lungfish Architects is typical of many recent new-build UK schools serving early years education. Whilst each individual school can personalise their internal spaces, and the sites themselves are unique to their location, projects of this nature have to create a standard set of provisions to meet their educational offer.

This makes shoot planning straightforward, as once site orientations have been established, time and need allocation is fairly standard. Ascertaining these elements ahead of a shoot is critical; once you arrive on site, you've got to swing into action rapidly. A small child's day is broken into bite-sized chunks and you may only have a single chance to capture specific aspects during the visit, as each activity might only occur once during the school day. Conversations were held at all stages with teachers, parents and the children themselves about if, where and how they were portrayed in these shots.

Consequently, for a project on this particular scale, I am likely to offer my client a part-day rate. Speed comes through experience, however, and only allowing four or five hours may be a tall order for those not used to directing children, styling or lighting spaces.

Even saying 'a part-day' for a project of this size has caveats. In the summer, one might anticipate that documenting a building on a modest scale could be accomplished within a morning. Therefore, could one shoot a second project in the afternoon? This is unlikely, as both projects will need to be geographically close, and each will need principal elevations facing opposing directions. If both face east, for example, visual compromises will need to be made in terms of the sunshine on the key facade of one or the other.

In addition, the working school day is often only a maximum of six hours, which means an extremely tight turnaround. How viable would it be to finish project number one, and then to pack the kit away and travel to the second destination? Whilst time is money, speed without sacrifice is only likely to be found with seasoned practitioners. It's unfair to exert pressure of this nature if it can be avoided. Allowing a little breathing space for 'on-the-day issues', especially where working with small children is concerned, is probably advisable.

On-the-day support

Simply having 'support' on the end of the phone whilst the shoot is taking place is probably the most reassurance anyone making images will need. If you (as designer) have instructed another person to carry out the shoot, you may be asked for your view on a specific angle where different outcomes are possible or be informed of a problem which may affect something you had envisaged. Contemporary video call technology could allow you to see views in real time and talk through solutions. If very specific angles of buildings are required to illustrate pre-existing documents, it makes sense for the image maker to communicate visuals of viable alternatives should they hit issues on the day.

With diligent planning ahead of time, the need to speak with one another whilst a shoot is taking place is unusual, but it is a good crutch for both parties where warranted. I can recall a few calls over the years where in addition to the original brief, a client has suddenly felt the need to request an extra view. These might come in the form of a "whilst you're there, can you just ...?". Be reasonable with the image maker. Taking one or two additional frames may be straightforward but asking for a suite of pictures that were previously undiscussed may throw a spanner in the works for both the photographer *and* the occupant, time and money wise.

Success on site is not simply down to the skills of an image maker. It's often a *collaboration* and others will play a meaningful part in the shoot. Let's look at some of these. There is no hierarchy. Each role is fulfilled by individuals and teams which may or may not be connected.

▷
For this image, the assistant's role was levelling some 80+ roller blinds to precisely the same height before recruiting models at the George Green Library, University of Nottingham, by Hopkins Architects. Timing was of the essence: the blinds couldn't be styled too far ahead of time as occupants could have begun to re-position them if the sun was still up, causing internal glare.

Photographer's assistant/filmmaking crew

Working as a team of two (or more), with direct responsibility to the photographer/videographer, being an assistant is often a role embraced by a younger counterpart, either as a college placement, internship or by an early career practitioner supplementing their income whilst building their own stable of clients.

Some assistants are 'career assistants', highly skilled hands for hire, who can be relied on to set up lighting and stage manage with authority. They usually charge by the day, and invoice for their services.

Experienced crew can be expected to arrive knowing their way round the controls and set ups of most brands of camera equipment, lighting and postproduction software. Once a working relationship is established between them and the image maker, expect productivity to soar. My regular assistants have an unspoken language with me, where we'll instinctively know how we will be tasked when we get to any space. That person will immediately swing into action helping with kit, looking to see what sort of shot I am constructing angle-wise and then commence styling attributes of 'the set' to best effect.

The Emily Wilding Library at Royal Holloway, UCL in Middlesex by Associated Architects. On shoots where there is no budget for an additional stylist, a photographer's assistant will help ensure that the space is neat and set out according to intended plans. Here, people standing and sitting chatting on each of the bridges below the camera and across the void are deliberately placed. Furniture in the lobby has been tidied and whilst the shutter fires, the assistant helps with flash lighting, adding a soft fill to the ambient illumination and lowering the contrast in the scene.

When it comes to sourcing non-professional models (bystanders, pedestrians, office workers, etc.) to appear in pictures, it is known as **street-casting**. Experienced assistants will have the confidence and maturity to go and recruit such individuals and bring them onto the set swiftly for direction and photography. They will deal with any associated paperwork in the form of model releases (see *Ch. 16 Ethics: Visual thinking and accountability*) and send volunteers on their way afterwards with a smile.

An assistant is there to help in whatever capacity needed, but 'free' help in the form of college placements is simply a pair of hands. They are usually eager to learn and take direction, but not get involved in any form of decision-making and cannot be held accountable for poor execution if left unmanaged. Taking this form of inexperienced helper can be limited in its usefulness. Instead, it makes sense to use their lesser skillset effectively – for example, when a photographer is carrying valuable kit, there is risk in putting it down to sort something out and walking away from it unguarded. Personal safety in some city areas will benefit from a second pair of diligent eyes and directing someone to sweep half the room and straighten blinds and chairs in the space is extremely time (and labour saving). For students and interns, their benefit whilst doing these chores must be that they can observe and learn the tasks that require greater expertise.

For filmmakers – especially where lighting is required, sound is recorded and interviews form pieces to camera – teamwork is a necessary part of the process for both technical need and in expediting production. Fees for a professional assistant usually travel at around a third of the photographer and videographer's own day rate in the UK, but the productivity of an experienced team will vastly increase the quantity and quality of output. Expect to see extra crew itemised separately on an invoice. Investment in skilled core personnel for image making is invariably money well spent.

Facilities management

The people in these roles at each site, for example building control, day-to-day management, security, etc., are often the key to success or failure in the overall mission. Without their blessing of the photographic exercise, the nuggets of gold needed – such as door-swipe cards to allow free movement, access to roofs, moving cars, getting lights back on after dusk when staff have long departed for the day or even a cup of tea when the photo-team are cold and thirsty – all make for significant losses or gains. It is the experience of all image makers that the folk in these teams are their new best friends who they will spend much of their time with.

These personnel work long hours and often have a background in the military or another uniformed service. They'll share all the in-and-outs of the building in question, they're strong, kindly and make sites the world over operate like clockwork in the way they need to. I'll get to know what makes them laugh, the names of their family members, etc., and then sadly, invariably, never ever see them again.

◁ + △
For the plates depicting Southwell Minster in the latest edition of *The Buildings of England: Nottinghamshire*[1], the facilities team were happy to liaise ahead of the day, taking care to make sure the grounds looked pristine. They also removed contemporary seating to allow a clear view down the nave to the altar. Concise briefing resulted in effective action during the shoot.

1 Clare Hartwell, Nikolaus Pevsner and Elizabeth Williamson, *The Buildings of England: Nottinghamshire* (Yale University Press, 2020).

I may never encounter these people prior to arranging your shoot, but trust in this, if I can find out who they are *prior* to the day and make the arrangements with them that are needed ahead of time, the project itself will go more smoothly and swiftly than otherwise. Having a budget with which to buy everyone a coffee (or stronger!) at the end of a long day to thank them for their dogged belief in the quest would be wonderful, but sadly almost never ever happens.

Creative or Art Director

Less the direct territory of architects, structural engineers and landscape architects, creative directors are more usually connected to interior design houses and product manufacturers who use advertising agencies to work with photographers. Where employed, the creative director will assume the lead role on the shoot. This relegates the photographer to be more of a 'camera operator', taking direction from the creative director, who in turn may be working to a set of pre-defined brand guidelines. These instructions may shape the compositions, the colour palettes, style of lighting, direction to models, etc., and the results may need to fit into the look of campaigns that are already within the public domain.

If we return to *Ch. 2 Representation of your work: Constructing your practice brand*, you will recall the discussion about working to brand guidelines. Architects may also be asked to follow these if designing for companies whose physical spaces must conform to a house-style (for example, franchise-driven retail premises). It might be that the photographs themselves need visually arranging to conform to a set of pre-determined rules. Creative directors are well versed in interpreting these brand directives and need to place such concerns at the forefront of the image making plans.

Your own involvement on this type of shoot may simply be in the form of a 'buy-in' whereby you are the architects of the scheme, but *another party* within the procurement framework has assumed responsibility for the visual documentation and you are simply co-funding the exercise. In this case, be sure to make known what images *you* specifically require, or risk being presented with an invoice for your stake in a set of photos which may not align with your vision of how your building could or should have been portrayed.

This is not to be dismissive of a creative director, whose training and vision is highly respected. It's just to express a view that the agenda for image making by advertising agencies can often take a different direction to that of specifically the 'architect as client', which we are primarily discussing here.

Stylist

Often employed at the behest of brands or interior designers, stylists play a different role to that of photographer's assistant, who will be expected to work with the technical aspects and logistics of the shoot. Instead, a stylist will take the heat off arranging and shaping the furniture, accessories and props and models for each space. They may not necessarily be responsible for bringing props or plants and flowers, it will depend on the shoot itself. In the example of hotel shoots, where branding is already present, the stylist will work to compose furniture and remove any off-message elements which could detract from the narrative.

For projects which are to be photographed very soon after practical completion, the stylist's intervention in creating a sense of place where one may not seem overly possible otherwise is extremely helpful. There are specialisms within the role too. **Prop stylists** function as the title suggests, to enhance interior design and lifestyle shoots (catalogue and editorial). They oversee the rental of specific items of furniture from prop houses and often have their own repository of soft furnishings and accessories that they bring themselves as well.

Regular photographer – creative director/stylist teams will work together for firms, creating a swift workflow which unites to the ethos and brand guidelines of the names they represent. If an architect is working on behalf of owners or occupants with an established brand, such as a hotel group, those clients may require the image maker to work in tandem with an Art Director and Stylist, who'll be on site during the shoot.

I spoke to Keleigh Swan, a consultant who heads the East Coast USA studio of photographer Ron Blunt.

KELEIGH SWAN
CREATIVE DIRECTOR

Usually, the Creative Director (or Art Director) is engaged to represent the client's needs and is likely to be hired and paid for directly by the brand. Following a degree of research ahead of the day, they'll oversee the shoot and establish the general visual direction, ensuring that the images being created reflect brand standards and current photography guidelines.

Whoever she's working with, Keleigh will advise the photographer on their desired views, and they discuss preferred lighting styles and styling guidelines. For her, briefs undertaken with Ron result in a unified collaboration between them as they've worked together for many years and plan projects side-by-side. Certain clients, including real estate developers and builders, benefit from art direction on their shoots, but they don't always have a Creative Director on-staff to fulfil this role. In this case, skilled practitioners such as herself can be hired. Keleigh explains:

> I'm a rarity, because I function in both capacities: Art Director and Stylist. It allows Ron and I to offer clients something unique: all-inclusive creative services. Depending on the scope of work and budget, I might provide a combination of art direction and hands-on styling services. Collaborating with Ron, I'll find dynamic views, style the shots and also manage the shoot to keep everything on track. I'm very client-focused, always keeping their vision in mind. Working with an expanded creative team that includes art director and stylist requires the photographer to be an artist, to translate the vision for the shoot, while working within the scope of pre-defined brand guidelines. Structure is not a limitation for a master photographer or stylist. It is a framework for crafting stellar images.[2]

As stated, these roles are less the territory of architects, but are often connected to hotels, retail, interior design houses and product manufacturers, as well as global brands who use creative agencies that commission photography as part of branding, marketing, advertising and PR.

2 Keleigh Swan, interview with author,
 13 September 2022.

◁

Aspire House McLean in Washington, VA
by Harrison Design with kitchen/sitting
room interiors by The Modern Bulldog,
Jonas Carnemark, and home office by
Jodi Macklin Interior Design.

Keleigh continues:

> **Hotel groups often have strict branding guidelines, including specific guides for photography. Rules might dictate that exterior images include their logos or signage, or to place specific types of fresh flowers in view. Every component must add to the brand reinforcement and viewer understanding.**

Whilst that might sound like a 'no' for designers if a space is to be guided by corporate diktat, interestingly (and to an architect's advantage), Keleigh says that most hotel and office brands require spaces to be pared back and de-cluttered. Instead, she works to simplify fussy and distracting elements, preferring the architecture and design profiles to stand out. The translation of 3D space into a photograph means that often objects which are apart in real life can seemingly touch, or overlap, which can overload the image. Keleigh needs to work in-camera with the photographer, so that she can edit the space as needed whilst they use focal length, viewpoint and lighting to help delineate elements.

▷

Spaces are ordered yet inviting. Placing of objects helps take the eye around the image, but the story always remains about the space itself. Thompson Playa Del Carmen in Quintana Rio, Mexico for Thompson Hotels

△
Distinctive spiralling columns and pendants in the Kingbird Dining Room of Luigi Moretti's Watergate Hotel in Washington, where Ron and Keleigh produced a series of images depicting Ron Arad's refurbishment. Clean styling aligns with the hotel's modern aesthetic.

△ + ▷
Curated furnishings in the Watergate's presidential suite and an aerial view of outdoor dining inspired by abstract art.

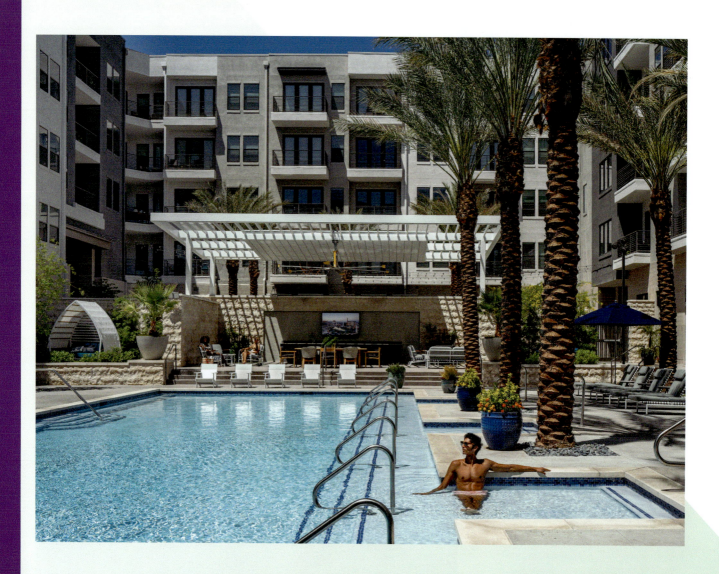

Stylists take direction from the photographer and/or art director. They assist the photographer in crafting the images: arranging furniture, visually editing the shots, and bringing in props and botanicals if it's relevant to the project. Photographers cannot be in two places at the same time (behind the camera and in front of it), and they're not necessarily skilled in styling. Keleigh elaborates further:

> **Styling is another layer of the photograph. Every client – architect, designer, developer – has a unique set of needs (including budgetary) which drive styling initiatives. Styling can be absolutely essential. The process is subtractive/additive. It's about editing (subtractive), then building in layers (additive) to ground the aesthetics. Whether it's an urban rowhouse [terraced home] or an expansive luxury estate, the process is always the same for me: start with a blank canvas, be a ruthless editor, then build in subtle layers, only as needed to enhance the design. Keep the images clean, focused, confident – no matter what the style. Let the space (and defining elements) shine through.**

△ + ▷

Working with Keleigh and Ron, professional models bring life to amenity spaces at Auric Symphony Park, an apartment development in Las Vegas by Southern Land Company and GDA Architects. The people are not the *story* of the shoot, it's always about the architecture, first and foremost, but how they appear on camera can be extremely important and stylists need to place everyone contextually.

Sometimes models will be cast for brand shoots to reflect guest aspirations or certain lifestyles and Keleigh works with them too, directing them in their acting roles throughout the shoot.

In summary, where the creative team is well known to one another, a swift and effective outcome is likely, and in the case of an experienced pair of creative hands to take care of curation, the photographer and assistant can concentrate on the technical and compositional elements of the shoot. Keleigh finishes: "Every client is unique and our work reflects an instinctive response to the design vibe."

If you're on the tools with fair weather and the most beautiful project in the world to shoot, the job will just not go as well without the help of others described here. If you as the architect are also the person wielding the camera, then you may have a real advantage in coming to know these individuals at the point your project springs into life. Their help, especially if you are a less experienced photographer, will be transformational.

If it's not you personally shooting, be ready to research and provide those contacts, as the photographer will need names and phone numbers of the team installed on site, or of those who your client is sending to work with them. Better still, call these people ahead yourself and make them aware of the image making exercise, how you might require their aid at the shoot and to advise them that the photographer will be calling. You want to be sure that your money is being spent in the most efficient and effective way possible.

Deliverables and archives

Briefing your image maker will naturally encompass what you want shot wise, but you should also think about the form in which you want your pictures. What are you doing with them? Now? Twelve months down the line? Further ahead?

Do you want high resolution digital files (usually 300dpi TIFFs) for large wall displays? Pictures capable of use for desktop printing (300dpi jpegs)? Small screen resolution images for web use (72dpi jpegs)? A set of prints for a physical folio, or perhaps a mixture of all of these?

Storing files at all conceivable dimensions is hard-drive hungry. Depending on the source equipment that image files are generated from, their optimum size may be significant; many professional camera bodies generate TIFF files of around 200mb and if you're storing a shoot's worth of images in multiple readily accessible file sizes, you may amass several terabytes of data in very short order.

A Guide to Files and Formats

MEDIA	PHYSICAL OUTPUTS – 300 dpi Adobe RGB Tiffs/jpegs	SCREEN OUTPUTS – 72 dpi SRGB jpegs
Exhibitors – Gallery Framed, Trade stand panels	✓	–
Banners – vinyls, posters, Lightboxes or panels	✓	–
Four colour print (bound) – books, pamphlets, leaflets, flyers	✓	–
Desktop publishing – inkjet originated, PDFs	✓	–
Email attachments	✓	✓
Screen presentations – powerpoint	✓	✓
Websites, Social Media – desktop, mobile devices	–	✓

Most professionals will state how many years they will store original client images for in their Terms and Conditions. Do check, because there may be a time-led obligation that your practitioner will adhere to, but beyond this, they may choose to delete project files that have not been called upon and are notionally 'redundant'. Storage is an issue for image makers, it always was. In analogue days, keeping not just negatives but printed stock took up physical space, especially for architectural photographers who worked with large format cameras producing individual sheet film.

Prior to the digital revolution in the imaging industry, photographic practitioners had film archive stores, which contained shelves and shelves of boxed

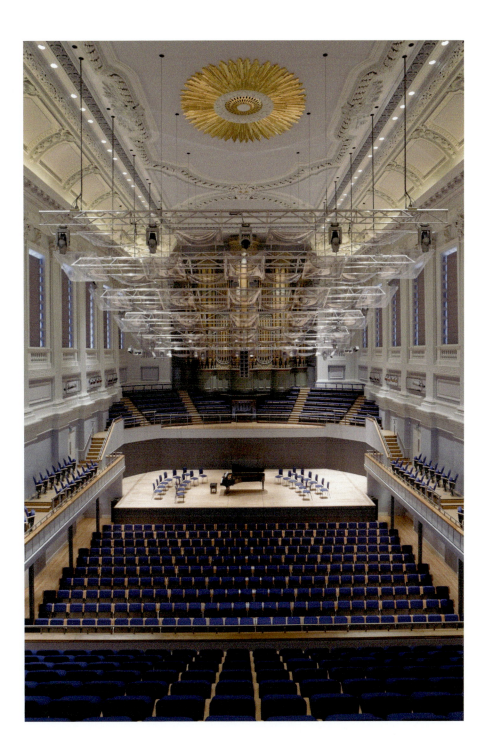

▷
Birmingham Town Hall, by Joseph Hansom (1834), was restored by Rodney Melville Architects in 2007. As a project still in demand for multiple applications and users, it is archived on mirrored hard drives in a fire safe.

On a project such as this, a building with a history beyond the most recent restoration programme, requests for the pictures may continue from third parties, long after the refurbishment. Knowing that the original file is still safe and accessible for the long haul is a sensible conversation to have with the person storing your photographic archive.

transparencies, negatives and prints. The 'stellar' projects may have been stored in fire safes. Fire safes filled up quickly due to the physical size of images, regardless of whether they were actual transparencies and negatives. Today, this is likely to be computer hard drives. The cost of constantly purchasing hard drives and physically having space for new fire safes to house them may partly attribute to the policy by some businesses of only keeping client work for a specified period.

In the case of architectural practices operating with in-house image makers, this subject needs careful consideration, as although physical storage space is moderate compared to analogue, the hard drives do mount up and cost money. Any business involved with extensive CGI work is long familiar with this problem, and whilst cloud storage is clearly a sensible option for one of the back-up resources, it makes sense for individual businesses to retain a physical hold on their materials as well.

Summary

In conclusion then, the topic of housekeeping for image files is very much aligned to the briefing for the project in the first place. Planning for each project shoot is vital, and well ahead of the day. How will you need pictures? In what form, and how swiftly will those need to be accessible? This will steer what you ask the image maker to provide for you. Your brief will need to have identified the time-frame for shooting, and those on site to help facilitate action by assisting before, on and even after the event.

Creating a shot list is sensible, the production of which is important not simply for handing to the image maker, but also for your own validation in identifying needs and outcomes for the exercise. This may need to be shared and supplemented by others involved in the image procurement framework. The shopping list may become exhaustive, and some images may subsequently not be needed, but the cost of returning to site *after* the event is more likely to far outweigh the cost of simply adding extra time or a second day to the actual shoot.

Staying flexible to the finer visual interpretation of the brief is logical, what you have inside your head may not exactly match the realities of the site's day-to-day operation and your imagined pictures may not always be realised. Heart-warming, anecdotal evidence suggests that frequently the results *do* exceed expectation, with a 'fresh' set of eyes bringing rewards (and even awards) above and beyond.

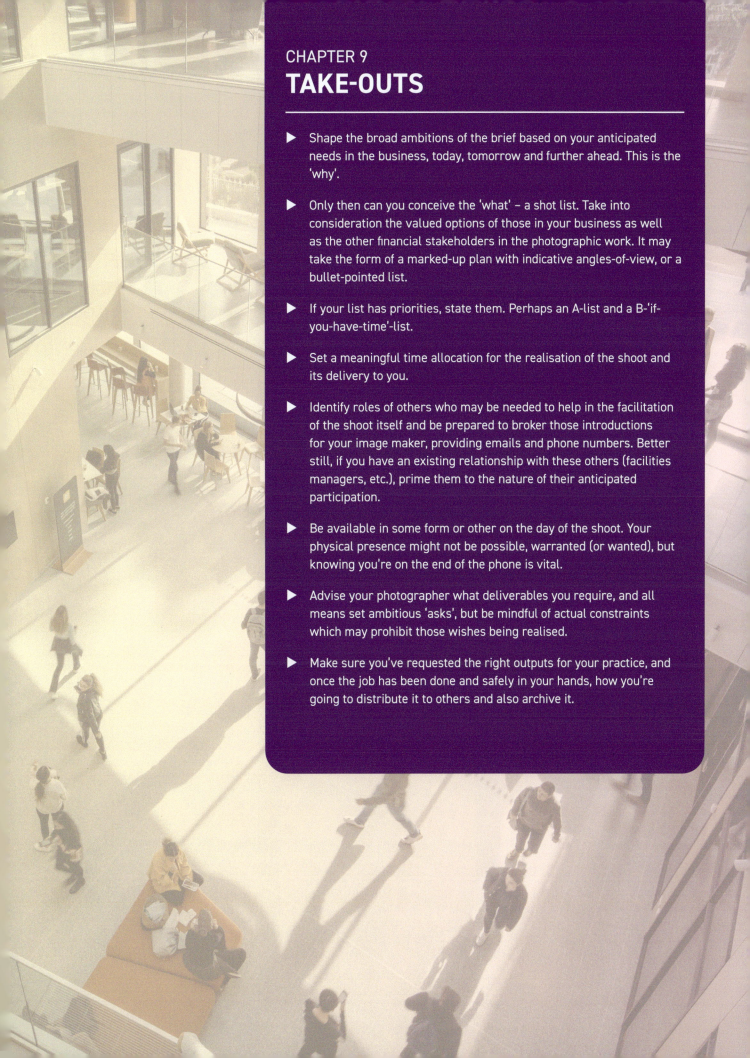

CHAPTER 9
TAKE-OUTS

▶ Shape the broad ambitions of the brief based on your anticipated needs in the business, today, tomorrow and further ahead. This is the 'why'.

▶ Only then can you conceive the 'what' – a shot list. Take into consideration the valued options of those in your business as well as the other financial stakeholders in the photographic work. It may take the form of a marked-up plan with indicative angles-of-view, or a bullet-pointed list.

▶ If your list has priorities, state them. Perhaps an A-list and a B-'if-you-have-time'-list.

▶ Set a meaningful time allocation for the realisation of the shoot and its delivery to you.

▶ Identify roles of others who may be needed to help in the facilitation of the shoot itself and be prepared to broker those introductions for your image maker, providing emails and phone numbers. Better still, if you have an existing relationship with these others (facilities managers, etc.), prime them to the nature of their anticipated participation.

▶ Be available in some form or other on the day of the shoot. Your physical presence might not be possible, warranted (or wanted), but knowing you're on the end of the phone is vital.

▶ Advise your photographer what deliverables you require, and all means set ambitious 'asks', but be mindful of actual constraints which may prohibit those wishes being realised.

▶ Make sure you've requested the right outputs for your practice, and once the job has been done and safely in your hands, how you're going to distribute it to others and also archive it.

▷ Part 3

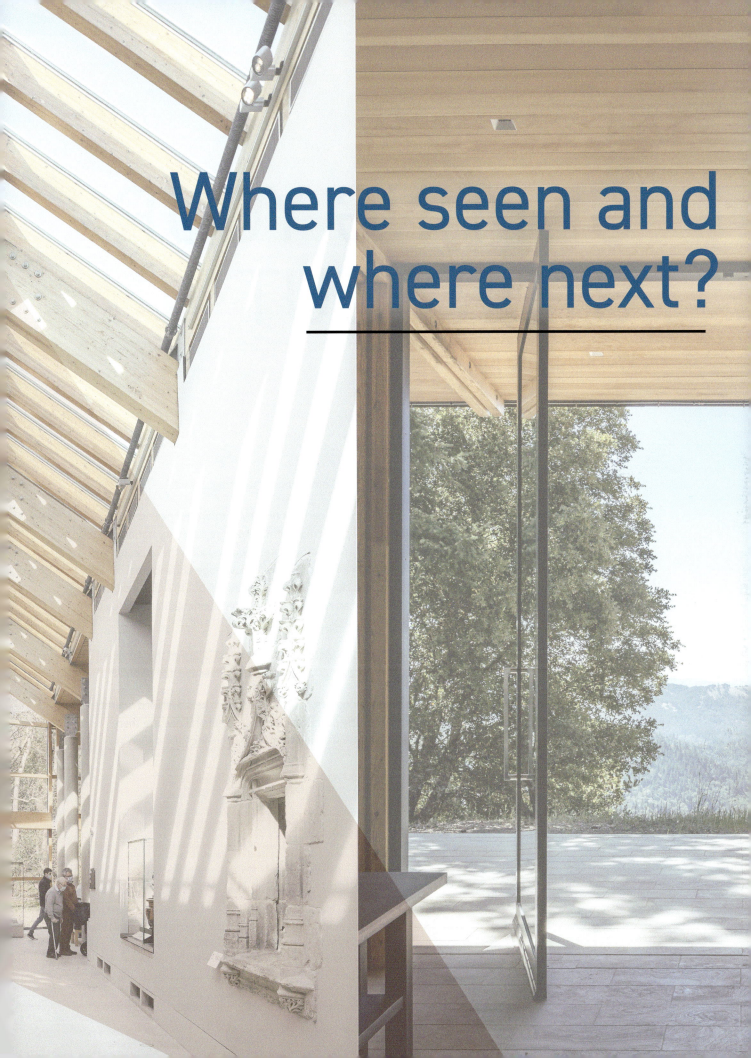

Where seen and where next?

▷ GETTING YOUR STORY OUT

Working with journalists

A good image, and moreover a good *story* about that image, is vital.

As discussed, set against a twentieth century history of informed peer critique and review, printed publications performed vital reportage for every nation's business community. Specialist architectural press worked with the expectation that readers held limited (or more likely, *no* prior) knowledge of the global buildings they presented. In this regard, little has changed, but in today's digital society, citizen journalism is just as responsible as professional editorial titles in carrying information to the masses.

A line from the Architect Marketing Institute's blog states: "Here at the Architect Marketing Institute, we have a saying, 'Architects don't advertise, they publish'."[1]

This process may be assisted by others, for example, PR firm BowerBird operates a subscription-based app whereby practices submit projects. These are then placed by their network of journalists with similar advice, "Architects: Don't advertise. Tell your story."[2]

1 Sienna Heath, "Can Architects Advertise? The Complete History of Advertising in Architecture," *The Architect Marketing Institute*, accessed 21 May 2023, https://archmarketing.org/can-architects-advertise/.

2 Ben G. Morgan, "Architects: Don't Advertise. Tell Your Story Instead," Workflow, accessed 21 May 2023, www.workflowmax.com/blog/architects-dont-advertise.-tell-your-story-instead. See also www.bowerbird.io.

The Grade II* listed School of Engineering at the University of Leicester by James Gowan and James Stirling has merited plenty of column inches in the press globally since its completion. Originally published in *The Architectural Review* in April 1963, it has appeared in articles discussing multiple aspects of its design, operation and status ever since.

How do you get your building into the hands of the press and thereby in front of a new, external audience? A relationship with journalists is one you may wish to pursue. This chapter looks at how one might go about placing the marriage of words and pictures into public view.

Your practice might be well placed to share information directly with your audience via various portals – more on this in *Ch. 11 Social media: Disseminating your brand online* – however, you might sense that there's negotiable editorial integrity with this approach.

You may feel that it's about a well-crafted press release; these are straightforward to compile and easy to publish. However, one could also argue that such bulletins are just as swiftly forgotten (headlines today, recycling tomorrow).

This chapter explores the contemporary role of the architectural journal and professional review, both in print and online, and asks, 'why use another's voice?'

- What value can journalistic review and critique add?
- Which audiences or markets can they reach that are difficult for in-house roles to broker?
- What (if anything) defines stories that get selected for publication?

It seems sensible to express how *Photography for Architects* is framing this perspective.

My own professional life has seen me working with specialist journalists and editors, illustrating their briefs for magazines, newspapers and books. In other words, a direct photographer–publishing house relationship.

In addition to this:

- My commissioned work is passed by architectural clients to their own third party contacts in preparation for such press use.
- Shooting directly for public relations and marketing agencies *has not* been a regular source of my income, and as such, I feel that the (arguably vital) role of the PR agent in disseminating editorial content is best left for others to describe.
- There are one or two dedicated books/editorials written by such voices which are available in the English language. It is recommended that readers directly consult these for advice on engaging consultants specialising in these services.

So, in understanding how to build case studies directly for editorial and news publication, what comes first? Words or pictures?

The case for the written word

As we explored in the first chapter of this book, the bedrock of our architectural knowledge is likely to have been via the printed page or screen editorial. Our learning is facilitated by words, but also accompanied (in the main) by photographs which introduce and explore new architecture and restoration projects across the globe.

Photography alone cannot teach us what a project means. We may be drawn to words by the actual images, but it is the text itself which leads what these visuals explore. By the same measure, simply engaging with a narrative will not give us enough value unless it is accompanied by rich imagery.

The two facets, words *and* pictures, sit hand-in-glove, side-by-side, worthy partners.

3 Hattie Hartman, "King's School Boathouse by Associated Architects," *Architects' Journal*, 27 March 2013, www.architectsjournal.co.uk/archive/kings-school-boathouse-by-associated-architects.

Photographs of a project may pre-date an editorial, be produced concurrently or happen after an article has been prepared. Certainly, for professional titles, it is unusual for a photographer to illustrate pre-written copy. If the writing element has been concluded prior, a journalist might prepare a shot list for a photographer to work with.

Wherever possible, a journalist will endeavour to visit a project *in person* if they're commissioned to write a case study on it. Even though they may be armed with pre-existing photographs, they're still likely to want to be able to validate their words by seeing the building first-hand. In addition, they may wish to conduct interviews with the key design team/client, some of which may take place on site.

▽

Architects' Journal sent Hattie Hartman to Worcester to cover the story of Associated Architects' new boathouse for the city's King's School.[3]

The review is delivered with the clarity of someone who has visited, toured and fully appraised the site and structure – outside and in.

NEWS COMPETITIONS BUILDINGS SPECIFICATION PRACTICE MAGAZINES LIBRARY PODCASTS EVENTS JOBS

King's School Boathouse by Associated Architects

27 MARCH 2013 • BY HATTIE HARTMAN

1/27

Associated Architects' boathouse at The King's School, Worcester, does not flout its robust environmental credentials, says *Hattie Hartman* Photography by *Martine Hamilton Knight*

The first boathouse at The King's School, Worcester was a barge purchased in 1914 for £18. Three boathouses later, an elegant prow-shaped building by Associated Architects has replaced a 1950s structure on the same site designed by the then master in charge of rowing. Every aspect of the new Michael Baker Boathouse (after an alumni donor) - from its careful siting to the flood-resistant design of the boat store to the meticulous selection of materials - has been lavished with attention to magnificent effect with a vigilant eye to sustainability throughout.

The King's School, Worcester occupies an organic accretion of buildings which front the southern flank of Worcester Cathedral. The boathouse is Associated Architects' eighth major intervention at the school over 14 years. Projects include: two 10-year masterplans, a library, and a new sports and performing arts centre, currently on site and due to complete in 2014. The architects' intimate knowledge of the school and its heritage context is made manifest in the boathouse.

The site is exceptional. Approached through a 2.6m-wide lane which defines the school's southern boundary, the boathouse sits roughly perpendicular to the Severn River. The cantilevering first floor forms a prow over the embankment, with its parade of handsome horse chestnuts and views of Worcester's twin landmarks: the cathedral tower and Glover's Needle, a reminder of the city's glove-making past.

The brief for the building was simple: a boat store with a multipurpose room above which could accommodate training for rowers as well as school and community receptions. The goal was to create a facility where every King's pupil would have an opportunity to learn the rudiments of the sport.

Project architect John Christophers brought a strong environmental agenda to the project, having completed Code Level 6/Passivhaus EcoVicarages for the diocese of Worcester (AJ Specification 02.13) and Cobton House, also on the banks of the River Severn, which won a RIBA sustainability award in 2005.

This modest building of just 772m² does what all good buildings should - it makes sense of its surroundings.

By locating an entrance to the upper floor on the axis of Glover's Needle in the adjacent Creighton Memorial Gardens, the practice has created an approach route through this previously under-utilised part of the school grounds and simultaneously provided wheelchair-friendly access to the building. Its cantilevered prow serves as a landmark on the embankment, anchoring the south-west corner of the campus. The planners were receptive to what Christophers calls 'a jewel-like modern incident along the embankment.'

The jewel reference is accurate. On the sunny day I visited, the diagonal-laid sweet chestnut cladding shimmered. The 32mm by 25mm chestnut laths of the rainscreen cladding are laid on a 15° angle, 'like a bias cut dress,' explains Christophers. The timber prow of the upper floor sits over a brick base which houses the boat store, with a flawlessly crafted 'belly' over the door fronting the river. The building's gentle curve echoes the site boundary which is also Worcester's Bronze Age fortification line. A rustic brick, chosen to marry with existing Victorian bricks and the local sandstone, is laid in English garden wall bond - three courses of double length stretchers and one course of headers - providing just enough texture to compliment the diagonal siding above.

A handsome timber door from the narrow lane opens onto a dramatic top-lit ice birch-lined stair. On the right, an interior window offers a glimpse into the boat store - which has double the capacity of the old building and is the building's raison d'être. Christophers refers to the store as 'sacrificial': it's uninsulated, outside the airtightness line and designed to flood. Since the boathouse was occupied last April, the Severn has flooded four times, bringing more than a foot of water into the boathouse without damage.

The immaculate detailing and sensitive choice of materials continues inside. A welcoming maple stair, with 450mm going and 150mm risers, is a marvel, each step carefully aligned with the brick coursing and the beech panelling on either side. Above, a bespoke run of flush rooflights follows the line of the curved wall in an alternating A BB A rhythm, creating a play of shadows on the wall. Motorised for ease of operation, the rooflights open to enable natural ventilation during training, while deep coffers eliminate glare. Triple-glazed windows and sliding doors open to the north overlooking the gardens and cathedral.

The boathouse's exemplary environmental agenda is simultaneously robust and imperceptible, an approach more practices should adopt. Because the programme required a multipurpose space for training, teaching and receptions, a lightweight responsive building was needed.

Paramount attention was paid to insulation and airtightness with all electrics located in the floor to eliminate penetrations of the airtightness barrier. The project team opted to monitor the building and share data on the CarbonBuzz platform (even though there was no fee to cover this work), a move more practices should consider.

'An overlooked aspect of sustainability is the need to inspire and delight,' Christophers told me as we departed. Each summer term, The King's School, Worcester celebrates its rowers with a black tie dinner and awards evening. It's hard to imagine a more magical spot for such a festivity than the prow of the boathouse with all doors thrown open overlooking the gardens' herbaceous borders.

With production costs being as they are today, it is very unusual for a title to hold a budget for professional photography. Hence the comment that the image making element may sit independently of the writing; most likely it will have been paid for by the project leads instead.

Who is wielding the pen and the camera?

There are few photographers who write, although there are some journalists who shoot competently and illustrate their own pieces. In the case of existing visuals, journalists may choose to supplement these with their own pictures. The UK's widely published Hugh Pearman is one such individual who is happy to pick up a camera, and academic David Grandorge had a strong career as an architectural photographer earlier in his working life, but now combines writing and shooting. In the main, however, the partnership of words and images incurs the talents and time of two separate parties independent of a project delivery team. It is these relationships we are speaking of.

I was interviewed for a piece by the UK's *Architects' Journal* magazine early in my career. "Why", they asked, "should an architect employ a specialist photographer?"

The answer given became the strapline for the actual article. It read: "Architects think, 'We've just spent ten grand on this door, so we've got to get a picture of it.' I just think; nice door."[4]

Looking back, it was a rather ill-phrased quote (for readers outside the UK, a 'grand' is slang for £1,000). The point I was making was that by placing some distance between the original designer and the outcome, there comes an opportunity for an *unbiased* visual appraisal of what has been achieved.

Another instance saw me walking the floor of a very high-profile project with my client, a globally renowned architect who was quite emotional about the way he felt the occupant was treating the space. In his view, a compromise had been made between concept and outcome, together with the reduction in ambition (and budget). By comparison, I only saw what had transpired: a rather fine building with decent contract quality, bespoke crafted and original detailing. Over the following year or so, the set of resulting photographs were placed with text into multiple award submissions – and duly won. The pictures were used to illustrate what was written about by journalists who delivered considered, positive appraisals. This was an example of the designer simply being too close, too involved and, quite possibly, far too tired to objectively analyse what had been accomplished.

So, a *visual review* taken from outside your walls is likely to achieve something distinctly different compared to casting your own eye across a project.

In the same way, written words from a journalist are neither your assessment of the build, nor the conclusion of your self-appointed public relations or marketing team. True journalism involves *impartial research* in order to realise a report/essay and may (in addition) also give opinion. Indeed, the hierarchy of the publication itself may even contribute to the dialogue, which is framed as such. The classic 'editor's comment' is proffered to the reader in the first-person, or

4 *Architects' Journal*, 3 November 1994, 62.

from the perspective of the journal as a full house. This is usually presented in a standalone section.

Placed together, the new team of writer and image maker will know nothing of the dynamics of your own firm and personal relationships with those you've created built environments for. No inkling of any heartaches, compromises or spats which might make their words and pictures harsh or critical.

Notwithstanding that every editorial and photograph is contextually subjective, the reader should anticipate (as much as possible) a clean page and an unbiased view, one which can give that project an entirely fresh purpose.

Large architectural practices may have the need for their own internal, but *externally facing*, PR teams. These staff don't work on actual building projects and therefore sit outside the day-to-day to-ings and fro-ings between site–contractor–client. Such in-house teams are highly beneficial to their employers, they can speak with authority, with insider knowledge, and yet still bring a degree of objectivity to affairs. Part of their skill is producing content which may be simply appropriated by a receiving party or portal ready for publication.

However, the main body of the global architectural profession is comprised of practices with more modest scales and budgets, and as such, these individuals and micro-firms will pursue direct relationships between themselves and titles/publishers.

Why do you 'need' to see your work in the press?

As ever, what one does in relation to commerce is about the bottom line. Can 'spreading the word' about a project outside the audience for which it was targeted towards, i.e.. the direct client, bring further measurable gains to your practice?

In nine out of ten cases, that answer is going to be a "yes", because enriched awareness of your folio is likely to result in a greater number of enquiries for future work. The odd thing about each industry's press, however, is that by its very nature, it is consumed by a readership on the *inside*. Your own future clients comprising homeowners/commercial businesses/cultural bodies/local government, etc., are simply not going to read an article in *Baumeister* and think, "gosh, I must engage G.Eneric Studio to design my next HQ". Indeed, they've probably never heard of *Baumeister*.

So, *why* do you and your colleagues aspire to gain coverage on these pages?

It's simple. It's for the same reason as entering professional awards which are rarely publicised outside each industry. It's about validation. And even when that validation is within the industry itself – via peer review and critique – the resulting **tear-sheets** (pages from a screen or print publication) are beneficial to the enrichment of your portfolio. Many architects' websites have a specific webpage titled 'press'. So now, that glowing review in *Baumeister* et al. *will* be on the client's radar. Such coverage assists the 'trust' building process with which you secure the next contract.

NOVEMBER 2019

How we Built Page\Park
by Net Magazine

PROJECTS

PRACTICE

THINKING

PUBLICATIONS

NEWS

CONTACT

JUNE 2020

Inside Outside
by Page\Park

Our outdoor spaces have never been more valuable. As we re-think how we behave as individuals and operate as businesses, centres of culture, learning, sport and health, our outdoor spaces give us optimism that we can still gather, and reclaim some normality. To do so relies on organisations turning themselves inside-out; casting a mould of their internal operations and culture, and bravely turning it out onto the pavement.

For some organisations, this is second nature, but others will need to take action to enhance or reinforce their external spaces, to enable people to come together. We recognise the significant shifts already happening, the temporary restrictions on cars for example, but also ask: can we push that further?

By understanding the challenges and opportunities that spring from this crisis, we aspire to support organisations transform our streets and outdoor space.

Hawkhead Centre
by RIBA Journal

Hawkhead Centre
by Urban Realm

Hawkhead Centre
by RIBA Journal

18 Critique
 Hawkhead Centre

Critique 21
Hawkhead Centre

The cost of a building is an important component in its assessment

The ceiling is the most crucial aspect of the project

◁ + △

Coverage in two magazines which featured Keith Hunter's images of Hawkhead Centre in Paisley for the Scottish War Blinded. This facility supports ex-service men and women who lost their sight during or after active military service. Designed by Page\Park, their own website has a dedicated press page which features tear-sheets from editorial articles. Hawkhead was covered by Isabelle Priest for *RIBA Journal* in April 2018[5] and also in *Urban Realm* magazine.[6]

Even in the case of considerable debate arising from a particular building, it's rare for significant 'damage' to be incurred or long lived. Most big-name architects have endured a little notoriety from time to time and yet continued to gain equal accolade and plenty of work for their studios.

We've discussed the command that editors held in years past, and how that power base has eroded as advertising revenues have fallen away (victims of the digital revolution). It takes a bold writer to openly critique a project these days compared to earlier times. Nevertheless, critique and review of this nature still occurs and, arguably, has its place.

When is now?

Certainly, the press speaks regularly about schemes which are conceptual or in planning, and you may choose to send your project submission at this point with drawings and CGIs. Consider the power of the design and the originality of the story that surrounds that project. Is there enough momentum to support interest now *and* interest after the event?

5 *RIBA Journal*, April 2018, 16.

6 *Urban Realm*, Winter 2017, 14.

Sometimes schemes which get featured are not unique, just fine examples of their genre. In these instances, it is likely that they'll only get picked up after the event. Photography is highly transformational at this time – especially if you demonstrate a building in use. 'A school' or 'a house' could be like any other of its type, and you could risk losing that coverage if you're too keen. But send it in after completion and occupation with a memorable set of images which convey excellence, and your story may get the page-count you believe it merits.

What can journalists do?

Compared to the self-penned press release, independent writers are more likely to canvass the views of others in their researching rather than simply proceeding based on I/we – a standpoint of one. This is more the trait of an in-house curated article. A journalist's version of 'I' will come from a non-partisan space, where a less biased idea may be presented.

An example would be Jay Merrick's article for the UK's *iNews* in 2019 about the re-building of Notre Dame in Paris following the devastating fire that year[7] At the time, the huge fire gained media attention on a global scale. In Merrick's editorial, as well as providing a brief contextual history of the cathedral and its notable spire, he cited multiple opinions from architects about potential competition submissions, which he'd gathered from press sources and his own enquiries. He questioned where proposed designs might come from and the quality of such submissions. He then offered his own sense of how such a commission might be awarded, advocating that the usual starchitect contenders should be placed on a level playing field via an anonymous competition process, open to all.

In another piece for *Architects' Journal*, exactly three years later, he reviewed the restoration of Glasgow's Burrell Collection.[8] The original scheme by the team of Gasson, Meunier & Andresen, subsequently delivered by Barry Gasson in 1983, was a fine design, held in high esteem by critics and the public alike. However, it was too small for the collection it housed and by today's standards, environmentally exhausting for the authority who administered it. Closed in 2016 and with £68 million spent developing John McAslan + Partners' vision, it is now able to display up to 90% of the Edwardian Shipping millionaire William Burrell's outstanding art collection.

Merrick's editorial is written first-hand. He visited the site and conducted a thorough appraisal, describing new interventions interfaced with the existing Grade A listed building with care and technical authority, but in a highly readable form. He cites consultants who worked on the project and offers a short, yet personal, conclusion on how he rated the work that had taken place. It is supplemented by an additional architect's statement, engineer's report and client view, which would have been supplied to the writer and subjected to editing where merited. It is accompanied by richly informative, perspective-controlled photographs by the notable architectural photographic team Hufton + Crow [Fig 10.1], along with landscape photographer Dylan Nardini.

7 Jay Merrick, "Notre Dame: The Battle between Architects to Design the Cathedral's New Spire is Already Causing Controversy," *iNews*, 19 April 2019, https://inews.co.uk/news/world/ notre-dame-the-battle-between-the-architects-to-design-the-cathedrals-new-spire-has-already-begun-282641.

8 Jay Merrick, "The Burrell Collection Reworked by John McAslan Architects," *Architects' Journal*, 14 April 2022, www. architectsjournal.co.uk/buildings/the-burrell-collection-reworked-by-john-mcaslan-architects.

Fig. 10.1

The overall tone of the article doesn't offer stringent criticism, but instead presents a non-biased and un-sentimental report on the work.

Another writer on the same building, Kieran Gaffney for the *RIBA Journal*, takes a tougher line, critiquing various elements such as the new central 'hub' which replaced a previous lecture-theatre. He moves on to assert that:

> *The most contentious move is the addition of a new entrance in the southeast internal corner of the plan. Numerous commentators and one of the original architects John Meunier objected to the disruption of the carefully thought-out entrance sequence: from the historic archway embedded in the southern gable to the courtyard, galleries and woods beyond. This decision was a result of consultation which read that the original entrance was unwelcoming and unclear, a view many have disputed.*
>
> *The actual experience is less fatalistic – the original entrance is still widely used (my straw poll found 60% of visitors using it) and this entry has been tidied up and decluttered with shop and main desk moved. Would this have been enough? The purpose of the second entrance is unclear, although it does help to connect the ground floor back out to the landscape and a new 'piazza'. This is perhaps a bit urban in this parkland location and only time will tell how successful it is.*[9]

9 Kieran Gaffney, "The Burrell Collection Renovation: For Better or Worse?" *RIBA Journal*, 10 May 2022, www.ribaj. com/buildings/the-burrell-collection-gallery-glasgow-john-mcaslan-and-partners.

10 Jennifer O'Donnell, "The Burrell Collection," *Architecture Today*, June–July 2022, https://architecturetoday. co.uk/burrell-collection-john-mcaslan-scotland/.

Despite his rather robust critique, he does conclude that the spirit of Gasson's original building is intact and that McAslan + Partners have created a far more accessible, not to mention sustainable, outcome for the Burrell.

A third building study by Jennifer O'Donnell appears in *Architecture Today*.[10] As a Glasgow 'local', the article is distinctly personalised, with reflections of visits past, but keeps its tone level throughout, giving a broadly open view of the contemporary interventions. Also writing from the UK, Tim Abrahams' piece for *Architectural Record* again references the prospect of the proposed modern

◁ + △

Hufton + Crow's images show the Burrell Gallery's restoration by John McAslan + Partners sensitively and faithfully. Their images transcend the boundaries of a single editorial feature, instead serving multiple narratives with different scribes.

11 Tim Abrahams, "The Burrell Collection, Glasgow," *Architectural Record*, 5 April 2022, https://digital. bnpmedia.com/ publication/?i=745418 &article_id=4259377 &view=article.

12 See www.dezeen.com/ submit-a-story/.

work attracting caution in some quarters but moves to conclude his article on a strongly affirmative note.[11]

In the face of today's reality, where full-time staff roles for journalists are few and far between, writers have to pick where they place their fights, and most building studies are unlikely to garner stringent criticism. Instead, the type of appraisals given by Merrick, O'Donnell and Abrahams still arguably carry weight and brevity when set against other forms of direct architect/PR agency generated postings on social and news platforms.

The key point here is that *all four* of these editorials are illustrated with the *same* set of images produced by Hufton + Crow (and three of the four using Nardini's as well). This clearly demonstrates that a *single* body of photographs can facilitate any number of third party editorials, as well as the usual award submissions and website needs.

Despite each magazine using the services of distinctly different scribes, the photographs travelled seamlessly across all titles, lending gravitas and validation to this auspicious collection of art.

In summary then, there's sense in allowing other parties to visit, document and review what has taken place, and if a project is significant, multiple iterations of written review may ensue, which can then be serviced by a singular set of images.

What do online architectural news sites say about buildings?

In a similar way, major global web titles such as Dezeen, DesignBoom and ArchDaily also publish editorial pieces, but by their own admission, they are less likely to be written and curated by their own teams.

Photographs and copy should be curated by designers/PR teams ahead of time. Release of materials for submission may take place at any point to suit you. It's absolutely in your best interests to make sure that what you send is (in your opinion) of the quality which you would expect to see when you browse their sites. This means proof-red, edited copy, plus drawings in a format which can be reproduced for screen, together with optimum photographs provided in jpeg form. If you consider the images to be just 'ok', then this suggests that you will stumble at the first conjecture. You need to be confident that the pictures are the best-ever that could possibly represent your project.

In the case of Dezeen they ask for text and images with copyright clearance, and they state (2022 guidelines):

> We don't have formal criteria for selecting projects but in general are looking for content that is fresh, innovative, newsworthy, has a good story behind it and fantastic images. We get tons of submissions and we can't reply to everyone, although we do try to look at everything.[12]

They affirm that:

> If we like the look of the project we'll be in touch. It may take us some time to get back to you. It's fine to send us the odd gentle reminder – we are only human and we do overlook things sometimes.

Photography is by Martine Hamilton Knight.

Here's some more information from Associated Architects:

The King's School, Worcester
Michael Baker Boathouse

Associated Architects' second ten-year Masterplan for King's Worcester included rebuilding the Boathouse, which was previously a small and unsightly 1950s building. The site is a focal point in the Masterplan, Conservation Area and in the Worcester City Council/Sustrans Worcester Riverside project. On the line of the old city defences, it is at the edge of the historic city core which has a rich history including Norman and medieval archaeology. The Masterplan proposal to create a striking modern building was welcomed by Worcester City Council planners.

△

It is worth returning to the same project by Associated Architects to discover how Dezeen tackles the issue of narrative coverage. Again, the same set of images facilitate the article (left to right), which has been complied by Amy Frearson. However, without the benefit of visiting, she is only able to add depth to image captions in order to steer the editorial and Dezeen is open about the fuller reporting as being from the architect's own hand. This is seen here in their statement which accompanied the piece.

So, Dezeen imposes some editorial gatekeeping as opposed to allowing self-publishing, however, this approach has come in for well publicised criticism in the past. The previously mentioned critic Owen Hatherley (see Chapter 1), who expressed disdain for the style of photographic imagery exposed on news sites, also added fuel to the fire in his article for *The Photographer's Gallery* back in 2012, by deriding Dezeen for not changing/editing copy received in press releases before posting.[13]

Whilst such sites might not produce a substantial amount of original content, what they do achieve is the facility to host commentary at the end of each piece. This does offer the opportunity for debate to proceed and can be a space where meaningful contributions and insight may take place on a deeper level. Indeed, Marcus Fairs himself (founder of Dezeen and sadly now deceased) had been known to wade in and offer opinion on articles which, following publication, subsequently encountered extensive dialogue.

A comment should be made here about 'risk'. Clearly there is risk every time a practice invites a third party to appraise their project, making those findings public. How might it feel to be the subject of a less-than-favourable editorial? Might a prejudicial review affect a subsequent award entry, for example? Each practice should court publicity with open eyes.

Certainly, the place and space for genuine review gets ever smaller. Following the Hatherley piece, British architect, writer and academic Douglas Murphy noted in his blog *Entschwindent & Vergeht*,

> *...it's an incredibly hard life, getting harder by the year, as the traditional media model sinks ever deeper. Dezeen have found a platform that works, that financially sustains itself, but it doesn't necessarily perform a useful role in terms of understanding, historical context or, of course, critique. Is the only way forward from here an ongoing obliteration of culture's independence from PR?*[14]

In the decade since Murphy made this point, many would say that little has changed, but in our eternal quest for new knowledge throughout our working lives which may enrich our contributions, we *should* champion opportunities for intelligent reason, insight and dialogue. I wanted to know more about curating a magazine, the differences in print and online journalism and, moreover, photography's place in this exchange. I spoke to architect, writer, television presenter and twice-editor of national architectural titles, Isabel Allen.

13 "Owen Hatherley on Photography and Modern Architecture," *The Photographers' Gallery*, 10 December 2012, accessed 21 May 2023, https://thesandpitdotorg1.wordpress.com/2012/12/10/photoarchitecture1/.

14 Douglas Murphy, "Owen, Dezeeen, Photography, Criticism and its Decline, etc etc," *Enschwindet & Vergeht* (blogpost), 17 December 2012, http://youyouidiot.blogspot.com.

ISABEL ALLEN
ARCHITECTURE TODAY

The youngest ever editor of the UK's *Architects' Journal*, 1999–2007, and co-founder and editorial director of BEAM (Built Environment & Architecture Media), Isabel is also at the helm of *Architecture Today* (hereafter *AT*), which like many traditional magazine titles, now operates as both an online and print edition.

I asked firstly how the team selects which projects will be featured. The answer was interesting and made me realise that as much as it is a mixture of news and technological developments, choices for editorial content are also driven by the individual interests of those curating features. Isabel elaborated:

> **The key thing is to focus on the readers, not the people promoting their content, so at one level you're always second guessing what the readership will want to see. That said, if you didn't let your personal taste and judgement come into it at all, you would end up with a pretty anodyne magazine – I think the best magazines say something about the interests and tastes of the team that puts them together.**[15]

The stimulus for this is very much down to the listening ear that an editorial team brings to things. Isabel and her colleagues are often guests at awards dinners, product launches, project openings and industry conferences. Here, they're in active conversation with architects and thus are constantly immersed in opportunities to pick up stories. With submissions themselves, they come from:

> **… all sorts of people all of the time, and I'm ashamed to say there are far too many emails that never get read. I'll always pay attention when I get an approach from an architect: partly because you know they'll know what they're talking about when they're trying to pitch their project, but also because they're a reader as well as a possible subject/contributor, so I'm always going to be interested in how they tick and what they have to say.**
>
> **There are some really good PRs, and some of them have become personal friends. They're a great source of content, but the ones that are most effective are the ones that exercise a serious edit on what they send through. If a PR routinely sends projects, or pitches for stories that are way off the mark, I'll pretty soon stop listening to what they have to say. Quality over quantity is key.**

This is not so very different to honing reader-appeal in a practice's own social media broadcasting, something we discussed elsewhere. Isabel is expressing that creators should understand that not everything they make is going to translate

15 Isabel Allen, interview with author, 3 October 2022.

well or connect to an audience. It needs to be well-judged, well-constructed and pitched in a concise and appropriate way, or face fairly rapid rejection. Indeed, the percentage of material that is placed in front of AT that never makes it to their web portal, never mind the print edition, is very high:

> **Maybe 80–90 percent? Maybe more. There are so many PR companies pushing content out in a pretty scattergun way. And it's much easier for them to send stories to everyone on their contact list than to pick and choose. So we get an awful lot of white noise. It's a shame, as it inevitably means that a lot of the really good stuff gets missed.**

This is quite disheartening, but given the number of annual project completions in a healthy economy each year, it is also quite understandable. There is simply not enough space for voices to be heard, whatever the portal. Offering exclusivity is one approach worth considering – every journalist likes a scoop, let's face it. Some projects are too good to miss as well, as seen earlier in this chapter, and Isabel comments further at this juncture:

> **Nobody wants to bore their readers. We all want to be fresh. That said, there are some projects that you accept are SOOOO important that everybody's going to cover it and have their different take. And occasionally you take the view that another publication's coverage has been so lacklustre that it doesn't really count! There may be a completely different angle such as a specific technical aspect. Or you might choose to wait until you can make an informed assessment about how the building has survived its first year, or years, of use.**

> **If you can offer a genuinely different perspective, and if the project is sufficiently nuanced and engaging for the reader to be bothered to read a range of perspectives, it might not matter at all. But realistically, these projects are few and far between.**

AT's original journalistic content is driven by their in-house writers and also by practicing architects whose voices they are keen to have contribute and give their view. However, this makes international projects trickier to cover effectively from a logistical perspective. A consideration, too, for any national title (as opposed to one whose readership straddles multiple borders) is that owing to the complexity of subject matter, there are significant technical variables that could become hurdles to understanding and relevance for the audience.

> **An international building, however interesting or exciting, is going to be somewhat compromised in that respect. It's likely to have been designed in a different cultural and regulatory framework; its detailing will respond to different climatic conditions; it may use products or components that aren't available here. Plus, there are practical and cost challenges in sending somebody to write a proper first-hand review. That said, we like to throw in the odd surprise, and every so often we find a reason to throw an international building into the mix. Sometimes it's because it has a special resonance for UK readers – so it might be by a British architect or for a British client. Sometimes it's just too good to pass by.**

The Lyth Building

Evans Vettori has designed a student hub and Environment Centre for Nottingham Trent University's Brackenhurst Campus. Sue and Mark Emms deliver their verdict on a project that acts as a new focal point for the campus and reflects a belief that learning and landscape should go hand in hand

Photographs by Martine Hamilton Knight

Content choice of what makes it to print and what stays online can be driven by multiple factors. With only six print issues annually now, much for *AT* remains consumed by screen, and discerning where the line falls on this can ...

... depend on the extent to which we have control over the project. If we know it's been pushed out to multiple publications we'll get it up online quickly, so that we're not churning out stuff that everybody's seen. On the whole, we'll only save something up for print if we have a clear understanding that it's not going to appear elsewhere until it's been in the magazine. There's also something about the complexity and nature of the project. Some buildings are good 'one-liners', great for social media and online. Others demand a more considered, curated approach. If we want to tell a story, visually as well as verbally, we're more likely to opt for print.

△ + ▷
Top and bottom: This is The Lyth Building at Nottingham Trent University's rural Brackenhurst campus by Evans Vettori Architects which featured in one of the printed editions.[16] Unusual in being a double-handed review by Sue and Mark Emms, both practitioners and academics, the building study is calm, measured and generous in equal measure.

AT has staff who've got measurable experience in online architectural journalism with the big global dailies, and Isabel asserts that having both their own print *and* online magazine allows them to treat content in different ways. She knows that the audiences respond well to certain topics online but that other story types work better on the printed page.

> **As mentioned earlier, there are some projects that do well online and on social media and not so well in print. Mostly it's to do with the way people use it. A quick 'money shot' works well in this format. There's also a lot more crossover in terms of professional and consumer press, so small-but-gorgeous extensions that aren't hugely significant in terms of architectural discourse but are likely to capture the interest of every design-savvy home-owner or wannabe home-owner work well online but wouldn't make it to the mag.**
>
> **Similarly, a blockbuster international scheme that is really eye-catching might make a great social media story, but we'd probably leave it there. So oddly, it often ends up that it's the bijou or the mega-projects that are the big successes online. Projects like schools and social housing, that are hugely important but maybe more interesting to a professional audience, will often make great magazine articles but work less well online.**

Having ascertained the framework for material selection, I was keen to drill down into the importance of images for the print and online editions. It's immediately clear that anyone sending material recognises the need for this, and almost all

16 *Architecture Today*, January and February 2022, 34.

enquiries come with photographs. As for whether they're actually fit for purpose, Isabel feels that as much as 50% of what she sees simply doesn't work, and that giving an architect a camera doesn't mean they become a photographer.

The days of magazines having budgets for images is long over, and sadly, a decent building, supported by poor imagery, can lead to rejection:

> **We don't have the budget to commission new photographs ourselves. That said, there have been numerous instances when we've said we like the building but the photography's not up to scratch. Then it's up to the architect if they decided to shoot the project again ... I can't speak for non-UK publications, but don't know of a single British publication that has any budget for photography at all.**

In the face of this, the team finds itself making recommendations to architects about 'how' or 'where' to source decent image makers, and from her perspective it doesn't stand up if a PR consultant or architect tries to excuse the project by saying, "... 'photographs really don't do this project justice'. If it doesn't work in photos, it doesn't work in print."

She also has some sound advice for those who think they'd like to suggest their project to the magazine, saying:

> **Don't write or commission your own critique! Just give us the facts – a clear pithy summary outlining what it is, and any particular points of interest. But the photographs will sell it. (Or not). Plus it's important to include site plans, plans and sections.**

And finally, on how she sees *AT*'s place, in comparison to the large multi-national online journals such as DesignBoom:

> **We're a much smaller operation serving a much more clearly defined community. We're not trying to reach out to a wider design-literate audience. For us, it's about providing the architectural community and the wider construction industry with information they need to help them to do their job well. Hence, I think we'll always be a carefully curated, highly focused source of inspiration and information tailored for a very specific and highly informed audience.**

It's a fair appraisal of *AT*'s seat at the architectural table. They're in keeping with other important titles which serve their distinct professional communities and have comparisons in magazine titles across the globe, servicing the interests of their respective domestic markets. To paraphrase Lord Reith from 1922 (first Director-General of the BBC – British Broadcasting Corporation), they keep their readership informed, educated ... sometimes entertained, and provide enormous value to a busy professional.

After all, you don't know what you don't know. It's Isabel's job to facilitate and enhance your subject-specific knowledge.

Newspaper journalism

Mainstream national daily broadsheets play a double-edged role in disseminating architecture, playing hardline news against softer editorials for their weekend supplements. Architecture rarely gets a major billing unless, of course, something has gone awry. Then, the spotlight falls for the wrong reasons. We all recall the case of the devastating London Grenfell Tower fire of 2017 when 72 people died, or the Champlain Towers South collapse in Surfside, Miami killing 98 sleeping residents in 2021. Acres of newsprint are then dedicated to the painful process of evaluating what, how and why such events took place, and justifiably so of course.

Newspapers also cover the annual gongs. In the UK, there will always be several column inches given over to the Stirling Prize shortlist and eventual winner. These may ripple out into further articles about either the respective practice or genre of building that the winner epitomised in a given year. Awards are massively validating in the press, and winners may continue to attract attention long after the initial plaudit is presented, helping them maintain a space in the public-eye. In *Ch. 12 Awards: Everyone's a winner*, we'll see how a ground-breaking building for its time still gains plenty of traction, including a front-page article in a national broadsheet, well over a decade after completion.

For traditional news groups, there's still sometimes a difference in what goes to print and what stays online, but one may still expect journalists to write for *both* outlets. The online channels do not simply become a haven for PR statements and self-penned reviews.

▽

Daniel Hopkinson's image of The Oglesby Centre at Halle St. Peter's, Manchester, by Stephenson Hamilton Risley Studio was given coverage by Katy Gillett in Abu Dhabi's *National News* in September 2021. It had just won a RIBA National Award and was therefore also the recipient of international press reporting.

Summary

Whilst print media circulations may be down these days in terms of news-stand revenues, the perceived value of the printed page is still high, and there is a healthy appetite expressed in the *quantity* of submissions received for consideration by the traditional architectural press. There is kudos in gaining print coverage. I witness a frisson of excitement from any practice broadcasting that they've scooped coverage in a daily broadsheet or monthly journal.

How one gets there – either directly, as we've concentrated on here, or via the services of a PR agency – is your call. From a photographer's point of view, a PR agency may feel like a barrier to direct communication between architects and the people speaking about the work. From an architect's perspective, perhaps they are a welcome buffer. You must decide for yourself if you wish to work independently with no broker involved, or whether leg work and gatekeeping by an appointed party is money well spent.

Nevertheless, what is important to appreciate is that with the media outlets, there are three distinct tiers to this form of communication:

1. Traditional *journalist-led* media outlets
2. A middle-ground, filled by the likes of Dezeen, DesignBoom, ArchDaily and e-architect. On these sites, there is plentiful appetite for the consumption of written copy, together with plenty of images and reader feedback
3. Finally, *self-service platforms.* These are the social media sites (Instagram, LinkedIn, Twitter et al.).

Common to *all* the mediums explored here is the opportunity for exposure, and most powerfully, perhaps, individual voices are often married to the *same* key visuals.

CHAPTER 10
TAKE-OUTS

▶ Unlike generating content in-house, expect a journalist to bring a fresh approach to the story of your project.

▶ A journalist will take a wide view on the context and background to a build – they will assume their readership has little or no prior knowledge of a new project and use their skill to set the tone for the ensuing review.

▶ Understand that as well as them canvassing your views, they may seek opinion from a number of third party sources.

▶ They will form views of their own and may express them.

▶ Be aware that there is a potential for your published project to backfire and affect your professional reputation if the journalistic review is very critical.

▶ Most titles like to be offered an exclusive scoop, but on occasion a number of publications will cover the same story.

▶ A top-notch set of photographs may travel with many voices, and today owing to budget constraints, these are likely to have been generated independently of the written coverage.

▶ Be mindful of submission criteria – every online portal and print publication will have guidelines and not following them faces instant rejection.

▶ When it comes to choosing images to accompany a submission, use the very best you can create or commission. Reading your written submission in detail is likely to hang on the power of your visual voice.

▶ Be discerning in what you submit. Choose your voice carefully. What gets featured is a mixture of timeliness, relevance and to some extent, personal interest. You are dealing with humans, not machine algorithms.

▶ Remember that there is importance in adding drawings, site plans and sections. You might be introducing a scheme at the beginning of the process, but if you do, make sure there is something about it which propels it into the spotlight. Otherwise, consider waiting until afterwards to demonstrate why your project is an example of excellence.

▶ Be aware of the differences between self-penned broadcasting, online news services and those titles which might use digital publishing in addition to print media and are, foremost, journalist-led productions.

▶ Finally, if you get published by one of the big titles for the right reasons, enjoy it and maximise the time in the spotlight for your business.

Chapter 11

▷ SOCIAL MEDIA

Disseminating your brand online

"On the internet, nobody knows you're a dog" was a one liner accompanying Peter Steiner's 1993 cartoon in *The New Yorker* magazine.[1] This witty caption under a pen and ink drawing showing two dogs, one with his paw on the computer keyboard, is one which, three decades after its publication, is probably just as relevant now as it was then.

At the time, the web's power was in the hands of a few producers – a 24/7 body of information coming at its audience, who were largely passive recipients.[2] Just *who* one was watching and listening to was, as the cartoon implied, debatable. Content creators could sit behind smoke screens, their identities masked.

Web 2.0 (first used in 2004) facilitated an active, vibrant social traffic comprising millions of independent voices. This became known as **social media**, with individual users subscribing to platforms which allowed them to broadcast for an invited audience, whilst at the same time growing one they didn't personally know at all. Whilst early intentions to foster community building were perhaps sincere – individuals talking to one another, educating and sharing information – it also became a vessel of mass self-centralism and in some cases the same anonymity, giving rise to trolling and other nefarious behaviours.

Timekeepers Square in Salford by Buttress Architects was photographed by Daniel Hopkinson and shared both on his Instagram site and that of the architects.

Dan's post references his client with an @ and hashtag # (followed by the relevant keywords) relating to the location, time and place. Buttress Architects follow suit and also use the @ to flag the scheme up for a conference taking place which features the development as an exemplar for new housing.

No matter how small or large your practice and your following, communicate with the audience you know *and* the one you seek by using social media.

1 *The New Yorker*, 5 July 1993, Vol.69 (LXIX), no. 2, 61.

2 For a brief history of the internet, see www.usg.edu/galileo/skills/unit07/ internet07_02.phtml.

Another analogy, this time from one of the founders of LinkedIn, Reid Hoffman, likened social media platforms to the Seven Deadly Sins.[3] This morphed into a meme which gained enormous traction and wry as it was in 2011, despite a change in some of the big names today, it is still very on-point [Fig 11.1].

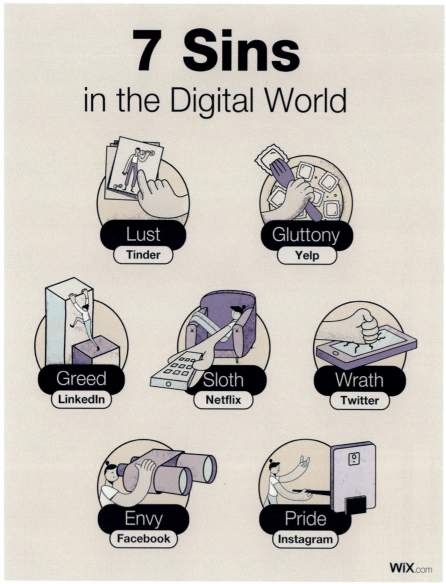

Fig. 11.1

As an architectural community, we might have treated platforms like Twitter as our local news desk in the past, but our relationship with social media often sits in a strange hybrid place. We're neither afraid of it nor terribly comfortable with it.

In the main, the digital revolution itself has shifted the way in which we communicate with each other by exchanging one familiar form of information-transfer (a one-way traffic of broadcasting via TV, radio, newsprint) to a different medium. In essence, the messages these new media carry are largely the same. The Swedish sociologist Simon Lindgren expresses it well, speaking of how one's contemporary digital actions still have their roots in analogue form:

3 Reid Hoffman's original views were expressed in 2011 in Pascal-Emmanuel Gobry, "LinkedIn Founder: Embrace The Seven Deadly Sins," *Insider*, 26 June 2011, www.businessinsider.com/linkedin-founder-embrace-the-seaven-deadly-sins-2011-6?r=US&IR=T, and the meme followed thereafter. Image courtesy of ©Wix, illustrated by Ira Sholk.

- Television → video streaming
- Books → eBooks
- LPs, CDs, radio → music streaming/podcasts
- Community → online community
- Encyclopedia → Wikipedia
- Activism → digital activism[4]

He recognises that these transformative communications are ones which couldn't exist without digital media. Disruptive business models such as Uber and Airbnb need viral speed *and* the communicative devices which they utilise for their success.[5]

In architecture, we're not really seeing a revolution in means of carrying the message ... yet. The language and intention of how we communicate is still the same, just faster and, unlike traditional broadcasting, two-way. Now the audience can speak back to us if they choose.

Who are *you* online?

Hosting a website is straightforward. To function effectively for you, it should be well designed, have great images (of course!), stay informed and be regularly updated so that it is your 24/7 ambassador. An architectural friend described the process of curation as 'formal and measured'. Social media is rather a different venture. This outlet is far livelier. It can be friendly yet advisory or it can shout and bully. It can entertain, but also bore. For every positive adjective, there is a negative to oppose it.

In order to get to a point where image making advice can be given for social media, we should explore how our profession broadly operates with this technology.

Where do you see yourself personally? Whether you are a passive listener or vocal lobbyist of the architectural world is up to you. It may relate to a mixture of one's age and also the size or organisation one works with. Digital natives, Gen Z, use platforms as fluidly as their mother tongue, often seemingly happier to converse via a keyboard than face-to-face. By comparison, the 40+ somethings who frequently sit at the head of businesses are far happier to pass the buck (and, where merited, the blame).

Designer Adam Nathaniel Furman's essay, 'The Social Media Monster: Dangers and Thrills Only Partially Glimpsed', poses that:

> *...the profession seems to view social media as, more or less, either a funny thing hipsters use to share images of their avocado-toast or simply as a free form of traditional advertising. Almost uniformly, architects seem to miss both its danger and its excitement, regressing to comfortable formats of magazines and journals – back, that is, to a near-luddite fetishisation of the printed object, and in doing so, eschewing creative or critical engagement with the very technologies that are creating and accelerating the ruptures in the world around them.[6]*

4 See Simon Lindgren, *Digital Media and Society* (London: Sage Publications Ltd., 2017) for an interesting examination of Visual Literacy.

5 Disruptive business models are those which bring innovation or technology into an already established marketplace.

6 Adam Nathaniel Furman, "The Social Media Monster: Dangers and Thrills Only Partially Glimpsed," in *The Identity of the Architect: Culture & Communication* (Architectural Digest) ed. Laura Iloniemi (John Wiley & Sons, 2019), 80.

A damning view of architecture's general relationship with social media perhaps, but also a point well made. This book you're reading now explores the virtues of the printed legacy form which Furman speaks of. I'm personally happy to acknowledge that in engaging with online platforms myself in the past, I've been unwilling to broadcast professional moments for danger of overt 'showing off' or 'humble-bragging'. This is a very real fear on behalf of micro-practices and sole traders, no less because one may see one's time comprehensively needing to be 'on the tools', and that social media activity does not constitute billable hours.

Furman continues by expressing disdain for dominant broadcasters such as Dezeen and self-congratulatory posts by high-profile practices who depict themselves at industry gatherings; 'simply thrilled to meet ...' or who 'can't wait to reveal ...' the latest project to their followers. He argues instead for a type of 'metaverse' where genuine discourse may take place and cites a choice few creative content generators who, in his opinion, lead the way in genuine critical architectural debate online.

This view is laudable, altruistic, but possibly not attainable when levied against most day-to-day needs of commercial enterprise. So, deciding where you personally sit, and then working to that end, is the name of the game.

Given that this book centres on photography, we shall limit discussion about the power of the hashtag and written word to make posts travel efficiently. This is because we are focusing on establishing sound working practice for *images* on social media.

No such thing as free: the contractual reality

Online, we develop personas. We speak in the first-person, or in the third-person – as the voice of the 'business', making regular (or irregular) bulletins about our work across a choice of online platforms. Some of us blog, situating ourselves as figurehead for our audience, a curated traffic of self-generated content. We invite commentary and review, gatekeeping what returns to us. This position can be very helpful to our brand but takes concerted time and effort to master and maintain.

More of us, however, simply sign up to a number of free social media accounts, generating short-form content. This is better placed to gain 'likes' and 'shares' from recipients if we illustrate our words with visual representations in one way or another.

Unfortunately, in this world, there are always strings attached, and whilst many of us wittingly sign up for these 'free' opportunities to broadcast our work, we may only be dimly aware of the exchange we are making each time we press 'publish' and 'share'.

This commitment relates to our intellectual property and **licensing** (the use of our work by third parties), a topic which takes centre-stage in Part IV of this book. It is a must-read section for any creative designer or producer. It assists you in understanding the terms of a contract with these behemoth social platforms, and what this permits them to do with your intellectual property. In *Photography for Architects*, my position is to advocate protection of your intellectual property as

▷
There are multiple social media platforms which favour the uploading of images but currently, none is more powerful than Instagram for pictures. Hootsuite's 2022 Digital Global Overview identifies that 61.6% of Instagram's users are between 18–34 and moreover that search engines are (or close to being) outranked by social media for online brand research for 16–44-year-olds.[7]

7 "2022 Digital Trends Report," *Hootsuite*, accessed 21 May 2023, www.hootsuite. com/en-gb/resources/digital-trends.

much as you possibly can whilst allowing the visibility of your folio to be where you need it – out there, working for your business 24/7.

The rights you are granting social media platforms are alarmingly all-encompassing. We shall use Instagram as a basis for examination, and under the curation of Meta (Instagram and Facebook), it is a sensible platform to speak about. Photographic images have been central to its consumption.

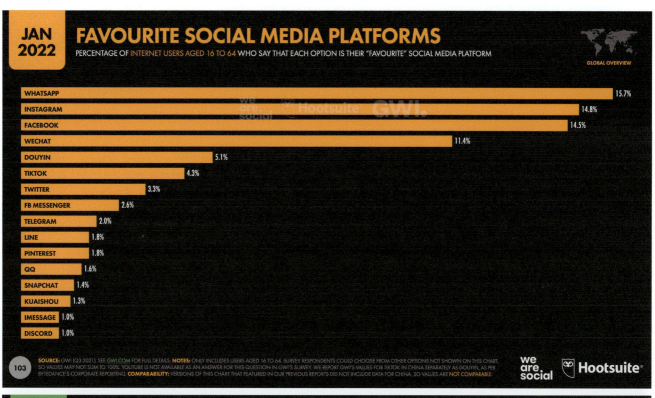

JAN 2022

FAVOURITE SOCIAL MEDIA PLATFORMS
PERCENTAGE OF INTERNET USERS AGED 16 TO 64 WHO SAY THAT EACH OPTION IS THEIR "FAVOURITE" SOCIAL MEDIA PLATFORM

GLOBAL OVERVIEW

Platform	%
WHATSAPP	15.7%
INSTAGRAM	14.8%
FACEBOOK	14.5%
WECHAT	11.4%
DOUYIN	5.1%
TIKTOK	4.3%
TWITTER	3.3%
FB MESSENGER	2.6%
TELEGRAM	2.0%
LINE	1.8%
PINTEREST	1.8%
QQ	1.6%
SNAPCHAT	1.4%
KUAISHOU	1.3%
IMESSAGE	1.0%
DISCORD	1.0%

103 **SOURCE:** GWI (Q3 2021), SEE GWI.COM FOR FULL DETAILS. **NOTES:** ONLY INCLUDES USERS AGED 16 TO 64. SURVEY RESPONDENTS COULD CHOOSE FROM OTHER OPTIONS NOT SHOWN ON THIS CHART, SO VALUES MAY NOT SUM TO 100%. YOUTUBE IS NOT AVAILABLE AS AN ANSWER FOR THIS QUESTION IN GWI'S SURVEY. WE REPORT GWI'S VALUES FOR TIKTOK IN CHINA SEPARATELY AS DOUYIN, AS PER BYTEDANCE'S CORPORATE REPORTING. **COMPARABILITY:** VERSIONS OF THIS CHART THAT FEATURED IN OUR PREVIOUS REPORTS DID NOT INCLUDE DATA FOR CHINA, SO VALUES ARE NOT COMPARABLE.

we are social Hootsuite®

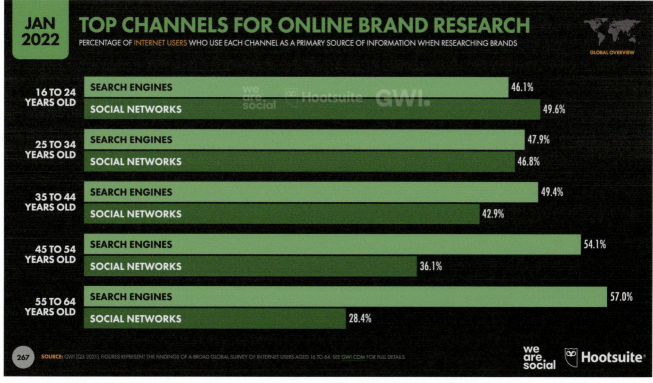

JAN 2022

TOP CHANNELS FOR ONLINE BRAND RESEARCH
PERCENTAGE OF INTERNET USERS WHO USE EACH CHANNEL AS A PRIMARY SOURCE OF INFORMATION WHEN RESEARCHING BRANDS

GLOBAL OVERVIEW

Age	Channel	%
16 TO 24 YEARS OLD	SEARCH ENGINES	46.1%
	SOCIAL NETWORKS	49.6%
25 TO 34 YEARS OLD	SEARCH ENGINES	47.9%
	SOCIAL NETWORKS	46.8%
35 TO 44 YEARS OLD	SEARCH ENGINES	49.4%
	SOCIAL NETWORKS	42.9%
45 TO 54 YEARS OLD	SEARCH ENGINES	54.1%
	SOCIAL NETWORKS	36.1%
55 TO 64 YEARS OLD	SEARCH ENGINES	57.0%
	SOCIAL NETWORKS	28.4%

267 **SOURCE:** GWI (Q3 2021). FIGURES REPRESENT THE FINDINGS OF A BROAD GLOBAL SURVEY OF INTERNET USERS AGED 16 TO 64. SEE GWI.COM FOR FULL DETAILS.

we are social Hootsuite®

Reading through Instagram's *Terms of Use*, we should pay attention to the following:

> ***We do not claim ownership of your content, but you grant us a licence to use it.*** *Nothing is changing about your rights in your content. We do not claim ownership of your content that you post on or through the Service and you are free to share your content with anyone else, wherever you choose. However, we need certain legal permissions from you (known as a 'licence') to provide the Service. When you share, post or upload content that is covered by intellectual property rights (such as photos or videos) on or in connection with our Service, you hereby grant to us a non-exclusive, royalty-free, transferable, sub-licensable, worldwide licence to host, use, distribute, modify, run, copy, publicly perform or display, translate and create derivative works of your content (consistent with your privacy and application settings). This licence will end when your content is deleted from our systems. You can delete content individually or all at once by deleting your account. ...*[8]

Instagram goes on to explain that once your contract has terminated with them, anything they've done with your work, and whoever else they've passed it to, is out there. You and they can take down material from Instagram itself, but it cannot be recalled, and they are not responsible for what data has travelled elsewhere. You're fully legally liable for anything you've shared with them. Your agreement when opening an account indemnifies them against any infringement suits brought to their door as a result of your original posts.

Instagram is not alone in its stance. Your permission for Instagram to work with your content as it chooses is broadly in keeping with other platforms: Twitter, LinkedIn, Pinterest, TikTok, Reddit ... really whatever the key portal of the day in terms of business and personal online communication happens to be.[9]

So, what does this mean for photographs?

Savvy creative practitioners know of the power of Instagram and harness it to their needs whilst being fully conversant with the terms. Venturi, Scott Brown's image maker of choice, Stephen Shore, has described it as creating opportunities which hadn't previously existed. He and others accept that there is an exchange of information and a passing of that licence to hosts in doing so. Shore's Instagram account has 220,000 followers (as of summer 2023), many of whom will be students of photography as he is a practitioner widely studied at university level. However, he is a good example of an artist who accepts the licensing implications for social media account holders.

Plenty of creatives actively use portals such as Instagram to solicit commissions and the market also knows to go and seek professional creative services via their pages too.[10] Certainly professional architectural photographers pick up commissions through exposure on Instagram and prolific shooters such as Ema Peter in Vancouver merit 59,000 followers whilst Hufton and Crow have 42,000. The German photographer Sebastian Weiss uses the name 'le-blanc' online and has 241,000 followers, with average posts picking up 'likes' into the thousands. Dezeen offers suggestions on which photographers to follow and whilst many 'fans' are likely to be students and dedicated photography enthusiasts, no doubt a good chunk are architectural practice employees and directors themselves.

This image supplied by Dima Yarovinsky-Yahel shows his 2018 artwork entitled *I Agree*. Exhibited as part of his infographics course at Bezalel Academy for Art and Design in Jerusalem, it reveals the terms and conditions which users commit to when opening an account with social media platforms. The pink roll represents Instagram. It runs to some 17,161 words and according to Yarovinsky-Yahel would take 86 minutes to read.

8 From Terms of Use, see Instagram Help Centre: https://help.instagram.com/581066165581870. Bold text is their own.

9 Licence terms you grant to social platforms: www.linkedin.com/legal/user-agreement#rights; https://policy.pinterest.com/en-gb/terms-of-service; https://twitter.com/en/tos; www.reddit.com/wiki/useragreement/#wiki_your_content; www.tiktok.com/legal/terms-of-service-eea?lang=en.

10 It's difficult to keep up with follower numbers on social media accounts when they are so fluid. The accounts described here were accessed mid-2023 but clearly are subject to change, mostly ever-growing, and are only used here by way of illustrating the points under discussion.

Weiss' image making style is distinctive and falls outside of the norms of commercial architectural photography practice. Instead, he meets an art-market with his graphic interpretations of building details which translate perfectly into eye-catching thumbnails for the web. This is not to belittle his folio as the work is stunning and this is someone who inherently understands the power of Instagram to benefit his marketplace. An architectural practice whose folio works in a similar way, translating into graphically led thumbnails with ease, is Zaha Hadid Architects (ZHA on Instagram) with 1.4m followers.

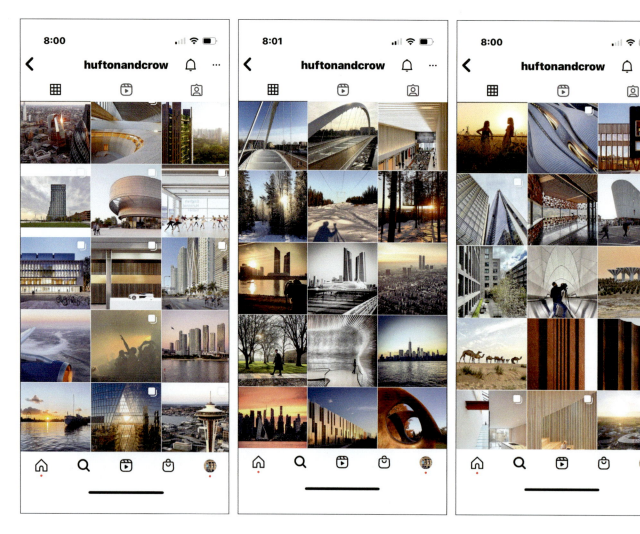

The architect and avid image maker John Pawson has 442,000 followers, and interestingly he is followed by other noted photographers including Ema Peter herself. On Pawson's account, as a keen image maker, he simply shoots what he loves rather than specifically marketing his professional work. Like Stephen Shore, he sees his images curated into physical exhibitions which are shown in art galleries internationally. Pawson's spring 2022 'Looking for Light' show was the opening event at Bastian Gallery in Berlin, a building designed by his own practice and featuring images taken at Pawson's home in Oxfordshire, UK.

△
Hufton and Crow's Instagram account is carefully curated, as the viewer scrolls their gallery, colours and shapes harmonise and complement one another. This is no accident; designers of online materials know that browsers are more akin to sharing and liking if they see panels of images with complementary colours/shapes.

The vast majority of architects and architectural firms, however, use Instagram as a means of widening visibility for their professional portfolio. Practices interviewed in this book such as KieranTimberlake are followed by Grimshaw, which itself is followed in turn by the likes of Dezeen and industry press such as *Architects' Journal* too. Indeed, the more you criss-cross the names, the more you spot the interconnectedness of each user and their respective accounts, all broadcasting to one another, and absolutely in line with the ambitions of a 'social network'.

Photographic manners: technical niceties

A sensible personal limitation to social media overlords such as Instagram is in taking care with the physical size of file that you submit to them in the first place. By controlling the dpi-count of the image you upload, you're still granting them the licence rights over that material, but you're making the offer less appealing to both the platform and potential infringers. If a file is 600x400px @72dpi it will load instantly and look good on a phone, but be of limited value to anyone wanting to reproduce it in any other form.

Beware of shooting images directly with your phone, however, and then immediately publishing them if you value them as entities. Today's smartphones create image files capable of print quality up to A3 in size and are therefore highly reproducible. It makes sense to take your photographs first into an intermediary app or through your desktop postproduction software to duplicate them. Retain a full size original and make a second, low-kilobyte copy which you then move into your social media accounts for publication.

This control will hopefully bring anyone genuinely wanting to utilise the asset back to your own door, whereupon meaningful negotiations for its onward use may begin. That's assuming a potential user is able to reach you. Sadly many social sites *strip* the **metadata** (identifying text-based information which travels with your picture in an attached sidecar **XMP file**).[11]

They blame the need for this on needing to moderate band-width, but it is bad manners, and illegal in Germany.[12] It is, however, very widespread with Flickr being a notable exception. Files uploaded to sites where this takes place become readily anonymous once removed from the context of their original post. This is at odds with digital photographs embedded into **Wordpress** websites, which can retain their associated file information. Metadata retention stays helpful to Google in placing and ranking the content correctly, as well as for rights owners. We delve deeper into site rankings and the importance of metadata in Part IV of the book.

If you are an architectural practice that wants your visual work to always be attributed to you, posting it on social media will *not* always promote that cause. One of the most problematic sites for creating non-indexed images is Pinterest. This is because the very nature of interfacing with this programme is about gathering influences from elsewhere and making notice boards or mood boards with the collections one gathers. The disassociation of source identity between the point of creation to final use readily produces what's known as **orphans**. We speak more about these in Part IV of *Photography for Architects* and why there is

11 For more about metadata, its importance and the embedded file data that digital images carry with them, see www.iptc. org/std/photometadata/documentation/userguide/

12 See https://freelens.com/politik-medien/like/, an article regarding a 2016 legal challenge by German photographer Rainer Steußloff vs Facebook for stripping EXIF data in his work on the platform.

a huge problem on the web with 'lost' files. The onus is on the gatherer to name the source and if one doesn't attribute, the image just becomes an anonymous picture. Be aware.

Another aspect of loading images to the web is to be mindful of the **colour space** which your image file is created in. Richly toned, high-quality print resolution photographs may commonly be prepared in **Adobe RGB**, **ProPhoto** or other wide gamut files, allowing for sumptuous art-prints and reprographic works to be generated from them.[13] In anticipation of such outputs, your photographic suppliers may well give you these files to work with.

The web can only reproduce restricted colours and cannot interpret Adobe RGB (and other photographic) colour space files accurately, leading to muted and under exposed looking renditions online. You should ask that suppliers give you **sRGB** 72dpi files that are highly compressed and in small file sizes. This will keep online versions fast-loading and with vibrant colouration.

An approach for storytelling with your photographs

So, having got the image size sorted, what should one actually post and how often? That's the hard part.

Designer Kat Irannejad wrote of content formation;

Don't overthink, don't make it precious – just post. Multiple times a week – post new work, old work, sketches, process/timelapses, behind the scenes, inspiration, case studies, thinking out loud doodles – it's all 100% good. Consistency is key. There are always new eyes looking, new followers who haven't seen the work – and even if they have, sometimes a reminder is a good thing. Even in retagging clients/brands/agencies – it reminds them of the work and perhaps that will lead to new assignments down the line.[14]

Keeping one's social feed 'fed', however, is a significant demand on time, and making space each day, every two days, once a week, or whatever one senses the level should be, is difficult. Finding new content to meet that demand, especially in the case of a small practice, or an individual running a business (myself included here), is nigh on impossible.

Moreover, constantly making new photographs to accompany your posts will incur time and cost, travelling to different locations to make new images with regularity. Even for large practices, such an outlay is just not economically sensible.

Whilst interviewing Alex Coppock from Communion Architects in Chapter 2's case study, a remark was shared with me that even notable social feeds such as those produced by Zaha Hadid (who Communion subscribed to) saw the same pictures being re-circulated, implying that the need for posting regular, fresh visual content cannot always be kept pace with and that the secret to audience retention might be varying the way one is saying it.

Communion's own approach to posting was to accept that the same single image or various photographs from the same project might be galvanised in the same, or more than one, conversation across different platforms. This could be

13 The spectrum of visible colours varies between screen and print outputs. How files are handled and what range of colours and tones are visible to the viewer relates to the type of colour space they are rendered in and handled by as well as what type of device they're seen through.

14 Kat Irannejad, "Instagram Has Changed the Portfolio Rules – An Illustration on How to Optimise Your Profile," *D&AD*, www.dandad.org/en/d-ad-instagram-changed-portfolio-rules-features-opinions/.

in the context of a case study about that particular building, an editorial about restoration or the use of specific materials, or a vernacular building type in a geographic area, for example [Figs 11.2, 11.3, 11.4]. From the perspective of a small business, Alex was emphatic that *re-use* of good photography was not an issue, indeed having those pictures 'working' for one's business in multiple endeavours made value of that particular investment. To only circulate something once was illogical.

Figs 11.2–11.4

Grimshaw's view on social media is to be sure that all of its content addresses a client need, challenge or interest. Moreover, it actively collaborates with clients and fellow consultants on the promotion of those external communications. It creates more traction for posts if Grimshaw and its partners co-broadcast their research, innovation and projects across a number of platforms. Together, they may promote consistent messaging for their audience and use a unified visual voice to strengthen it.

Reinforcing Grimshaw's brand by enriching what it posts in short-form via social channels is done through additional media content. This directs viewers out of third party platforms back to its self-hosted films, podcasts and in-house journal. This is a clever strategy as it can bring an audience 'inside the brand' through the door of social posting, and then educate via a more robust means.

Bounce rates (pages that are landed on by searchers who don't find what they want and promptly leave the site again) are lessened. Attention spans are longer than those garnered in the usual swipe-action browsing that takes place on social media.

Hashtags on all socials, whatever platform one is uploading to, are needed to move the post further afield than your own personal connections. Owing to the dominance of paid-for content across sites, organic (non-paid) content can expect fractional circulation compared to several years ago. Whatever message a firm wishes to deliver and however limited the audience in real-terms, the bait for posts can be broadly dangled via visual methods – and that means making memorable photographs or films.

The psychology of 'catching fish' - i.e. getting someone to pause at your social post when they're casually browsing - is where the images and headline text need to be at their most powerful. You need this to happen, alongside familiarity with your name in written form. Your company name is an immediate headline grabber for an audience who already knows of you.

When you look at a picture you often notice elements in the following order:

1. A face (and/or human figure)
2. Text or symbols/logos
3. The brightest part of the frame
4. The most vivid colour
5. The element most in focus

These are criteria that will assist in getting someone to break their scrolling activity. In this way, the visual attributes stated earlier will endear, and therefore reinforce, the viewer's desire to engage.

Clearly, content itself has to be of interest in order to keep audiences connected and reading on, especially if you have a 'call to action' in the post itself which then requires a **click-through**.[15] This is equally the case for any web browsing, it is not just peculiar to social media engagement.

Architect and academic Nigel Coates has said of one's approach to social channels such as Instagram:

> To show architecture successfully, and enrapture your audience, you need to make a narrative shift and enlist make-believe – as miniature, as movie, as constellation. Even Instagram can be made to exploit its own particular space. The grid format accumulates as a kind of architecture filled with the content of individual posts. As curator of your own account you can quickly follow those accounts that interest you, and hope they follow you. Insta has its own democratised levelling: if you find an account to be too narcissistic (selfies), or boring (cats, food), or boastful (follower thresholds), you can cancel it. The potential for criticism resides on pithy text.[16]

▷ This image of Richard K.A. Ketting's State Capitol in Utah is a story about the architectural grandeur of the Neoclassical space. But always, the human comes first. The viewer's eye sweeps straight down to the two figures and then beyond to the single person near the staircase at the rear.

If nothing else, this is a strong argument for driving visual stories about architecture seen *in use*.

15 Click-throughs are helpful links to take traffic to other sites which you might directly control – your own website, perhaps, or to a personal email which can then be translated into meaningful action.

16 Nigel Coates, "The Selfie of an Architect found in Architectural Digest," in *The Identity of the Architect: Culture & Communication* (Architectural Digest) ed. Laura Iloniemi (John Wiley & Sons, 2019), 128.

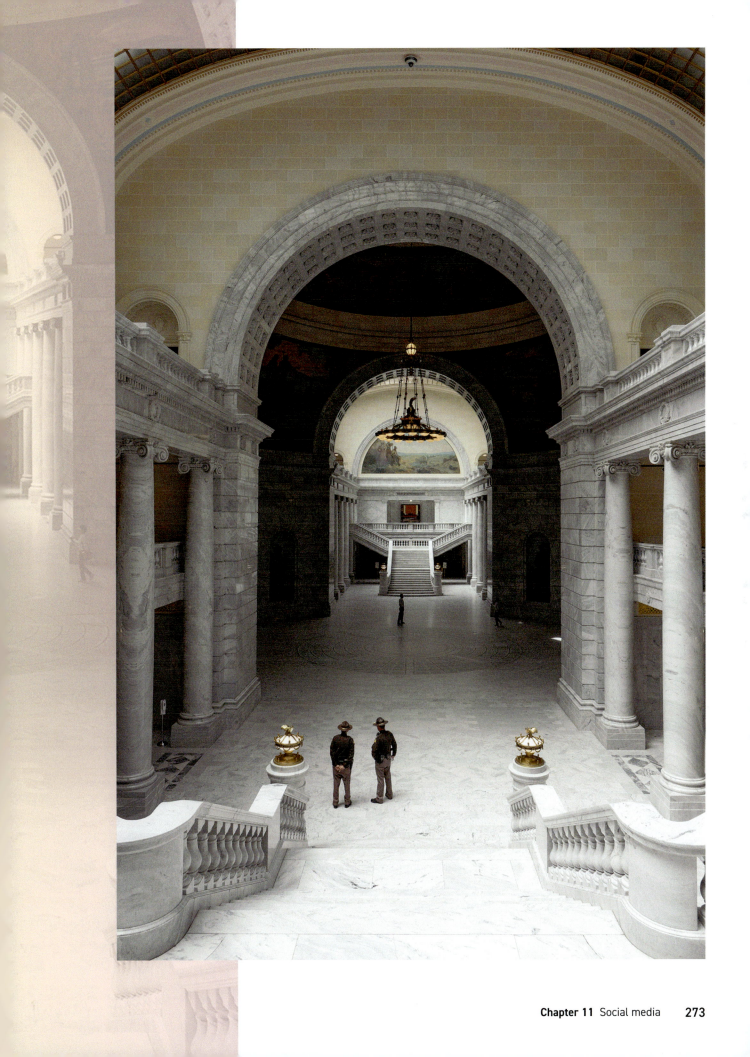

Another valid comment comes from photographer Tim Griffith who recognises that images for social content have intrinsically different values to those in wider folios, explaining:

> *It's important that photographers understand how images are going to be used, and then creating images specific for those outcomes. An image that's good for Instagram may be different to that for an award entry. I'm not devaluing the Instagram shot in terms of value to the firm, but it may be irrelevant for other needs. It's imperative that the firm briefs the photographer properly in order that they receive material appropriate for all the ways in which they want to market the project. If you put a really complicated image on Instagram, no one is going to look at it. It's too busy, and people don't have time. It's a different set of parameters about what makes an effective Instagram image, or a publication image, or a good award image. They all serve different purposes.*[17]

Which platforms should you especially engage with?

The date you read *Photography for Architects* will likely as not depend on which social channels you interact with most. Some of the names from early web 2.0 have long bitten the dust and as new stars ascend, others may fade. Instagram has been discussed in detail and many architects work extensively with LinkedIn and Twitter. Given the longevity of these, we might assume that they are enduring, but one can never give firm assurances.

Certainly, LinkedIn has remained far freer of commercial advertising and personal agendas than some other channels and is a widely accepted voice of business. That's not to say that it is immune to showing-off disguised as news. We are possibly all guilty of this. And certainly, if we think back to the Seven Deadly Sins meme, Twitter's capacity for stone throwing as well as reporting on real current affairs can be cringe-worthy, noble and entertaining all rolled in to one. Nevertheless, it's likely that together with Instagram, these may continue to stay the big three for the creative design industries for some time to come.

During 2020–2021, social media usage increased globally. This was inevitable, given the nature of the period, but since then we've got even more connected. Hootsuite's Digital Global Overview 2022 survey revealed that globally more than 13 new users took to social media every single second with 4.62 billion users browsing for an average of 2.27 hours per day.[18]

The number of users online for business-related networking is perhaps lower than you'd imagine – at only 22.9%. Yet, as one moves up the charts, researching products and brands is the highest-rated reason for being online. Of 16–64-year-olds (a huge age range), 76.1% say that they use social media for this purpose. Surely, architectural firms wish to see themselves in this marketplace, communicating their practice activities to an online audience? Wherever your target market, and whatever age, they're browsing right now, en-masse and you should not ignore them.

17 Tim Griffith, personal conversation with author, 11 July 2022.

18 Simon Kemp, "Digital 2022: Global Overview Report," *DataReportal*, 26 January 2022, https://datareportal.com/reports/digital-2022-global-overview-report, slides 9 and 18.

Where one spends time will depend heavily on the interests of you and your professional partners. As well as photography, film and video are big considerations for social broadcasting. If this is you, then in addition to placing short reels on Instagram, you may choose to use YouTube and TikTok as well.

TikTok hasn't been overtly positioned as a business tool; nevertheless, like any platform, content creators don't need to sit at the margins in order to create a meaningful audience for themselves and TikTok's share of professional web traffic has grown rapidly.

ArchDaily's Haley Overstreet made the point:

> *Due to TikTok's popularity, architecture on Instagram has perhaps met its match. Instagram over the past few years was already becoming an increasingly saturated digital world where imagery quickly favoured quantity over quality. At first, it seemed like the ability to share work from all over the world would benefit and inspire en masse, but perhaps the ability to share ideas too frequently, and too easily, meant that their power and purpose became lost and diluted. It is difficult to ensure that Instagram uploads contribute value to both the architectural profession and discourse. TikTok, however, demands an additional level of editing, thoughtfulness, and elevated sense of creativity that has contributed to its wide success.*[19]

Indeed, short form video is useful for time-strapped professionals, although from spring 2022, the channel increased submissions up to ten minutes in length. This was a huge jump from the previous three and way beyond the original 15-second loopers which grabbed the headlines on launch. Will this expansion simply create another YouTube in the longer term? Of all the sites we engage with, after Google itself, YouTube sees the heaviest traffic, outpacing Facebook, Twitter, Instagram and LinkedIn added together. TikTok has a huge amount of ground to make up to threaten YouTube, but one thing is for sure, nothing online ever stays the same for long.

Many image makers have recently taken to Vero to promote their work. Vero has been around since 2015, and at the point of writing, has stayed close to the concept of 'social media', but with no advertising and genuine circulation of posts to self-selected audiences. Now with stable apps for Apple and Android, it is growing. Fast.

Where you exercise your voice may stay consistent, or shift. Assuming you choose to reach your audience in this way, there is a role in your business for anyone adept in this form of communication.

An architectural communicator producing online social content with a slightly different position to that of a brand manager for a regular commercial practice is Chicago-based Stewart Hicks.

19 Kaley Overstreet, "'TikTok-itecture':
 Is This the New Digital Media for
 Architecture and Design?" *ArchDaily*,
 27 December 2020, www.archdaily.
 com/954080/tiktok-itecture-is-this-the-
 new-digital-media-for-architecture-
 and-design.

STEWART HICKS

SOCIAL MEDIA BROADCASTER, Associate Professor and Associate Dean in the College of Architecture, Design, and the Arts at the University of Illinois, Chicago

I spoke to Stewart who writes for *ArchDaily* and also creates short programmes and lectures for students and professionals which are hosted on YouTube. These have reached audiences beyond the core market of architectural students and practicing professionals, by engaging photographers, designers and a wide range of design orientated professionals and enthusiasts across the globe. A 2022 judge for the AIA's Film Challenge, Hicks has become a leader in architectural commentary online.[20] On his channel named *Stewart Hicks*, a 41-second opener positions him as the host and guide to the material, a friendly guru who seeks to educate on a wide range of topics.

His subscriber numbers (over 385,000) belie the actual number of average views his short films garner, with some getting over two million plays.

If you personally decide to take the plunge and produce content which people listen to (Podcasts) or watch, a major consideration is over *who* 'fronts' and 'fields' that dialogue. Stewart is on screen and narrates much of his content too. I wondered if appearing on camera (literally the face of his brand) was something which he made a conscious decision about, or whether it was happenstance.

> **My first thought was that people likely find architecture to be intimidating, disconnected from their lives, or pretentious. So, being on camera, walking through ideas might ease people into it. However, I do not like being on camera and have entire videos where I never appear, and others where I'm on screen for too long. Honestly, I think it can work either way. 'The Art Assignment' channel is great because the host walks us through her personal views on art.[21] I find that comforting that she's sharing her personal opinions. It's almost as if it gives the viewer permission to have personal opinions even if they're not experts in the subject.**

20 The AIA's Film Challenge champions moving image productions about architecture projects that transform communities through design: https://aiafilmchallenge.org.

21 The Art Assignment is hosted by Sarah Urist Green: www.youtube.com/@theartassignment.

22 Stewart Hicks, interview with author, 1 July 2022.

There are other channels where the host's personality comes through in their voice and editing. Their physical absence from the video keeps things focused on the content at hand. Architecture seems particular in that it's 'placed'. So, if I'm not at the building I'm talking about, I prefer not showing myself at home. That feels difficult to follow if I'm showing a building from one location while I'm in another. Also, if I do go visit a building, I try to keep myself in a few scenes on location, but then only do voiceover for other parts.[22]

Stewart makes a point tying into what Adam Nathanial Furman called for earlier in this chapter – a place online where rather than self-congratulatory posts there should be a home for *informed* writing and debate:

I began the channel because I felt like I could find a space on YouTube for the kinds of discussions me and my colleagues have. These aren't well represented on the platform besides the occasional lecture or symposium recording. But the public won't know how to find these without looking for them specifically. I'm seeking to make architectural conversations accessible and discoverable.

He goes on to clarify this further:

I'm an advocate for architecture. My hope is that more people will see the value it brings to the world. Maybe I see the channel like an ambassador of architecture. There is a misalignment of conversations between architects and the public. The goal is to find common threads and touchstones for an exchange where neither side is misrepresented, everyone is entertained and learned something along the way.

▽

Stewart Hicks anchors his YouTube channel; each film offers personable, professional insight and opinion. Robert Becker's photograph records Stewart broadcasting on location.

Many videos about architecture are short-form, under five minutes, but this time-frame presents barriers to their narratives becoming immersive. Educating an audience requires a different approach compared to short, punchy promos. For Stewart's topics, he explains:

> **The length of the videos are determined by a confluence of factors. Just informally, I noticed that typical 'explainer' and video essays are around that [*roughly equal*] length. [*Just*] above ten minutes seemed right, and I found a groove in writing 4 pages of script per video, which keeps it around 11–12 minutes. When I interview other folks, that will take the length up a bit.**

Interestingly, although TikTok has increased its run-time limits, Stewart keeps his work contained mostly to YouTube. Although he has a presence on other portals, he is aware that his audience knows where to find him and has no desire to either dilute that message by placing it elsewhere, or to try and curate other audiences by moving to different media. In terms of advice for architects, he acknowledges that there's plenty of traction to be gained across a number of other portals, however:

> **I know folks who are exploring right now with YouTube Shorts that they also post as Instagram Reels and on TikTok. They say they get very different reactions and audiences on each platform. Each has a place and what's good for one doesn't necessarily translate to the other. Architecture can be slow to adopt new forms of communication and exploring these media is great for the discipline.**

Stewart is aware that intellectual property is a challenge, both with regard to his self-authored content, and also the use of third party material in his broadcasts. When he is unable to shoot his own footage and stills (some of the stories he makes feature buildings and processes far beyond his campus in Chicago), he tends to lean on stock footage sites for material. These include Shutterstock, Storyblocks and Getty. He's comfortable with the checks that YouTube themselves make about others using his material and embedding it into other forms within the channel, but struggles to 'police' users outside of YouTube. Instead, he hopes people will observe copyright laws and seek his consent prior to usage.

Regardless of whether viewers find the associated advertising content distracting, he notes that it brings needed benefit as it: "... helps offset the cost of making videos. It's a necessary source of revenue for purchasing equipment, employing people when necessary, paying for stock footage services, etc."

Certainly, making television programmes is a big budget, multi-person undertaking, and whilst Stewart's pieces are more modest, the material and labour endeavour is still a big drain on time and finance. The university supports his practice, knowing that his research brings wide benefits for all.

WATCHING ONLINE VIDEO CONTENT

JAN 2022

PERCENTAGE OF INTERNET USERS AGED 16 TO 64 WHO WATCH EACH KIND OF VIDEO CONTENT VIA THE INTERNET EACH WEEK

GLOBAL OVERVIEW

ANY KIND OF VIDEO	MUSIC VIDEO	COMEDY, MEME, OR VIRAL VIDEO	TUTORIAL OR HOW-TO VIDEO	VIDEO LIVESTREAM
91.9%	51.4%	37.1%	31.3%	30.4%

EDUCATIONAL VIDEO	PRODUCT REVIEW VIDEO	SPORTS CLIP OR HIGHLIGHTS VIDEO	GAMING VIDEO	INFLUENCER VIDEOS AND VLOGS
29.8%	27.7%	28.5%	27.4%	26.7%

54 SOURCE: GWI (Q3 2021). FIGURES REPRESENT THE FINDINGS OF A BROAD GLOBAL SURVEY OF INTERNET USERS AGED 16 TO 64. SEE GWI.COM FOR FULL DETAILS.

we are social Hootsuite

△ Hootsuite's 2022 report shows use of video content online by percentage of overall users in the 16–64 age bracket. It goes on to state that 46.6% of worldwide users are using 'how-to' tutorials or educational video every week. More specifically, 26.7% of those viewers are consulting **vlogs** – self-created content. Stewart's catalogue is a good representation of materials that are designed to reach the 29.8% educational sector identified in this table.[23]

He sees Instagram as being pivotal to architects, personally knowing practices who've seen elevated visibility for their work in this way. Nevertheless, when I asked him how he saw the future for social media, he responded:

> That's a difficult question! It seems largely consumed with self-promotion in the architectural space. Not sure this will change, but it would be good if it did. Despite the ability to reach a wide array of people, there is not much incentive beyond personal brand to do much else.

This is perhaps a less optimistic note to end on, but his view is on-point. Of course, we need to share what we are doing, we have businesses to market and a need to stay financially viable. If social media can assist this without significant capital outlay, then naturally we are going to engage. But Stewart, despite not quite having or needing the same agenda as a private commercial practice, manages to create entropic, insightful and visual content in a way that we would all benefit taking a moment to watch and learn from.

23 Simon Kemp, "Digital 2022: Global Overview Report," *DataReportal*, 26 January 2022, https://datareportal.com/reports/digital-2022-global-overview-report, slide 54.

Final points

Social media is designed for a world on the go. It's about instant thought and reactions; sometimes real-time conversations and visual records which are punched in and spontaneously shared. In this regard, your visual work is going to be received and consumed in a different way to your other outputs.

One of the really vital take-outs, with Instagram especially, is to recognise that fundamentally it's a very different portfolio tool to your website. The photographs which showcase well on it are not necessarily going to be the same as those in your wider folio, nor the same as the ones for award submissions and fee bids. The bottom line with Instagram and indeed most of the platforms is the *scale* those images are seen at.

Small.

So, what works best is bold, graphic, punchy. If you're viewing the page grid, think clean, crisp and uncluttered visual cohesion.

With any social media, it's vital that you recognise a partial release of authority over your brand management, whether it's through the conversations that people hold or the pictures that they post. Daniel Preston at KieranTimberlake provides a useful insight here;

> *We've seen the importance of informal photography. We love seeing how people use spaces in our buildings – we recognised that we lose control on social media and we've embraced that, we have to accept that, but we maybe don't lose out. We see a new perspective and we see human-centred design at work and the way occupants are using our spaces which is pretty inspirational.*[24]

So, what we're saying is that one can anticipate two visual voices working for a project. One uses your own controlled outlets for images which will dominate in Google search, such as Tim Griffith's images of KieranTimberlake's Keeling Apartments for UCSD [Figs 11.5 & 11.6].

Other, unsolicited messages come from users of your projects and can be seen across sites such as Instagram where (in one instance) student Diana Castillo expresses her delight with: "Sunset View from the Keeling Apartments at Revelle UCSD. I really love this school."[25]

Can you initiate commentary in addition to 'likes' and 'shares'? With luck, the feedback of others from outside your own walls will be just as valuable to your stories as your own voice in telling them.

24 Daniel Preston, interview with author, 20 December 2021.

25 From Diana Castillo's Instagram post, 28 November 2019, www.instagram.com/ yve24/?hl=en-gb.

Figs 11.5 & 11.6

Summary

Ensure the conversations you hold, both visual and written, contribute quality you can be remembered for. Post at a time when you know your audience is most likely to see and engage, planning to coincide with their work, leisure or viewing habits. For example, in the UK, one of the most architecturally notable terrestrial TV shows is *Grand Designs*. Any residentially focused practice could sensibly schedule home design posts in the immediate time-frame of the broadcast.

Instagram is just one of many platforms, of course, and every user has their own audiences and therefore associated needs, merits and considerations. So, take the time to consider. Be selective. Make each post work for your practice in the way that you need. Stay up to date, be aware that the technology is fast-paced and competitive.

At the time of writing, Instagram was prioritising **Reels** (moving image content) over still images in a bid to meet TikTok's audience. Twitter had been taken over by Elon Musk and user numbers were plummeting. In the world of social media, nothing is assured, it's always fluid. Other platforms exist and there will be other, new means of broadcasting to come.

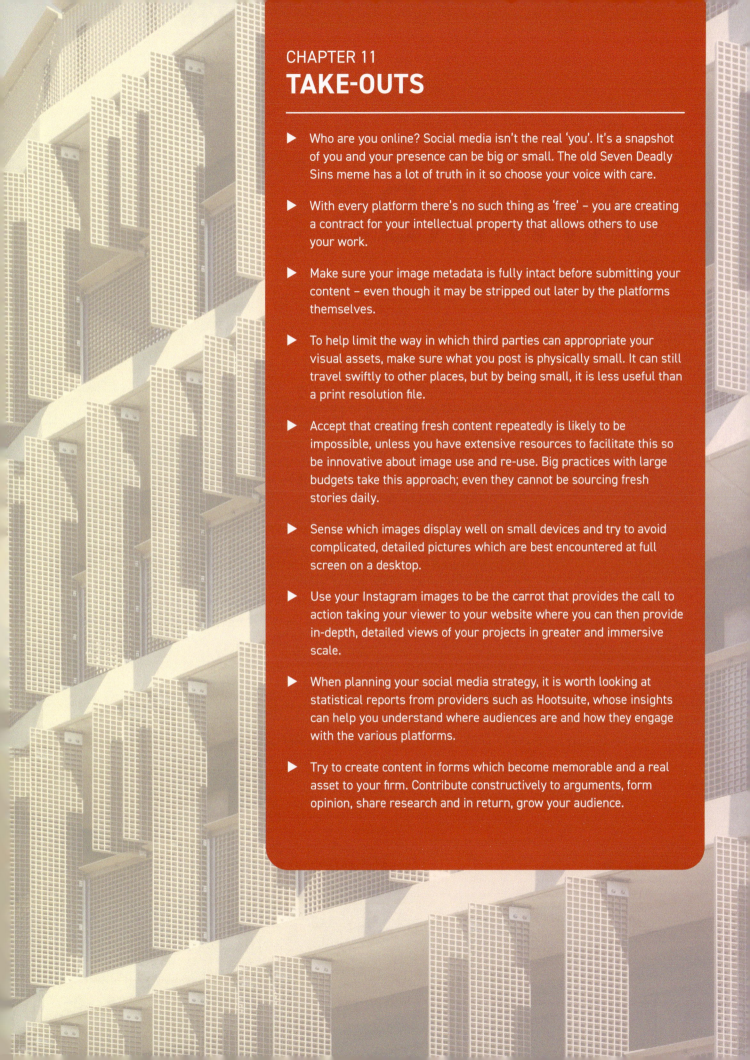

CHAPTER 11
TAKE-OUTS

▶ Who are you online? Social media isn't the real 'you'. It's a snapshot of you and your presence can be big or small. The old Seven Deadly Sins meme has a lot of truth in it so choose your voice with care.

▶ With every platform there's no such thing as 'free' – you are creating a contract for your intellectual property that allows others to use your work.

▶ Make sure your image metadata is fully intact before submitting your content – even though it may be stripped out later by the platforms themselves.

▶ To help limit the way in which third parties can appropriate your visual assets, make sure what you post is physically small. It can still travel swiftly to other places, but by being small, it is less useful than a print resolution file.

▶ Accept that creating fresh content repeatedly is likely to be impossible, unless you have extensive resources to facilitate this so be innovative about image use and re-use. Big practices with large budgets take this approach; even they cannot be sourcing fresh stories daily.

▶ Sense which images display well on small devices and try to avoid complicated, detailed pictures which are best encountered at full screen on a desktop.

▶ Use your Instagram images to be the carrot that provides the call to action taking your viewer to your website where you can then provide in-depth, detailed views of your projects in greater and immersive scale.

▶ When planning your social media strategy, it is worth looking at statistical reports from providers such as Hootsuite, whose insights can help you understand where audiences are and how they engage with the various platforms.

▶ Try to create content in forms which become memorable and a real asset to your firm. Contribute constructively to arguments, form opinion, share research and in return, grow your audience.

Chapter 12

▷ AWARDS

Everyone's a winner

Most architects in the UK will be well aware of the Carbuncle Cup, a prize given to projects by the industry stalwart *Building Design* magazine. Last awarded in 2018, it represented the pinnacle of … bad buildings – poor design and poor responses to context rather than poor execution. Indeed, many of the winners represented multi-million-pound investments with plenty of time spent refining their design and detailing in the process.

The annual cup was first presented in 2006 and named after a quote by Britain's then Prince Charles. He launched a tirade against Ahrends, Burton and Koralek's design for a proposed extension to London's National Gallery, describing it as a "monstrous carbuncle on the face of a much-loved and elegant friend."[1] In the end, Venturi, Scott Brown's restrained extension, got the commission for the National, and the inaugural winner of the Carbuncle was Chapman Taylor with the Drake Circus Shopping Centre in Plymouth, Devon.

▷

Hufton and Crow were commissioned by Ström Architects to photograph its project for a private client on the Isle of Wight. Known as Island Rest, it scooped British Homes Awards 'Small House of the Year' and the RIBA South House of the Year 2022.

In this chapter we look at the business of awards and ask: Are they worth the effort in putting a submission together? What role do images play in the submission process? What can shortlisting or winning mean for a building and the practice team behind it?

1 "A Speech by HRH The Prince of Wales at the 150th Anniversary of the Royal Institute of British Architects (RIBA), Royal Gala Evening at Hampton Court Palace," 30 May 1984, https://web.archive.org/web/20070927213205/http://www.princeofwales.gov.uk/speechesandarticles/a_speech_by_hrh_the_prince_of_wales_at_the_150th_anniversary_1876801621.html.

Even heavyweight Rafael Viñoly has scooped the infamous prize, with London's much talked about 'Walkie Talkie' (20 Fenchurch Street) in 2015. Despite this, and according to a report in *The Guardian* newspaper from September that year, London's chief planner of the time, Peter Rees, steadfastly stood by it, declaring it to be:

> ... the figurehead at the prow of our ship, complete with a viewing platform where you can look back to the vibrancy of the city's engine room behind you ... The building's raison d'être was to provide a new kind of Assembly Rooms ... a place where city types could go in the evening to harrumph and hurrah, then stagger back to Liverpool Street station – and it's worked enormously well for that purpose.[2]

The notoriety of these 'winning' schemes across the years possibly didn't cause the various trophy holders to lose too much sleep; after all, there is some truth in the advertiser's adage that any publicity is good publicity. Certainly, placing oneself in the public eye and potentially the gaze of one's next client is an attractive proposition and one (Carbuncle Cup notwithstanding) which few practices can afford to overlook.

This chapter asks: How do you see your company increasing its visibility if not via your images? Can you broadcast effectively via awards, and how can photographs assist this process?

Nothing should allow a poor building to win awards (unless it's an award specifically for failures), but a decent project poorly represented may easily lose a deserved placing. Sadly, poor architecture has occasionally been over-celebrated simply through powerful representations made by talented image makers and marketeers.

Which awards?

There are multiple awards programmes globally. They exist at local, regional, national, and international levels, celebrating all manner of aspects of architecture and design. General and subject-specific categories are arranged by architectural bodies and associations. Industry product manufacturers and professional business organisations orchestrate annual affairs, mostly fee-bearing and with varying degrees of aligned promotion for the winners.

How visible and ultimately meaningful such gongs are is entirely debatable, depending on one's stance. For most winners, a prize (whatever it might be) is good for the practice CV, and if you are in receipt of such accolades as The Pritzker, Aga Khan, The AIA Gold Medal, Emirates Glass Leaf Awards, The Royal Gold Medal or the any of the RIBA's Awards which include the prestigious Stirling Prize, you will have every right to be feeling good about your work.

Exposure thereafter, such as with Architizer, whose relationship with Monacelli/ Phaidon ensures entry into a glossy hard-bound book, or online in Dezeen, Arch Daily and Design Boom, means that the title-winning project – indeed, *all* of your folio – should see greatly enhanced exposure to markets. This degree of promotion will be far more substantive than your own budget and network could levy.

2 Oliver Wainwright, "Carbuncle Cup: Walkie Talkie Wins Prize for Worst Building of the Year," *The Guardian*, 2 September 2015, www.theguardian. com/artanddesign/architecture-design-blog/2015/sep/02/walkie-talkie-london-wins-carbuncle-cup-worst-building-of-year.

For these reasons, it makes logical business sense to undertake research into which award programmes your customer target market is likely to see and respond to. There's little point entering a wildcard into an awards scheme where it won't sit well, as even at local and regional levels, juries are selected for their understanding of the aims and ambitions of the bodies they represent, and you could immediately face rejection, and of course a loss of your time, effort, and not to mention cash, entering.

What can awards mean?

Awards are validation. Validation is important in any industry and much of an architect's output is hidden away, visible in its context for sure, but unless an audience knows to go looking for it, much of what you design is received and understood by the client you're working for and not many others outside of your world.

Validation brings confidence, and award winners exude confidence, plus, hopefully, more enquiries for future work. But running an annual awards schedule as part of your business plan costs time, money and effort. You need to see awards as an active facet of your marketing strategy. It's not just the entry fee to consider, the vast majority of programmes rely on a shortlisting process and then a second fee-paying event at which to learn the outcome. Mind you, these industry soirees and dinners are where professional relationships are often cemented and new work brought to life, as taking one's client of the nominated building to such events is a 'given'.

▽

Peter Durant shot the Rijksmuseum, Amsterdam by Cruz y Ortiz Arquitectos. A recipient of the Abe Bonnema Architecture Award, it also won a LEAF Award for its interiors designed with Jean-Michel Wimotte.

It's also the case that certain markets may ask for awards honours as part of their own validating process – Chinese tenders often expect awards listings as part of the specification process.

Even entering competitions can be daunting for a small practice, setting oneself up for scrutiny can be nerve wracking and risk laden, especially when weighed against billable hours. It makes sense therefore to ensure that you spend time researching the best programmes for your projects and once committed, making sure your entry is able to work in your best interests at all levels.

Writing award submissions

There is skill involved in any form of document writing, whether it is for fee bids and tenders, design and access statements, press releases, content creation for the web ... the list is endless and you will readily be able to identify members of your team who best represent your interests in each area. The same goes for award entries and, certainly, a bunch of great pictures won't carry any weight if the words aren't equally strident in endorsing what the photographs indicate. The visual assets for any submission are there to support what you say. As a starter for ten, say it well first and then go on to prove it with your images.

Get the entry criteria right

I have sat on several jury panels over the years, for awards representing a number of different bodies, targeting a variety of different aspects of design and construction in the built environment. Competent architectural photographers can make decent judges; they may cover a huge number of projects annually for multiple different practices across a wide number of sectors. They understand what they are looking at and they know how 2D plans and photographs translate into 3D forms. When on site working for their clients, they hear both the plaudits and woes from occupants in equal measure any time they stop to listen.

Shortlisting days are fascinating. In the main, entries will have already been sifted through for clerical and inadmissible errors prior to this point, although it is shocking to learn how many people entering competitions simply do not read the Terms and Conditions thoroughly. I should add at this point that for every jury I've sat on, anyone with a vested interest in an entry will always declare and remove themselves completely from the discussion to ensure parity across the proceedings.

Drilling down into the all-vital Ts and Cs is imperative, as some entries fail at this first hurdle. One of the critical elements is likely to relate to the age of the project at the time of entry. Many awards prohibit buildings from entry which are complete but not operational.

Speaking to administrative teams for a variety of awards bodies, they report that common mistakes tend to relate to missing information, and of course grammatical errors and typos. Be professional, get your entry proofread by others in your team, but then send it out to those who are outside of the project itself – a friend, not a consultant on the build with insider knowledge. Does it read well to them?

This is important as you are introducing your project to an audience that simply doesn't know it like you do. Can they understand what you are trying to convey in the written narrative?

Some organisers will chase you for missing information, especially if there has been a change to criteria. Beware of awards which have been in operation for years and have a repeated style to their format. Paying scant attention to entry requirements can lead to seemingly minor omissions, and lots of bodies won't come back to you for the extras if you've missed something that hadn't been previously asked for.

Photography as part of the entry criteria

You would expect written descriptions and site plans to form part of the entry, but there will be few architectural awards where photographs are *not* encouraged as part of the submission folio. Unfortunately, it's at this point that many submissions flounder, not simply because the photographs are inadequate, but for the fact that sometimes submissions lack them all together, instead, being reliant on CGIs or elevational drawings and in extreme cases, simply a written description. Frankly, only including these suggests a proposed scheme, not a completed and fully functioning building.

It is absolutely in your best interest to ensure that any entry to a completed building award programme contains irrefutable evidence that the building actually does what you are saying it does. Jury discussions share incredulity at the lack of supporting visual evidence which expresses the form, function and physical operation of a project. Even if these images are hasty phone snaps, making clear to a panel that you have finished the job is part of a confidence building exercise that starts to validate a jury's faith that something is worthy of investigating further, prior to possible shortlisting. With puzzling supporting evidence, you may invite a visit, but equally you risk inciting rejection, which is a waste of your business's time and effort.

▽

Holkham Hall Stables and Pottery Building in Norfolk by Hopkins Architects won a RIBA East Award 2017 and the RIBA East Conservation Award 2017.

△ + ▷

Storey's Field Centre and Eddington Nursery in Cambridge by MUMA seen left, and Bushey Cemetery, Hertfordshire, right, by Waugh Thistleton Architects for the United Synagogue. They were selected by myself and fellow panel judges (pictured here) to be prizewinners of the 2018 RIBA East Awards.

An architectural photographer visits multiple sites to shoot in any given year, and has the skills to appraise form, function and contract quality. From the shortlisting day onwards, the panel and I asserted that both of these buildings were outstanding. Others were in agreement. Both projects were subsequently subject to National Awards and thereafter shortlisted for that year's Stirling Prize.

Accepting that photographs are necessary, one needs first to adhere to the image-specific Ts and Cs.

Suggested Ts &Cs Photography Checklist

Photographs	Most awards will specify a maximum number of images to be submitted.
Additional Supporting Material	Check that this total does not include additional plans and drawings – sometimes site plans are a separate appendix.
File Size	The photographs are likely to have a size requirement and you may be asked to supply images in more than one size and resolution too – the UK's RIBA awards, for example, have had criteria for two separate sizes and resolutions, 72dpi for the web and 300dpi for press and print.
Labelling	You may be asked to label the images in a very specific way – *Pinmarsh_Academy_002_ABC-Architects_Martine_Hamilton_Knight.jpg*, for example.
Image Permssions	You will be asked to confirm that the photographer has consented for the pictures to be used in this way – thus complying with copyright laws.
Consents	The same will apply to people modelling as well; General Data Protection Regulation (GDPR) is at stake here. Be sure to have the right consents in place. You're unlikely to need to produce model releases, but the awards programme will need to know that they have the clearance to use the pictures in associated publicity for the awards during and after the process of judging.
Rights	Some less scrupulous competitions will ask for the transfer of copyright for material and reproduction rights as part of submission. Do you want to even enter such a programme?

You then need to plan how and what the images might show. Absolutely adhere to *Ch. 8 When is now? The right time to shoot your project*, and be confident that your building looks how you anticipate it should. Most competitions run on a set 12-month cycle. If you had to submit a building for a closing date of 1 April this year, you can bet your bottom dollar that next year's deadline will be within a week or two of the current one.

This allows you to plan the timing for your photography with diligence. If you're asking a photographer to visit, go yourself ahead of this and see what's going on inside the four walls since you signed the project off. Not only does your site need to be operational, it needs to have been functioning long enough at the point of capture to mean that occupants have unpacked and are running the facility as designed. You may also need to check that the occupant hasn't taken interior design matters into their own hands!

What's the weather doing? Is now the right season for photography? No? In that case, wait and pick your moment within that 12-month window which best reflects what you are trying to illustrate.

If you are choosing this time to photograph your project in full, then your image haul may be far higher than the number permitted for entry, and that's just fine. However, on the basis that for this particular need, you might be required to submit a total of ten shots, here's how they might run:

- Consider how you introduce the completed work to your audience for the first time. The judges will want to understand the context of the scheme and its outward appearance within its setting.
- Good light, as ever, is important for these photographs – you need to convey the three-dimensional nature and strong directional key lighting from the sun facilitates this.
- At this stage of the awards process, you cannot appear with your work in person and explain it to the panel. Therefore, the images must reference what your narrative describes – the two aspects should complement one another. Show what you say. Create a compelling visual folio with the highest-quality images you can provide.

▽
CPMG Architects' Vijay Patel Building for De Montfort University in Leicester won an RIBA East Midlands Award, the ProCon Award for Large Non-Residential Building and an East Midlands LABC Award for Best Educational Building in 2018. A mixture of retrofit 1960s and new build, it is home to the school of Art & Design.

A notional panel of ten photographs might expect to be ordered as follows:

1 If the setting includes external works, be sure to capture an establishing shot which shows the scope of the project. This is your 'hero shot'.

2 Did you create a visualisation for the project that also is represented by this hero shot? If so, you might choose to use one of your set of ten as a CGI. It doesn't need to mirror the actual power picture, it can be from a different angle, but what it should do is convey how closely you've been able to create what you planned for the site in the first place. A 'before' and 'after' if you like.

3 The palette of materials on the build is important; does the next photo show these clearly? This picture might be of the principal elevation, closer in – but still highlights the nature and scale of the building. It might be single-point perspective or two-point perspective, showing two elevations. Again, strong lighting will show physical depth and type of materials on the facade – recessed or projecting elements, the pattern/rhythm of cladding/glazing/brickwork, etc.

4 What of the entrance? Perhaps a close-up view might show this, which might be where important design details lie too.

5 The principal internal circulation space may come next. This might be the reception, or a central gathering point/hospitality/focus place. And capture it in use. Always, if you can gain permission to show your building in operation, do so.

6 And why have you created this building? Who for? What do these people do in it? Can you convey this? And if the nature of the occupancy prohibits showing them in person, can the spaces be dressed to illustrate this function?

7 The seventh shot should carry on with this theme. Make sure it's sufficiently different, but equally enlightening, and if image 6 is a landscape format, consider this one as a portrait. Press and marketing needs if your scheme is shortlisted may warrant use of landscape shots, but also portrait – for mixed orientation in editorial layouts.

8 Let's have a detail next, unless they've all been value-engineered out!

9 If you're aiming to single your submission out for specialist endeavours – innovative design or methodology, structural challenges and engineered solutions, prototyping for materials, etc. – the penultimate image should highlight these.

10 Finally, many buildings respond well to being captured in twilight – and this is a chance to show off lighting design.

What happens next?

Assuming you've created a correctly planned entry, now comes the waiting game. You've done your best. Behind closed doors, your project will be read, shared and the subject of discussion amongst the judges, usually (unless in the case of international juries) face-to-face.

It's at this time that your photography is playing its most important role as advocate for your work. Expect the set of images to be either physically laid out or shown on screen for collaborative discussion, in context with the written narrative. Juries often have expert witnesses within the make-up of the panel – these individuals will have a first-hand experience of either the buildings themselves, your practice outputs or at the very least, familiarity with the building type and construction.

I have taken part in conversations where I, or others, have contested what the photographs depict from a technical perspective. Beware extreme wide angles which distort a sense of perspective and the physical relationship of one object to another. Such images may look dramatic, but if they are at odds with submitted plans or first-hand knowledge, will mean that the entire entry is on shaky ground. Robust discussions make sitting on juries rewarding, educational, informative and progressive; everyone is there with a desire to interpret, learn, understand and come away enriched by the creative and technical design solution which you are sharing.

Assuming your project passes this point intact, for the time being, the work of the photography is done. It cannot influence any longer. Any awards where shortlisting is followed by site visits mean that a tour will take place and at this time, you are likely to be invited to this viewing, along with a representative from the client and/or user. You are able to make an active contribution now and become the voice of your scheme.

During Covid, many competitions were paused, simply because the value placed in physical tours as part of the judging process could not take place. Since then, most programmes seem to have started up again in the same manner, but you may find some which use short films as their 'tour' of the site. This approach might be taken for international competitions where extended time and travel required for jury tours would make the costs of facilitating the programme prohibitive. Filmmaking may be part of a long listing process, ahead of shortlisting visits perhaps. You are unlikely to be asked to shoot videos yourself but be sure to be vested in making sure the site appears as you'd wish it to be seen by the team who record the footage and when the occupant facilitates the jury's visit.

During this time, the awards body will have used this window to publicise their programme, and photographs of these shortlisted schemes will move into the public eye. This is potentially the most active publicity point for your practice, as generally there will only be one winner, but quite possibly half a dozen or more contenders and that's the time when you personally need to galvanise on this moment and energise the marketing activities of your practice. If you did make more images at the time of your own site photography, bring them into play on your social channels, but always making sure to place them alongside the key set of pictures, as each of these add power to your voice. Engage your client and your framework involved in the build on this activity – you need to maximise your moment in the spotlight.

Bodies such as the RIBA and Architizer's awards publish their guides to shortlisted buildings at this point. Coffee table books ensue. If you're appearing in these, you can expect your project to see daylight long after the actual winner has been announced. Great.

Eventually, the real winner will be revealed, and if that's you, those images will carry on working for you for the next 12 months, gaining traction with each and every reference made about the project. If these conversations are being held within earshot of your target market, then that entry will have become a very effective branding strategy for your firm indeed. Winners come in all shapes and sizes, and whilst we know that the big and mighty win awards, a true competition should be a level playing field for great architecture, however small and modest the budget.

I chatted to the architect of one such project, a four-bedroom home, part refurb of a Victorian terraced house, part new-build on an inner-city street in Birmingham, UK. The 'Zero Carbon House', as it became known, has received press across the globe since its completion in 2008, and despite its relative age, is still the subject of contemporary press interest globally. As a winner of multiple awards, I was keen to understand how John Christophers, the designer of his own home, has successfully utilised award entries to convey his message about sustainable construction and lifestyles for everyday living.

JOHN CHRISTOPHERS
ZERO CARBON HOUSE

3 Deyan Sudjic, "Mud, Mud, Glorios Mud," *The Observer*, 14 November 2004, accessed 21 May 2023, www.theguardian.com/ artanddesign/2004/nov/14/art. greenbuilding.

John's website about the project states that Zero Carbon House was the UK's first zero carbon retrofit, and the only such residence graded at Level 6 of the UK's original Code for Sustainable Homes. Today, there are a handful of other homes to Code 6; but this is the first and only example of a retrofit house. As part of his professional practice with Birmingham-based Associated Architects, John is no stranger to award-winning environmental and sustainable builds, including Cobtun from 2005, a new-build in the city of Worcester which was constructed from rammed earth, timber and large light-filled living spaces overlooking the River Severn [Fig 12.1]. It was described by the architectural critic Deyan Sudjic in *The Observer* as "an advertisement as much for the pleasure to be had in building ... as a manifesto for sustainability."[3]

Fig. 12.1

John's home build was run as a project independently of his day-to-day job, however, and because of his firmly held beliefs about sustainability and the accountability of architecture in this process, he knew that publicity for the scheme was vital. He needed to spread the word to both his profession and future homeowners about what they should do to become aware of carbon reduction and to pass the baton on:

> **Designing our own home was certainly a creative and financial and domestic risk – but also a unique opportunity to design, build and embody my deeply held beliefs. The UN Secretary General says 'We are on fast track to climate disaster – code red for humanity.' In 2009 no-one was talking in these terms – and much mainstream media still isn't. So for me the risk of not doing everything I can on climate, speaking out, designing and showing the solutions we need – is much bigger than the risk of a bruised ego.**[4]

If one goes to Google Images and uses the keyword chain 'Zero Carbon House Birmingham', the photographs that appear on the first page of the search are the ones John used for his first award submission and have come to signify Zero Carbon House ever since [Figs 12.2, 12.3, 12.4]. As an independent practitioner, John made a leap of faith in commissioning these from a known (and therefore not necessarily 'cheap') photographer. I asked him if he felt as if the resulting visual folio played any part in the understanding of the project by shortlisting panels in the early days?

> **For me it was essential the project was photographed sympathetically by the very best photographer I knew … particularly as the project was unusual and close to my heart, the quality of the images had to beguile the audience – journalists, juries, other architects, policymakers etc. Although there's no substitute for visiting a building, yes, I do think our expectations and perceptions are strongly influenced (positively or negatively) by photos we may see in advance – essential for reaching a shortlist. An example is the unfortunate telegraph post in front of the house: the mind will often edit the extraneous out of our perceived experience: an intelligent photograph can do the same!**

The first recognition came in the form of a 2010 RIBA Award for Architectural Excellence and multiple other marks of recognition followed thereafter. With regard to what difference these made to John and the project, and which of them had the most impact, he went on to explain that in the UK:

> **I think the RIBA and the Civic Trust Awards are the most highly respected. The Retrofit Awards were launched the year Zero Carbon House was completed, so we were delighted to be their inaugural winner. Winning the RIBA award attracted some news coverage, but I think the RIBA Manser Medal [now replaced by 'House of the Year'] shortlist made the most difference to Zero Carbon House. Although we didn't win, I was invited by RIBA as a conference keynote speaker, and we attracted coverage in The Times, Telegraph, *New York Times*, *Shanghai Times* etc – incredible for a domestic extension!**

4 John Christophers, personal conversation with author, 28 April 2022.

Figs 12.2–12.4

Indeed, the house was described by Ruth Bloomfield in *The Times* as "I've seen the future – and it's in Birmingham".[5] Clearly press reporting such as this can be transformative to the visibility of a project and its perception in the public eye.

From working closely with the construction team and aligned suppliers, John and his partners on the project co-curated the momentum with further submissions. One such example was winning the 2011 Considerate Constructors Award. The judging panel said: "It was very obvious that an excellent working relationship has been built up with the client/architect on what is a difficult project because of the unique nature of the work in trying to achieve a 'zero carbon' house." Despite the fact that this prize was aimed at and publicised by a slightly different market and (by proxy) audience, the gains were no less significant.

> **The Considerate Contractor award was initiated by Spellers [the builders of Zero Carbon House], and I would certainly advocate team submissions for awards – all members of the team have different contributions: client vision, design, cost, energy performance, build-ability and any award submission is mutually strengthened by collaboration.[6]**

Over a decade has passed since completion, yet still this house gains significant press, including a segment on national UK television in 2021 under the banner of 'Going Green', and a section in Jared Green's well reviewed 2021 book, *Good Energy: Renewable Power and the Design of Everyday Life*. Green's use of Zero Carbon House as one of his international case studies is a clear example of enriched traction for the project.

As Princeton University Press carried out their publicity endeavours on the publication of *Good Energy*, the media wanted insights into what had been showcased and why. Despite the number of worthy builds Green had written about in his book, John's home was cited again. An article on Dezeen in September 2021 [Fig 12.5] was illustrated with the original photographs coupled with Green's insights on why this small Victorian terrace was one of his 'Ten global projects that demonstrate the possibilities of low-energy architecture'.[7] Spring forward to autumn 2022 and it merited the front page of the weekend section of one of the UK's principal broadsheet newspapers – *The Financial Times* [Fig 12.6].

No doubt this small dwelling will continue to be spoken about in the public, transported from the league of 'new, groundbreaking and attention worthy' into 'currency though legacy'. How does this make John feel?

> **Surprised, delighted, sad, and hopeful. At one level I'm amazed the house has – and is still – attracting such interest: we just wanted somewhere to live aligned with our values! But at another level, the urgency of climate is now greater than ever and the gap between policy and the action needed is huge. If people see the house as 'groundbreaking', I'm hopeful that more ground will be broken at much greater pace now – and I think ACAN, LETI, Extinction Rebellion etc are signs this is happening.**

5 Ruth Bloomfield, "Living Without Carbon: How to Make Your Home Green," *The Times*, 11 June 2010, accessed 21 May 2023, www.thetimes.co.uk/article/living-without-carbon-how-to-make-your-home-green-vpltmvztvdv.

6 John Christophers, personal conversation with author, 28 April 2022.

7 Cajsa Carlson, "Ten Global Projects that Demonstrate the Possibilities of Low-Energy Architecture," *Dezeen*, 14 September 2021, www.dezeen.com/2021/09/14/ten-global-projects-low-energy-architecture-jared-green/.

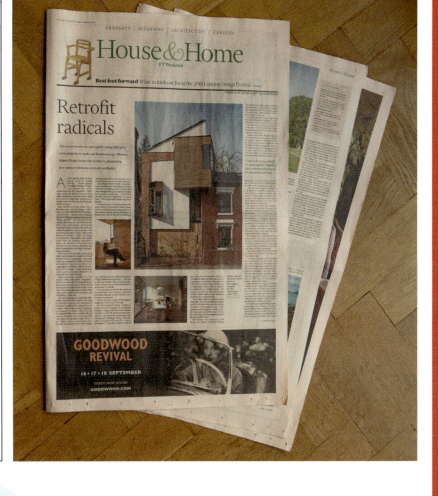

Figs 12.5 & 12.6

Finally, what advice does John have for sole traders/micro businesses who might not feel that the entry fee is worth the risk of submission, even though they feel that their project is award worthy? "If you instinctively know that something is right, then go for it. Especially for small businesses who don't have PR people, the oxygen of publicity comes for free with the awards."

Fundamentally, though, John is living what he preaches, none of this activity is PR for PR's sake. Despite this being his family's home, he still lectures at academic institutions about the project, runs tours and hosts public open days coinciding with local and national design initiatives to raise interest in design and sustainability. Indeed, his passion (together with personal fear for the planet's future) has kept Zero Carbon House in the public eye long after other newsworthy projects from the same period have faded from view.

Certainly most every-day projects are unlikely to sustain such momentum, but as a considered case study of something that would otherwise sit unnoticed on a suburban street, the strategy of a plan encompassing good photography; strategically written award entry; and invested spin-off projects which maintain visibility and interest have served this particular practitioner well.

Summary

Wherever you are based in the world, there will be local, regional, national and international award programmes that are vested in the awareness of architectural design. What is running where and when is simply too long to list here, and doubtless is subject to change. Nevertheless, developing a code for your practice to follow, with an annual timetable of entries, makes good business sense.

Sit down at the beginning of each year, go through the list of what's taking place throughout the next 12 months and how entry deadlines sit with your own project completions. Look forward. What you're working on now for your clients will come to fruition and then (with regard to your day-to-day money earning activities) be completed and parked. Don't close the door on it yet if it's good; you might need to give it another 12 months – at least – of airtime, so that you can square the circle and offer the project the chance of game-changing outcomes for you and your practice.

CHAPTER 12
TAKE-OUTS

▶ Consider the direct and indirect financial value to your practice of creating publicity via strategic award entries.

▶ Take the time to research what is operating near you that may make a difference to your visibility in your market. Entering something which brings recognition for a service you don't want to continue to offer isn't sensible. Even if it was a good project, if getting there was painful, not cost effective to your practice, and a stretch that you and your team have no wish to repeat, don't talk about it too loudly.

▶ What do prizes mean to your market? In certain territories and sectors, cited award placements are an essential validation marker for the tendering process.

▶ Read the Ts &Cs thoroughly. Be sure to go through requirements with a fine-tooth-comb annually. For example, as the rhetoric (not to mention evidence) has changed in the last few years regarding climate change, more and more programmes are putting extra sustainability criteria or end-user experience into to their conditions of entry.

▶ Plan your submission's visual supporting evidence with care. When should photography take place to best showcase the scheme? Refer to *Ch. 8 When is now? The right time to shoot your project* to help you decide the best point to send your image maker out.

▶ If the photographs are specifically for the award entry itself, make sure your photographer has sight of the requirements and plan the shoot with them accordingly.

▶ Watch for specific requirements over file sizes, image labelling, metadata, etc.

▶ Once submitted, expect a period where shortlisting announcements are to be made and schedule this as a period of peak press opportunities for you. If you're in that group of 6, 12, whatever ... you should be talking to everyone and anyone about why this project has been highlighted.

▶ Make sure the news moves across multiple channels, use your network of contractors, clients and suppliers to help spread the word.

▶ If the ultimate prize lands at your feet, you've now got another 12 months to keep it up for air. Make it work hard for you.

▶ If there really is something special about your work (of course there is), then look for other opportunities to continue that visibility for the project and any wider conversations you may have about it, and with that body of images. Google is always watching and listening.

Chapter 13

▷ LEGACY VALUE

Books, shows, and printed folios

Consider extending the shelf life of your visual portfolio.

As part of your activity to secure new work, you might create printed, bound materials for project pitches, competition entries and planning documents. Along with written information, visual assets may consist of technical drawings, CGI visualisations and photographs to indicate the proposed site and its current state. These documents have a specific role and a finite timeline. They're unlikely to be consulted *after* a project has gone through its planning and design stages. It's possible that only one or two of the visuals and accompanying narratives will be transferred to web pages for long-term discovery.

Your business may have taken stands at industry shows or events where you created printed collateral for display. These items may have been in the form of pull-up banners, prints on a wall, or take-away leaflets. They may have been re-used for other occasions, but they're likely to be seen in the context of short-form broadcasting, rather than for posterity.

Pictures speak louder than words, isn't that what someone once said?

BDP's award-winning Armada housing in the Netherlands has appeared in print multiple times since its completion in 2003, including in BDP's 50th anniversary book authored by Hugh Pearman – *Continuous Collective (2011)*. Using your visual archive to promote your practice long after the newshounds have left the launch party makes perfect sense.

Both activities are directly aimed at current and future business. They're positioned to *look forward*. But, what about looking back? If you've been in business for some time and have a significant anniversary or milestone on the horizon, why not mark that point with a printed book or physical exhibition which describes the legacy of your past work? It is common for architects to move from one completed project to the next and not ever take the time to pause, reflect and take stock of their past achievements, never mind share these images with an external audience.

If this sounds familiar, you're not alone.

modern UK multiplex cinema, **The Point, in Milton Keynes.**
Ten screens! Restaurant, bar and nightclub! Designed for
maximum impact on minimum money, a reflective ziggurat
within its red-painted steel pyramid frame, it was not intended
for a long life but nonetheless lasted into the 2020s, latterly
housing a charity. It is still there at the time of writing, though
probably not for long, despite moves to save it. It is fondly
remembered: it marked an important cultural moment.

1970s:
Another now-listed building, an extraordinary place,
is the headquarters for what was the UK's largest mortgage
and savings provider, the **Halifax Building Society.** Diamond-
shaped in plan, elevated on four stout legs (also diamond-
plan) to make a covered plaza, it sails above the rooftops of
this hilly Yorkshire milltown like a bronze-clad battleship. The
mortgage deeds and correspondence of a quarter of the
nation's home owners, in those pre-digital times, were stored
in a huge basement vault, retrieved on demand by a robot
system. This was the era of Bürolandschaft or organically-
planned open-plan offices, as was BDP's pioneering first
studio in Preston. BDP designed everything right down to the
smallest details of the interior design, and returned to the
building for interior upgrades in 1996 and 2002.

1990s:
The **St Peter's University Campus, University of
Sunderland** was a ten-year programme over three phases,
started in the mid 1990s, to make a complete university
campus on the site of former shipyards on the north bank
of the River Wear. This academic township was therefore
as much an act of masterplanning and urbanism as of
architecture. It also marked the clearest expression yet of
BDP's increasingly Scandinavian-inflected design direction
at that time, a particular interest of its then design lead,
later chair, Tony McGuirk. In his youth he had worked with
Anglo-Swedish architect Ralph Erskine on the extraordinary
Byker Wall project in nearby Newcastle. So the St Peter's
campus was doing a lot of things at once, from post-industrial
regeneration via interlinked external and internal public
space to setting a marker for a different, more organic and
expressive kind of modernism. It was an important statement
of intent for the wave of 35 new British universities, former
polytechnics, launched by the 1992 Further and Higher
Education Act. Its urban-led design approach came to
permeate BDP's design thinking, not least in more recent
university projects such as the XJTLU South Campus in
Suzhou, China.

1980s:
Postmodernism was in the air and the start of the
decade found the youthful me working in the London studio
as an in-house editor, an unusual role for a design firm at
the time. As Thatcherism took hold, this was the moment
of maximum danger for the BDP ethos: other partnerships
were floating themselves on the stock market and (briefly)
getting rich on the proceeds. Commendably, BDP with its
long-term view chose not to go down that route: most of
those who did fell by the wayside as the economy contracted
and the unforgiving market tore them to shreds. From this
period comes a commercial yet democratic building: the first

12 **Hugh Pearman**

◁ + ▽

Ten years on from their 50th
anniversary, BDP created a second
book, and again their photographic
archive (including St. Peter's Campus
in Sunderland from 1994) brought
vitality and new conversations into the
celebrations.

Only considering your portfolio in the
short term makes little financial sense
and projects will remain more visible if
you and others continue to talk about
them. Have a reason for this activity.
Not many practices get to 60, but six is a
great number too. For a young practice,
make sure that there is quality in your
images from the go-get, so that when
you reach a milestone, it's all there,
ready to roll out as you require.

Selected highlights from 60 years of practice

14 **Hugh Pearman**

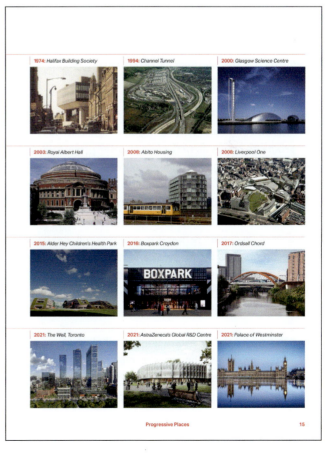

Progressive Places 15

The justification

If you have a business that has completed several projects over the course of a few years, then you have a *legacy folio*. If there is work on that list that you are proud to speak about, why not make it active for sharing with your past, present and future clients in an *offline*, permanent form? Choosing a point in time when this may occur could form part of the overall marketing strategy for your practice.

To contextualise this, let's return to the concept introduced in *Ch. 8 When is now? The right time to shoot your project*, where mapping photography and video into the cycle of work was proposed. I placed Stage 9 as being the logical point for *Legacy* – when your building is at a point for re-fit, re-use or *re-evaluation*. Marking meaningful milestones and celebrating archive projects for your business resonates well here too: a reinvigoration of your worth.

This may sound like an expensive investment, and indeed it can be if you are talking about any of the lavish architectural monographs by starchitects that you'll have seen in a favoured bookstore. The same goes for an exhibition of the type experienced in a traditional gallery where images are archival printed, mounted and behind glass.

There *is* just cause in going to such lengths if there are a high volume of prestige projects to share, or if you're developing technologies and new methodologies which are of interest to a wide audience.

The case study for this chapter looks at the work of one such practice, KieranTimberlake in Philadelphia, whose projects are the outcome of significant specialist in-house research. However, KieranTimberlake does not just limit its printed books to high-end, commercially produced, retail-distributed volumes which are sold across different continents. It also creates small, bespoke printed books which showcase specific projects on completion which are shared with a limited audience.

Earlier in *Photography for Architects*, we exampled Herefordshire-based Communion Architects' marketing strategy. Like its American counterparts, it also produces books as part of its regular project workflow. As a small practice, it does not have huge financial resources and more pertinently, it does not have the need to produce materials in high quantities. Instead, like KieranTimberlake's smaller volume productions, Communion can create personalised, printed bound books in short runs that may be updated at any time. The message this sends to both sets of its clients is that it is professional and trustworthy. Its documentation is not positioned as throw-away and is plausibly more memorable than the same information would be if it was only disseminated online. Alex is very clear that the delivery of Communion's books to its clients 'completes' the transition and elevation of what's delivered from 'building' to 'architecture' in their minds.

Using this approach to create limited, single-edition, bound materials for a specific pitch, competition entry or portfolio is more an investment of your *time* than it is actual expenditure. You're already in possession of much information already too, as part of your post occupancy evaluation.

So, what extra considerations are there to be made for such a venture?

Who is your audience?

As with most decisions you make regarding the marketing of your business, you need to ask a series of questions:

- Is the audience a known group of people or clients?
- Is it an anniversary or milestone you wish to mark?
- Has the business undergone a change of ownership, promoted new partners, been subjected to a re-brand or changed direction?
- Do you need to create a gift for a client to celebrate the completion of a scheme?
- Can you share a new technological advance, innovation or the outcome of a body of research?
- Do you wish to reach an audience that you don't personally know, but hope to engage with in the future?
- Do you want to educate? If so, is it a student demographic, professional client base or a mixture?

You are your own fully functioning PR machine, and you should look at who you are targeting as you weigh up the options of taking your story 'out there' in a printed form. You may choose to make a printed folio, book, exhibition or all three. By re-contextualising your historic archive – celebrating anniversaries, restorations, re-uses, etc. – you're getting extra value from the images you've already commissioned. All three of these formats create occasions which have a measurable value to you, your brand and your clients: the bottom line of your business.

You will need to justify their existence beyond your own sense of purpose, otherwise there is a risk that others may brand them as purely 'vanity projects', and that could bring high expenditure coupled with limited benefit to your firm.

Let's look at printed outputs first.

▽

Hopkins in Nottingham: Nottingham on Camera in May 2014 was an exhibition of photographs which celebrated two decades of high-profile buildings in the city by Hopkins Architects. Organised by the RIBA and Nottingham Trent University, it was a focus point celebrating the School of Art & Design's 170th anniversary that year. It created an opportunity to extend networks as well as cementing existing client relationships. This image taken at the launch is by Dan Billings.

Forms and formats – brochure vs book

It makes sense to discern between what makes a book and what is seen as a brochure. In the RIBA's *Good Practice Guide* from 2010, one of the facts given was, "the average time that a reader will devote to a printed brochure is around nine seconds".[1] How this was substantiated is not clear, but even so, at a time when lithographic printing was commonplace, it assumed that we recognised the difference between what we regarded as 'marketing' and what we might value as a book. Perhaps this is even more clear today.

Books, unlike brochures, do not usually represent overt advertising of goods and services. The two items may only have subtle differences. They both may discuss a single project, or a collection of projects, either in completed form, or in progressive analysis from concept to occupancy. However, the way they are offered to the viewer, through the manner and format of their design, will absolutely change the viewer's perception of the intentions and therefore the legacy value of that item.

We mostly engage with brochure information at the point of decision-making *before* an event, as part of our research work. We're unlikely to re-use or re-visit it once the moment has passed, unless we attribute value to the document on its own merit, perhaps as an exemplar in design or print quality.

A book is not like that. We invest more care and time with them when we handle them, we understand that they are a different form of consumption to that of a brochure.

Jan Knikker, marketing director of Dutch practice MVRDV, writes in his 2021 book, *How to Win Work*: "... if a client pays £100,000, they pay for design services and not for a book. However, in many practices, the book is the only product the client can hold in his or her hands and share with others."[2]

Echoing this, it was established earlier how (from a client perspective, and especially perhaps in the case of residential commissions) a project will begin its life in the form of gathered impressions, drawings and photographs, which may find their way onto paper to act as an impetus for design ideas. At the very end of the process, when a building exists, there is likely to be a transition of that 3D reality into a transmutable form through a set of case study photographs. Placed within a bound-book, legacy for that project is created. Yet, for any project book and despite all the design hours of work that go into creating them, they might only ever be printed as an edition of half a dozen copies or even fewer. Perhaps what we are establishing here is that the financial investment you will make with this scale of venture is in the *human endeavour* needed to realise a book, in the narrative, the design and (of course) some fine photography to go with it. However, compared to a brochure, if you consider the longevity of visible exposure and therefore, lasting measure of that item, it could constitute a meaningful return on such an investment.

What type of book?

For some architects, a foray into publishing may be in the form of a request from a third party to write a chapter for a specialist publication which relates to their area of expertise. Adding one's voice to another's output is unlikely to be income-generating, but visibility to the practice, especially when that narrative is illustrated by photographs of one's work, is extremely helpful.

1 Michele Jannuzzi, "Section 5: Branding and Architectural Practice," *Good Practice Guide: Marketing Your Practice* (RIBA, 2010), 79.

2 Jan Knikker, *How to Win Work: The Architect's Guide to Business Development and Marketing* (London: RIBA Publishing, 2021), 95.

If you're an architect with any form of part-time academic position – a role especially recognisable to sole practitioners – then editorial and research contributions to books and journals will be welcomed and positively encouraged by your institutional employer. This is especially in the case of academic publishing, where contributions by individuals are incorporated into the formal recognition of a university's research ranking. This adds to its academic standing and future funding income. You won't financially benefit personally, however your institution may allow you time for research and writing within your contracted hours.

Be aware that if you have commissioned photography of your buildings and the images are being supplied to a third party for their onward use, a licence granted to you, the commissioning party, may not automatically extend to use by another. Legally, this would be seen as a separate usage that is outside of standard copyright terms and may incur reproduction fees, payable by the main author/ publishing house. See *Ch. 14 Whose Right and who's right? Understanding and controlling copyright* for more information. Do not assume that simply because you paid for images of 'building X' and are now writing about that particular project for use in someone's book, that you have the right to pass them on to the third party for inclusion and subsequent publication.

▽ + ▷

When RIBA worked with multiple practices compiling their 50th anniversary guide to buildings of the East Midlands, they communicated with the respective image makers on each case study.

Permission had to be sought for use of Clash Architecture's Level Centre in Derbyshire (cover shot) and GSS Architecture's now sadly demolished Nene Park Restaurant in Northampton which features inside.

If you are self-publishing, and the context of use for the photos is still in line with the purpose for which they were commissioned, this is more likely to be allowed, but a conversation should be held with the image maker in question prior to publication. If the photographer/architect was you and the book you're contributing to is edited by another, fine. It's your project and your copyright, but even so, good manners suggest you might clarify that the agreement you made with the occupier of the building allows it to be passed on to others without issue. Again, this is discussed in coming chapters which examine legalities for image makers.

For most individuals and practices, the opportunity to have one's work in print is likely to be self-instigated and an early decision will need making over engaging a specialist publisher. If financially justifiable, then this contract may include the services of a design and layout team, copy and proof generation, ISBN registration and retail distribution. Books cost less per copy to print as the print run increases. However, architectural titles have traditionally very low sales, they're unlikely to be picked up by any other than very specialist retailers, although you may be able to supply directly through the likes of Amazon, etc. If you're publishing research materials, academic libraries will favour e-books and hard bound editions, but again, the numbers stocking a physical copy may be very low.

For a specialist architectural publisher, every title represents a risk because of these reasons, and it is not uncommon for a publishing house to expect writers/practices to subsidise or even fully fund titles, even if the work is innovative. You might have heard the phrase 'vanity publishing' and practice monographs especially may be seen in this vein. The more well known the brand, the lower the risk, and mainstream publishers such as Phaidon and Taschen have invested in significant print runs and global distribution off the names of Zaha Hadid, Frank Gehry et al.

▽

Tim Griffith's photographs of View Hill House in Melbourne's Yarra Valley have been widely circulated in print, including Birkhauser's 164-page *Houses* monograph which examines six residential projects by Denton Corker Marshall.

It should be noted that since the digital revolution there has been a collapse in traditional print production and the number of independent publishing houses. Very recently, however, there has been something of a renaissance in printed formats. Online fatigue has seen readers recognising the tangible pleasure of books in their physical form.

Changes in digital production have meant a reorganisation in the historic role of publishers and printers, together with a system which previously anticipated high-volume production and large-scale distribution. To some extent this has now largely been replaced by the introduction of online template-driven software. This allows individuals to design and upload their own illustrated manuscripts for printing. Where once individual typeset plates were made for 4-colour print runs, today, now digitally driven print presses create professional, short-run or even single edition bound books for nominal sums.

Volume is still the economic driver. Digital-print houses – Blurb, Cewe, Mixbook, Snapfish, Shutterfly, Photobox (there are many more; see online review articles which regularly pitch them head-to-head) – rely on the use of their services by many thousands of individuals. Even though each creation may be limited by low numbers, the sheer volume of individual albums each business despatches daily allows them to be profitable.

For every architect, there is now an opportunity to create bound folios or books, for a single copy price. These costs frequently match the amount one would be prepared to spend on a quality book in a traditional retail environment.

For a heavyweight publisher hoping to keep production, editing, printing and sales teams active, an editor may need to see several thousand copies of a 160-page title selling at $40 USD before they begin to relax. If you are creating your own 40-page work for your client with text and photographs on every page, you could pay a similar price for one copy and still expect it to look professional on delivery.

Book design

Having made the commitment to create a book, the design and layout of the content should be driven by who is going to read it:

- What do you want to say – who will write it?
- Who is speaking – is it one voice, or will there be multiple contributors?
- What do you want your book to show – who will illustrate it?
- Will it use existing visual assets, or will it require new original photography and illustrations?
- Is it 'new' news?
- Are you re-airing past successes, giving credibility to past design work which you deem is still timely and relevant?
- Who will design it?
- Who will select the font, the graphical elements and the colours (typography)?
- How many copies will be made and what type of readers will be consuming the work? This will affect both the design and the printing method you choose.

Making a **treatment** for your book is a must-do for the project, as costs and time spent can easily spiral out of control if they're not researched and anticipated. A treatment is a document commonly produced by the creative industries where there is an original work being made. Such outputs (often advertising campaigns or films) require a production plan which will be used collectively by all the teams vested in the project's creation. Treatments include concept, mood boards (samples of the visual assets required), creative direction, time schedules, budgets and a list/contact details of all involved in the production.

To reiterate, regardless of whether you're producing your book in-house or out-sourcing, the largest cost to the practice will be in human-hours and whoever and wherever those hours are coming from, they will need accounting for. A treatment is a very good way of pre-planning for that investment.

Types of print binding

If a book is expected to have light handling, which in the case of many short-run, individually produced outputs is likely to be the case, **perfect binding** will suffice. Perfect binding means that a section of folded pages, known as a **signature**, is glued together and then supplemented with other signatures into the spine of the cover. This is the system of soft jacket binding, introduced in the 1920s, and allows mass production for magazines and paperback novels. Books created in this way do not lay flat, so using photographs across double page spreads is not a good idea. Over time they will exhibit wear as the glue becomes brittle and, ultimately, separation. It is possible to have a hard cover for this type of binding which will enable slightly increased durability.

△
Folded sheets: 'signatures' may be grouped together and glued into a jacket creating enough density required to form a book – perfect binding.

△
Wire-o binding allows for flat-lay viewing, ideal for photographs. When protective board covers are applied, these books can be very durable and budget friendly.

For budget flat-lay products, **comb**, **spiral** or **wire-o** binding can be utilised, and these formats are often used by architects for short-run proposal and planning documents generated in-house via an office inkjet printer. This method is less popular for books than perfect binding, although the outcome can be longer lasting.

Ultimately, for a book to become robust, it needs to have the signatures sewn together. The simplest form of stitching is known as **saddle-stitching** and can be used on a single signature for a flat-lay quality leaflet. Art galleries regularly use this method for low page number, high-quality exhibition catalogues.

Using saddle-stitch and then gluing into the spine gives a large book the ability to be opened flat too. This type of production can be used with a soft jacket [Figs 13.1, 13.2], but even more impressively into a hard cover, giving a heavyweight, quality feel to the item. As expected, this type of production is far higher in cost.

Figs 13.1 & 13.2

The true archival method of binding is known as **smyth-sewn**. For this, a series of signatures are collected and stitched together individually along the folds. Each thread is stitched through a page before being tied off. Once a section is finished, it is sewn together with another **book-block** using thread. Finally, glue is applied along the edges of the collected sections to create a robust spine and the cover of the book is attached [Figs 13.3,13.4].

Figs 13.3 & 13.4

Decorative binding types such as **coptic-stitch** and **Japanese-stitch** may be chosen for exhibition style documents, and these can be made by hand, eliminating the need for any specialist materials other than a needle and thread. For a sole practitioner wanting to hand create a bound edition with self-printed materials, it is entirely possible to create something bespoke and collectible. You could specify unusual papers and original mounted photographic prints for something really bespoke. It will rely on a good eye for design and tidy execution though, if the work is to attain a level that you wish to represent your professional output. It's a popular approach for fine artists and art photographers who wish to bind and display their work.

Printed folios

Printed brochures are an overt marketing tool for a firm, but printed, bound visual folios are seen more as a hybrid venture – neither blatant marketing, nor a fine-art output. They are typically image-heavy and text-light, with a high print quality and designed with a pre-requisite for a flat-lay viewing, allowing large images across double page spreads.

Again, there are a multitude of different print methods, and returning to the online-on-demand suppliers, they will certainly boast sections of their websites dedicated to promoting photography to its highest level. Expect double-weight photographic papers bound in durable covers. At a price. Nevertheless, for a tribute to one's output over a period of time or for a specific project, they will command a high-profile space on the office reception desk or coffee table.

Short books of the nature described earlier are sometimes seen accompanying exhibitions, so let's now look at what displays and gallery shows might encompass in terms of organisation and investment.

▷
Flat-lay bound folios may be printed on heavy weight glossy, silk, lustre or textured papers. Underhill House by Seymour Smith and FaulknerBrowns' Baddiley-Clark Building at Newcastle University are shown. Perhaps it's easier to think of these as 'photo-albums' rather than books in the conventional sense, even though they are bound in the same manner.

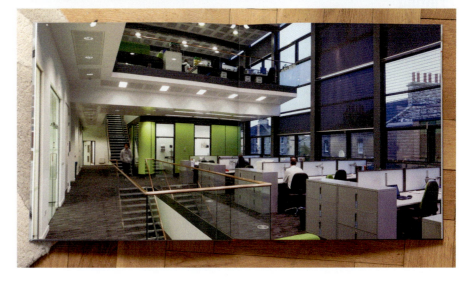

Exhibitions

When we say 'exhibition', we are not thinking of trade events, where a practice might expect to have a display of materials encompassing past, present and planned works along with marketing materials. Instead, we might consider a notable occasion where one might expect the firm's output to be displayed as a gallery-stye endeavour, and for more time than one or two days, allowing for multiple visits by numerous visitors to view the work on show.

As with the book concept, a show is likely to be driven by a timely occasion: a milestone event, an anniversary or a merger in the life of the practice. I've had my pictures in exhibitions celebrating 10, 25 and 50 years of various architectural practices I've worked for. They've been used to mark the geographic location of a particular starchitect's output, the centenary of an architect's birth, another's death, the publication of a book by a client and the completion of a major scheme ... the list goes on.

These endeavours were all single company/individual name driven, but group shows under a specific topic are another (and perhaps more probable) route for your work to be shown. These events are more likely to see regional or national municipal galleries getting involved. Shows may exist to celebrate a particular movement or period of buildings, a place, a festival/expo or a topic for discussion, e.g., sustainability, renewal, or a material (for example, concrete). Again, I've had photographs appearing under all these themes, and one of the most interesting was to celebrate the twinning of two cites. This meant taking the work of many practices to China, showcasing outputs to a previously 'unknown' audience on a very different stage.

Dependent on how an exhibition comes into being and under whose patronage it takes place will dictate how your materials are displayed. Certainly, shows under one's own creation are likely to draw on existing materials which the practice has previously created. These may include drawings, CGIs and physical models as well as photographs. The scale at which they are displayed should bear a direct correlation not just to the venue's size, but with consideration to the assets themselves.

Printing

Ch. 9 Briefing your image makers: What should they be doing on your behalf? touched briefly on output size as part of deliverables. Screen resolution is a lowly 72dpi and photographs printed at this setting will look fuzzy and difficult to view. The smaller the file size of the photograph you hold, the poorer the image quality will be at larger scales. You will doubtless have visited exhibitions where the dimension and scale of the works on display have been taken far above their comfortable size. In any type of print output, the dots-per-inch or pixels-per-inch, which inkjet prints use to spray the colours onto paper, need to be relative to the viewing distance by the visitor. In most cases, this is either 240dpi or 300dpi.

How far physically one can stand back and look at each print with comfort will dictate the largest size you may print to. Vector drawings and CGIs may be enlarged without overt quality compromise, but the same may not be said of photographs, whose original format *must* be taken into consideration.

▷

Consider the size of the original file generating the print. Whilst I chose the output size for two of my shows at Lakeside's Galleries in Nottingham (top and centre), the designers based at Ningbo Museum, Zhejiang Province, China printed several of my images for the exhibition there extremely large. Luckily the TIFF files supplied were over 100MB each.

If you are generating prints from archived 35mm negatives and slides – a format that many architectural practices will recognise in their files – quality considerations also apply. Prints from 35mm black and white negatives can sometimes cope with going larger than A3, and 35mm slides *projected* can still look decent at scale, given the nature of the transmission.

If your show features older work from the company's history, use of projections is considered 'old-school' but likely to be regarded with affection. If you're showing existing colour or black and white prints than you own, that's great. If your archive holds unprinted negatives or transparencies/slides, be aware that an intermediary scanning process will need to take place before printing.

Larger format film emulsions will mean a greater size of output before quality deteriorates. Scanning analogue photographic materials is a slow and often costly process. The larger format the original film, the higher this cost will be. For built environment subject matter, professional architectural photographers previously worked on cut sheet film, with cameras generating 5x4" transparencies and negatives. Because of their large surface area, these were subject to dust and scratches, and if you hold sheets which were also once used for drum scanned lithographic printing, then they may be quite damaged.

When film was loaded in dark-slides for shooting, it was prone to capturing dust. When these archival film sheets are scanned today, additional particles in the atmosphere may be recorded during the process. This results in extra work post processing; digitally cleaning them up. There is no magic button, instead it requires painstaking time sat clicking a mouse, 'painting' them away with the 'heal' tool.

The Ikon Gallery by Levitt Bernstein and no.2 Brindley Place by Allies & Morrison are seen here on the cover of the book celebrating the redevelopment in the 1990s in this part of Birmingham. Captured at a time when digital photography was not possible, the 5x4" transparency was lithographically drum-scanned for publication. It is possible to see the extensive marks on the sheet of film (left) which were revealed after scanning but prior to cleaning.

Expect the re-touching associated with these new scans to be time consuming and therefore rather expensive. A single 5x4" transparency may take a notional couple of hours of work to accurately remove all traces of dust and scratches, together with matching its colour fidelity with others in the photographic

collection. High-quality scans from 5x4" sheets can yield exhibition quality prints on a vast scale though. They can be quite something to behold.

For digital photographs, whether scale becomes an issue will again depend on the file size you're working with. If you're not the image maker, speak to them and ask if they might supply you with an RGB TIFF to work with. To recap, TIFFs are stable, lossless files which will retain fine detail and colour integrity when created from a camera's RAW files. Again, the more professional the image maker, the higher quality of camera equipment they're likely to be shooting with and the final size of your prints may be of considerable scale.

We have been talking about the limitations of grain in analogue film and the pixelation factor within digital files when viewing fine details in a scene. Remember as we've said, the larger you print, the greater the viewing distance your audience will need to appreciate the full impact of the piece. You'll always need to design your display in conjunction with the actual venue you are planning to show in.

Be aware that if you're having a book created from analogue film stock, the same intermediary scanning and cleaning process will also apply before your publisher can proceed with their printing task.

▷
Stanton Williams' Whitby Abbey Gatehouse was shot on 5x4" transparency. Scanning at a size too small relative to the display size required for a typical exhibition print would result in noticeable pixelation, colour banding and a second-rate outcome. It is possible to see blocks of pixels across the blue sky. Keep materials small in such instances.

Venue options

Municipal galleries are likely to respond to proposals for shows by the famous, or those working with known historic buildings. This is understandable and leaves commercial spaces as the more obvious route for short-term rental. However, creativity and resourcefulness are things which architects and image makers share, so thinking *outside* of the obvious routes with regard to an exhibition venue could leave a larger budget for the materials you wish to have on display. Assuming the desire to mount an exhibition is self-generated and plausibly self-funded, looking at means of mitigating cost and reaching your target audience is vital. What venues do you have to hand?

Venue Type	Pro's	Cons
Your own offices	Free – a good reason for a tidy up and an opportunity to show off your operation.	For smaller practices anxious not to reveal the nature or scale of their operating space, this might be less welcome.
Local cafes, community, cultural spaces and visitor attractions	Public, private and not-for-profit operations may have wall space that they will lease for a period at a nominal cost and may come with the hospitality amenities associated for that all-important private view.	Such places may ask for what you show to tie in with their own visitor demographic. That's great if your portfolio is visually empathetic, but not so good if your output is industrial warehousing and distribution or business parks.
University Gallery spaces	Many architects enrich their career pathway through associating with their alma-mater or architectural department of their local university. Most institutions have their own showcase space and if such links between you exist, they may be prepared to host your exhibition for little or no fee if you are prepared to fund the materials, design and curation for it. Tying in alumni success or work experience options for their current student body can do much to further your desire for a holding a show.	Beware peaks and troughs in the academic year. You are likely to meet with a conflict over timings for spaces being available, e.g., mid-summer which means a dearth of campus activity, versus student presence and therefore an impetus for the institution to work with you.

Consider your show as an opportunity for involving stakeholders who have a vested interest in what you are doing. Your exhibition may be about you and your work in the first instance, but architecture is always a collaborative process and there could easily be other teams in a project's framework, known to you personally or in your geographic environs who will either match fund financially, or in-kind with premises. Add their own marketing and networking weight to the mix, and you may find you're able to use your exhibition concept as a reason to celebrate whatever it is you wish to mark, but also as a means for reaching greater markets for your skills.

Curating new audiences, as well as enriching relationships with your existing clients, are likely to be core objectives of your book or exhibition concept. I spoke to Philadelphia-based architect James Timberlake and members of his team at KieranTimberlake about projects and research that they've successfully taken to a wide international audience in a number of different forms.

Venue Type	Pro's	Cons
Pop-up gallery	Dependent on when you are reading this book, we may be in a period of economic flux, and there can often be empty retail or commercial spaces available in city centre locations with agents who could be receptive to the idea of a pop-up gallery space.	Beware of lighting in non-designed spaces. Pop-ups may have connected services, but they may also have large curtain walling facades, allowing for uncontrolled daylight and glare on glass frames or print surfaces.
	Such units are likely to boast connected services, white wall space and staff amenity areas, meaning restroom and kitchen provision.	Especially in older premises, internal lighting may be a colour that is not conducive to the work shown; it may be too warm (orange), too bright, or even not bright enough.
	These are considerations for the all-important reception and private view, accompanied by high street accessibility for general public visits.	How will security work for premises which either front onto a busy street, or conversely are in a remote situation?
		Another consideration is negotiating leases on short-term rentals. Any agent will be reluctant to commit to you until the last hour, in case this precludes a new long-term tenant signing up with them.
Premises associated with your professional network	Of course, if your own client base is one which includes commercial developers, there's always their own activities and connections; might you have a project for them that's a speculative build?	Using someone else's non allocated space is fine but beware an offer from a kindly client offering their own operational premises, or risk your show being about them and their interests.
	If so, both they and their letting/sales agents may be receptive of a reason to bring visitors to their door.	

KIERANTIMBERLAKE

Founded in 1984 by partners Stephen Kieran and James Timberlake, the practice operates out of a single office with over 100 staff. The company ethos rests on: "Provoking change within the practice of architecture by pushing the boundaries of current norms for design and construction..."[3]

This is through robust research and continuous deep questioning about materials and methods. Their output has received hundreds of design citations, they employ in-house research staff and to-date, between them and their research staff, have authored a total of eight books. These have covered a variety of areas, some as single project case studies, such as the broadly circulated *Loblolly House: Elements of a New Architecture* (2008). *O*thers investigate processes, such as *Refabricating Architecture* (2004) or most recently, *Fullness* [Fig 13.5], published by Monacelli Press in 2019. Their work is held in multiple international university libraries and studied by students and fellow professionals alike.

Fig. 13.5

Fullness is a boxed pair of books comprising a hard bound image album, running to 365 pages. It features 17 separate built projects, lavishly illustrated with barely any accompanying text. The album is preceded by a co-authored essay from Stephen and James and supplemented by a second, soft jacketed 247-page

3 See https://kierantimberlake.com/page/ profile.

collection of written (and further illustrated) accounts of the design, function and execution of each project. These volumes offer an insight into the work of the company and allow for validation of a mature, confident and ever-innovative practice whose outputs are operational on both sides of the Atlantic.

Whilst in conversation, I asked about the unusual approach taken in *Fullness.* This elevates photography beyond mere illustration, allowing it to become something seemingly far greater for their work.

Despite having an extensive photographic archive, KieranTimberlake's previous books have been more text-based to convey their extensive inquiries into design and processes. For their latest venture, however, they wanted to gain a balance between the two aspects of their work, their research-based practice, together with visual exploration of the buildings they deliver, hence double folios.

Daniel Preston, Visual Communications manager picks up the story:

> **"*Fullness* was our first divergent in that direction to really use images and graphics to explain who KieranTimberlake is, and the KieranTimberlake ethos. This is a balance of both the written word, the images and supporting visuals… one of our first forays into using images as methods of storytelling and communication. Publicly, at least we do that in interviews and proposals all the time."**

Daniel asserts that the practice website and in their marketing materials, photographs have always played a substantial role too. Yet, with *Fullness*, they saw an opportunity to fully embrace the photographic image and the partnership that goes with the photographer and architect, something that *Photography for Architects* also affirms. James explained that he and Stephen learnt of such importance whilst under Venturi Scott Brown's tutelage. He went on to say that they both came to sense that as designers:

> **"We and the photographer are essentially joined at the hip. Selecting the right photographer is always a critical element in terms of shaping or representing our brand vision, because we're trying to communicate certain things about space or about the elevation."**

The practice understands that operating *without* robust visual documentation is a struggle, and that readers of their books need to see what has taken place in the creation of a building. In the case of *All In*, these significantly outweigh the written word. Indeed, James stresses that without photographs, "… we can't leave behind the legacy of the kind of research that we do. We know students and other architects often buy our books, [to learn] 'how did they do this?'"

In *Fullness*, the depth of coverage for each building varies according to which of the two volumes one is perusing at the time. The soft jacket version, titled *In All*, is immersive for both its narrative, the use of technical drawings, discussion of site topographies and a mixture of both construction shots and post-occupation photographs.

△
The practice describes having a stable of 'go-to' photographers it uses, selecting who they feel holds the right approach and empathy for any given project. Here, their natural choice was Tim Griffith who shot High Horse Ranch in Willits, California.

▽

With full bleed images (no white space) and generous white borders on other pages, images throughout *All In* have room to breathe and allow the viewer an unabashed private view of each building. Other than a single paragraph opener, the viewer is invited to browse slowly though the projects revealing a series of spaces in use, with no text, graphics or any other means of distraction from photographs.

With a subtle shift in context name-wise; the hard bound album – *All In,* is a very different experience – rather intimate. It's akin to spending quality time with each project, a sort of gallery 'private view'. This feeling is possibly down to the way in which the volumes are designed and presented in their slip case. Other than a short paragraph ahead of each set of plates, there is no narrative. One's time with each building is communicated entirely through the photography. Throughout *All In,* the reader is given *space* to visit private houses, university residences, academic buildings, spaces for art, worship and public realm, offices and finally, the US Embassy in London.

△
The US Embassy in Nine Elms, London was shot by Richard Bryant over several days, and he was visited on site by James Timberlake as part of the practice's quest to support its image makers in the field.

Despite the quality of print and production contributing to a 'trip to an exhibition' feel to one's journey, the images are *alive*. These buildings are not ghost towns with tumbleweed rolling through iconic white-cube spaces. Instead, they contain students, workers and the general public. Each location is animated; living and functioning as intended. The photography communicates success, affords James and his team respect and credibility, yet when aligned to the accompanying *In All*, it never allows the venture to become 'show-off'. This is because the publication also serves to inform and educate.

James feels this positioning was vital for the practice, explaining he perceives that many architectural monographs by headline firms are image based, often sitting:

> ... as big pictures on coffee tables and they're known [these practices] for their brilliant beautiful work, but they don't say many words.... *Fullness* was addressing a criticism that we felt before we won the competition for the [American] Embassy that somehow our work was research-driven and process-driven. Or that the beautiful outcomes were, subjectively, not up to, Foster or Rogers or somebody else like that. And I think, we 'know better', and we see that photography knows better because of the images that we have. We've got beautiful photography going back 37 years.
>
> Ultimately, it's the wholeness of it, the holistic nature of our work that we wanted to represent in Fullness. So, it is not just about superficial beauty and that kind of image of the building, but it was also the depth of what's behind those images and the beauty that underpins all of it.

This is a high-cost venture, and one which few businesses would be able to justify, yet supported by KieranTimberlake's other stable of publications, *Fullness* has space to function in this manner amply. The last chapter illustrates the American Embassy in London. For this set of photographs, James worked with UK-based Richard Bryant.

Bryant's images have come to represent globally what people understand of the Embassy. It has many private parts to it, as well as public spaces and a facade which communicates the confidence and authority of the country it stands for.

Interestingly, James and his team recognise that not every audience is likely to engage with *Fullness*, and they have also created a standalone 48-page building study on the embassy, which is not distributed through retail sale [Figs 13.6, 13.7, 13.8, 13.9, 13.10]. Aimed at their own professional network, this allows for a wider use of the images, in context with narrative and plans. It sits as a short-run, perfect-bound portfolio for this specific project.

They use materials like this *not* to supplement the voice that *Fullness* has, but to sit independently of it. Both outputs have distinctive roles and are understood within the hierarchy of the firm's brand. Indeed, as James observes, "We don't exist without sales, so the photography has to be turned into values somehow. Otherwise, nobody knows what we do."

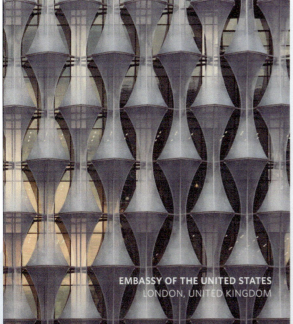

EMBASSY OF THE UNITED STATES
LONDON, UNITED KINGDOM

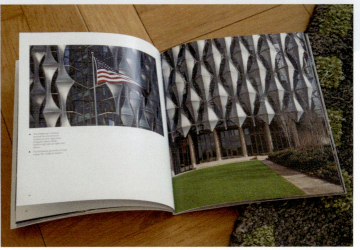

Figs 13.6–13.10

Today, where one would expect the dissemination of information about architects and their outputs to be online, KieranTimberlake uses the images it curates in multiple endeavours, extending to books, printed folios and (although not discussed here) exhibitions too. They truly understand the value of high-quality, communicative photography within this process.

Summary

Remember, with any endeavour, unless there's a need to disseminate your work for reasons which are greater than you and your work are personally, then most book and exhibition exercises will need to refer to the bottom line for your business.

As a single event, they may be more than justifiable, but are unlikely to see regular repetition as their financial impact may be difficult to bear too often. Make sure you put on a great display, not just a 'dog and pony' show, and then your past, present and future audience may just come along for the ride.

CHAPTER 13
TAKE-OUTS

▶ Most singular showcase events do not relate to the regular business year. Small, printed books, larger editions or exhibitions will be staged in honour of something 'significant' to you. As part of your business planning, factor this in to your long-term ambitions.

▶ Define – what is the occasion? Aim to mark it accordingly.

▶ What is your audience for such a venture? There must be a reason, and a market for this work, otherwise it is at risk of being labelled a vanity project and could gain little support from those who deem it risky and pointless.

▶ For publications, the smallest venture can be meaningful, but be sure to understand the difference between a brochure and a book. They both have different and worthwhile functions, and your audience will need to be clear which type of artefact they are engaging with.

▶ Being asked to contribute to another writer's book is one means of allowing both your voice and your work to be aired with limited, or even no, financial risk to your company.

▶ When creating your own publication, be sure that if you are not your own image maker that you have the rights to be able to use visual materials of copyright holders in this way. See *Ch. 14 Whose right and who's right? Understanding and controlling copyright* for more information about intellectual property and *Ch. 17 Forever in view: The global image market* about licences.

▶ For short runs or single editions, compare the plethora of on-demand digital print houses whose template-based software generates hard or soft jacket books with a professional appearance. These can run to any number of pages.

▶ If you're not using a template approach, carefully consider the design, form, paper choice and printer for your book. Do you wish to sell it? Then you'll need a distributor and an ISBN for stockists to work with.

- ▶ Create a 'treatment' for the project, which will help it stay on time and on budget.

- ▶ If you're planning an exhibition, again, be sure of your reason for staging it when you do, as it is likely to be self-funded and will need a reason to come into being.

- ▶ Consider the scale of materials on display: quality, size and viewing distance should be carefully planned.

- ▶ The show itself will need a design concept, navigation and with that 'call to action', i.e., to come and visit your show, what are the viewer's take-outs? How does your show function for the audience? This needs careful curation.

- ▶ if you're using existing archive films, you may need to get them scanned and retouched prior to printing. This exercise may have time and budget implications.

- ▶ For contemporary digital photographs, be sure to use high-quality RGB TIFF files for printing with and choose 240dpi as a minimum for output.

- ▶ If an existing gallery space is not possible, consider your own network. Your alma-mater or current educational links may offer space. Pop-ups are an option, or utilising your own client projects, or client connections may yield terrific locations for a show.

- ▶ Watch out for lighting and security issues with non-specific venues.

- ▶ Finally, whatever it is you choose to create as legacy, make sure it does what you want – to bear witness to your work, share it with others, and enjoy that moment.

▷ Part 4

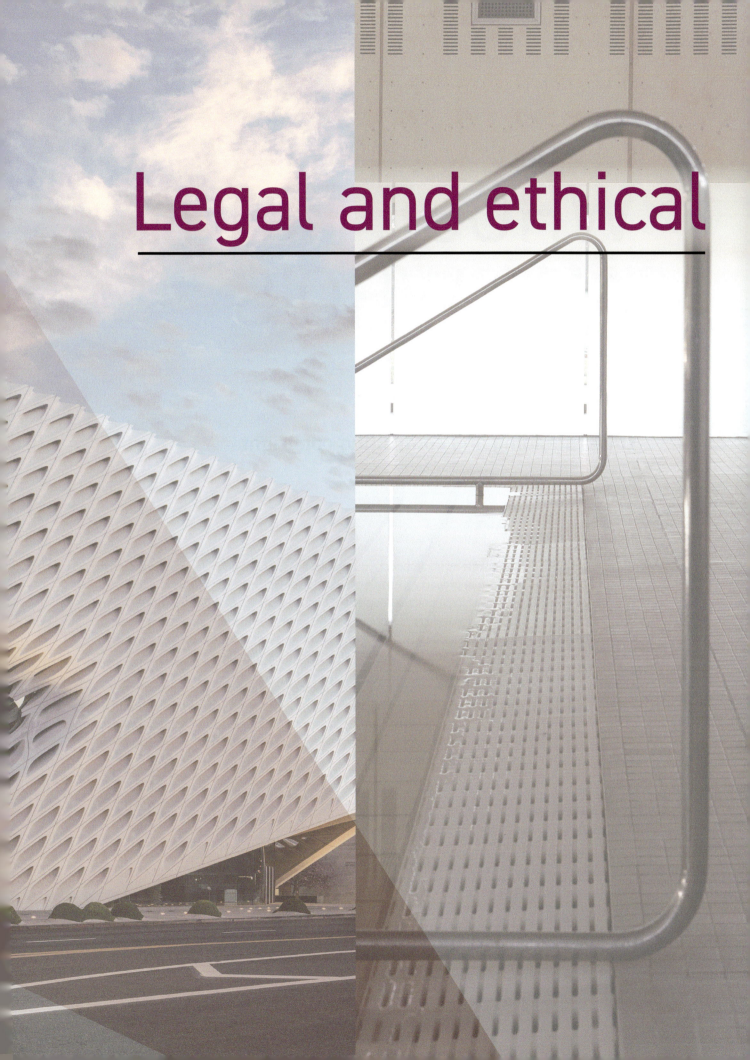

Legal and ethical

WHOSE RIGHT AND WHO'S RIGHT?

Understanding and controlling copyright

In your role as an architect, you should already have an understanding of what **intellectual property** (IP) or 'matters of the mind' mean to you, as it is part of the professional practice element of degree study – within 'Part 3' in the UK. In the case of visual representations of buildings there are IP interests in these materials too. *How* and *where* we use creative visual assets is affected by legal rulings, with variances in rights and restrictions globally.

I will mostly revert to talking about 'photographs', but this also encompasses the moving image – films and videos. How they are treated is in tandem with IP rights granted to designers of built environments, together with the drawings and plans for them. However, there are specifics relating to original images *and* their copies which we should cover.

▷

Having the legal ability to be able to use your images will be vital to the success of your brand. Giving them titles is equally vital if they are to communicate effectively.

In *Photography for Architects*, labelling this picture of Victoria Leisure Centre by Levitate Architects is both a moral and legal obligation. If Levitate was to use this image, they, in turn, should credit the photographer, in this case, Martine Hamilton Knight.

We shall briefly look at patents or trademarks, which are a form of IP in their own right. Being respectful of their existence is vital as some of the designed but industrially manufactured items or objects we include in our photographs could be protected by patents and trademarks. Infringements of any of these may attract attention and possible litigation.

Laws change over time, but more pertinently, so might one's position too, from that of creator of original works to being the recipient and user of such output. As a result, it's probably first worth checking what is understood by intellectual property and the protection that is afforded to it under the title of **copyright**.

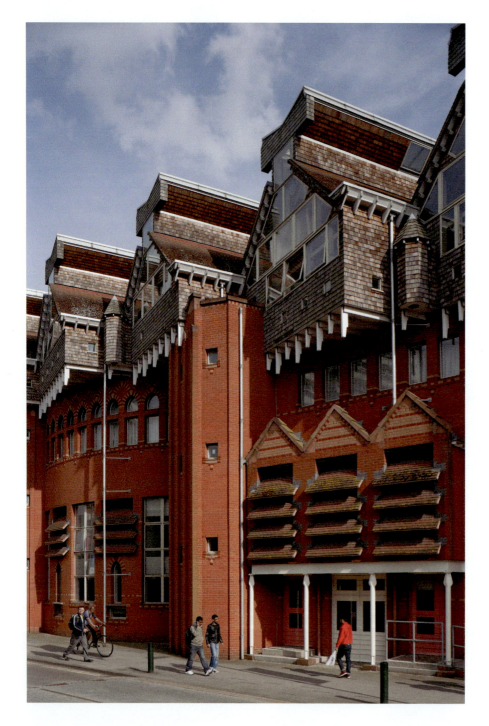

◁

The Queen's Building at De Montfort University in Leicester by Short Ford Associates was completed in 1993 and is Grade II listed. We recognise that listed buildings are afforded protection and that the original design of such a structure is subject to a country's copyright laws too. They protect the original designer from having their work lifted and directly copied by others.

Copyright protection is also given to images and artworks made of realised designs. The creators of original drawings or photographs hold their own rights which may be identified by the © symbol preceding their title.

What is copyright? What does it cover?

Firstly, one cannot assert rights over thoughts, conversations, concepts or ideas.

Original artistic works such as photographs and architectural designs attract intellectual property rights. These are *rights of ownership* over those ideas once manifest. So, a conversation about ideas relating to architectural designs can only be protected if the conversations are recorded in some form.

Copyright is a *property right* (from a physical standpoint) but, perhaps confusingly, it is also an intellectual property right, because it concerns matters 'of the mind' as well as in the physical form it might take. Creative materials are afforded legal protection for the owner. Beware not to confuse the term 'property right' as a right relating to physical buildings. In this book, we refer to property rights as relating to *images*.

It is important to understand that whilst copyright applies to 'things' rather than 'ideas', it still exists beyond the physical output. Buying a CD, book or framed photograph from a gallery might mean that you own the material asset, but you do not automatically control the intellectual rights associated with the item. You cannot duplicate that artwork and re-sell it onwards under your own name, you've simply acquired a non-exclusive item with certain limitations over your use of it.

Territories

Geography has an impact on the laws which surround image makers and designers. Under each country's government umbrella organisation, individual legislation defines the specifics of their affairs. For the purposes of this book, and for each of our topics not to become sprawling in content, it has been decided to focus on British, European, US and Australian Law. The subdivision of intellectual property laws which relate to single (still) and moving images of architecture are **Copyright Laws**.

Foundations of copyright laws and the bodies protecting them

From a broadly global perspective the **World Intellectual Property Organization (WIPO)** protects matters relating to patentable and copyrightable works. As original creators, individuals can assume legal protection in some form or other, wherever they reside. The right to be attributed as a creator is known as a **moral right**, which we discuss later in this chapter. Copyright laws cover duplication, reproduction and circulation of materials, together with the right to economic recognition where appropriate.

Detail varies from country to country, but within continental boundaries, norms exist and a number of conventions and treaties protect the rights of member states and their respective residents. The United Kingdom, Europe, North America, Australasia (indeed, a total of 179 countries) lie within the jurisdiction of a nineteenth century agreement, the **Berne Convention for the Protection of Literary and Artistic Works (1886)**.[1] This was later supplemented by the **Rome Convention for the Protection of Performers, Producers of Phonograms and Broadcasting Organisations.**

1 The Berne Convention, adopted in 1886, deals with the protection of works and the rights of their authors. It provides creators such as authors, musicians, poets, painters, etc. with the means to control how their works are used, by whom and on what terms. It is based on three basic principles and contains a series of provisions determining the minimum protection to be granted, as well as special provisions available to developing countries that want to make use of them. See www.wipo.int/treaties/en/ip/berne/.

Architectural designs, photographs and the moving image fall within these bodies of legislation. Under the Berne Convention, all literary and artistic works receive automatic protection *without* the need to register their existence with any governing body.

In the UK, original works and their interests are protected by the **Intellectual Property Office (IPO)**, in Europe by the **European Union Intellectual Property Office (EUIPO)**, the USA by the **United States Patent and Trademark Office (USPTO)** and Australasia by the **Australian Copyright Council**.[2] Other countries each have their own bodies dealing with their respective jurisdictions.

Given that the UK was part of the EU until recently, there are strong parallels between UK and EU copyright regulations, so UK readers should also use this as a basis for broad European understanding. However, where the UK and Europe deviate in their approach relates to their stance on property right ownership.

As a property law, there are responsibilities which come with the ownership of that property. Any exceptions or limitations mostly apply to **Human Rights**. This is because Article 27 of the **Universal Declaration of Human Rights** decrees that:

- Everyone has the right to freely participate in the culture of the community, to enjoy the arts and to share in scientific advancement and its benefits.
- Everyone has the right to the protection of the moral and material interests resulting from any scientific, literary or artistic production of which he is the author.[3]

These points mean that interpretation and argument can be founded on two very different voices, dependent on one's perspective and geography. UK, Australia (as a Commonwealth country) and the USA laws broadly fall into line over economic exploitation. This is recognised as the **Common Law** tradition.

In the European Union, the precedent is with **'droit d'auteur'**, which places personal or moral rights *above* those of economic interests.[4]

So, in essence, point i) states that we all have the right to enjoy artistic endeavours, whilst point ii) says that the creators of such endeavours are to be recognised for their works, both from a naming perspective and an economic one. Depending on where you are working in the world, then those interpretations may shift in emphasis between favouring either the artist or the subject of the work itself.

Current legislation in Europe

As implied by the nineteenth century date of the Berne Convention, copyright legislation has existed for a long time and throughout that period, the methods of making creative works have evolved from traditional analogue processes to largely digital ones. Protecting the intellectual property of a drawing or photograph generated by a unique physical negative used to be relatively straightforward owing to the limited means of duplication and distribution of that asset.

2 The following URLs will take you to the websites of the governing bodies for each territory: www.ipo.gov.uk, www.euipo, www.uspto.gov, www.copyright.org.au.

3 See https://en.unesco.org/human-rights/cultural-life.

4 The direct translation of 'droit l'auteur' is 'copyright'.

Today, creation and dissemination can be almost instantaneous, universal and once into the hands of third parties via the web, it is largely unstoppable. This has very real ramifications for the elderly copyright laws which currently enshrine protection.

The EU recently issued a directive which contained guidance for uses of works in the digital realm, and it is down to member states to place these within their own frameworks as they see fit. Reading through this documentation may be of use as it introduces some of the issues at stake when dealing with the mass distribution of copyrighted materials across the web.[5]

Copyright laws in the UK

Until 1988, copyright rested with the commissioning party, and this was defined within the 1956 Copyright Act. For those hiring creatives, the work done under contract came under the full ownership of the paying party. Following the passing of the **Copyright, Designs and Patents Act 1988** (hereafter referred to as CDPA 1988), this has no longer been the case. This act also covers architectural designs and, as such, is a useful piece of legislation to come to understand.

Today, creators maintain control of their works, even after the invoice has been paid. Commissioners will have rights to do certain things with the materials as part of the commission, for example, to use them in publicity, but these permissions may come with limitations set out by the creator and agreed with the commissioning party. Because of overlaps with other matters of law, including those of contract, competition and human rights, interpretation and application of copyright law can sometimes be tricky to pin down.

Copyright in the USA and Australia

The USA's main act came into force in 1976 and Australia's Copyright Act is even older, from 1968.[6] Each set of laws have had updates since, indeed, in the USA, the current legislation protecting architectural designs came into being in 1990. This defines 'architectural work' as 'the design of a building embodied in any tangible medium of expression, including a building, architectural plans, or drawings.'

Still fit for purpose?

Despite various updates in each country or group of countries, it may be argued that copyright laws globally should be revised in their entirety. Because of the dynamism of the world wide web and its ever-changing forms and authority, many legal frameworks can best be described as 'inadequate' given that they were conceived in a thoroughly pre-digital era.

In addition, our online world means that very urgent conversations need to be held about AI – 'Artificial Intelligence' – and fully automated digitally created content.[7] As a starting point to this, the USA's **Digital Millennium Copyright Act 1998** made it illegal to copy another's work in a digital format.[8] Whilst enshrined through US law, the act now extends through to countries operating under WIPO treaties, so it is fairly universal.

5 New Directive on Copyright and Related Rights in the Single Digital Market – https://op.europa.eu/en/publication-detail/-/publication/288dad28-9d3d-11e9-9d01-01aa75ed71a1/language-en/format-PDF/source-164638297.

6 USA Copyright law foundations and principles – www.copyright.gov/title17/; Australia's 1968 Copyright Act – www.copyright.org.au/ACC_Prod/ACC/Browse_by_What_You_Do/Photographers.aspx.

7 Spring 2023 saw an explosion in awareness of how much AI was beginning to take centre-stage within the spectrum of visual content. Long superseded, https://thispersondoesnotexist.com/

8 The Digital Millennium Copyright Act 1998 – www.copyright.gov/legislation/dmca.pdf.

Copyright protection for built architectural designs

It is important to recognise that whilst an architectural form in its three dimensions is an artistic work protected by copyright, in the UK and some other countries including Australia, the following actions *do not* infringe these copyrights:

1. Making a graphic work representing the structure
2. Taking a photograph of, or filming, the structure itself
3. Broadcasting, or including in a cable programme service, a visual image of the building

An architect does have the moral right to be named as the designer of the building when photographs or films of the building in question are published or broadcast. Copying the *design* of the building itself, and physically constructing another building in the same form, however, is a copyright infringement. The visual recording of structures in graphic works, photographs and moving images is permitted through what is called **Freedom of Panorama**. Given that these rights are to do with *where* one is physically taking photographs from and *what else* they include, we shall deal with Freedom of Panorama in *Ch. 15 The law and you: Legal rights and obligations.*

▽
The *form* of the Manchester Civil Justice Centre (affectionately known as 'the filing cabinet') is protected under copyright to Denton Corker Marshall as the designers. The visual representation seen here by photographer Daniel Hopkinson is protected by copyright too. Images and films may legally be made and broadcast without infringement.

Duration of copyright

As we've established, in the first instance, the copyright of a photograph belongs to the creator. In the UK, EU and USA, this right exists for a period of 70 years beyond the creator's own life span. Outside of these areas, any other country which signed the Berne Convention adheres to a period of 50 years after the death of the author. There are a few exceptions to this, for example in Mexico life is +100 years, so do check. As a property right, copyright is part of the owner's estate and on death may be passed to those inheriting it.

Once copyright expires, generally others are free to use the work as they require; the work is deemed to have entered the **public domain**.[9] There are certain territorial differences again though; if a work has entered the public domain in one country, it may not necessarily have done so in another. One such exception may be the USA.[10]

How to establish the timing for copyright attribution

The 'time clock' for starting copyright protection usually means from the point that others become aware of an artistic output existing. This is known as **First Publication**.

In analogue materials, the only way of finding the correct attribution for a protected work is to read any physical documentation travelling with it. Today, the use of analogue film is unusual, although it is still favoured by art photographers. Analogue materials do not carry date-related information embedded within them, and therefore date of first publication becomes difficult to ascertain without recourse to the original creator.

For a digitally captured image, this critical information may be found within the **metadata**. This is written information which travels alongside a photograph in a sidecar file, also known as **EXIF data**. This data is revealed via the use of certain image-based software. In terms of actual copyright 'start', the metadata created by a digital camera registers the date and time point of file creation and if GPS-enabled, also the location. This is stored within the file itself and proves its point of creation. Photographers can enter their name and even their contact details in their digital camera which embeds itself in the sidecar files generated by the camera as well.

If you are asserting copyright for visual images using photographic-based software, there will be a way of making the metadata template visible and allowing you to record information relating to the ownership and many other aspects of that file's status in the various fields within it. Commonly used image software includes Adobe Lightroom, Adobe Photoshop and Serif Affinity. Using dedicated programmes allows you to create standardised templates which may be applied in 'bulk'. This is timesaving if you are working with multiple files of the same project.

9 See www.dacs.org.uk/knowledge-base/
 factsheets/works-in-the-public-domain.

10 A useful table helps understand
 differences on date for works entering
 the public domain in the USA –
 https://copyright.cornell.edu/
 publicdomain.

△
Darlaston Pool in the West Midlands by Hodder Associates was photographed in 2002, prior to widespread adoption of digital cameras. In its original form this photograph exists as two physical sheets of 5x4" transparency film, one of which is held by the photographer and another by the architect.

Only by asking the image maker or architect when the picture was taken could anyone know. Even scanned today, it still would need the date manually inputting into the title or the accompanying sidecar files that are created with digitally created scans.

▽ + ▷

Walsall's Premier Inn by Shed KM Architects is a digital file. On almost every type of digital camera it is possible to enter the photographer's name and basic details into the software via the camera's main menu. This information gets recorded along with other data about camera settings every time you activate the shutter and create an image file. This is stored in the XMP data with the picture. At the point of downloading the file from the camera, it is common practice for a photographer to immediately embed any supplementary copyright details into the metadata, even if they don't add the project name and architect at this point.

Copyright is thus asserted as shown along with file creation date which the camera itself records at the moment of image capture. There are other fields in the template which are of great relevance when a photograph begins an online life, which we cover in *Ch. 17 Forever in view: The global image market*.

Interestingly, for a UK project like this one, the copyright date will only run from the point of first publication. The file may be held privately for a period and the clock's ticking can be deferred until the picture leaves the photographer's computer and is passed onwards for first use by the client. Sadly an issue rests over metadata's ability to be stripped out; however, as creator, you should still hold the original file with the earliest file date which can be used in a legal challenge.

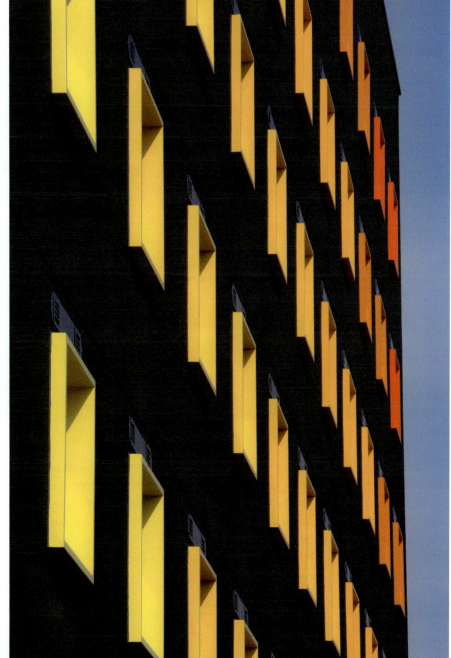

Viewing metadata for a photograph is possible without utilising specialist software too. Simply right clicking on an image to reveal 'properties' or 'info' in a standard image browser will bring up the details, as seen here in Leonard Design's first phase of Nottingham's Broadmarsh redevelopment [Figs 14.1,14.2]. Adding your own information to individual files is possible by opening the image in the default programme or photo app, and entering detail into the various fields, e.g., title, caption, location. For more on metadata, including the addition of keywords, see *Ch. 17 Forever in view: The global image market.*

Figs 14.1 & 14.2

In practical legal terms, 'publication' might not mean in a book. It simply refers to the point of first distribution, when it leaves your hard drive (or for celluloid film work, the darkroom) for the first time and is placed into sight of others. In practice, it could mean when being used in a social media post – a broad, public and unspecified audience – or attached to an email for a client – a closed audience. The image has left the privacy of the creator's desk and this first date means that the work is now in circulation.

Enhanced copyright protection – USA

In the USA, the time clock begins ticking from the moment of creation.

Even though it is not a legal requirement as copyright is already in place, assets registered within five years of their creation with the United States Copyright Office can be afforded enhanced protection.[11] This is a paid-for online service for creatives. There are separate sections for registration within the gateway site which administers this system. It's important to note that recording actual architectural designs falls under the category 'Visual Arts', whilst photography is listed as its own entity. Whilst registration is actively encouraged by legal representatives, not all image makers and designers engage with the process as it is seen as time consuming.

It is not possible to file a copyright infringement suit without having prior registration. Copyright is a federal law and copyright cases must be held in those courts. If it is decided to register works there is only a three-month window to do so *after* the work is first published. Certainly, from a litigation perspective, any monetary damages awarded for breaches of copyright are considerably enriched as a result of having undertaken the formal registration process.

'Work Made for Hire'

Under the USA's 1976 Copyright Act, there is a specific legal section which addresses 'Work Made for Hire'. Like elsewhere, the most obvious interpretation of this relates to images made within the course of employment. America's slight peculiarity is whereby in certain specific circumstances a commissioning party may also be considered the author.[12] Section 101 of the 1976 Act confirms the employee relationship, but also 'a work specially ordered or commissioned for use' in certain areas.

None of these really typify the appointment of freelance architectural photography which is usually on a 'per day' or 'per project' basis. If you plan to commission image makers in the USA, it is vital to have an upfront conversation about the individual practitioner's business policies. In the main you can expect a photographer to retain copyright, but they must state this in writing. Interestingly, copyright in 'Work Made for Hire' is far longer than self-created outputs. In these instances, it is 95 years from the first date of publication or 120 years from the date of creation, whichever expires first.

Ownership of copyright – independent creators

If you are using an image maker who is within your direct employment as covered in *Ch. 6 Working with a professional: In-house or out-house?*, then most likely you control copyright. This reason, and this reason alone, may play a part in some practices deciding to take the plunge and employ in-house. However, in most cases globally, photography of architecture is in the hands of skilled freelancers. These individuals own the expensive kit required to create such images, and legally it is those creatives who get to call the shots over the pictures and their use, not you.

11 For image makers in the United States, creating an account with the Copyright Office – www.copyright.gov/registration/ – is encouraged. Filing copyright for works may be done in batches rather than as individual images which saves time. This may be paid as a single fee if submitted at the same time.

12 Section 101 (title 17 of the *U.S.Code*) – www.copyright.gov/circs/circ09.pdf – will help you to understand why architectural photography is unlikely to sit comfortably within these definitions.

The reason we are spending time establishing the title of ownership and the extent of control it affords owners is that whilst architects will understand that these laws protect their own designs, they must also appreciate that, in turn, the same protection is extended to any independent image maker of these buildings once they are in existence. This is where some misunderstanding has arisen in the past on the part of the commissioning party who believes that once they are in possession of physical or digital materials depicting their buildings, they then get to control how they are stored, modified and to whom they are disseminated thereafter.

When an output is a team effort, for example in a film about a building, where there may be collaborative endeavour in its production, the copyright will need asserting in writing by the main person involved, often the producer. Other members of the crew will need to operate under contract law with terms agreed prior to filming. Again, there will be territorial differences so please check the facts in each country of operation.

All this being said, it is not sensible business practice to deny a commissioning party the ability to utilise materials that they have paid for. Through fair negotiation via contract law, expectations for usage of the work by both parties should be defined. When a party commissions a photographer, the written terms of that contract (even simply in an email form) will have what's legally known as **implied uses**. These are the reasons for the work being undertaken in the first place.

Regardless of a more detailed contract coming into play, a court may reasonably assume that permission to use the images in the manner described would be part of that order. Uses over and above the original order will fall back into the control of the owner. Beware ambiguity. Plan for how you want those images to function within your practice. Embedding where photography sits within your design and delivery cycle (Stages 1, 4, 6, 8 & 9 for example) will allow you to be effective with your instructions.

Any photographer worth their salt should have clearly displayed Terms and Conditions either on their website and/or paperwork (estimates/invoices). Within these, there is likely to be a formal assertion of the legal act under which they are asserting their copyright and perhaps a claim to moral rights identifying them as author. Expect to receive a licence stating the extent of permission entitlements granted to the purchaser. The metadata template embedded within the photographic file can also be populated with this level of detail.

We cover licences in a more detailed form in *Ch. 17 Forever in view: The global image market*. However, even when copyright is retained by the creator of the works, licensing will often permit the original client the ability to use the material in promotion of their practice in a fairly all-encompassing manner, and perhaps in perpetuity. Licenses may be **exclusive**: only for use by the owner, or **non-exclusive**: more than one licence may be granted over an image, allowing varied uses to others by negotiation.

△
Photographs taken of Glancy Nicholls' Meadow View Care home in Derbyshire appeared in directly related architectural press – in this case the UK's *RIBA Journal*. This was an *implied use* under the terms of the licence with the work. The images were then passed for onward use by the UK Government for a document on housing and care for the elderly.

Does this shift in context and application sit within original licence parameters? This will vary according to whoever you are working with, but you should not make assumptions. Check. The original copyright holder should be credited too, do not pass work onwards under your own name only.

For example, if your business works with a PR or marketing agency, part of their contract with you will be regarding the designed work they do for you. This may relate to the branding they create for your practice. You are likely to receive a licence to use these designs/logos/website templates as your company's graphic identity for a duration of time, but the copyright usually remains theirs.

Where restrictions may begin to apply is most likely to be over the right of the architect (if they are a licensee) to act as syndicator of the images to third parties. This form of third party licensing usually stays within the control of the creator as copyright holder (licensor), and in reality can be to an architect's advantage. This is because it allows conversations about your work and brand to be held far more widely than you otherwise may be able to achieve when acting alone.

It is possible to allow broad and free use to others by assigning a **Creative Commons** title to your work. We expand on this in *Ch. 17 Forever in view: The global image market*.

In practice, however, potential infringements are best avoided by actual display of the **copyright symbol ©** (Alt G on a Mac and Alt 0169 on a desktop PC – laptops can have variances dependent on keyboard type), in association with the works themselves.

As we've discovered, many social media uploading processes strip metadata from pictures, thus casting ambiguity on their status. Any files where assets are stripped are still under copyright protection, but the onus is on the viewer or user to find it if they want to use it themselves. This is far harder if there's no visible marker accompanying a social post. Part of the legal obligations under copyright is the naming of the creator in association with use of the works. You should not apply changes to an image's copyright status yourself if you are not the original owner.

Moral rights

We've established that moral rights are covered for creatives over and above who **owns** the copyright itself. This means that provided they assert it in writing, photographers have a legal right to be attributed as the creator of the work, even if copyright has been passed elsewhere. The same goes for your own designs as you should expect your name to appear with your work. In practice, this tends to

△
ENESS's light sculpture *Airship Orchestra* is pictured at Washington's Yards for Light Yards Park (M. Paul Friedman & Partners). The shot is published on ENESS's website and they hold IP rights on the artwork itself, but the copyright of the image belongs to the photographer, Ron Blunt.

In this instance, if the work was commissioned by the artist, then the agreement for use is between the photographer and his client. For the architects or any other third party to use this work, an agreement would need to become the basis of a separate negotiation. There is no implied use for a third party, even if it is incidentally showing the work of other trades in the image. We discuss more about what might be 'incidental inclusion' in the next chapter which looks at Freedom of Panorama.

happen in editorials and photographers themselves are generally good about making acknowledgements on your behalf too. They understand their rights and are keen to see a partnership with you in this endeavour. Try and be consistent in your own attribution and theirs, especially when working online.

Part of the retention of moral rights includes right to object to derogatory treatment of one's work. This may include distortion, mutilation or acts that are prejudicial to your reputation as creator. This is important if a picture incorrectly represents you as designer of the building or for the image maker whose picture has been adversely altered. Moral rights last for as long as the period of copyright.

Fair dealing and exceptions

Internationally, an IP owner has to comply with laws allowing certain extensions in order to allow certain third party uses. These include:

1. Use by educational and government sectors for use in research. This is considered non-commercial use if it is part of research or for private study.
2. Exceptions for education permit the copying of works to illustrate a point made in a class, solely for teaching purposes.
3. Exceptions apply for journalistic use. Photographs of buildings subject to legal disputes may be published in connection with those news stories without the media organisation needing to contact the copyright owner. A good example of this would be *Castillo v G&M Realty LP*, a New York court case culminating in 2020, whereby a developer lost a case brought by graffiti artists who had their work whitewashed over by the building's owner.[13] Photographs may be used by the media because information about the legal dispute is deemed to be 'in the public interest'. These rights fall under the term **fair use** and the nuances of this will vary from country to country. Moral rights still apply to photographers.

▷
This photo, one of a series by Duncan Cumming, was used in news coverage of the legal case in New York surrounding a group of 21 street artists who had used a building known locally as '5Pointz'. for their art. They prosecuted the building's owner for destruction of their work prior to redevelopment of the site. Images may be used under journalistic exemption in the interests of public information.

13 Jessica Meiselman, "How 5Pointz Artists Won $6.75 Million in Lawsuit against Developer That Destroyer Their Work," *ArtMarket*, 14 February 2018, www. artsy.net/article/artsy-editorial-5-pointz-artists-won-675-million-lawsuit-developer-destroyed-work.

4. Editorial uses and current events are *not* 'news' and therefore return to standard copyright terms. Users should apply for a licence. In gathering third party photographs for this book, which I do not already have rights over, I have had to seek permission and check how creators wish to be attributed.

5. **Fair dealing** applies to criticism, review or quotation. Always, the key when citing works is to use the correct citations.

The term 'fair dealing' is difficult to define, whatever country you are in. In UK law there is no statutory definition. The UK government's own website states:

> *It will always be a matter of fact, degree and impression in each case. The question to be asked is: how would a fair-minded and honest person have dealt with the work?*
>
> *Factors that have been identified by the courts in determining whether a particular dealing with a work is fair include:*
>
> - *Does the work affect the market for the original work? If a use of the work acts as a substitute for it, causing the owner to lose revenue, then it is not likely to be fair.*
> - *Is the amount of the work taken reasonable and appropriate? Was it necessary to use the amount taken? Usually, only part of a work may be used.*
>
> *The relative importance of any one factor will vary according to the case in hand and the type of dealing in question.*[14]

The last section of this wording expresses that photographs are complete works in their own right and even if shown as a series of pictures, they are still generated as individual files. Therefore, if a third party lifts them, changes the context and re-uses without permission, this would most likely fall outside of fair dealing.[15]

In countries where British legal history law has *not* been a foundation for legislation, the terms 'Fair Use' and 'Fair Dealing' require further investigation. Examples in US law include commentary, search engines, criticism, parody, news reporting and scholarship.[16]

Patents and trademarks

Wherever you are trading, it is highly probable your completed buildings may include furniture or products which are subject to their own intellectual property entitlements. These may be in the form of individually patented or trademarked objects and brands. They may also be in industrially produced designed products, which makers may claim are 'works of artistic craftsmanship'.

Three-dimensional pieces of this nature, which in the UK historically only attracted 25 years of protection, have now been brought into line with Europe. Here, the duration for these 'artistic works' is until 70 years after death, thus placing previously expired items back under copyright. To comply, the work must be seen to combine both artistic quality and craftsmanship.

14 See www.gov.uk/guidance/exceptions-to-copyright#fair-dealing.

15 For more on UK exceptions, head to www.gov.uk/guidance/exceptions-to-copyright.

16 Code 106 of the USA's 1976 law relates to these matters. See www.law.cornell.edu/uscode/text/17/106.

17 Australia's Designs Act came into being in 2003 – www.legislation.gov.au/Details/C2015C00043.

△
Croftway, North Yorkshire, by
Wildblood MacDonald is a private house
with both artworks and mass-produced
industrially designed furniture in situ.
In this photograph, no single item is
given especial weighting or treatment;
the shot is generic, showing the interior
layout of a domestic environment. The
image is not advertising any of these
specific items for sale and is designed to
be part of an editorial narrative for the
practice's portfolio.

This is different to a photograph
created specifically for advertising
purposes, for example, a fashion shot
in a residential setting. In that scenario,
items or furnishings with IP or patents
may appear expressly with the aim of
alluding to a 'lifestyle' associated with
the brand in question. In these cases,
licenses may need to be sought. Your
country's Intellectual Property Office
will be able to advise.

What specifically is covered and what is still fine to appear in commercially led
photographs without further recourse is open to individual cases. The UK's
2016 law change was designed to help prohibit the repeated physical copying
of many designs, so it is safer to work to the principal of 'incidental inclusion'
in a wide-angle photograph. This is distinct from representations specifically
made of individual objects which could be argued as a necessary step for those
involved in the (fraudulent) replicating of it. Actual legal cases taking place where
challenges have been made against 'incidental inclusion' in a photograph have
not been sourced at the time of writing.

In the USA, under federal law, some aspects of furniture design are considered
unique endeavours, and are protected by legislation in the same manner as
architectural plans and photography. The functional or utilitarian aspects of
objects designed, however, are covered by patent laws as opposed to copyright.
An example of an object subject to scrutiny over physical reproduction is the
Eames DWS Chair by Ray and Charles Eames (1950), which is reputedly one of
the most widely copied furniture designs.

In Australia, designs for furniture are registered under the Designs Act 2003,
although these rights only run for a total of ten years, and not for the life of
the creator.[17] The design must be new, original and registered in order to gain
protection. If the design has not been registered, then copying is permitted, and it
would be logical to conclude that picturing such works is permissible too.

In all cases, it seems sensible to avoid taking photographs of objects in isolation which may plausibly bear protection. However, architects, designers and architectural photographers typically make images which show such objects in context with other designed elements and spaces. Moral attribution for works where original creators are known is, at the very least, the polite thing to do.

In summary - have a conversation

If you are unsure about the rights you have over images you might commission, ask the photographer to explain things to you prior to the shoot. Both parties need to be clear about expectations and attempting to simplify matters by asking them to sign over the copyright is likely to be met by a robust defence. Moreover, it is likely to invite elevation of the project fee to offset loss of potential future licensing over and above the intended use. This may seem peculiar, or perhaps unfair, but to make it balance out as a concept, it would be the same as a developer retaining project drawings and rolling out the same building again elsewhere, without recourse to yourself. Your design for a specific site is granted for use by licence to your client and you will have placed specific inclusions and exclusions within it.

Non-Disclosure Agreements may need setting up with your image maker if you have been working on a project where circulation needs to be embargoed for sensitivity or until a certain date.

Expect to find differences in business practices regarding embodiment of copyright permissions and restrictions between different individuals in the same country as you. Certainly, you might expect to find differences in other geographic territories. It is up to each party to define and operate within the remit of their respective laws as they see appropriate and fee scales may reflect those varying interpretations. It is in the interests of both parties to be confident, avoiding confusion and potential infringement issues.

Being the owner of copyright doesn't mean that you are able to use your photographs *exactly* as you wish, even though you have the legal ability to control their dissemination. There is a whole myriad of legalities, together with ethical considerations, which must be borne into account before placing images in the view of others. In the next two chapters we will consider some of these aspects.

CHAPTER 14
TAKE-OUTS

▶ Copyright cannot be applied to ideas, concepts or conversations. You must create a physical or digital output.

▶ Copyright is a form of intellectual property, and a property right, exclusive to the owner.

▶ Ownership gives authority to license, distribute, syndicate the work and assign economic value to it.

▶ Copyright exists upon creation and runs for periods of 70 years after a creator's death in the majority of countries (please check for exceptions).

▶ The law also places limits on an owner's rights. These may permit certain uses by others which are deemed to be of benefit to society (or certain sections of society). These uses may be without payment to, or permission from, the creator and owner.

▶ Registration to an authority is not mandatory in most territories. However, the globally understood manner of recognising that copyright is in force is through the active use of the © copyright symbol.

▶ Each country has a legal government body which will assist in the understanding and enforcement of copyright, patents and trademarks.

▶ Digital cameras generate files which travel alongside the image, confirming date of creation. If set up by the camera owner, their name and contact details can be input. This data carries legal weight. Assets made using analogue materials do not have this information and will always need the owner's name physically attached to assert the rights they have with them. Beware that some software strips data. This is unlawful if done deliberately.

▶ Owners have the right to have their work attributed to them. These are known as Moral Rights. Even in the case of copyright being assigned to a third party, the right to acknowledgement as creator is still enduring. This is important on so many counts, as even if active 'control' over one's work is removed, the 'brand-value' of its association to a creator may still have considerable weight in non-remunerative forms. If an image bears no attribution and no mark of copyright assertion in the metadata, it will state 'unknown'. This does not mean there is no copyright holder, simply that ownership is unstated.

▶ If you see © >name>date>all rights reserved, this means that the creator has asserted both copyright *and* moral rights. Expect to find copyright statements on websites of image makers, press and marketing agencies, and please make sure to do the same on your own materials.

▶ There may be limited instances where use of copyrighted works without permission is allowed, but these need examination on a case-by-case basis to see if they fall within the exceptions granted by the laws of the country protecting them.

▶ Be careful when capturing interiors containing items (industrial artworks, furniture or products) which may carry their own IP protection. Seek licences to permit their inclusion in images where necessary.

▷ # THE LAW AND YOU

Legal rights and obligations

In the previous chapter, we established that the intellectual property rights in creative works entitle an owner to control the circulation and usage by others of these materials within the public domain. Now we turn our attention to wider legalities surrounding the making of creative works and more specifically, photographic images.

If you're making pictures of your active site, access is likely to be straightforward and much of this chapter will be academic. However, some photography might take place as research (Stage 1 in our image making cycle) or for legacy purposes (Stage 9), where relationships with owners and occupants are either not yet in existence, or have since lapsed.

Laws, as ever, vary from country to country, but we shall place emphasis on the UK with some notable commonalities and variances in Europe, the USA and Australia. Establishing the framework of laws regarding public access and movement wherever you are working in the world is the first vital step to *commercially* photographing the built environment with confidence.

▷

Ajadye Associates' Winter Park Library in Florida, pictured by Ron Blunt. It is a building for the public, sited in a park without gates or ticketed entry.

However, what would be the implications for you to stand there and take a similar view? The camera is outside, but is this land public access?

If you were the architect or their representative, could you use the image commercially without recourse to anyone else?

What if a third party also wished to use the images for their own commercial gain?

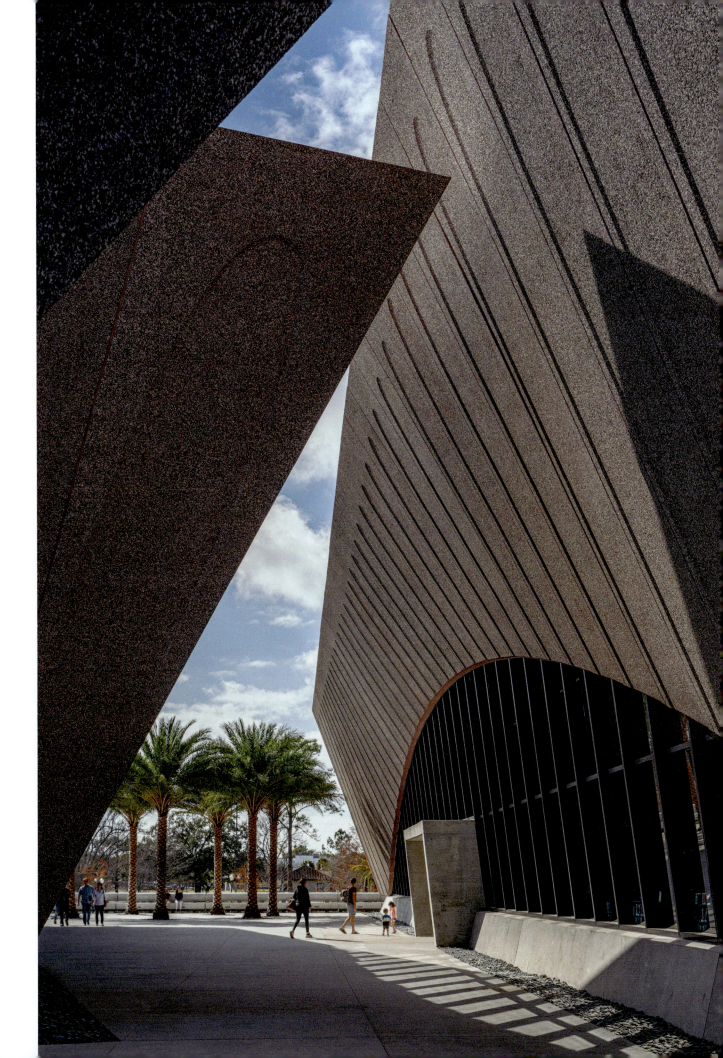

In the main, the taking of photographs in the open air is legal. It is what you choose to do with them thereafter which may become problematic.

The key concerns regarding image making in the open air are:

* Where are you standing to shoot?
* What are you pointing the camera at?
* Where are the images going?
* How are they going to be used?
* What else, or who else, is in them?
* How does the intellectual property of objects/structures featured in your picture impact on your documentation and subsequent usage?

Let's look at the types of regulation dictating the legalities of our actions when photographing outdoors.

Public order offences

We begin with what may appear rather dramatic but is a set of laws which may be cited to you as a reason for desisting with your image making. These laws relate to safety and security, and in this context, issues which surround buildings and land which are vulnerable to actions regarding their protection.[1] **Public Order Offences**, by their title, might imply that they're aimed at prohibiting criminal activity or civil unrest. Taking photographs may be seen, by some, as being part

▽

Access was sought ahead of time from the managing rail company to permit photography of Nottingham Station for BDP. Not only were images taken on the busy concourse, but also on the platforms. Permission was sought from the identifiable people in the pictures too. More on this type of informed consent in *Ch. 16 Ethics: Visual thinking and accountability*.

Be mindful that any mainline network and airport terminals in the UK are overseen by British Transport Police (and by similar authorities in other countries). Their powers encompass upholding many acts relating to trespass, terrorism and public order; all are reasons for desisting photography without prior consent.

of such activities. If you are the architect of a police station, courthouse, military installation, power facility, airport, railway or port building, in whichever country you trade, you should clear photography with the bodies that administer these facilities ahead of time.[2] In addition, the individuals who carry out work within these structures and who are often in uninformed roles will expect to have their privacy protected. There are further laws relating to this aspect which we shall deal with further on.

In public order offences, photographers may fall within the arresting powers of police, who can cite reasons such as the photographic activity causing 'harassment, alarm or distress'. In the UK, harassment is a repeated offence; it must be seen to have occurred on more than one occasion. However, most public order reasons relate more to the photography of *people* rather than *places*, and it is specifically structures in the open air which we are addressing here.

It should also be said that arresting a photographer is a very extreme action. Reasons for desisting from photography should give no grounds for arresting you, seizing your camera, requesting you to delete or even simply showing someone your files.

In the way?

Be mindful of laws relating to **obstruction**. These are more likely to be given. Where are you standing to take your photographs?

Areas defined as 'public land' and 'public rights of way' allow free passage, so you may be stopped and challenged if you're deemed to be impeding movement, especially if this could cause an accident. Being asked to leave is unlikely if you're simply holding a camera, but much architectural photography is conducted using a tripod. If you're on a footpath or pavement (sidewalk) and restricting the ability for pedestrians to walk in safety, away from passing traffic, this would enable a police officer in England to cite the *Highways Act 1980*. Blocking the pavement with your tripod and bag would count as creating an obstruction and you should promptly comply and move on.

Establishing land ownership

It can be difficult to establish what is *public land* and what is *private*. You will know the boundaries of your own site, but what about others? If you feel the need to understand whether the lands (and footways crossing them) are public and allow you the right to roam, local councils may publish guidance and local maps might define their boundaries too. This is worth checking out if you're about to embark on a new project and have ambitions to document it at regular intervals from set spots throughout the construction period.

If you are on private land with *public rights of way* across it, be aware that you are only permitted to stand on the actual right of way itself to work and straying off it may be deemed trespass. Even on a map showing land as 'open access', certain structures are 'excepted' as these may be *private* structures. Both the buildings and the land they are on (including courtyards) may fall within this provision.

1 In the UK, the Terrorism Act 2000, or in Australia, the Defence Act (1903), may be given as a reason for ceasing photographic activity. In America, taking a photograph may not be described as a terrorist act and officers should not request to view images without a warrant.

2 Structures of the type just described will be subject to protection by a variety of legislative papers. Whilst the laws in various countries are too numerous to list here, you should maintain an awareness of the diligence needed when photographing projects that are afforded these protections without prior arrangement.

Construction sites, parks, gardens, railways, tramways and industrial lands such as quarries sited on open access lands are likely to bear some controls over free access.

The exception for parks and gardens is an interesting one, and custodians of these spaces may impose fines for commercial activity within their boundaries. This applies even if you are restricting your image making from paths marked as 'rights of way'. The Royal Parks in London are one such example, and they ask for fees up front if you are working within them. Fees might also be levied even if you are photographing a building outside their perimeters and only incidentally including their gardens as a foreground.

This is the same for privately owned and administered sections of cities where one might naturally assume to have free passage. Again, taking London as an example, it includes Trafalgar Square, the City of London and large tracts of the Embankment, from Westminster Bridge all the way down to Tower Bridge. You will see people taking photographs in these open spaces 365 days of the year, but the land is protected by ownership laws. The laws permit 'right of passage' across them, but critically, not commercial activity taking place on them. So, if you do see third party concessions operating within their boundaries, the operators will have (unless they're street hawkers) pre-arranged licenses to do so. Look out for wall mounted signage, often accompanied by notifications of security surveillance also taking place, or metal studs in the pavement denoting a boundary [Figs 15.2, 15.3]. In the case of London's Embankment, the threshold is only about 1m from the River Thames wall.

As an architect, you'll regularly create drawings showing site boundaries, so this advice is aimed more towards third party image makers working on your behalf.

Bodies that own (or care) for open countryside and buildings may prohibit commercial photographic activity on their land without prior negotiation. An architect working for such organisations and institutions of this nature in any country will need to check if they may document building projects and use the images freely in their brand promotions. Certainly, prior dialogue is logical. Do not assume clearance at a local or regional level, simply because you know the team you are working with. You may find you need to consult policy makers centrally and abide by their terms.

In North America, public land is divided into management by three separate bodies for federal, state and local lands. Whilst federal areas are governed centrally, state and local lands vary across the country in the way they are administered and policed. Public lands encompass wilderness, national, state and city parks, national forest lands, national monuments and some

Figs 15.1 & 15.2

rivers. The National Mall in Washington DC, for example, is overseen by the National Parks Service. Photographer Ron Blunt has this advice:

> *I have shot on the National Mall and in National Parks for architects, museums, magazines and advertising agencies, for example I used to shoot magazine covers for Landscape Architecture magazine there. In every case, I was required to apply for a filming permit, weeks in advance of the shoot – and pay the fees.*
>
> *The National Parks Service needs to know what you are shooting, crew members involved, a detailed description of equipment and vehicles and the end use of the shots. Fees range from a couple of hundred dollars and up, depending on the size of the production. Bottom line: if you have a crew of people, and you are using tripods, ladders or computers, you will need a permit; if you are shooting handheld and solo, you will not have any problems.*[3]

So, although you may be able to avoid getting noticed without kit and assistants, the end usage (seen as commercial) may still imply the need for a permit. For architects working on these lands, you are likely to become familiar with your rights and restrictions in these places, but for outdoor areas outside of these, you are strongly advised to check ahead about where you might stand to carry out any commercially driven photography.

▽
Ron Blunt's image of the Smithsonian National Museum of African American History and Culture by Adaye Associates on The Mall, Washington DC. Seen across Ralph Applebaum Associates' reflecting pool – it was taken with a tripod and permission.

3 Ron Blunt, personal conversation with author, 13 September 2022.

△
This busy shopping street seems a
natural candidate to be a public right of
way. The Rock in Bury, Lancashire, is a
mixed-use retail, leisure and residential
scheme by BDP. However, it is a private
development and therefore subject to
control by a management company. If
you are standing on private land in order
to shoot a structure within or outside
the boundaries you'll need permission
to carry out your work. This is not about
obstruction, which always should be
avoided, but instead, trespass.

In Australia, photography is generally permitted in public spaces, but like the UK, there are a few notable exceptions where activity deemed as 'commercial' is prohibited without making a payment. These include the Sydney Harbour foreshore, the Luna Park in Sydney and the Olympic site in Sydney.

There are one or two Australian local authorities that exert wider restrictions, for example Waverley Council in New South Wales for their parks and on beaches. For a general guidance policy, it is worth familiarising yourself with publications on **Street Photography** by Arts Law in Australia.[4]

Wherever you're photographing, if officials observe the use of a camera, particularly one mounted on a tripod, they may deem your actions 'commercial' and require further information from you about intended usage. Best to check regulations up front, explaining how and why the images are to be used. Fees, where applicable, are preferable to fines.

There's an interesting article under the heading of *Fabric of Place* written by Bob Allies of Allies and Morrison which talks about public, private and communal space, how it is administered and how tracts of it are gradually being withdrawn from daily life.[5] The gradual removal of rights of way and control of land and access doesn't just affect photography; it is an ongoing story affecting all of us.

Trespass and photographing privately owned buildings

In the UK, shooting a *private building* from a *public* place, for example standing on a street and photographing an office block, retail premises or a residential dwelling, is not seen as a problem and permission from the owner is not required in order to proceed. Images may be used for commercial purposes.

For types of land ownership in the USA, there are variances from state to state. Working on privately owned land is a potential felony dependent on the building type, for example, schools or public utility properties. With private land, standing within the boundaries to take a photograph of either the owner's property or simply using that vantage to photograph something else 'from' it, may seem innocuous. However, you will need to define if you've breached a formal notification denying passage.

Criminal Trespass is actively violating a 'denied entry' which has been notified by a sign although signage itself might not always be conventionally marked. In Indiana, for instance, there's a colloquially titled 'Purple Paint law' which allows the application of the colour purple on posts or trees to denote a boundary.[6] Straying within it to take your pictures would constitute a breach.

4 See www.artslaw.com.au/information-sheet/street-photographers-rights/.

5 Bob Allies, "On Public, Private and Communal Space," *Allies and Morrison*, www.alliesandmorrison.com/research/on-public-private-and-communal-space.

6 In 2018, Indiana's General Assembly introduced – Indiana Code IC 35-43-2-2 aka. 'purple paint law'. Other states include Texas, Illinois, Missouri, North Carolina, Maine, Florida, Idaho, Arkansas, Montana, Arizona and Kansas.

Ticketed entry

Generally, if you have ticketed entry to an event, even if it that event is conducted on public land and regardless if admission is free-of-charge, there may be conditions attached to that entry which curtails photography. In Case Law, the right enabling organisers to attach restrictions to entry (and extending to how photographs taken therein might be used) was enshrined many years ago. A lawsuit was brought concerning a set of images made at a public dog show which were subsequently published. Suffice to say, if you are working anywhere as a photographer in the open air and formal admission is involved, you will need to check out what you are able to do with the images thereafter.

Shooting *inside* ticketed buildings is frequently forbidden without pre-arrangement, and in tandem, if the building is functional, it introduces other areas of law relating to photography of the occupants.

◁ + △

There are four tiers of operation to the image making in Hufton and Crow's images of Tottenham Hotspur's stadium by Populus. In the public realm (above left), the tripod is on the highway and photography can take place at any point and for commercial use without recourse to the owners. In the open space inside the ground (top image), the public may move about as they wish, but in this case, they're on the far side of a private boundary. Photographing people and the building in context with one another at this point is then within the behest of the Football Club's permissions.

Inside the stadium involves negotiating with the club as there are no spectators (seen left on p.360), but for the final image, seen at twilight when the match was in progress, despite people being small, generic and *not* the focus of the picture, anyone who was present had the right to be able to request they were excluded from the frame. This is part of **GDPR** (General Data Protection Regulation) which we look at in the next chapter.

Copyright, trademarks and rights protecting the 'look' of a building

As discussed in the previous chapter, copyright protection for building designs in the UK has been in place since 1988. In the USA, copyright protection for buildings did not come into play until 1990, meaning the majority of older structures are public domain. There are some exceptions to this, however, in the form of **trademarks**.

Trademark violation may come into play with specific forms if they are photographed in isolation or through brand associations which are used commercially. Think of iconic buildings or structures in public view, such as the Hollywood sign, or those (which are mostly modern) such as The Shard in London by Renzo Piano Building Workshop;122 Leadenhall Street, London by Rogers Stirk Harbour + Partners; or the Trans America Pyramid in San Francisco by William L. Pereira & Associates.

Structures such as the Eiffel Tower in Paris may not be photographed at night. This is because the light show (rather than the structure itself) is protected. The Eiffel Tower's website explains how protection for various aspects of the site operates.[7] It serves as a good example of how the various tiers are ringfenced in clear language. Trademarking is less likely from the perspective of the architects or collaborators on the design work, but instead from the patrons of a project, the financial stakeholders who wish to ringfence the intellectual rights associated with the structure in question.

This means that even if you are involved in the design framework, you could have limitations placed on your rights to showcase the project as part of your own commercial activity. There are also issues for potential third parties wishing to syndicate images once they're made. We explore this further in *Ch. 17 Forever in view: The global image market.*

These examples and exceptions, however, now become part of this chapter's central preoccupation, driving how we may proceed in our roles as photographers.

7 See www.toureiffel.paris/en/business/
use-image-of-eiffel-tower.

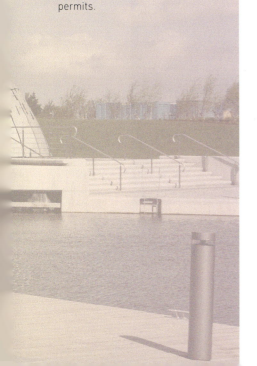

△ + ▷
Keith Hunter's images show the 30M (98ft) Kelpies in Falkirk by sculptor Andy Scott. Although a publicly funded, open access artwork, the local authority that administers the land around them invites enquiries from external parties who may wish to use them as a setting for commercial activities to apply for permits.

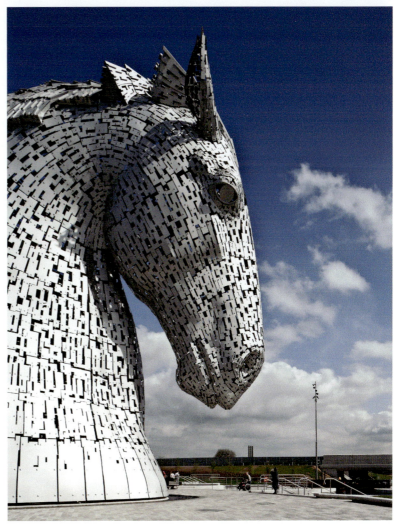

Freedom of Panorama

Depending on where you are based, the right of Freedom of Panorama is an image maker's best friend. In short, it allows the making and circulation of images containing depictions of copyrighted works located *permanently* in public places, *without* the consent of the creator. In the case of such IP assets, any photographic files depicting them are known as **derivative works**: they are merely *representations* of copyrighted works (in this case buildings, sculptures and monuments) sited in public places. The key to this exception is the fact that these buildings, sculptures and monuments are not on temporary show, they're resident in their situation. What's being made of them are simply *impressions* of their 3D forms in 2D images. The photographs are not replicas of the actual things.

Careful reading is imperative. Differences occur between the specificity of *what* the works encompass (given that 'architecture' and 'sculpture' are named), and also what is deemed a 'public place'. The Berne Convention's protection of artistic and literary works is the bedrock of this freedom, and the form of it protects copyright. Freedom of Panorama's copyright exception exists to serve the cultural, educational and other interests of society, so the two may (in certain circumstances) be seen to contradict one another, hence the various national or state variances in interpretation, a couple of examples of which you are reading about here.

▽
Anish Kapoor's Sky Mirror is a permanently sited artwork outside Peter Moro's Nottingham Playhouse. Images may be made of the building showing the art in context without the need to refer directly to the artist for permission. There are versions of the Sky Mirror outside Monaco's Casino, the Hermitage in St. Petersburg and the Dallas Cowboys AT&T Stadium in Texas.

△

Photographing buildings on tight city centre sites, such as 52 Lime Street in London, by Kohn Pedersen Fox, is potentially problematic in more ways than one. There are other recognisable buildings by prolific practices in close proximity and the site is also within the City of London, so there are implications with shooting on this land too.

But here, the story remains about the central protagonist, 'The Scalpel', as it is colloquially known. Capturing the building in isolation on such a tight site would be very difficult and its relationship with its neighbours is part of the visual narrative that assists in driving the story. For Hufton and Crow's pictures here, Freedom of Panorama permits these exchanges.

Murals in public places are treated separately and tend to fall under the standard copyright terms of each country in their respective dealings with painted artworks.

For the UK, Section 62 of CDPA 1988 allows third parties to capture the likeness of a copyrighted structure within a photograph or film. Certainly, a good litmus test to judge whether that resulting photograph doesn't contravene other trademark or copyrighted material is to consider the presence of contextual elements present in the picture. If we look at the skyline of London, for example, there are several recognisable copyrighted (and sometimes also trademarked) structures in any given vista.

So, what's your story? Is the photo about your building sited adjacent to others? In the UK this is fine under Freedom of Panorama. And if a third party is taking a picture of your building for their own use? Also fine. But it is not the same everywhere.

Under the European Copyright Directive 2001/29/EC, member states may decide how to implement the right within their respective laws. These variances extend to either permitting or declining commercial usage, and of course commercial usage is what most architectural photographers need clarity about.

▽
Tim Griffth's image shows The Broad in Los Angeles by Diller Scofidio + Renfro, which is adjacent to Gehry Partners LLP's trademarked Disney Concert Hall. The concert hall is allowable for use as incidental inclusion in a photograph and whilst still highly recognisable, it is not the focus of this image.

Even with permanently situated buildings and sculptures, there are caveats to this copyright exception. There are currently several EU countries excluding Freedom of Panorama in its broadest sense: Belgium, France, Italy and Greece. Greece's consent is only for mass-media which is unhelpful for architects. In Italy, no provision is given. France limited its Freedom of Panorama to non-commercial use in 2016.

For those based in Europe, a highly informative paper by Anna Shtefan offers a way of navigating the various permutations, and even includes a three-step test to aid understanding.[8]

Both the UK and Australia offer a Freedom of Panorama for image making extending to commercial usage.[9] In the USA there are state-by-state variations.

Knowing and understanding Freedom of Panorama allows an image maker to proceed in their job. Commissions to capture a structure will doubtless include its context (urban or rural), and work of this nature forms regular day-to-day activity for most architectural photographers like me. The ability to proceed as needed, working my way around a site and its perimeters, are the nuts-and-bolts of most building studies.

If we think of a city scene, and an establishing shot which places the context and setting for your project, those views may likely embrace the outputs of other practices within the same image. It would be unreasonable to Photoshop those structures out, for fear of contravening copyrights or trademarks. They are there, they do exist. The new documentation is about your project, simply *contextualised*. Would the designer of that other building press a legal case against you or your photographer for incidental inclusion, even though the picture is commercial in nature and usage? Unlikely.

Wherever you are photographing, in Europe or otherwise, in partnership with interpreting the legislation, balancing risk should be aided by taking an ethical approach to what is being considered.

- Does inclusion of a protected building or sculpture within your image cast unreasonable prejudice on the legitimate interests of the author of that work?
- Is *your* use of *their* work prohibiting their own gains or interests? A good way of looking at this would be to judge how, and *if* that inclusion might be seen to be a 'commercial endorsement' of your own product (in this case the building).
- What if someone were to park a luxury car outside your building and begin to advertise that car, based on its link with your designed work? That's brand association, and the creation of a tangible relationship of one unrelated product to another with direct commercial financial gain at stake. Now permissions (and mostly likely fees) are likely to enter the equation.

Perhaps a cloudier area could be where there actually is a direct relationship between the building and what is being advertised, for example a brick manufacturer who supplied the actual bricks to a project. This may take the form of an advertorial or even a direct advert.

8 Anna Shtefan, "Freedom of Panorama: The EU Experience," *European Journal of Legal Studies* 11, no. 2 (2019): 13–27. https://cadmus.eui.eu/handle/1814/63307.

9 For Australia, see www.artslaw.com.au/information-sheet/street-photographers-rights/. For the UK, see www.britishcopyright.org/ –the fact sheet on exceptions and fair dealing is of interest.

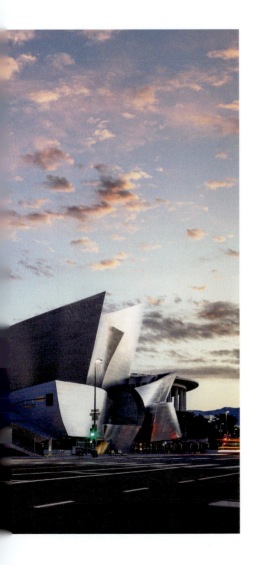

Whilst one might argue that use of a photograph in this way is directly benefitting the manufacturer, it may also be argued that it is publicising and endorsing the attributes of both building *and* designer. There's an act of representing a third party which is taking place for sure, but it is one with a heavily vested interest in the direct success of the project and the architectural firm whose names might be actively (and positively) described in the advert.

These relationships are often the product of everyday business activity, but one should always think about clarity in purposeful action. This is not news or journalistic photography and is premeditated. For further reading on matters covered in the last two chapters on IP rights, photographic rights, uses and legal permissions relating to US rights laws in particular, there are several books recommended in the almanac.

△

If your buildings are in the public eye, allowing others to work with them for other means may be complimentary to your practice profile. Both of these images were commissioned independently by their respective architects, Hopkins Architects on Jubilee Campus for the University of Nottingham, left, and BDP for their University of York – Heslington East campus, right.

Syndicated by the copyright holder to the UK Government as part of the publicity in overseas territories for the 2012 Olympics, they represented the globally renowned status of a UK degree education through their architectural offer. These posters were erected in airports, railway stations and on commercial advertising hoardings and remained in the public eye in this manner for several years.

The benefits of this form of cross-fertilisation may be incalculable for your profile and potentially open up markets for which you were previously unaware of and unaligned to. We speak more about this is in *Ch. 17 Forever in view: The global image market*.

Summary

Whilst much of what has been discussed may seem to erect barriers in carrying out photographic work, plenty of legislation is about public safety or property/ design ownership. When this is framed in context, logic can serve as a useful driver for your decision-making ahead of time *and* on the day.

Police and other public authority agencies are primarily concerned with the well-being of users in and around a building, whether they are going about their daily work or simply visiting. Some of the protections may be to do with the nature of the building, and some may be about the people themselves together with the ethics of your purpose (more in the next chapter). It might simply be that you are blocking a thoroughfare or an exit with your tripod and by placing items in a careful position, you're able to carry on operating unimpeded.

Assuming you're safe to work, the next consideration is the ownership of the land or structure you're standing within to make your images. Defining who these parties are will allow you to plan effectively. One of the aspects that they will be most concerned with is the purpose of your image making. The usage of your images by either you, your client or the nature of their onward distribution and/or syndication will dictate whether or not they fall into what is deemed 'commercial use'. Experience suggests that arrangements are often by negotiation, and unlike product advertising, much architectural photography is used in an editorial context and may not attract fees at all.

There can be confusion about where boundaries fall between public and private lands. This is especially with regard to city centres where spaces are owned and managed by private companies and yet traversed freely by pedestrians and traffic daily. In your position as a purposeful photographer, you will know which building it is which you are photographing and are likely to have permission to do so, but simply standing on the land described here will need specific clearance. Again, it is my considered experience that prior conversations with the bodies that administer such lands tend to lead to a positive outcome. This is especially if you are simply standing in a (safe) place within their boundaries but photographing a structure beyond. Be polite, friendly and clear about how the images are going to be used. Hopefully you will still be able to proceed, even if your need to stand where you'd hoped to was a spontaneous decision and couldn't have been envisaged prior to your actual shoot.

Finally, don't assume that you are the only party interested in these photographs. Much successful image making is the result of co-collaboration, whereby an authority, owner or controller may see value in your endeavours and end up being your champion to wonderful photographs as opposed to becoming the annoying red tape which stops you creating them in the first place.

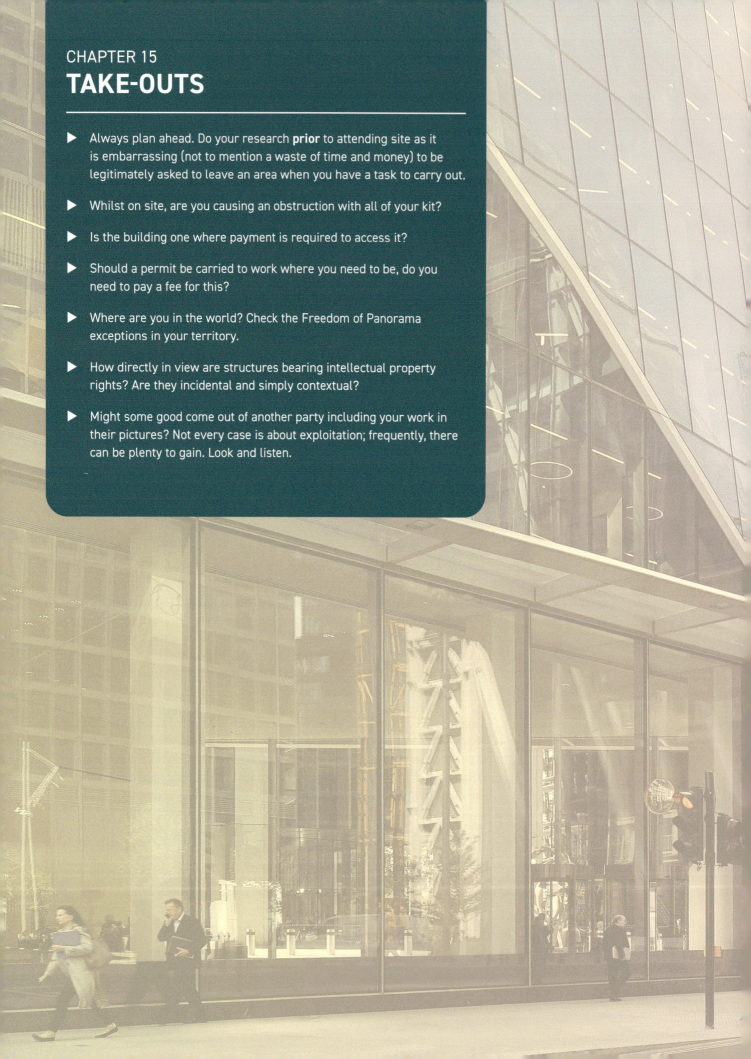

CHAPTER 15
TAKE-OUTS

▶ Always plan ahead. Do your research **prior** to attending site as it is embarrassing (not to mention a waste of time and money) to be legitimately asked to leave an area when you have a task to carry out.

▶ Whilst on site, are you causing an obstruction with all of your kit?

▶ Is the building one where payment is required to access it?

▶ Should a permit be carried to work where you need to be, do you need to pay a fee for this?

▶ Where are you in the world? Check the Freedom of Panorama exceptions in your territory.

▶ How directly in view are structures bearing intellectual property rights? Are they incidental and simply contextual?

▶ Might some good come out of another party including your work in their pictures? Not every case is about exploitation; frequently, there can be plenty to gain. Look and listen.

Chapter 16

▷ # ETHICS

Visual thinking and accountability

People and their context: *who* they are and *what* they are doing brings several considerations for camera users. These matters are legal and ethically founded. Respect for individuals and groups appearing in pictures is vital, but what form should this take? To whom and how are architects and image makers accountable?

We finished the previous chapter by concluding that in multiple ways, architects/image makers are unlikely to be the only parties to have a vested interest in the creation and circulation of pictures. The legal implications of making these also need to be taken into account. Whilst taking a photograph might be a physically solo endeavour, the *impact* of that activity will require careful thought. We now understand that, generally, photography of architecture and the built environment is rarely likely to be a pursuit that is prohibited in its action. It's what we *do* with images that counts.

Let's partner our earlier conversation about the physical location of projects and their function together with another about *people*, examining further legal and ethical aspects of photography and filmmaking.

▷

Pupils conduct an experiment on the forces of gravity in the science block designed by architects Broadway Malyan at St.Catherine's School in Middlesex.

To convey school design and function is a difficult call without the assistance of the principal protagonists – the children themselves. Wherever you trade in the world, minors are likely to be unable to appear in pictures without explicit consent being granted by their parents or guardians.

An understanding of the legal and ethical clearances necessary to create meaningful images is vital.

People in pictures

Purposeful photography creates a meaningful narrative for our various audiences. When they view the images, especially without the helpful assistance of accompanying text, they need to swiftly understand the following:

- What is the design and function of the building?
- Who is using it?
- How and why?
- Is it successful in its day-to-day operation?

We know that many who see our photographs will not have the opportunity of visiting a site to experience it for themselves. If these viewers were to, they might speak to the occupants about how *they* feel about their use of it. Because our audience is only examining pictures or watching films, photographers might choose instead to use the people working/living there to become 'actors' for us. They will appear in the pictures to help convey purpose or reveal the success of design elements; a 'visual interview' if you like.

The role that all these people play in images is vital, but as the one tasked to document the location, you, the image maker, might have never met them before. You might not even speak to them as you're working either, you're simply capturing them as they pass by. However, they are now in your photographs or films, they're plausibly identifiable, and you're likely to place your work into the public domain by publishing those images online or in print.

But *after* the event, when you're back in your office, it's too late to ask those people if they minded appearing as they walked by, sat at their café table, played with their children, etc. Having them 'in' your pictures adds power to their purpose, it enhances their validity, this is a *real*, working, living environment. These 'actors' provide enormous benefit by their presence. You'd far prefer to have them in shot, rather than out.

So, what do you do? You want to know:

- Was your activity legal in capturing them without their permission in the first place?
- Did you speak to them when you were working, did they know you were taking their picture?
- Is placing your photographs in public view now *illegal*?

This will depend on where you're situated geographically. In certain countries, photographing people in public places is a completely legitimate action. The publication of these works, provided they are not seen to be causing undue distress to those individuals by you doing so, is equally allowed. Use of images containing individuals for overt *commercial advertising* purposes is another matter, however. It is rarely permitted, and not the focus for the type of camerawork discussed in this book. In all cases, we are speaking about adults being photographed in such a manner. Children are another subject and will be considered later in this chapter.

Let's look at pictures taken outdoors first.

△
Millennium Point in Birmingham by architects Patel Taylor is a busy public park connecting multiple buildings. This image is a general overview where the people appearing in the image are 'incidental' to the scene, they assist in its narrative, but do not formally 'drive' the story, composition or visual content.

Photography taking place in the public realm and including passers-by who are recognisable has become known as 'street photography'. It is a term mostly used to describe the act of placing people in images who have not been formally contracted to appear as 'models' or 'actors' in the pictures or footage.

If you're in the UK, the USA and Australia, activity along the lines described is generally fine, but within the EU and further afield, countries vary. France, in particular, has very stringent rights laws about people and photography.[1] The French legal system places emphasis on rights of privacy for its citizens outside the home, just as they might expect within it.

1 See www.service-public.fr/particuliers/
 vosdroits/F32103?lang=en.

Our principal subject matter is buildings, but because what we are mostly concerned with is business promotion, the creation of photographs containing people in France is deemed contentious if explicit consent in writing has not been gained. This is extended beyond a mere 'yes' into requiring specificity: use, duration, which medium and which media?

This right is even the case in public places, assuming the person is isolated and recognisable. Here, people have a legal **right to be forgotten** – one may directly ask the author for images to be taken down off websites, for example.

This continues right through image making, in any context. As an example, if you're part of a French practice that has taken a group photograph of your own team but thereafter one of them changes their minds about appearing, they do not have to prove *why* they wish the picture to be removed. The copyright owner should comply. There are journalistic exceptions to this limitation, and we look at this topic shortly. In the main, France's approach to privacy for individuals in a public or private space is very difficult for image makers. In some instances, this may prohibit photography and video from taking place in populated areas.

Returning to outdoor photography, Germany, Belgium, Switzerland, Spain and the Nordic countries also require further reading.[2] In every territory, an expectation of privacy is the main basis from which to begin assessing photographic activity.

So, who might expect privacy, and how do we gain consent to use someone in our images?

Information about individuals

Data is information. Information is powerful in the hands of others, especially personal information. Photography is *visual data*, often associated with written descriptive information accompanying it in the form of a label or title.

Personal visual information about an individual in a photograph may allow them to become recognisable through their dress, their personal accessories or their specific location. These attributes may link them to certain professions, bodies or beliefs whereby they may be singled out or targeted by others who wish to cause them distress or harm.

As a result, regardless of your country, expect to find privacy regulations surrounding people who may be found in the following locations:

- Police stations, justice facilities, buildings linked with security roles.
- Financial and legal buildings.
- Airports, railway stations and ports.
- Military premises.
- Healthcare facilities, hospitals, medical practices.
- Educational institutions – more those concerned with minors and vulnerable adults, and not Higher Education (post-18) where adults can self-consent to appear in images.
- Certain spaces where people might expect a degree of privacy (e.g., public conveniences/washrooms or swimming pools).

▷

Deansgate Square in Manchester pictured by Daniel Hopkinson, shows Simpson Haugh's residential towers fronted by two people on the tram platform. The story is benefitted by their presence, yet their anonymity allows use of the image in multiple contexts.

It *is* possible to create compelling imagery without always needing to identify individuals.

2 See https://commons.wikimedia.org/ wiki/Commons:Country_specific_ consent_requirements – this is a good starting point to indicate where further reading is needed regarding country-by-country variations.

Many of these places listed are where you'll encounter either uniformed roles or 'care' roles aligned to those they're working alongside. It's a good indication for you that for both the staff on site and anyone they're dealing with/caring for are likely to have some form of protective legislation associated with them and their identity.

So, if you're photographing in a hospital, for example, *and* want to show it in use, it's about gaining permission to doing the following:

1. Work in the building itself
2. Photograph the uniformed staff – medical *and* security roles
3. Gain consent from each individual patient featured. This form of associated safeguarding is often termed **Patient Confidentiality.**

Such regulations may be nationally recognised legal obligations, or they may be simply implemented at local levels. Nevertheless, your taking of the images may be legally permissible, but your subsequent circulation of those images without overt consent will not be. This difference will still allow you to make pictures as part of necessary documentation, for example during an active building or refurbishment contract as part of your project research. The privacy restriction will stop you photographing the location *in use* for publicity purposes after that project is complete though without relevant permissions and paperwork set in place.

▽

Both Nottingham's Harvey Hadden Pool by Levitate and The Wave in Coventry by FaulknerBrowns feature groups of people who must grant their specific, signed consent owing to the protective legislation surrounding them. Whilst it can be achieved by considerable planning, generally photographing public sessions is difficult, due to the impracticality of gaining numerous written clearances from multiple parties enjoying their swim. Contacting clubs or training squads where specially created agreements can be put in place ahead of time and working with their members is a more logical course of action.

Across the European Union, a blanket piece of legislation came into force in May 2018, named **GDPR 2018** (General Data Protection Regulation). Despite the UK leaving the EU, it still upholds this legislation, and its authority forms the principal guidance on capturing visual data for all photographers working in this group of countries.

With many readers of this book being placed within the EU, let's drill down a little deeper into the key points affecting image making in occupied spaces.

GDPR – key points

GDPR controls and regulates data privacy for all EU citizens.

There are two main types of data:

- Personal – name, address, age, contact numbers, email address.
- Sensitive – personal beliefs, sexual orientation, health, etc.

The key risk is where a photograph of a living person is named, together with any other personal data about them, either in visual form, accompanying captions or in the metadata. On the basis that GDPR is about data, privacy and informed consent you need to recognise:

- That a photograph of a living person is data from which they may be identified.
- If you are gaining model releases (more on these later), they validate proof of informed consent. However, the information should be stored carefully and not circulated with the image itself unless necessary.

Holding detailed personal information may position an architectural firm as **Data Controllers** and data controllers should be registered with a country's Data Protection Office. How is the making, storing and sharing of this data with others administered and managed? You need to couple the law with common sense and not be exposed to risk.

Data controllers register their status and will need to pay an annual fee to prove their compliance with a respective country's laws surrounding the data itself.[3] If you are an architectural practice with employees, you already keep information about your staff on file which is shared within the team and with financial authorities. Therefore, you may already be registered. Images with accompanying written titles and information about the people appearing in them also fall into this category as the rest of the particulars.

3 In the UK, the Information Commissioner's Office (ICO) regulates those who make and store information about others – https://ico.org.uk/for-organisations/guide-to-data-protection/guide-to-the-general-data-protection-regulation-gdpr/key-definitions/controllers-and-processors/. It is advised to seek out the relevant authority in your own territory.

Exceptions (journalistic and legitimate interests)

There are a couple of exceptions to the ruling about photography of people. The first is journalistic and news reporting, permitting images of celebrities or newsworthy people to be used. The legal basis for this processing is called **Exemption for journalistic purposes** – GDPR (Art 85).[4] Unless your building is in the news for some reason, giving the general public a right to know why, this is unlikely to apply to you.

The second exception is **Legitimate Interest**. This relates to instances where naming would be expected (often aligned to moral rights). Think of a portrait of your staff team or senior partners, for example, where it would be logical to express their title and role. For architectural photographers, simply citing 'legitimate interest' might seem like an obvious caveat permitting your activity, but there has to be clarity in what this entails. It takes the form of a three-part test. You will need to:

- Identify a legitimate interest.
- Show that the processing is necessary to achieve it.
- Balance it against the individual's interests, rights and freedoms.

Legitimate interests can be your own or of importance to third parties. These can include commercial interests, individual reasons or give broader societal benefits.

- The processing of data must be necessary. If you can reasonably achieve the same result in another less intrusive way, legitimate interests will not apply.
- You must balance your needs against an individual's. If they would not reasonably expect the processing, or if it would cause unjustified harm, their interests are likely to override your legitimate interests.
- A point for argument here, however – it's *not* a 'get out of jail free' card. The privacy of the individual is likely to be considered over and above your (and your clients') needs.

In my experience, the vast majority of architectural images are unlikely to be seen as challenging, in terms of either the behaviours of people appearing in the shots, nor in their use by clients and via syndication to third parties.

Usually, the likeness of individuals is not being used to endorse or advertise specific products in the form of sales advertisements where overt profiteering is taking place. Images are generally editorial narratives, competition entries concerning design merits of the actual architecture or advertorial case study literature for the products used within the build. People are 'accessories' to the cause, not the cause per-se, nor is their presence a necessary part of brand authentication for the building product depicted.

There is usually a very different approach to architecturally led advertising work, where the use of people is far more purposeful, the models are character and role driven in their positioning.

▷
In these two examples for residential architecture by Sally Ann Norman, the first shot is 'character' driven, even though the *setting* for the narrative is the subject itself. The second is purely location and prop led. There's still a visual story about space, purpose and place – for Life Kitchens in Gateshead, but no use of models. Both scenarios would be described as 'lifestyle' photography, but the subject is the space design.

4 See https://gdpr-info.eu/art-85-gdpr/.

▷
Photographers would term this image of University Training College in Newcastle upon Tyne by Sally Ann Norman as 'environmental portraiture' – clearly it is planned just as the mother and child shot is. The participants in this editorially led scenario are integral, they *drive* the story. Without them there would have been little narrative value in placing the camera here, other than to reference the siting of electrical services.

◁ + △
Could Daniel Hopkinson's images of No.1 Old Trafford by Jon Matthews Architects still have been taken without the presence of people and still been able to convey the purpose of the work? Clearly their presence benefits the outcome and helps drive the story, but there is plenty enough in the frame to remove them and still justify making the shots. Certainly, the interior would have been taken with the permission of the individuals featured but both exteriors show passers-by, *street photography* of sorts.

A good 'test' for assessing whether explicit consent is necessary for photographs is whether you would have still taken the images *regardless* of the presence of people appearing within them? If the answer is yes, this implies that the subject matter is indeed the building or its environment. People are complementing and enhancing the story, but the story is about the space itself, its look, its placement, the light falling on and within it, the materials it is built from and the furnishings and finishes it is completed by. The mother and daughter in the kitchen story here do not conform to this approach – the kitchen becomes a 'set' for them, their lifestyle and aspirational attributes. The image without them expresses what takes place in the kitchen through the props and styling, but it's still a story about the design of the kitchen itself.

Working outdoors and capturing people on camera as they go about their daily lives can invite a fair degree of challenge when you're in the field. Claims of "stop taking photographs, you can't do this, you're harassing me, I know my rights!" might be heard, but in the UK, to be accused of harassment has no foundation on a first occasion.[5] Here, it is a repeated offence – it would only be counted if you photographed the same individual, sat at the same table in the café you've designed, together with their objection to being photographed on multiple occasions. In these instances, they may have grounds for complaint. As ever, no one should force you to delete your images, or seize your equipment because you've photographed them without their permission.

Even though GDPR is not law in the USA, some states have since adopted their own codes for personal data privacy, including California, Colorado and Virginia. Currently the Australian Privacy Act 1988 still prevails.[6]

Photographing adults indoors

Since GDPR came into force it has been standard practice to post notifications in prominent positions in interiors where photography is taking place. It doesn't make much difference if it is a public venue, commercial retail premises, a workplace or university setting. They're *all* locations where people are likely to circulate and they have a right to know what is happening.

Signage can be both simple, effective and, most importantly, legal. It should be displayed on entrances and other obvious places inside, e.g., primary circulation routes, or on doors into rooms/areas where the actual photography is happening. It should state who the work is being done for, how it is being used and that people have the right to ask to be omitted from picture making activity if they find themselves already involved.

I have used this system of informing building users on multiple occasions and it works well for broadly generic spaces where there might be groups of people present.

5 See www.cps.gov.uk/legal-guidance/
 stalking-and-harassment.

6 See www.oaic.gov.au/privacy/guidance-
 and-advice/australian-entities-and-the-
 eu-general-data-protection-regulation.

Fig. 16.1

The same approach is carried out by Ron Blunt in the American interior spaces of institutions such as IM Pei's National Gallery of Art in Washington DC [Fig. 16.1]. He explains:

> When we are shooting a museum with members of the general public in view, a notice is placed at all the entrances to the museum. The notice informs entrants that a photoshoot is happening that day, and that by entering they are agreeing to having their picture taken and agree to the images being used by the museum. This only extends to adults. When anyone under the age of 18 is in a photo, I will ask an assistant, or member of staff to have a parent or guardian sign a model release that has been generated by the museum.[7]

Children and families

Minors (under the age of 18 for most countries) are not legally able to self-consent to appear in photographs. Instead, prior permission should be sought from a legally responsible parent, guardian or carer. In the UK, this is recognised as 'safeguarding'. Whilst age is obvious in pre-pubescent individuals, many aged 15, or thereabouts, can easily appear to be older. My son, for example, hit 6ft 2 (1.88m) aged 16 and could easily pass as a university student. As a capable and independent individual, he might easily have been assumed to be able to accept or decline a role in a candid image. However, for him to self-certify would be wrong and for you to publish such an image for commercial purposes is in breach of the law. If in doubt, cease your activity.

7 Ron Blunt, personal conversation with author, 13 September 2022.

△ + ▷

Considering whether you would still
instruct photography to take place
without the addition of models is a
good barometer of whether consent
is needed for image making to take
place. In the case of the three here,
the answer is 'most likely, yes' from
the perspective of the architecture as
these are clearly stories about design
and form rather than portraits 'per
se'. However, you must still consider
who the models might be. Kings Oak
School in Yorkshire by HLM Architects,
Paulton's Park in Hampshire by HPW
Architecture and Willenhall School
in Warwickshire by Atkins all contain
minors. In all cases written consent
was gained from parents ahead of the
shoot and in the case of schools will
be a condition of access if pupils are to
appear identifiably.

As ever, common sense prevails. Architectural spaces in use by families will invariably make joyful images, with much more depth than an otherwise unoccupied picture. Simply approaching the parent/carer with solid reasoning for participation will often be met with a smile and a positive affirmation. Do remember that you're asking something of these people, and it is good form for an 'offer' to be made in return. A simple emailed copy of the picture is usually welcomed and all that might be required to broker the exchange. In gaining these details, you've negotiated consent too. Get it in writing: embed your legal position.

△
Peter Durant's shot of Alsop & Stormer's Peckham Library shows a busy square with families enjoying the open plaza in front of the building. Whilst the seated children are not easy to identify, as a family group they are recognisable and moreover would have been aware of a photographer working in close proximity with professional kit.

Chatting to people on site, gaining their permissions, 'street-casting' them in the process is a good way to broker successful images. Working in similar circumstances, I am always mindful to take an email address and send a copy to the model for personal use as a 'thank-you' for their kind participation in the shoot.

Other groups of people

Vulnerable adults, perhaps those in care facilities with special needs, cannot be consented by staff and instead family or formally appointed representatives will need to sign clearance on their behalf.

If you are photographing in such a location, this is likely to be by prior arrangement rather than a coincidental encounter, and you may have to carry certification to prove that you are legally cleared to work in these spaces.[8] Active consents for the inhabitants will need to have been sorted prior to the day too. Be sure you have clearances in place, or empty rooms will be all that you can capture with confidence.

Empathy is the driver here – aim to inspire positivity and exude warmth. Such situations are tricky: both client and family relationships are at stake.

8 In the UK, this is called a DBS form – Disclosure and Barring Service. It allows you to work without continuous supervision from others, as you are certified as trusted in your activity around vulnerable persons or minors. An individual is unable to apply directly, it must be made by a body or organisation on your behalf. See www.gov.uk/government/collections/dbs-checking-service-guidance--2.

▷

The Outlook Centre in Derbyshire by Evans Vettori is designed to meet the needs of people with profound, complex and multiple disabilities. For projects of this nature, explicit photographic permission is required by next of kin as well as staff *prior* to any work taking place. Moreover, in instances like these, you will need to make it clear how the images will be used in the public domain, considering ethical as well as legal implications.

It is important to consider legacy and research (Stage 9, cycling back to Stage 1), ensuring that over time the images do not fall outside the scope of any intended future use.

Model releases

We've already alluded to contract law and gaining permission from participants in its simplest form, but there is a manner by which you can become certain of your use of images, and that is by carrying and executing the process of consent via a **Model Release Form**.

In the photographic world, this legally binding paperwork is mostly associated with formally appointed models and indemnifies the image maker and their appointed representatives from further legal liability when using the work in multiple forms thereafter. The formats and the nature of the usage will be described on the form. Good releases will have ensured a **term of consideration** is included (an exchange of some kind, and in the fashion world this is usually monetary).

The paperwork will state the territories and the duration over which the permission is granted. It bears a description of the work that took place, the contact details of both involved in the exchange and, vitally, a date and signature on the document gained from *both* parties. Copies should be retained by both signatories.

There are multiple examples of model releases on the web. Architectural image makers may know enough to then carry them, but by only following the online formats seen across the web, they can sometimes be guilty of 'over-specifying' needs. This immediately induces fear in the model over what they might be signing away! Good legal examples are produced by the various professional photographic bodies which represent the industry. In the UK, these are the Association of Photographers (AOP) and the Royal Photographic Society (RPS); in America, it is the American Society of Media Photographers; and in Australia, a good resource is Arts Law.[9]

However, it is advised that significant amendment and customisation is required if you decide to carry them. Does the average architect really need their models to consent to terms such as 'above the line advertisments', 'point of sale merchandise' or 'cinema broadcasting'? Highly unlikely.

Instead, consider *how* your images might be used and make sure you're in the clear to do so. Regular instances could include:

- Use in both printed and online formats.
- Use in books and exhibitions.
- Use in professional award submissions and their associated publicity.
- Use within moving image presentations broadcast via the web.
- For syndication in editorial features.

These examples capture the majority of uses for architects. They permit the likeness of such individuals appearing in both single frames and moving image productions which may be broadcast across a variety of media and by a variety of parties.

Again, be aware that a respect for privacy of individuals and the data you are capturing should be at the forefront of your activity. Just because you have a signed consent doesn't necessarily mean that the information you have gathered on the model release needs to ever be associated with the broadcasting of the actual image.

▷ A very simple example of a model release form where there are terms of consideration, acknowledging a contractual exchange, together with a description of the title in the images and who this intellectual property belongs to. It states what the images may be used for, the duration and scope of the term. Vitally, it is to be signed and dated by both parties. For record purposes and those of the model, it may be useful to attach or embed a thumbnail of the image(s) in question for added clarity. For practices generating their own paperwork, consider IP interests for both creative parties as well as rights for the model.

I create my own and these state the client who I'm shooting for and lay out each party's rights to use the images. Sometimes the venues I am shooting in will have produced their own releases which they wish to retain. I then add my details and that of the architect to these as well. It is important to consider the future use for the work – Stages 1–9 of the image production cycle – and be confident that you have the right informed consent.

9 The AOP themself displays a sample release, but use this link to explore other interesting considerations in association with street casting and informed consent – www.dacs.org.uk/latest-news/copyright-uncovered-photography-framing-and-tips?category=For+Artists&title=N. In the USA, the ASMP's website is excellent – www.asmp.org/releases/model-releases/recommended-form/ (it has links to forms in other languages too). In Australia, the Arts Law body aids the generation of such paperwork too – www.artslaw.com.au/product/photographers-model-release/ (although on this site they ask for a fee). (Accessed 27 June 2021).

KIT JOHNSTON

52 Sunny Street, Anywhere, ZZ1 6TB

kit.johnston@buildingsandpeople.url
07123 1234567

ARCHITECTURAL PHOTOGRAPHY

MODEL RELEASE

MODEL'S NAME: _____

MODEL'S AGE IF UNDER 18: _____

MODEL'S CONTACT DETAILS: _____

SHOOT DESCRIPTION: _____

ARCHITECT/BUILDING AND CREDIT LINE: _____

DATE OF SHOOT: _____

Permissions and Rights granted

For good and valuable Consideration of the photograph(s) described above – tick and specify as appropriate:

> Prints or files for personal use _____
> Gift as specified _____
> Expenses/fee: £_____

I acknowledge as received, and by signing this release I hereby give Kit Johnston my permission to use the photograph(s) for purposes which may include – tick as appropriate:

> Use in print media _____
> Use in social media _____
> Use by Architect/designer promotion in web/press/pr/exhibition _____
> Use for Photographer's promotion in web/press/pr/exhibition _____
> Licence for use by a third party eg Professional Award Submission/Editorial use _____

I agree that the photograph(s) may be combined with other images, text and graphics, and cropped, altered or modified for print and electronic media. I agree that I have no rights to the photograph(s), and all rights to the photograph(s) belong to Kit Johnston, and any licensees or assignees. I agree that I will make no further claim for any reason to Kit Johnston, licensees or assignees. I acknowledge and agree that this release is binding upon my heirs and assigns. I agree that this release is irrevocable, worldwide and perpetual, and will be governed by the laws of England.

Model's Signature _____

Signature of parent or guardian if model under age of 18 _____

Date _____

Photographer's Signature _____

Date _____

Working with animals

A final word should be regarding who or what else might appear in your photographs whose rights may be protected by legislation, and that's animals, especially wild animals and birds.

Whilst this is a very specialist sector, there are architectural practices whose workload may encompass animal care or encounters with wildlife. Worldwide, specific licences may be required to work with wild animals, and penalties can be issued for disturbing breeding species.

If this is your area of specialisation be sure to check out the legal and ethical procedures. For example, if you have designed wildlife reserve architecture and wish to use drones to capture the buildings in association with the surrounding lands and enclosures with animals within, there may be implications of you doing so which need consideration. Many of the facilities you may be working with will already be compliant with the various bodies that legislate and oversee care for wildlife and animal husbandry.[10] Seeking their guidance is advised prior to working.

Pictures of buildings for domestic and farm animals will be just like their human equivalents – massively enriched by the presence of their occupants, and like anyone featuring in a photograph, their interests should be given consideration. Photographer Keith Hunter notes:

> Extra patience is the main attribute you need to bring to the shoot and an understanding of the surroundings and potential movements of the subjects when dealing with animals. They can be quite inquisitive so be prepared for them approaching and don't make any sudden movements ... give them space and never assume what they will do. Be prepared to capture the right moment in an instant.

> With the horses [at Sheppard Robson's Large Animal Research & Imaging Facility for The University of Edinburgh – Figs 16.2 & 16.3] they weren't anywhere to be seen when I arrived at the spot to set the camera up, and by the time I was ready to shoot there they were all lined up and looking straight at the camera. They didn't move until I was finished![11]

Working with confidence

As we've ascertained, regardless of whether you're working outdoors or inside, for most buildings and spaces, it is reasonable to assume that you will personally know only a limited number of people that you encounter with your camera (if any at all).

As a result, you will need to plan who is on camera, how large they appear in the frame and if they are easily identified via their participation over and above 'a.n.other'. With the exception of a few countries, assuming they are just 'man in red shirt at table in the sun' or 'group walking along pavement', it is your call over whether you purposefully intervene, declaring yourself and what you're up to. Externally, if they're within conversational distance and you wish them to specifically be a part of the composition as opposed to simply passing through, it is usually a good idea to speak about what you're doing and why.

10 In the UK, the government issues guidance and a good starting point is with the UK National Wildlife Crime Unit – www.nwcu.police.uk/news/wildlife-crime-press-coverage/wildlife-photography-could-you-be-breaking-the-law/. In the USA, the body to work with is the U.S Dept of Agriculture's Animal and Plant Health Inspection Service – www.aphis.usda.gov/aphis/ourfocus/animalwelfare/SA_Regulated_Businesses/.

11 Keith Hunter, personal conversation with author, 21 September 2022.

Figs 16.2 & 16.3

◁
The same space in Blairdale School in Glasgow by Holmes Miller Architects is shown by Keith Hunter in two ways – one whereby the identity of the children is revealed, and the other where it would not be prohibitive to the shoot if consents had not been gained.

▷
Working in the National Galleries
of Scotland, where notices of
photography are placed on entry
points, Keith again shows the space
and meaningful use of gallery
visitors without overt emphasis
on their identity. Images such
as this function well in placing
people centre-stage and driving
the purposefulness of the story,
yet without their becoming
personalities.

Occasionally, their being disturbed might act as a disruptive consequence to what might have otherwise been a very relaxed scenario. If you sense this may be the case, take the shot whilst the scene feels natural, but be prepared to delete the frame if they do decline participation when you've spoken to them. There is no point having a picture you cannot use. In most cases, your need for making the work is in order to broadcast it to an extended audience via the web, so confidence in your actions is vital.

For interior spaces, your arrival is far more likely to be noticed, and people will swiftly make it clear if they do not wish to be in images once you begin to go round and speak to them. You should facilitate the placement of notices stating that photography is taking place and if there's a central email system for employees where work is taking place, ask for notifications to be sent out.

In cases where people are unable to move out of the way of the camera easily, for example if they're at a desk and you're shooting a busy office, build trust by suggesting they have their back to you and then *you're* the one moving the camera to a part of the room where they're recorded simply as an anonymous human form. They are still vital to the narrative, but fully ambiguous. The helpful aspect of digital media allows you to demonstrate the image to them so that they can see they're not caught in a way which they feel compromised.

Summary

This section has been about working with those who might appear in your pictures. International legal frameworks regulate such activity and are primarily concerned with expectations and needs for privacy on behalf of those groups. In addition to the legal requirements, much of your conduct may be driven by your own personal and professional ethical code. Your business may have personnel guidelines driving the ethical conduct of its employees and this is likely to embrace your position as image maker too.

Whilst it is rather unorthodox to introduce a new concept into a conclusion, it is worth mentioning a system of ethical analysis entitled TARES.[12] This acronym stands for Truthfulness, Authenticity, Respect, Equity (and) Social Responsibility. It will help shape your judgement of whether to photograph someone, over and above the actual legalities of your activities, such as Freedom of Panorama. Mostly associated as a code for the advertising industry, to help judge the implications of their actions, TARES can be seen as a solid guide for any image maker in *any* field. In our case, this is architectural photography, where impromptu casting is a regular part of our task.

Nicely summarised by Paul Martin Lester in his book *Visual Ethics,* they run as follows:

> *Truthfulness – To persuade others through deceptive messages is harmful and undermines trust. It is possible to deceive without literally lying. The principle of truthfulness requires the persuader's intention not to deceive. It is an intention to provide others with the truthful information they legitimately need to make good decisions about their lives.*
>
> *Authenticity – Values associated with the principle include integrity, personal virtue, sincerity, genuineness, loyalty and independence. A personal and professional sense of credibility is a major facet of authenticity.*
>
> *Respect – Requiring that visual communications regard other human beings as worthy of dignity, that they not violate their rights, interests, and well-being for raw self-interest or purely client-serving purposes. It assumes that no professional persuasion effort is justified if it demonstrates disrespect for those to whom it is directed.*
>
> *Equity – Appeals that are deceptive in any way clearly fall outside of the fairness requirement. Vulnerable audiences must not be unfairly targeted. Persuasive claims should not be made beyond an audience member's ability to understand both the context and underlying motivations and claims of the persuader.*
>
> *Social Responsibility – Professional communicators should be sensitive to and concerned about the wider public interest or common good [and acting] in harmony with this principle would not promote products, causes or ideas that they know to be harmful to individuals or society....*[13]

If you *personally* believe that your activity with a camera is justified, that you're acting within your legal rights and can express this to your models – and moreover, have them comfortable with the proposal – you are likely to be able to proceed as you need. Due diligence by affirmation in a signed document is also probably sensible where possible.

Once gained, simply keeping the consents on file at your office is the logical pathway. Store them separately to the photographs themselves. Images may bear the title of the building, the architect and the nature of the activity taking place in the embedded metadata. You are now ringfenced in the broadcasting by yourself (and others) of those photographs and can concentrate on telling the story of your building, confident that your actors are happy to have fulfilled their role in that descriptive process.

12 The five-part TARES ethical model was defined by Sherry Baker and David Martinson and first published in 2001 – Sherry Baker and David L. Martinson, "The TARES Test: Five Principles for Ethical Persuasion," *Journal of Mass Media Ethics* 16, no. 2–3 (2001): 148–175.

13 Paul Martin Lester, *Visual Ethics – A Guide for Photographers, Journalist and Filmmakers* (New York: Routledge, 2018), 54–5.

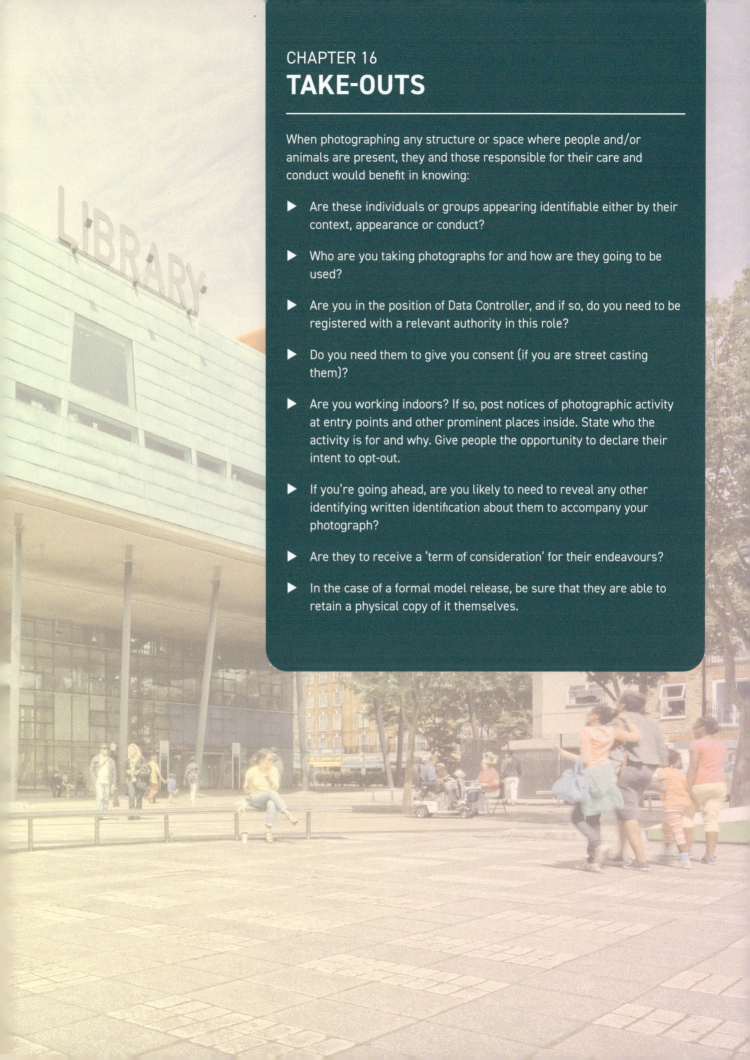

CHAPTER 16
TAKE-OUTS

When photographing any structure or space where people and/or animals are present, they and those responsible for their care and conduct would benefit in knowing:

▶ Are these individuals or groups appearing identifiable either by their context, appearance or conduct?

▶ Who are you taking photographs for and how are they going to be used?

▶ Are you in the position of Data Controller, and if so, do you need to be registered with a relevant authority in this role?

▶ Do you need them to give you consent (if you are street casting them)?

▶ Are you working indoors? If so, post notices of photographic activity at entry points and other prominent places inside. State who the activity is for and why. Give people the opportunity to declare their intent to opt-out.

▶ If you're going ahead, are you likely to need to reveal any other identifying written identification about them to accompany your photograph?

▶ Are they to receive a 'term of consideration' for their endeavours?

▶ In the case of a formal model release, be sure that they are able to retain a physical copy of it themselves.

▷ # FOREVER IN VIEW

The global image market

Make no mistake, every section of this book has been written with the challenge in mind of pushing your visual folio beyond your own network, actively and successfully working on your behalf 24/7, 365 days a year, every year. The idea has been that you personally should create or commission the best images that you can to represent your built designs, pushing them towards whatever audience you are targeting, for *maximum* effect.

This chapter pulls everything together, looking at the photographs you encounter in your working (and frequently online) life. Your pictures, of course, but also the ones yours fight for space with; everyone else's. It asks, on the web, why do some project photos always come up on the first page of search results when you're wanting information, even though you know there are other pictures out there of the same building? And furthermore, why do you sometimes see a specific image in use repeatedly in different contexts?

▷

Maggie's Centre in Dundee by Gehry Partners, LLP has been photographed by Keith Hunter on more than one occasion. Initially for *Architects' Journal*, he subsequently worked for the garden designer Arabella Lennox-Boyd and in addition, Maggie's, who wanted this shot as the cover for their book, *Architecture of Hope*. The image has been re-used by *Wallpaper Magazine* in an article about the V&A's exhibition where it appeared.

Pictures may travel in many forms, both in print and on the web. This is facilitated through licensing.

We began *Photography for Architects* with a quote from a German magazine published in 1932 about the plethora of photographs dominating communication.[1] Ninety years thereafter, this omnipresence is the *Networked Image*, powerful photography in circulation travelling fluidly between different parties and mediums.

Today pictures are moved around via **syndication**: the passing of material from the original source to others for distribution, who act as 'agents'. This distribution of IP is facilitated by licensing models and the use of descriptive words which accompany a picture. We need to expand on matters introduced in *Ch. 14 Whose right and who's right? Understanding and controlling copyright* and examine licensing and its different forms, including how to track the life of the images your practice creates long after they've left your desk.

We return to how 'naivety' in sharing our work might mean certain parties access and re-use our images without recourse to us, and on a more positive note, we reflect on how effective image makers have galvanised partnerships with others through licensing. An example of this was given previously, through global use of photographs of university campus architecture by the UK Government for five of its seven-year marketing period for the 2012 Olympics. Arrangements such as this allow photographs to reach considerably larger audiences than might otherwise be expected.

Our final chapter take-out is extended into two parts. There are points relating to licensing and distribution, but also for *Photography for Architects* as a whole. It proposes a strategy for effective management of your visual voice, providing you with a plan for image making in your business wherever you're trading, for today and for the future.

The well-designed website

Will shall stay with a single search engine for the purposes of this narrative, but whatever you choose to conduct searches with will operate on a similar principle. We understand that when we look for information online, answers are given on the basis of **keywords**. These are meaningful words to describe what it is that we are seeking information about.

For any search results, you'll discover certain websites always rank highly and when it comes to finding visual answers, in Google Images, specific photographs come to dominate that list too.

When I used the following three keywords: '*Oculus New York*,' (by Santiago Calatrava), identical pictures appeared several times as I scrolled down the page. This is despite the huge number of photographs that have been made and uploaded of that project by professionals and city visitors, not just monthly, but almost on a daily basis since its completion. Why?

We need to look first at the way Google calculates its answers to search enquiries – firstly in relation to the websites themselves that images are embedded within.

In *Ch. 2 Representation of your work: Constructing your practice brand*, we introduced Google's methods for ranking information using its E-A-T algorithm.

▷

A detail of Santiago Calatrava's Oculus in New York. Shot by a tourist and not for commercial purposes. In fact, it is not even posted on the web, but if it were, it would appear in a Google Image search if appropriately keyworded.

Does the fact that it's a holiday picture that I took some years after the project was completed make it less credible than one professionally created by the architect's original photographic team? In Google's eyes? No.

But if uploaded, the chances of it being seen by browsing public are virtually nil. Why?

1 "Bildermüde" in Das Kunstblatt, 16 March 1932.

This is based on core values of Expertise, Authority and Trustworthiness which it established in 2018 and still adheres to.[2] We explored why the quality and consistency of your photography might affect the ranking of images you upload to the web. We ascertained their leverage in endorsing your visual voice – your brand. If you show a potential client a great picture of your work on a well-designed and legible site, they're likely to stay browsing the page. If they promptly left, this would affect the **bounce-rate**. Bounce-rate speeds are one of the means Google uses in ranking algorithms. It also uses multiple other measures to decide on a site's value (and by implication, the pictures in it).

With regard to each page on a site, it asks:

Content and quality:

- Is the content original, comprehensive and 'beyond obvious'?
- Are there descriptive, helpful summaries of page content in title tags and headings?
- Would you want to share or recommend this page?

Expertise:

- Is there clear sourcing of material, giving evidence of the authors' expertise and authority?
- Do you get the impression that this site is well trusted?
- Is the information timely and relevant, or outdated and no longer trustworthy?

Presentation:

- Are there any typos or mistakes in the visual content?
- Does the page content appear mass-produced?
- Is the page well laid out for rapid understanding and clear viewing?
- Is there a good mobile experience when browsing?
- Are load speeds swift?
- Are there excessive pop-up ads which block the main body content from appearing?

Rankings are then created through automated actions based on continuous machine learning. They're measured by the word structure of the websites – their SEO worth (search engine optimisation) together with our engagement with them as we search and browse.

Sites following the E-A-T guidelines should expect to rank well in organic (non-paid) listings. The caveat, always, is your understanding that Google is a money-making behemoth. According to statista.com, in 2021, Alphabet, Google's parent company, made $257 billion USD, 82% of which was directly from advertising income. If your site is top notch *and* you are prepared to cross Google's palm with silver, the paid results (identified by the boxed [ad] prefix), will always appear higher up the page than organic sites.

It follows, therefore, that photographs embedded into websites which demonstrate a high-ranking outcome will likely also place high up in image search, as they are backed and validated by a measurable SEO worth.

2 See https://developers.google.com/search/blog/2019/08/core-updates.

If lots of people are talking about Calatrava's Oculus, and specific photographs accompany that conversation across multiple sites, then it is logical that these same individual images will list high up in image search. Powerful sites, whose content is updated daily – ones with huge audiences in multiple territories – are known as **authority** sites. Examples for architecture would be Dezeen or ArchDaily. Despite (literally) thousands of decent photographs generated of Oculus floating across the web, the chances of them moving up and outranking what's already shown on the number one page is probably very limited today, because of the dominance of those hosted on sites already benefitting from top E-A-T rankings.

As a result, it pays for an architectural practice to be in the driving seat when it comes to defining *which* photographs represent its projects, as the greater the number of parties come to reference them over time, the more dominant they will become in search outcomes. Projects featured on authority sites especially will do very well indeed. This is a bit of a slippery slope and opens up a whole separate line of debate about the dominance of certain outcomes on the web. By implication, the results are never neutral. Frankly, the odds are stacked in favour of very few....

However, there are two other big forces at work for image search outcomes – more than simply placing a photograph on the pages of a high-ranking authority website:

- One is the power of **keyworded metadata**: written information accompanying a visual file stored in the sidecar EXIF data.
- The other is the leverage of **stock** and **stock libraries**. These are as their name implies, repositories storing stock images, made available for hire or purchase.

The power of the keyword

We will deal with keywording first, because stock *needs* keyworded metadata to allow pictures to 'travel' across the web. Using keywords for your images to help their retrieval in your office image management is sensible too. You might currently store a single photograph under multiple headings and in multiple folders for future use based on different types of association. If you have employees, even using networked computers, they might hold that same image in their own individual folders for ready retrieval.

If you use a photographic software programme, there will be an ability to search and retrieve a picture, not just from its title, e.g., 'Summerhill House', but also by other keywords associated with that project. You need to input this data into a photograph's XMP file, most sensibly at the point of import, but it can be supplemented with further information if needed thereafter.

With appropriate software and effective keywording, a photograph may be catalogued by a library under multiple different headings, yet that single image will only need to physically exist in *one* place. This is far better for avoiding hard drive storage issues.

Ch.17_Keywording_Theatre_Royal.jpg

Basic	Document Title: Royal Centre Nottingham-13721-155
Camera Data	Author: MARTINE HAMILTON KNIGHT
Origin	ⓘ Semicolons or commas can be used to separate multiple values
IPTC	
IPTC Extension	Author Title: Martine Hamilton Knight
GPS Data	Description: Nottingham's 1865 Theatre Royal is by Charles J Phipps and
Audio Data	remodelled by the renowned Victorian architect Frank Matcham.
Video Data	The four tiered auditorium has a capacity of 1186 people. It
Photoshop	adjoins the Royal Concert Hall from 1982 by RHWL Architects,
DICOM	Rating: ★ ★ ★ ★ ★
AEM Properties	Description Writer:
Raw Data	Keywords: Theatre; Nottingham; Frank Matcham; Royal Centre Nottingham,
	lighting, Victorian theatre, auditoirum, proscenium arch, safety
	curtain, chandelier, stage lighting, balconies, green interior, royal
	box, dress circle,

ⓘ Semicolons or commas can be used to separate multiple values

Copyright Status: Copyrighted

Copyright Notice: ©Martine Hamilton Knight 2021
All rights reserved. www.builtvision.co.uk
@martine_hamilton_knight

Copyright Info URL: https://www.builtvision.co.uk/copyright-policy/

Creation Date: 26 Jul 2021 at 1:44:03 pm

Modification Date: 6 Sep 2021 at 6:30:22 pm

Application: Adobe Photoshop Camera Raw 13.3 (Macintosh)

Format: image/jpeg

Powered By
xmp

Preferences Template Fo... ⌄ Cancel OK

◁

The keywording for an image file sits in the metadata template (usually XMP) that travels as a sidecar file with the photograph. Try to think of the photo itself as the 'front cover' of a small booklet. Illustrated here is a 'cover shot' of Frank Matcham's Victorian Theatre Royal in Nottingham. You can see Page One of the template (labelled 'basic' in the LH margin) has been populated with a significant amount of written information. If this picture is online, Google will draw on this data to make sense of what it is seeing.

Looking at this template, underneath the document title is the name of the author (photographer). Following this, the description assists SEO – it is far richer in detail than the title allows. Below, keywords are listed: words or phrases separated by a comma, and these may be as few or as many as you wish. A good number is 10–15, but more may be helpful dependent on the subject.

404

So, in essence, keyworded images are vital for the web in understanding what it is seeing and allowing images to appear in search results *beyond* the scope of their actual title – xyz_office_chicago.jpeg, for example. Keywording is also a practical means of effective image management within your own business too. With the right software, multiple users can access a photograph without there needing to be numerous copies of it sitting on individual hard drives, each labelled in different ways in order to be found.

This brings us on to stock libraries.

These are not a new phenomenon in the world of photography, and they are, quite simply, repositories for borrowing or, more commonly today, 'buying' images which are pre-made and ready for use. This differs from pictures being the outcome of your own time or commission.

As we examine *what* stock collections mean for pictures and why they should rank well, let's also include licensing and how photographs gain the status of becoming rentable or buyable from a third party collection.

The rise and rise ... and rise of stock

One of the things which makes photography and art different is an oil painting's 'one-ness' as a singular item, where reproductions of it are not the same as the real thing, they are copies in another medium. Photography's defining feature is its endless reproductivity – in its original form. This makes mass copying, and therefore mass distribution at the same high quality, entirely possible.

Make no mistake, the dominance of stock images across the global image market is all-encompassing and, moreover, today is mostly under the umbrella of a few key organisations.

Back in 2003, photographic writer Liz Wells observed:

> *Seventy percent of the images currently used in advertising & marketing worldwide are now purchased from two image banks ... the more multipurpose and generic they are, the more reusable they are, and therefore the more they will sell. The blank or reduced background, by de-contextualising the subject enables the images to act as generic types.*[3]

What Liz was referring to was the power of many images to be tasked for their original need and then re-purposed for multiple other uses. In architectural terms, this could be photographs of famous buildings, monuments, views and cityscapes. But it could also encompass very generic subjects such as door or window details, family housing types, workplace interiors, retail environments or vernacular architecture – country churches, rose covered cottages, harbours, lighthouses, parks and public spaces.

3 Liz Wells, *Photography: A Critical Introduction*, 3rd edn (Routledge, 2003), 201.

If we think of markets for these subjects, broad representations of them are ideal for everyday editorial illustrations, or for use in advertising for lifestyle and brand campaigns. Each respective application indicates a *unique* opportunity for the owner, and expands the visibility and (by proxy) ranking power and position with each subsequent online use.

So how is this process of moving images from party-to-party possible from a rights perspective?

Licensing rights for creators

Building on Chapter 14's coverage of Copyright Laws, we return to the UK's CDPA 1988 (based on the Berne Convention's 1886 agreement) as a basis for understanding here.

Copyright gives the owner the rights to control:

- *Copying* – or reproduction rights.
- *Communicating* the work to the public.
- *Issuing* copies to the public.

This means that the IP holder's property rights in the title allow them to carry out this process themselves through licensing. They may also appoint another party through syndication to do this for them.

We previously explained that licenses could be exclusive – granted only for use by a single party, or non-exclusive – more than one licence may be granted over an image, allowing varied uses to others by negotiation.

So, with the reminder that it is the copyright holders themselves who control the dissemination of work, it follows that restrictions can be placed over the right of a client (if they are a licensee) to act as syndicator of the images to third parties. Instead, the overseeing of third party licensing usually stays within the control of the creator as copyright holder (licensor). If you are using someone outside your own organisation to create work for you, this can be to your advantage. This is because it allows conversations about one's work and brand to be held far more widely than otherwise might be achievable when acting alone.

Some creators may want their output to be accessible by others on an open basis. It is possible to allow broad and free use to others by assigning a **Creative Commons** title to the work.[4] For a photograph, you'd need to check the box in the metadata's XMP file (side-car file), stating that the work is available for use under this term. In practical applications, it is usually applied to works which the owner wishes to circulate for research and educational purposes. Moral rights are still invariably in place, the work is not an orphan; there is a distinct difference between the two states.

△
The Creative Commons symbol is only one letter apart from the standard © mark but represents a world of difference when it comes to re-purposing the asset. Applicable to any IP bearing work, one travelling with a CC licence honours the naming of the creator but allows use of it by third parties without recourse to the creator. They're giving away permission but not copyright. If you encounter works with this symbol, it is important to explore sub-levels of permission that one may also find aligned to them.

4 To understand more about CC licensing, visit https://creativecommons.org/licenses/.

Lost IP attribution – orphans

Orphans are a really big problem in the world of images. In the days of analogue photography there was only one original master version of a picture and copies made from each negative or transparency were either in the form of prints, which people could affix labels to on the reverse, or via lithographic scans at a print house. After copying, the original source film was returned to the owner.

Since digital's inception, the issue of orphans has risen exponentially. This is because of naivety regarding metadata on behalf of people with cameras and phones uploading to the web. The problem is massive, and a global issue. If one thinks about the need to gain active consent from a legal perspective before using a photo that you've discovered online, an inability to contact the rights holder is a comprehensive barrier to use.

It is in your best interests to make sure that any images representing you and your work carry the written information allowing known (and unknown) users who encounter it online to understand the rights and restrictions placed over that work. That means embedding your details into the camera so that your name is always recorded in files and, moreover, making use of the vital sidecar XMP file which was exampled in *Ch. 14 Whose right and who's right? Understanding and controlling copyright.*

Models of licensing

For rights owners, traditionally there have been two distinct models of licensing for stock images. **Rights-managed** and **Royalty-free**.

Rights-managed (RM) is the rental of a picture for a defined period under a specific set of uses. Once this has expired, the rights are rescinded. It's like renting a deck chair on a beach: it's for your exclusive use during that period, but with a finite endpoint when the sun goes down. Other factors in setting the price for the rental include the scale (size) of the file, which dictates the output quality, together with the geographic territory across which the licence extends.

RM offers the best of both worlds to the copyright holder: the ability for the work to circulate to a wider platform than by one's own hand, with caveats benefiting the original creators, plus renumeration.

The second route, and far more simplified, is royalty-free (RF). Unlike RM models, where each rental is an individual transaction with a number of variables, RF is a straight sale, no questions asked. Again, it's non-exclusive, so one person might buy the picture and own the material asset, but they do not control the copyright, and there's nothing to stop the next person also buying the same picture either. With RF, that non-exclusive licence is in-perpetuity and the commercial uses of it by you are often *limitless*. Put it on your office wall, in your brochure to indicate the type of work you do and, if so inclined, you could also print the picture on a T-shirt and sell it on the high street.

For the original creator, the headline rate for RF is higher than RM. However, given the infinite uses, selling an RF licence could provide a good income in the case of the average small business purchaser, but may seem exploitative when a major fashion brand has also paid the same (and by comparison) very modest rate to reproduce it globally on 20,000 items.

Returning to Liz Wells' quote about the dominance of stock images in circulation, it is important to note that she wrote it 20 years ago.

Since then, stock holdings have moved to a position close to totality in terms of accessible, purchasable imagery. What was once a market provided via large numbers of individual producers is now at the behest of a select few. In the case of Getty Images, a well-known name, by 2022 they had taken over the previous giants of Corbis, Tony Stone, Hulton and several other large stock houses as well as multiple small, specialist archives. With over 488,000 contributors granting them an archive extending beyond 496 million assets, they eventually floated on the stock exchange with a value of $4.8 billion USD.[5]

Other players in the market include Shutterstock, whose reach is even more phenomenal, together with Adobe Stock, Alamy, iStock and news agencies such as Reuters, Associated Press and Agency France-Press. Interestingly, journalistic images are circulated as stock these days, despite the nature of their specific locations and visual contents. Between this cluster of libraries, together with Getty, it is possible to see why stock now accounts for well above 2003's 70% statistic of photographs produced and viewed in any context.

Given that a single stock image is rentable by anybody for almost any need, it is at risk of being seen in multiple contexts at any one time, and therefore not unique. So why would anyone want to procure a photograph for their practice by this means? Quite simply, the model by which a stock library operates in the digital world is based on instantaneous supply of the requested image for use. Especially in the case of stock libraries offering free image bundles, this may seem like a swift and effective way of visually populating a website.

A picture of a historic windmill such as Green's Mill in Nottingham [Fig 17.1] could be listed as:

- Windmill
- Circular building
- Brick building
- Building for food production
- Vernacular building
- Agricultural building
- Power generator
- Wind power
- Pre-industrial revolution building
- Historic structure
- Farm building ... together with as many others as you'd care to think of

5 See https://investors.gettyimages.com.

Any story or advert needing such a picture under a broad range of applications could rent or buy this photograph and run with it. None of these phrased keywords relate to the windmill's original architect or specific location. The point of successful stock is that it is generic, multi-purpose.

A shopper browsing a stock library's archive simply selects what they need, downloading the image with the associated licence, making payment and proceeding directly to a position of use. No sourcing of a creator is required, no waiting for weather, permissions, models, postproduction time ... in other words, *no risk*.

By implication, it is quite likely to be a far lower cost than one would incur to create the same unique photograph for real. For start-ups and practices with a limited visual profile, the ability to illustrate their trade by populating their websites with generic stock images can be achieved at the click of a mouse and a very modest investment (in some cases, nothing).

Fig. 17.1

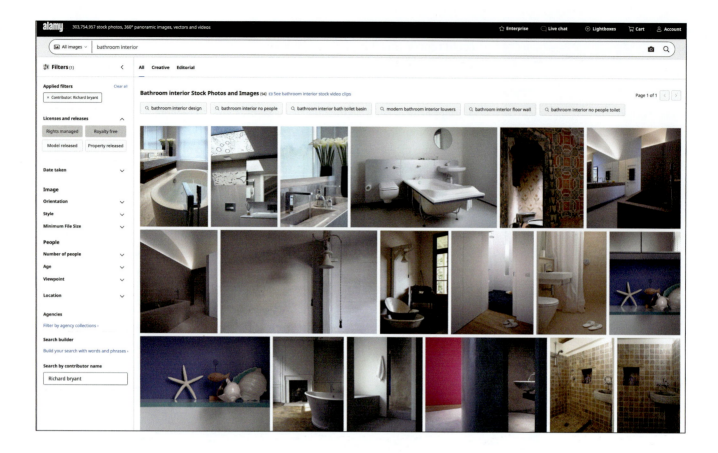

Going back to '*Oculus New York*', we already knew the name of the project and the location. If we'd just hit 'New York' in Google image search, the same photos are likely to have appeared too, they'd have just been massively diluted and downgraded in their visibility by the (literally) millions of other New York pictures. But given that 'New York' is in that metadata, they'd still appear at some point.

So, despite the fact that there are now an estimated 136 billion images on Google Images, if you are searching for a photograph of a sash window, a two-storey family home, a meeting room with a video conferencing wall, a bathroom interior or a rather well-known transport interchange at Ground Zero ... then the chances of you seeing the same search results from your desk in Chicago, an office in Sydney or your studio in Edinburgh are probably almost equal.[6]

That, in summary, is the ubiquitous image.

Where has my picture gone?

As discussed, syndication allows photographs to travel *beyond you*. Once they're online they have the power to move very swiftly into new contexts, disassociating from their original purpose. You may be interested to discover where photographs of your projects are placed, so there is a useful method of tracking an image. This is called **Content-based Image Retrieval**, more commonly known as **Reverse Image Search**. The outcomes can be extremely rewarding if you discover your work moving into markets which are unexpected. Indeed, it may account for new enquiries coming to you which you hadn't previously envisaged.

△
Using the search term 'Bathroom Interior' under the contributor Richard Bryant brings up 94no suggestions for photos in Alamy's collection. Widen that search to *any* contributor and the same keywords give over 150,000 possible choices.

6 For facts and figures about the ubiquitous image from 2022, see https://photutorial.com/photos-statistics/.

To conduct a search, you can use most browsers. Searches may be done with phones but using a desktop is more straightforward. You may search by either using a physical jpeg on your hard drive, or a URL where it is currently placed online.

Drag and drop method:

1. On your computer, open a browser, for example Chrome or Firefox
2. Go to Google Images
3. Find the image you wish to seek uses online for
4. Click the picture
5. Hold down the mouse, drag the picture and then drop it into the search box

Searching via a URL/image on a website:

1. On your computer, open a web browser, for example Bing or Safari
2. Go to the page of the website where the picture you want to use is displayed
3. To copy the URL, right-click on the picture
4. Click Copy image address
5. Go to Google Images. You will see the outcome in a new tab

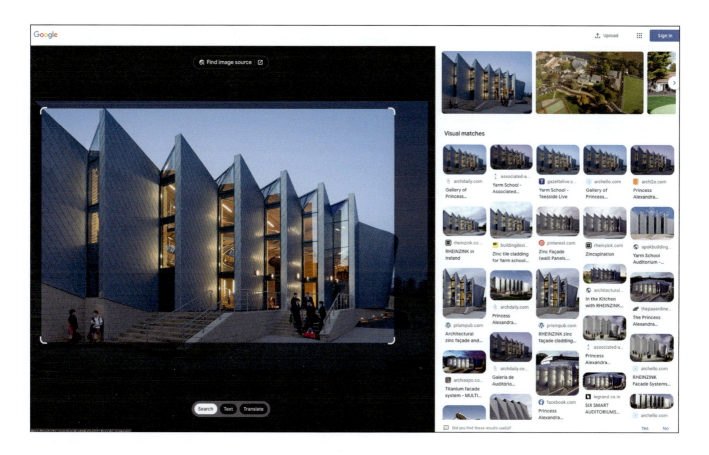

△

This shot of the Princess Alexandra Auditorium at Yarm School in North Yorkshire by Associated Architects appears in a number of guises through Google's Reverse Image Search, revealing that it has been re-used, re-shared and seen in several locations beyond its original context. The result also picks up shots which look similar to the one you're searching for.

Reverse Image Search can also be conducted via other search engines including Tin Eye and Duplichecker.[7] Carrying out a reverse search is helpful to detect copyright fraud. It is also useful to see where your work has been placed if it gets picked up by third parties as the result of you issuing a press release, for example.

It can be a double-edged sword in allowing major portals access to your intellectual property. As we discovered in *Ch. 11 Social media: Disseminating your brand online*, once platforms have your assets through submission of files onto their system, you are comprehensively granting them the rights to work on *their* own terms, even though you still retain the copyright.

'Giving it away' – for good or bad?

The BBC, a publicly owned broadcasting company in the UK, has such conditions of submission. Several of my images have been passed to them by my clients in connection with completions, awards, newsworthy events, etc. over the years. In the main, the initial usage is within the primary context of whatever the building was shot for, but once submitted to the BBC, drilling down into their terms and conditions reveals the following:

We may:

"Use it with our tools for making creations or remixing content … these might:*

- Put your creations on display to inspire other people.
- Invite others to use your creation to make their own creation.

Moderate it*

Which means we can review, edit, remove or decide not to display it. … And we can use your creations:

- Anywhere in the world.
- In any medium (for example TV, the internet, radio).
- For as long as we want – even if you stop using our services.

And anyone we work with can do those things too …

A note about your "Moral Rights"

When you upload something, you give up your moral rights to it. This means we can use it without identifying you as creator. We can also edit or change it without your permission. And you won't have the right to say we've treated it in a "derogatory" way.[8]

Terrific. As an image maker/architect that might *not* always be in your best interests, it depends on who is doing the sharing and using.

7 Websites https://tineye.com and www.duplichecker.com/ allow you to open an account and check for uses and rights breaches. There are other software providers who also provide this service. Not all are free.

* Indicates the BBC's own use of bold font.

8 BBC – What can the BBC can do with your images – www.bbc.co.uk/usingthebbc/terms/what-can-the-bbc-do-with-the-content-that-i-post/.

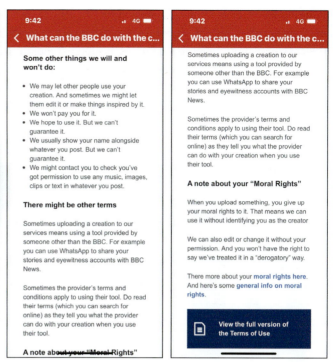

A respected news organisation profiling your work is one thing, but it's not such a happy discovery if you find that your project images have been appropriated by others and are being used for commercial gain in the name of someone else. Both I and my clients have encountered this problem in the past, with disingenuous photographers, architects, product manufacturers and suppliers passing off the work as their own.

It is a crime. It is a blatant breach of copyright.

It is occasional rather than regular. Sadly, it's the way of the digital world which allows the facilitation of such activity. Your best defence is always to avoid creating orphans, but as noted earlier, my clients and I have seen this happen with metadata enriched material which unscrupulous users strip, or occasionally aren't sensible enough to strip – in which case, they're easier to spot. Be diligent. If you trade in a country where copyright registration actively takes place, such as the USA, consider subscribing to this system.

Powerful positive partnerships

Sometimes, you may have a client whose own brand has significantly more authority than that of your own, your image maker and your connections combined. In these instances, they may take the helm when it comes to image making of your project. For both you and your photographer as intellectual property creatives, playing a more passive role in the control and circulation of the resulting work is very unlikely to be of detriment to your visibility and reputation.

Working for household brands and institutions usually grants aligned marketing budgets which may push your work *far* farther out than you could alone. In the case of photographer Peter Durant, his long-standing relationship with the Victoria & Albert Museum in London sees the work of the associated gallery and exhibition designers (such as designers of their Medieval and Renaissance Galleries: McInnes Usher McKnight) actively promoted in multiple forms and contexts [Figs 17.2, 17.3, 17.4].

Fig. 17.2

The best licensing relationships are those where your partnership as designer or photographer is with a party or parties who (and assuming you are also able to negotiate terms for your own use which make sense to you) have the potential power to take your brand beyond the scope and richness of your own personal professional network.

Summary

The movement of images to different contexts for new purposes has been possible since the invention of photography. What was originally a manual process, allowing intellectual property owners to easily monitor where and how their film-based images were being re-used, today is extremely difficult to police. The digital revolution has brought benefits for users of visual assets, with their duplication and dissemination almost instantaneous in our online lives. However, this fast-tracking of sharing files from party-to-party can bring headaches too.

Implementing a considered methodology for your business to facilitate the best use of your photographs in-house via keywording is a first step to good practice. Secondly, circulating images via effective keywording will allow your work to travel online to the *right* markets for your story via appropriate licensing. This process might be managed by you, your image makers, third party syndicators or a mixture of all three. These are steps to making your brand powerful and ultimately more profitable.

Fig. 17.3

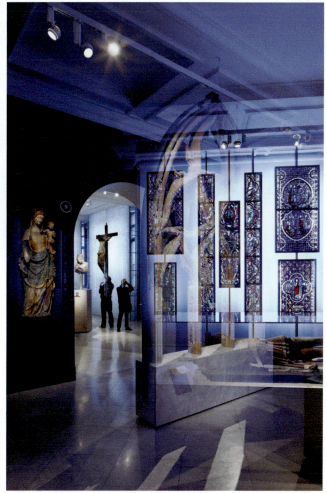

Fig. 17.4

CHAPTER 17
TAKE-OUTS

▶ With an understanding of Google's E-A-T, try to make sure that the images others seek when they conduct an online search are the ones *you* are vested in.

▶ Beware of uploading orphans – images which have no traceable owner.

▶ Assuming you have the software to facilitate it, get into the habit of keywording your work. It will help people in your own business find the right pictures for the job they're doing (think about all nine stages of the project design and delivery cycle).

▶ Once your work is online, know that well keyworded photographs are more likely to be discovered by ranking higher in search outcomes.

▶ Understand the difference between Rights-managed (a limited licence with a set term of use) and Royalty-free (a 'buy-out', meaning that you do not need to negotiate future use).

▶ Remember that both models are non-exclusive – meaning that they may be re-licensed to other parties on the same or different terms.

▶ Know that you may track the life of an online image through Reverse Image Search and discover who else is using the same image file in other websites, editorials and news.

▶ Be aware that when you upload images for news stories or to online portals, the terms of submission may mean that whilst you are not parting with copyright, you're losing control of almost everything else relating to that image's onward dissemination. This may even include moral rights: the right to be named.

▶ Keep an eye out for unscrupulous use of your work. It happens. As rights holder, you may legally pursue infringements.

Photography for Architects: What's next?

In the fast-moving world of the web and new technologies, there are shifts and changes afoot. We have discussed the circulation and use of images created by us, but there are big implications for our creative professional lives as designers and image makers if we begin to think about automated and machine-made content creation. Head to the final section of the book to see where this concept may take us. For now, it's important to ringfence what we do *today* with our approach to visual communication.

The last 17 chapters have taken us from a start where architectural photography may have been a part of your professional annual workflow ... or not. By now, even if it wasn't, hopefully the idea of embedding it is no longer theoretical or speculative, but ready to be *active*. Dependent on where you stand, I propose a strategy for future image management within your business.

Here, a considered approach for image procurement for your practice – *a model for working* is arrived at. This is what we've been building on throughout *Photography for Architects*. Two strands are proposed. The first is about photographic practice itself. It is based on my own business model and has evolved from a historic way of working in the days of film, but one which I continued after moving to digital capture. It offers a model for commissioning bespoke, quality, affordable, effective image creation and dissemination.

THE BIG PLAN 1

Photography for Architects – a strategy for your image makers

Peculiar to the publishing industry, there's a **First-Rights** licensing model which is, as its name indicates, the ability to protect works for a first usage, and it is a system with which I and my fellow architectural photographers have traditionally worked under with our editorial clients. In the past, the architectural press commissioned photographs, as explored in *Ch. 1 Contexts and frameworks: Foundations of the architectural image in print and press* and *Ch. 10 Getting your story out: Working with journalists.* This worked on the basis that a magazine or newspaper could be first-to-press with a story about a newly completed building. The title commissioned the photographer for a modest sum which generally covered the travel expenses, film and processing element of the shoot, plus a very small working fee.

This placed the photographer somewhat in a risk position.

However, once published, the images and the full rights were handed straight back to the photographer for onward sale and distribution, and the photographic practitioner would immediately broker the work to the respective architectural team and their delivery partners for *their* own continuing use in marketing. It created an informal, yet *collaborative licensing system* for shooters which, long *after* the first-rights tradition with the architectural press have ceased to be the norm in the building industry, still endures.

Myself and other photographers, who I've associated with across the years and have contributed to this book, have built on this same principle by setting up *pre-defined funding frameworks* for the procurement of photography. These arrangements facilitate equitable, non-exclusive licensing across multiple parties involved in a build.

For me, in a time when low-fee shooters flood the market, and every architect carries a phone, this approach still works for my business model. It seems to work for many of my contemporaries too. Top line architectural photography of the nature described in this book is not a two-penny investment. As seen, it takes time, skill and the effective management of multiple factors to realise a successful, highly creative outcome.

To respect the legal rights afforded to a maker of rights-bearing work, facilitating them to disseminate high-quality photography across teams with a vested interest in a building project is logical. Everyone gets that same set of approved, high-end pictures. Everyone shares the financial load, and the image maker is paid a fee commensurate with that effort. Moreover, in the context of this chapter, Google places high value on the assets within its E-A-T parameters.

The resulting photographs and films become the 'face' of that project; trusted, powerful, high ranking in page results and, happily for all parties, an assurance of being *Forever in View*. This creates a suggested pathway to negotiate with image makers who work for you *outside* your direct employment.

▷

* Every single one of these photographs is the result of a framework agreement between myself and my architect clients. It is then brokered across the design and delivery teams, ranging from two to a dozen parties in total. Each contributor receives the same set of pictures with a non-exclusive licence. The copyright remains with the photographer, in this case © Martine Hamilton Knight, but the conditions granted to the licensees permit them to use the work in-house across platforms for their marketing and PR including marketing, fee-bids and design award submissions. Images may not be passed to third parties for onward use. Moral rights are asserted.

Fees and expenses are shared equitably. The original client, in my case most often the architects themselves, handles the instruction. They liaise with their own client in relation to site access for me and deal with any information exchange which needs to take place to facilitate the legal and access arrangements.

Architects supply drawings, a shot list and gather other contributors' requests for images. At this point an estimate for the work is prepared. When the architect and client agree that the site is ready for photography, I then conduct my own research ahead of the shoot, contacting the occupants to arrange a mutually convenient window of time. This is then pre-determined by weather/activity on site and image making takes place when the two conditions best align. Any paperwork relating to consents (legal and ethical) needs to have been prepared ahead of time. Depending on the scale of the project, sometimes extra assistance on site is needed to help facilitate the administration of this.

The day of the shoot is long, intensive and energised. There is always much to achieve and the number of variables between anticipation and reality on location can be extensive. From lighting challenges, street-casting, set styling … *Photography for Architects* has taken the last 17 chapters to discuss this.

Following the shoot, postproduction may take several days, at which point I release a set of proofs to my client for image selection. Dependent on the framework, either some or all of the photographs are put through retouching and image-finishing before distribution to all. Work is provided via online transfer, together with licence and billing details.

Now, the onus shifts to everyone within the circle to begin working with their pictures as they choose, speaking about them to their respective audiences. Each post or publication *names, validates and extends* the visibility of both the project in question and the team involved. Google listens through the keyword chain, and swiftly, that set of pictures become dominant in search, taking the word (and of course, pictures!) out.

Job done.

* Project credits are listed at the end of the chapter.

The second pathway is about your future image management, a plan which may encompass people in your team, working with specialist image makers like myself or be a role fulfilled by you personally.

THE BIG PLAN 2

Photography for Architects
– a strategy for your business

If you are the architect-photographer, or directing in-house image makers, it's that same policy I'm advocating – make pictures *work hard*. There is every reason to be discerning with how you approach the visual capture of your projects. You are in control.

- You now understand the value in making your existing visual folio cohesive in its appearance: discard poor images that do not communicate your brand values.
- For whatever kit you're working with to make images, upskill to the best of your ability. Whatever limitations you're working with, do your best to remove full automation and become the one who is in control of focal length, exposure and composition. It will pay dividends.
- Define the right time for image making by choosing the time of life in the building and its occupancy, the time of year and calculate the real deadlines driving your need for pictures.
- Set a brief for the work. Don't just go out there to shoot. Plan how the pictures are to be used today, tomorrow and thereafter.
- Develop an imaging strategy and embed it into your practice's Plan of Work. Use the 9-Stage Image Cycle.
- Will you communicate with writers and specialist third parties to share your story?
- Will targeted, curated social media become part of your communication strategy?
- Consider longer-term goals of transforming your current projects into ones with legacy value. Map awards and milestone markers into your imaging plan.
- Understand the rules of navigation to safe productivity. Know the legal and ethical frameworks surrounding image production in your part of the world.
- Finally, use the same approach as specialist architectural image makers cited in *Photography for Architects*. Make your pictures work effectively for you, but also those you work with. Be effective with your metadata and keywording, assert your copyright and moral rights, be known for who you are and what you do.

In conclusion, 'being known for who you are and what you do' through effective photography and moving image has been the story of this book.

Project credits for final image collage

Row 1

Curzon Building, Birmingham City University
ASSOCIATED ARCHITECTS

BIC: Wellcome Genome Centre, Cambridge
FAIRHURSTS DESIGN GROUP LTD

Wixams Academy, Bedfordshire
LUNGFISH ARCHITECTS

Row 2

Lincoln Transport Interchange
JOHN ROBERTS ARCHITECTS

Vijay Patel Building, De Montfort University, Leicester
CPMG ARCHITECTS

George Green Library, University of Nottingham
HOPKINS ARCHITECTS

Row 3

No.1 Nottingham Science Park
STUDIO EGRET WEST

Oakdene Farm, North Yorkshire
HORSLEY TOWNSEND ARCHITECTS

Derby Arena
FAULKNERBROWNS

Row 4

Green Street Housing, Nottingham
MARSH:GROCHOWSKI ARCHITECTS

The Curve, Teesside University
AUSTIN-SMITH: LORD

Afterworld

Chapter 18

▷ TOMORROW IS TODAY

Future technologies

We've spent the last 500, or so, pages talking about your practice and the role that image making plays within it today. There have been multiple discussions around your agency in embedding photography and video as a strategic part of your business when it comes to the way you *see*, and are *seen*.

Having concluded what's *now*, it would be foolhardy to leave this book without touching on what's *next*. Following a century of stability in analogue film-based photography and moving-image from 1900 to 2000, technology is galloping away from us. Indeed, it could be argued that since the broad adoption of digital imaging, developments have never stopped in their momentum.

In 2003, having moved her business from analogue film to digital capture, Sally Ann Norman wrote a compact guide for her clients educating them on how best to work with the new files. Her conclusion stated: "Digital photography is an enormous subject and the technology is still in its infancy. In less than ten years' time, this booklet will be comical."[1]

1 Sally Ann Norman's booklet, titled "The best brief guide to digital photographs ever," was self-published in 2003 and designed for clients to accompany the CD-Roms she was sending out at the time. These contained photographs commissioned by them. It was sponsored by Arts Council England and One North East.

▷

What comes next in the world of photography and moving image? Are we shooting to the moon?

It would be wrong to simply conclude *Photography for Architects* by proposing a strategy for operation today, without giving a sense of its legitimacy for the future.

As every digital user knows, technology is ever-changing. This chapter gives a sense of what may come in the image making 'after-world'.

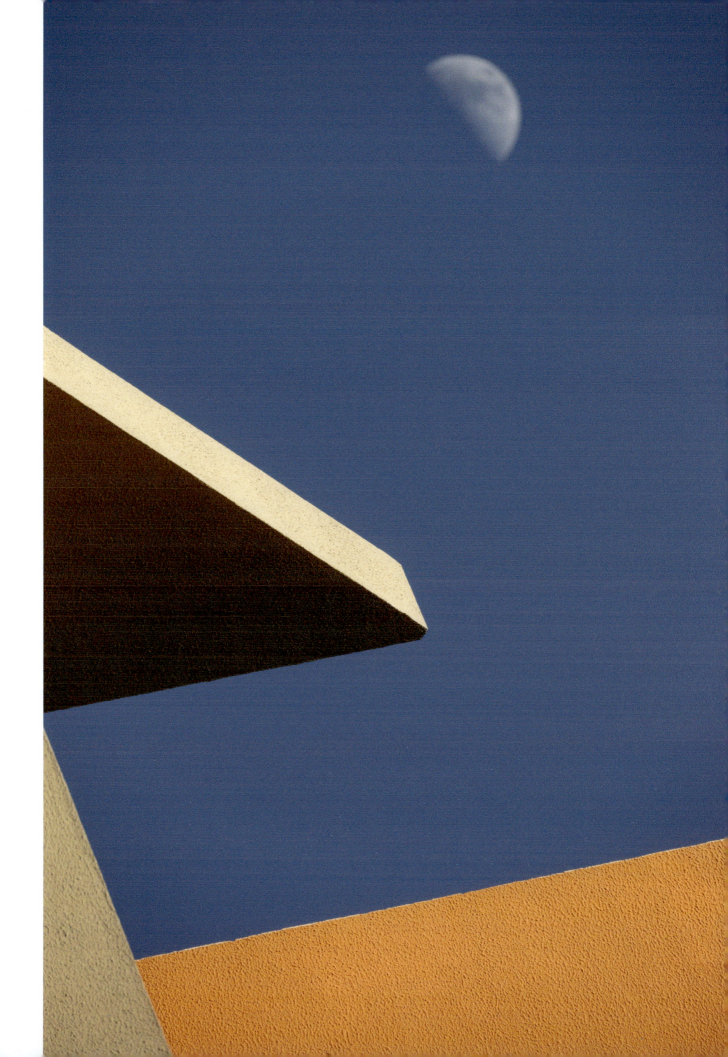

Two decades have now passed, and she was wrong about the comedy. Sally's advice regarding file types, their printing and storage still stands, but the sands continually are shifting. This places me in a tricky position. Should *Photography for Architects* robustly investigate the myriad of options at our doors and offer a pathway for imaging investment? The trouble with early adoption is that it is fraught with risk. Risk is a game that only smart businesses with an appetite, coupled with a hefty financial buffer, allows them to explore without fear of major damage.

On the basis that the majority of readers will be in small to medium practices with great ambition, but whose bank balances are modest, it seems sensible just to touch on what advances are being made, what's out there *now*. Speculation about what's *coming* is simply that: conjecture. As multi-disciplinary software specialist, Alan Warburton, stated in 2022: "... digital media, techniques, materials, labour markets and workers are constantly mutating (because new media, of course, continues to be new)."

He elaborates further: "... working with emergent platforms involves the creation of entirely new workflows, creative strategies and algorithmic techniques that attempt to match or exceed the standards of fidelity, immersion and photorealism that prior platforms provided."[2]

The 'photorealism' that we've been seeing since spring 2023 in the form of Artificial Intelligence (AI) outputs, evolves in its sophistication almost daily. On this basis alone, I've made the decision not to illustrate this chapter. Everything I write about here has the potential to be superseded in output and application rapidly, but words alone can act as prompts for further enquiry. Images to illustrate those points may invite the comedic reactions which we've just been speaking of. On this basis, here is a brief guide to what's already in use and that which is on the 'verge of mainstream' at the point of publication.

3D image capture with your phone

In addition to still and moving 2D representations which we are familiar with, the affordability and accessibility of 3D capture should also be considered as part of your business. Even without investing in high-end specialist kit, the latest generation of smartphones can create and process this data, so quite plausibly, it is technology that you already have in your possession but might not be actively utilising.

Some high-end smartphones can create 3D renders of built environments using their built-in hardware and software technologies. Images made with them are generated using **Lidar** principles and combined with multiple photographs to create **Photogrammetry**.

The two technologies are different and work together to create an outcome:

- Lidar, which stands for **Light Detection and Ranging**, creates 3D depth-maps by using high-resolution infrared laser scans overlaying real life spaces. Radar is radio waves, Lidar is light waves, and it has been in existence since the 1960s.
- Photogrammetry is multiple individual photographs taken from different angles around the same subject and stitched together to create 3D renders.

2 Alan Warburton, "Soft Subjects: Hybrid Labour in Media Software," in *The Networked Image in Post-Digital Culture*, ed. Andrew Dewdney and Katrina Sluis (Abingdon, Oxon: Routledge, 2022), 117 and 125. This book is a collection of pieces examining the fluidity of the image in today's society.

Using both methods to capture data, the measurements and images are then blended seamlessly into a composite 3D image by an in-phone app. The app processes the files to create an output of an environment revealing texture and modelling of surfaces which can be displayed, rotated and seen from multiple different viewpoints.

Let's drill down a little further into the laser-measurement aspect.

3D Lidar capture

- Lidar uses ultraviolet, visible or near infrared light to record the relative depth of objects by measuring the time delay of a laser beam's reflectance.
- Whilst traditional lidar is used for mapping and meteorology, deployed at long distances from aircraft and satellites, lidar emitters on phones can only detect surfaces at relatively close quarters – mapping objects which are usually under 5m from the camera.
- This means high ceilings and large-scale objects where certain surfaces are beyond this reach are not possible.
- For smaller environments, domestic residences, showrooms, architectural models and sculptures it is ideal. The outcomes are compelling, allowing detailed inspection and understanding of form, depth and dimension.
- Because lidar works by measuring distances based on interpreting light waves reflected from the object back to the sensor, low light capture (or even dark capture) is still possible to give an outcome. With a phone or standalone camera, conventional image making requires a reasonable amount of light to be successful, so this presents an alternative to recording spaces with modest volumes in restricted light.
- As an interesting side bar, using lidar allows you to record fairly accurate measurements of the objects or spaces that you're scanning. When surveying sites, this could be extremely useful.

The iPhone 12 Pro versions upwards have the facility built in. A variety of different app manufacturers make sense of the data, compiling it into finished 3D image files for saving and re-viewing. At the time of writing there is *no* Android device currently capable of such capture. Indeed, Samsung dropped the sensor from its Galaxy S21 back in 2021 and announced that its successor, the S22, wouldn't possess one either.[3] Polycam was developed for iOS, but has been available for Android since 2022. Another alternative is 3D Live Scanner, an Android app which is compatible with Sketchfab for viewing files once generated.

Apple's built-in iOS operating system currently only allows the viewing and manipulation of 3D renders natively. To capture and process a lidar scan on an iPhone Pro, one will need to download a dedicated app to access the lidar scanner. There are multiple apps on the Appstore that are either free or subscription based.

If you're an iPhone owner, how might such renders be best employed in your business? They're incredibly useful when making surveys for projects and conveying space, but probably less useful for marketing with. They impress for sure, but perhaps don't facilitate emotion and empathy in the way a curated still image or filmic moment can.

3 "Will 3D Depth Cameras Return to Android Phones?" *edge ai + vision*, 1 April 2022, www.edge-ai-vision. com/2022/04/will-3d-depth-cameras-return-to-android-phones/ (originally published at Yole D éveloppement's website).

Virtual tours

Often associated with real-estate and tourism but different to CGI fly-throughs whose speed is pre-determined, virtual photo tours have been around for a while. They take a set route around a structure, allowing the viewer limited interactivity in the process, whilst giving a decent general impression of a built environment. Separate again, 3D experiences of the type engaged with via a headset are usually computer created environments as opposed to live footage, and more utilised for gaming.

Where recent growth has taken place is via virtual environment software. Again, it uses a form of lidar and can be utilised by non-specialist operators, most notably badged under providers such as Matterport, VPiX and Autodesk. Broadly speaking, their dedicated cameras create 360-degree panoramic images which are viewed in **equirectangular** form via Enscape or Autodesk 3DS Max, for example.[4]

Instead of them being flattened in static capture, the 3D content allows a viewer to move the view position via a keyboard or mouse action and self-navigate the space as if walking through it, without being restricted to a single pre-recorded axis.

With Matterport's own capture system, both 2D and 3D recording is possible, and anchor points can be GPS geo-tagged and located for accuracy. Further information may be added to these anchor tags allowing creators to annotate tours with supplementary explanatory text anchored on objects of interest. For retailers and tour operators, the ability to 'upsell' or simply provide enhanced descriptions of objects and products displayed in a space is good commercial sense.

At the time of publication of *Photography for Architects*, Matterport dominated the marketplace for this type of image capture, having floated on the NASDAQ in July 2021.

It operates on what's known as a 'freemium' business model, whereby limited access to the platform is given for free, with premiums granting accessibility to enhanced features and functionality of its cloud platform. Whilst Matterport and Autodesk are competitors, they both centralise on facilitating Autodesk BIM 360, which places their respective software as a likely choice for architects over and above other providers. Matterport's own Pro3 camera creates 134MP, 4K files which yield a high-quality viewer experience, although other camera manufacturers such as Ricoh produce a camera that also works with Matterport's software.

This company also offers a cut-back programme for use via capture on both iPhone and Android systems. Whichever form of 3D tour, either on consumer smartphones or via one of the dedicated cameras, the argument for a place in the toolbox for this technology by architects is compelling. I have seen a rapid increase in my clients engaging with the system, mostly at the point of practical completion and handover, as a first-sight tour of new projects.

4 Equirerectangular images have a distinctive look, epitomised by the 360-degree view of the planet in atlases, flattened out in order to be able to see all continents and both poles. In these images, all verticals run up the page, whilst the horizontal axis runs L–R despite the reality of the 3D form being otherwise.

I chatted to photographer Tim Griffith who made some observations about the difference in the service area that 360 VR views address. He recalled a conversation with a client not long after digital capture first came into being, who said:

> Don't forget we are paying you for as much as what you DON'T show, as we are for what you do. We don't want to see everything; we just want to show the good stuff. This is fundamentally what we are paying you for.[5]

It is a salient point. As Tim elaborates:

> It's about the intent of the image. Real Estate is a product for sale, but for architecture you are illustrating an 'idea'. Using Matterport imagery when you are buying a product, you need to see EVERYTHING. If you're renting a venue, it's great. For a more nuanced suggestion of a design aesthetic, a mood or an esoteric construct, that imagery doesn't translate well.

He knows another photographer whose clients are primarily hotels and clubs where the user wishes to see the full range of spaces. Where there is certainly potential for architects to utilise interactivity in the documentation of their work, Tim feels that architects have yet to embrace this:

> Architectural Photography is about communicating the 'experience' of being there, in lieu of actually 'being there.' What technologies like Matterport offer at the moment is fairly new and architects are still exploring ways to utilise it. For the moment at least, they can't place it in an award submission, or in a print form. But it works in a meeting, say for in-house uses, or for presentations within bids. So, I guess it comes back to how our clients expect to use their imagery. The technology has yet to establish its 'long term' value. Does it have legacy in the same way as still images? Will the files even be readable in 20 years? There are multiple considerations to think about.

Certainly, being able to walk through a space at one's own speed, browsing details and then clicking through to discover more about various aspects placed in there is very helpful to a shopper/researcher. At the time of writing, I've not come across it being embedded into possible criteria for award submissions but it could find a good place elsewhere, perhaps in bids, in the same way as augmented reality.

Happily, the need for 'real' photography and filming from a narrative standpoint remains currently unaffected. Navigational tours, whilst immersive and insightful, are unlikely to create emotive and memorable outcomes in the same manner as a stunning single frame or a narrative-driven film, which gives the viewer opportunity to contemplate and reflect upon.

The final area for discussion in this book relates to image making which *doesn't* involve wielding a camera or fall within the realms of creation by you, your colleagues or anyone you may personally employ. Aligned to a number of different technologies, it both creates and also makes redundant a wide number of tasks currently undertaken by us in our architecturally related professions.

5 Tim Griffith, personal conversation with author, 11 July 2022.

Machine learning and AI created visual content

This is the world of Artificial Intelligence and the ability for content to be completely software generated. This technology has been around for some time and rapidly developing in its sophistication. For visual content, advances in motion graphics and gaming have moved far beyond entertainment as a marketplace and have been adopted across other industries. In your practice, you are likely to be well-versed in creating simulated environments as a part of the planning process.

Immersive gaming environments built using platforms such as Blender and Unreal Engine may be harnessed by planners and designers to authentically 'road test' place and space prior to realisation.[6] Their architecture section strapline invites you to 'design tomorrow, experience today' and features simulations of buildings we know. Doubtless, these real structures were conceptualized using software of this ilk, sent for approval to planners and subsequently constructed. Unity's blurb invites you to connect your BIM data and proposes that every part of the AECO (Architecture, Engineering, Construction and Operation) cycle can be integrated.[7]

Computer software eases the designer's workload, refining and simplifying tasks. Education in interfacing with this technology is in demand. Isabel Allen reflected on the broader need for the workplace to upskill when she was speaking about content scheduling for Architecture Today:

> "The urgent need to deliver a net zero construction industry has generated an unprecedented thirst for technical information. Rapidly changing regulations, and a super-informed client base, are putting pressure on architects to skill up and learn fast, and, in many cases, to forget and re-assess everything they thought they knew. I think this will inevitably lead to a blurring of the boundaries between communications and education. Over the last couple of years, we have seen a step change in demand for technical articles and webinars, and I'm sure this will only increase."

Clearly, investment into such technology is substantial, but as a lifelong traditional image maker I ponder over whether the need or desire to send a photographer or filmmaker out into the field will gradually fade. With the continued convergence of gaming and visualisation software through photographic realism *and* the ability for machines to self-generate compelling outcomes, why keep doing it for real?

There's a different level of 'acceptance' over our comfort with what we 'know' to be *not-real*, versus the feeling that are being 'hood-winked' and challenged when presented with a text or visual outcome which traditionally has been the result of a fully human endeavour.

As far back as 2013, homeware giant IKEA has not been photographing its room sets, but instead showing spaces in its catalogue which mimic domestic environments through ultra-realistic photographic representations. At that point IKEA began offering their customers the opportunity to project virtual items of furniture into their own home, using an app for Android and iPhones, in conjunction with images screen-grabbed from their paper catalogue. Even then, IKEA described their catalogue as featuring '3D renders', rather than 'actual photographs'.

6 https://www.unrealengine.com/en-US, https://www.blender.org

7 https://unity.com/solutions/architecture-engineering-construction

Currently, software cannot teach itself. For sure, it builds knowledge through repetition of task, but it is greatly assisted by the assertion and validation of human workers cross-referencing its own attempts to learn.[8] At the time of writing, we've been grappling with the assimilation of ChatGPT into our professional lives. It is still currently possible to discern the software's outputs against our own. Recently, I've assessed a handful of student submissions and have witnessed a style which can only be described as 'vanilla'. Overly upbeat, the language used to articulate their work comes across as overwhelmingly positive and polite, and with similarities in phraseology across one set of papers to another.

Doubtless this will continue to be refined. The more noticeable traits of 'assistance' will become increasingly difficult to question, until we are 'sure' we are reading content which we would expect from a person we know and therefore trust. Is this troubling?

For image-based content, the ability of the software to return what you ask for when you describe something you want it to create is in the specificity of the language used to request it. Asking for 'a house with a garden' is one thing but wanting a 'sunrise with a two-storey thatch-roofed cottage and a garden on the front', or a 'Maine beachfront house in the rain' infers an actual vernacular. This is enhanced further with an instruction on *how* to render the light falling on that scene together with the appropriate shadow massing and colour temperature.

Google Bard, 'your creative and helpful collaborator' (their words), pulls information off the web and includes images in its answers. In their user instructions they encourage the uploading of photographs to use in the assistance of generating outputs, giving examples of prompts to use with them such as: Help me finish my art...[9] The greater the number of Maine beachfront houses we upload for it to work with, the more it can do to seamlessly generate the photograph you'd take in real life.

At least Google Bard is *asking* you to share your photographs with it.

Data mining and IP challenges

With all this newly created 'creative' content, there are enormous implications for intellectual property. Debates are raging within government bodies about how best to police the assets and economic values in machine-assisted or fully AI generated outcomes.

In 2022, the UK announced a proposed amendment to the previously advantageous CDPA 1988. It concerns AI, **Text and Data Mining** (TDM) and introduces an exception to copyright protection for creatives. If adopted, it will allow commercial exploitation through machine-mining of all imagery digitally published online. For photographers and architects with content-rich images of built environments which are currently copyright protected, this exception circumvents the licensing process. Practically speaking this means that bots/crawlers will access websites at neural speeds, extracting images and embedded metadata, making fresh copies for AI platforms to 'learn' with and create new visual outcomes. Outside the UK, other countries are exploring in parallel how to police the IP issue.

8 Look at *Amazon Mechanical Turk* (MTurk) whereby ranks of crowd-sourced remote workers may be assembled to carry out labour tasks such as data collection, analysis and accelerate machine-learning development.

9 https://support.google.com/bard/answer/13275745?hl=en&co=GENIE.Platform%3DAndroid

There has been an admission by more than one company in the 'scraping' of data from millions of pictures online for use in training their programmes.[10] Legal action is taking place with heavy financial penalties issued, but the cat is out of the bag and there is likely to be little come back for those whose copyright protected assets have been utilised. You can see if your photographs or design visuals have been harnessed in this way by checking with a website called '*Have I been trained?*'[11]

In a 'dystopian' type scenario, AI's utilisation of original design work and imagery creates a man vs machine-endeavour marketplace for independent creative output. Artistic endeavour was previously seen as one of a human being's unique attributes. This is troubling. The UK's Association of Photographers suggests that your website contains stringent instructions within the Terms and Conditions page prohibiting such activities from taking place. If you assert that data mining of your visual media is *not* permitted in writing, perhaps your intellectual property can be ring-fenced for the time being.

Photographers I know are investigating programmes such as DALL-E 2, Midjourney and Stable Diffusion to create work with. Adobe Photoshop is learning swiftly as I consider whether to accept or reject content in-fills it proposes for re-touching 'fixes'. Yet I have to confess that I embrace such things with reluctance. I took pride in diligently clicking away on my Wacom Tablet and removing the bunting from the front of John Carr's elegant Newark Town Hall (p.37) for *The Buildings of England.* Yet these hours of work can now be attempted in seconds, simply through an input of written instructions. What's not to like? Surely, I can spend my time more profitably elsewhere?

Photo libraries such as Shutterstock have paid close attention. Back in 2021, they spent $75 million acquiring the 3D-render stock agency TurboSquid.[12] These assets comprised software generated images, and Shutterstock's customer base soared during the 2020 global lockdown at a time when actual, physical photographic shooting was curtailed by the pandemic. Today they're transparent about their collections of 'traditional' photographs and moving image, together with their rapidly expanding AI generated content. They overtly invite creatives to join them and make new content for it, stating that they (Shutterstock) are operating under their own ethical code.[13]

The final word

Certainly, artificial intelligence is rapidly advancing its prowess in design innovation and true-to-life renderings. This, in turn, will create outcomes which can be mass manufactured and distributed. Whether these are *things*, or as we are discussing here, *image-based content*, is almost irrelevant.

Whilst the time, financial commitment and processing power needed to generate virtual built environment tableaus is still considerable, and whatever one's personal view on the subject, it's coming to make its place in our lives. Throughout the writing of this book, there was a sense that it was coming very soon. As I sign off, I know it is here *now*.

Legally and ethically, the governments of this world must swiftly create a set of codes which we can comfortably live by. Lobbying bodies such as WAI (Women

10 https://petapixel.com/2023/03/29/clearview-ai-has-scraped-more-than-30-billion-photos-from-social-media/ plus https://petapixel.com/2022/12/21/midjourny-founder-admits-to-using-a-hundred-million-images-without-consent/ and https://petapixel.com/2022/05/23/clearview-ai-fined-9-5-million-for-illegally-collecting-peoples-photos/ There are doubtless others complicit in this activity.

11 https://haveibeentrained.com explores the Laion-5B and Laion-400M image datasets, which at the time of publication are the largest public text-to-image datasets. They're used by models including Stable Diffusion, Stability AI and Imagen, which AI systems utilize to create new works. Laion doesn't host the works, merely the urls where the images are hosted, therefore they're not breaching existing copyright laws. *Have I been trained?* has been set up with a group called Spawning, who, once you have registered with them allow you to request removal of work and opt in or out of future permissions.

12 https://investor.shutterstock.com/news-releases/news-release-details/shutterstock-acquire-turbosquid-worlds-largest-3d-marketplace

13 https://www.shutterstock.com/blog/shutterstock-building-ethical-ai is a blog which speaks about Shutterstock's approach to using AI as an aide for human creative thinking.

in AI) are trying to encourage career pathways for women and minorities in the sector. They have members in 140 countries.[14] This is just one example in the field promoting new professional pathways, but also trying to protect the worth of humans in their own right.

A final conversation with the writer of *Photography for Architects'* foreword, Lynne Bryant, on the subject daunts me and drives me towards new areas of research as I close this book. She questioned, could AI jeapoardise the viability of architectural studios themselves? The data mining affecting photographers' visual output has doubtless been plundering the vast global vaults of online planning applications and design proposals too. This wealth of material, when coupled with our images of projects, provides machines with an ability to manage the *entire* design cycle. Now that's dystopian.

Collectively, architects and image makers will need to swiftly apply cognitive thinking and place a value – both monetarily and morally – on our own endeavours, and *not* leave it to cognitive AI to apply its own.

For now, at least, and hopefully *always,* there will be a good number of architectural firms who want to show their built projects photographically. This promotes the requirement for strong image making, of *real, living structures in use*, being enjoyed by the humans they were created for. The best images will win.

14 https://www.womeninai.co

ALMANAC AND GENERAL READING

This section is an appendage to the book, allowing a cross referencing opportunity for independent research and enquiry by readers. It will also function as a gazetteer to the contributors who have provided information and insights for chapters.

Books

On the history of architectural photography

As a division of photography itself, there are few books on the subject; however, the built environment is always featured in general photography history books. The few specialist titles that contribute to historical understanding include:

Elwall, Robert. 2004. *Building with Light – The International History of Architectural Photography*. London: Merrell Publishers.

Higgott, Andrew, and Timothy Wray (eds). 2012. *Camera Constructs: Photography, Architecture and the Modern City*. Oxon: Routledge.

Redstone, Elias, Pedro Gadanho and Kate Bush. 2014. *Shooting Space – Architecture in Contemporary Photography*. London: Phaidon Press.

Shulman, Julius. 1998. *Julius Shulman – Architecture and its Photography*. Cologne: Taschen.

On learning photography, postproduction, and lighting

There are so many 'how-to's' online and in printed materials that it is difficult to isolate titles, but these three offer not simply the 'how', but also the 'why':

Hirsh, Robert, and Greg Erf. 2018. *Light and Lens – Photography in the Digital Age*, 3rd ed. New York: Routledge.

Suler, John, and Richard D.Zakia. 2018. *Perception and Imaging: Photography as a Way of Seeing*, 5th ed. New York: Routledge.

Hunter, Fil, Steven Biver, Paul Fuqua, and Robin Reid. 2021. *Light, Science & Magic – An Introduction to Photographic Lighting*, 6th ed. New York: Routledge.

On architectural photography – 'how to' guides

In a book about architectural photography, many might expect a full guide on how to operate the tools. However, this aspect is well covered in the two books listed; hence the conversations in *Photography for Architects* have been happily focused on other vital considerations. If you are making pictures of your projects, both shown here will assist:

Ewing, James. 2017. *Follow the Sun – A Field Guide to Architectural Photography in the Digital Age.* New York: Routledge.

Schulz, Adrian. 2015. *Architectural Photography – Composition, Capture and Digital Image Processing*, 3rd ed. Santa Barbara: Rocky Nook.

On copyright and legal matters

Part IV of this book uses footnotes for online resources, however, legalities affecting intellectual property, laws, and ethics are important for all creatives to keep abreast of and the following books offer more insight than space has allowed for in *Photography for Architects*:

For UK legislation

Dunmur, Nick, ed. 2023. *Beyond the Lens – Rights, Ethics and Business Practice in Professional Photography*, 5th ed. London: AOP (Association of Photographers).

For those with EU offices (written with an Irish marketplace in mind)

O'Flanagan, Michael. 2019. *Photography and the Law – Rights and Restrictions.* Oxon: Routledge.

For those trading in the USA

Greenberg, Edward C., and Jack Reznicki. 2015. *The Copyright Zone – A Legal Guide for Photographers and Artists in the Digital Age.* Oxon: Routledge.

Krages, Bert P. 2017. *Legal Handbook for Photographers – Rights and Liabilities of Making and Selling Images.* New York: Amherst Media.

Wolff, Nancy E. 2007. *The Professional Photographer's Legal Handbook.* New York: Allworth Press.

These guides, together with updates found online through case law, form the best recourse for understanding what rights and obligations image makers have.

An organisation which helps pursue financial copyright recognition for image use in publication is Picsel: https://picsel.org.uk

Directory

Contributing specialists to *Photography for Architects*

Isabel Allen
ARCHITECTURE TODAY

Isabel Allen is the editor of Architecture Today and Editorial Director of BEAM (Built Environment and Architecture Media). Previous roles include editor of *Architects' Journal*, *Citizen* magazine and curatorial posts for exhibitions including the London pavilions at Shanghai Expo 2010 and the 2019 Seoul Biennale. With four years on the Stirling Prize jury, Isabel is also an Honorary Fellow of the RIBA and a Fellow of the Royal Society of Arts.

www.architecturetoday.co.uk
Instagram: @arch_today

John Christophers
SUSTAINABLE ARCHITECTURE

Pioneering green architect and winner of the national RIBA Sustainability Award in 2005, John designed the UK's first zero carbon retrofit, his family home in Birmingham (2009). A former partner of Associated Architects, he now works as a freelance consultant and lecturer, advising on the intersection of design and sustainability. In 2022, he co-created Retrofit Reimagined festival, championing community-led neighbourhood retrofit and leading change in Birmingham's diverse inner-city areas.

www.zch.org.uk
Instagram: @zerocarbonhouse

Alex Coppock
COMMUNION ARCHITECTS

Founded by Alex Coppock in 2008 and specialising in ecclesiastical and residential design, Communion Architects works closely with people to deliver exceptional projects that transform spaces and change lives. Alex believes successful buildings are the result of people working together to deliver a shared vision. Communion designs closely with clients to deliver exactly what they need, building strong relationships with other stakeholders too, creating value, quality, reduced timescales, and cost.

www.communionarchitects.com
Instagram: @communion.architects

Liz Earwaker
GRIMSHAW

Director of Marketing and Communications at Grimshaw, Liz has a background in visual communications, managing photographic libraries early in her career. Today she combines this experience with copywriting and editorial expertise for the design and construction industry. Building brands and creating compelling campaigns, Liz has assisted architects, engineers, and contractors to effectively engage and connect with clients and stakeholders. Her role at Grimshaw involves working with the partners to manage the strategic vision and communications of this globally renowned architectural practice and their output.

www.grimshaw.global
Instagram: @grimshawarch

Stewart Hicks
BROADCASTER

Stewart Hicks is an Associate Professor at the University of Illinois at Chicago and an Associate Dean in the College of Architecture, Design and the Arts. He is the co-founder of the practice Design With Company and creator of the YouTube channel *Architecture with Stewart*. Featuring bi-weekly 10–15-minute videos and with over 385,000 subscribers and over 40 million views, Stewart explores a wide range of architectural topics with curiosity and humour.
www.youtube.com/channel/UCYAm24PkejQR2xMgJgn7xwg
Instagram: @stewart_hicks

Keleigh Swan
CREATIVE DIRECTOR

With a background in interdisciplinary visual arts and architecture, Keleigh collaborates on photography projects for world-class architects, artists, museums, creative agencies, publishers, and luxury travel brands. Co-owner and Creative Director of Ron Blunt Studio, Keleigh runs a consultancy with high-profile clients including Smithsonian, Apple, National Geographic, and Mandarin Oriental. She produces photographic portfolios, books, exhibits, and creative content featuring art, design, and the built environment.
www.ronbluntphoto.com
Instagram: @ronbluntphoto

James Timberlake
KIERANTIMBERLAKE

A founding partner at Philadelphia-based KieranTimberlake, James's influential work has been recognised with the Benjamin Latrobe Fellowship for design research from the AIA College of Fellows. Ground-breaking projects include the development of SmartWrap™ and Cellophane House™. Under his leadership the firm designed and completed the new US Embassy in London. Since 2002 he has co-authored eight books with his design partner, Stephen Kieran, and has been a visiting professor at several universities in the United States.
www.kierantimberlake.com
Instagram: @kierantimberlake

Contributing photographers

Richard Bryant

A trained architect, Richard Bryant's career encompasses a number of firsts, shooting Zaha Hadid's earliest built commission, Gehry and Ando's first international buildings, and the first photographer awarded an Honorary Fellowship of the RIBA. The choice of Foster, Rogers, and Stirling, he has worked with global brands including Armani, Bulgari, Gucci, and design consultancy Pentagram. With a substantial folio of historic subjects, ongoing personal projects include the output of Carlo Scarpa and his work is held by institutions and private collectors.

www.richardbryant.co.uk
www.richardbryantphoto.com
Instagram: @richardbryantphoto

Ron Blunt

Shooting globally from Washington, DC and Florida studios, Ron Blunt was born in England and tutored by the celebrated Magnum photographer Martin Parr. Curating images with bold colour and natural light, his clientele includes leading architects, designers, major museums, luxury hotels and resorts, advertising agencies, and cultural institutions. His architectural and design photographs are published worldwide and held in private collections.

www.ronbluntphoto.com
Instagram: @ronbluntphoto

Peter Durant

A London-based Austrian-British photographer working with international architectural practices as well as major museums, property developers, and manufacturers. Peter originally trained as a civil engineer, later studying photography. His photographs have been published in architectural and design magazines worldwide, as well as architectural books and monographs. With a keen interest in the history of photography, Peter has an understanding of the photographic print as fine art and his graphic compositions are often influenced by early modernism.

www.peterdurant.com
www.peterdurant.art
Instagram: @peterdurant

Tim Griffith

An Australian working from offices in Melbourne and San Francisco, Tim travels extensively on assignments in Asia, Europe, and North America for a number of the world's leading design firms. His inventive and crafted images are included in several private and public art collections, widely published in a diverse range of international design journals, and sought after by corporate and advertising clients around the world. Since 2011, Tim has been on the faculty of the Palm Springs Photo Festival.

www.timgriffith.com
Instagram: @timgriffithphoto

Daniel Hopkinson

Manchester-based Daniel Hopkinson works closely with his clients, striving to capture the joy of projects through light, people, and structure. A self-confessed sun chaser, his work has been published across the world in architectural books and journals. With a spell working in-house for a nationally based architectural practice, he understands the day-to-day needs of a client and using this insight he is able to deliver communicative imagery of the built environment.

www.danielhopkinson.com

Instagram: @danhoparchitecture

Hufton and Crow

Nick Hufton and Allan Crow were friends growing up in northern England. Today, their business is based in London from where they travel globally working together and sometimes on separate commissions. Using a mixture of ground and aerial capture, their images grace the covers of a wide range of titles as they shoot for household names. With a large following on social media, they understand the power of visual communication across a variety of media in both printed and online formats.

www.huftonandcrow.com

Instagram: @huftonandcrow

Keith Hunter

Based in Renfrew, Scotland, Keith photographs the very best of architectural design in the north of the UK and beyond. Working in his father's architectural practice during his formative years, he has an intrinsic understanding of the client's needs. With projects appearing regularly in publication, Keith takes great pride in producing creative high-quality images, with attention to detail and has a clear empathy with the people and places his images depict.

www.keithhunterphotography.com

Instagram: @keithhunterphotography

Sally Ann Norman

Born in north-east England, Sally discovered a passion for photography as a teenager shooting the industrial architecture of Teesside and the natural landscape of the Lake District. Initially focussing on the built environment and working for the architectural press, more recently Sally has pursued a long-term project about the Durham Coalfields, widening her interests, specialism, and client base. Today, her practice encompasses more editorial work, with a particular focus on construction and place.

www.sallyannnorman.com

Instagram: @sallyannnorman

General reading

Much of note has been given in chapter footnotes, but books, magazines, and online articles of related information empirical to my research are provided here.

Abrahams, Tim. 2022. "The Burrell Collection, Glasgow," *Architectural Record*, 5 April 2022. https://digital.bnpmedia.com/publication/?i=745418&article_id=4259377&view=articleBrowser

Boddy, Adrian. *Australian Architectural Photography and Architecture Australia.* www.adrianboddy.com/?p=683. Accessed 16 June 2022.

Davies, Paul, and Torsten Schmiedeknecht. 2005. *An Architect's Guide to Fame.* Oxford: Architectural Press/Elsevier.

Emms, Sue and Mark Emms. 2022. "The Lyth Building," *Architecture Today*, January & February 2022. Built Environment and Architecture Media Ltd.

Epead, Amany, and Ayman Othman. 2014. *Marketing Strategies for Promoting the Architectural Engineering Profession in a Rapidly Changing Business Environment*, March, Conference Paper, International Conference on Industry Academia Collaboration, Cairo, Egypt, Volume 1.

Frosh, Paul. 2013. "Beyond the Image Bank: Digital Commercial Photography." In M. Lister, ed. *The Photographic Image in Digital Culture*, 2nd ed. London: Routledge, 131–48.

Gaffney, Kieran. 2022. "The Burrell Collection Renovation: For Better or Worse?" *RIBA Journal*, 10 May, www.ribaj.com/buildings/the-burrell-collection-gallery-glasgow-john-mcaslan-and-partners

Hannay, Patrick. 2009. *No Break Out Insight.* University of Wales Institute, Cardiff, UK 1 Proceedings of the Conference held at the Occupation: Negotiations with University of Brighton 2–4 July.

Hartman, Hattie. 2013. "King's School Boathouse by Associated Architects," *Architects' Journal*, 27 March, EMAP, www.architectsjournal.co.uk/archive/kings-school-boathouse-by-associated-architects

Higgott, Andrew, and Timothy Wray (eds). 2012. *Camera Constructs: Photography, Architecture and the Modern City.* Oxon: Routledge.

Koren, David. 2005. *The Architect's Essentials of Marketing.* New Jersey: John Wiley & Sons Inc.

Kieran, Stephen, and James Timberlake. 2019. *KieranTimberlake: Fullness.* New York: Monacelli Press.

Knikker, Jan. 2021. *How to Win Work: The Architect's Guide to Business Development and Marketing.* London: RIBA Publishing.

Lester, Paul Martin. 2018. *Visual Ethics – A guide for Photographers, Journalists and Filmmakers.* New York: Routledge

Lindgren, Simon. 2017. *Digital Media and Society.* London: Sage Publications Ltd.

Mannering, Virginia, Camilla Burke, Laura Courtney, James Harbard, and Mitch Keddel. 2012. "We Don't Need Another Hero," *Architecture Australia*, September, issue online 4 December 2012. https://architectureau.com/articles/we-dont-need-another-hero/

Merrick, Jay. 2019. "Notre Dame: The Battle Between Architects to Design the Cathedral's New Spire is Already Causing Controversy," *iNews*, 19 April, https://inews.co.uk/news/world/notre-dame-the-battle-between-the-architects-to-design-the-cathedrals-new-spire-has-already-begun-282641

Merrick, Jay. 2022. "The Burrell Collection Reworked by John McAslan Architects," *Architects' Journal*, 14 April, EMAP, www.architectsjournal.co.uk/buildings/the-burrell-collection-reworked-by-john-mcaslan-architects

Mitrache, A. 2012. "Branding and Marketing – An Architect's Perspective," *Procedia, Social and Behavioural Sciences* 62: 932–6

Murphy, Douglas. 2012. *Owen, Dezeen, Photography, Criticism and its Decline, etc etc* – from blog - Enschwindet & Vergeht. 17 December, http://youyouidiot.blogspot.com

O'Donnell, Jennifer. 2022. "The Burrell Collection," *Architecture Today*, July, https://architecturetoday.co.uk/burrell-collection-john-mcaslan-scotland/

O'Hagan, Sean. 2018. "What Next for Photography in the Age of Instagram?" *The Guardian*, 14 October.

Pallister, James. 2013. "Picture Perfect – When Does Architectural Photography Flatter to Deceive?" *Architects' Journal*, 7 January, EMAP.

Pardo, Alona, David Company, and Elias Redstone. 2014. *Constructing Worlds: Photography and Architecture in the Modern Age*. London: Prestel.

Picton, Tom. 1979. "The Craven Image or the Apotheosis of the Architectural Photograph," *Architects' Journal*, 25 July, EMAP, p.189.

Picton, Tom. 1979. "The Craven Image Part 2," *Architects' Journal*, 1 August, EMAP, pp 225–42.

Ruiz, Javier. 2016. *Org Response to EU Consultation on Freedom of Panorama and Publishers' Neighbouring Rights*. www.openrightsgroup.org/publications/org-response-to-eu-consultation-on-freedom-of-panorama-and-publishers-neighbouring-right/

Volk, Larry, and Danielle Currier. 2021. *No Plastic Sleeves: The Complete Portfolio and Self-Promotion Guide*. 3rd ed. New York: Focal Press.

Wainwright, Oliver. 2015. "Carbuncle Cup: Walkie Talkie Wins Prize for Worst Building of the Year," *The Guardian*, 2 September.

INDEX